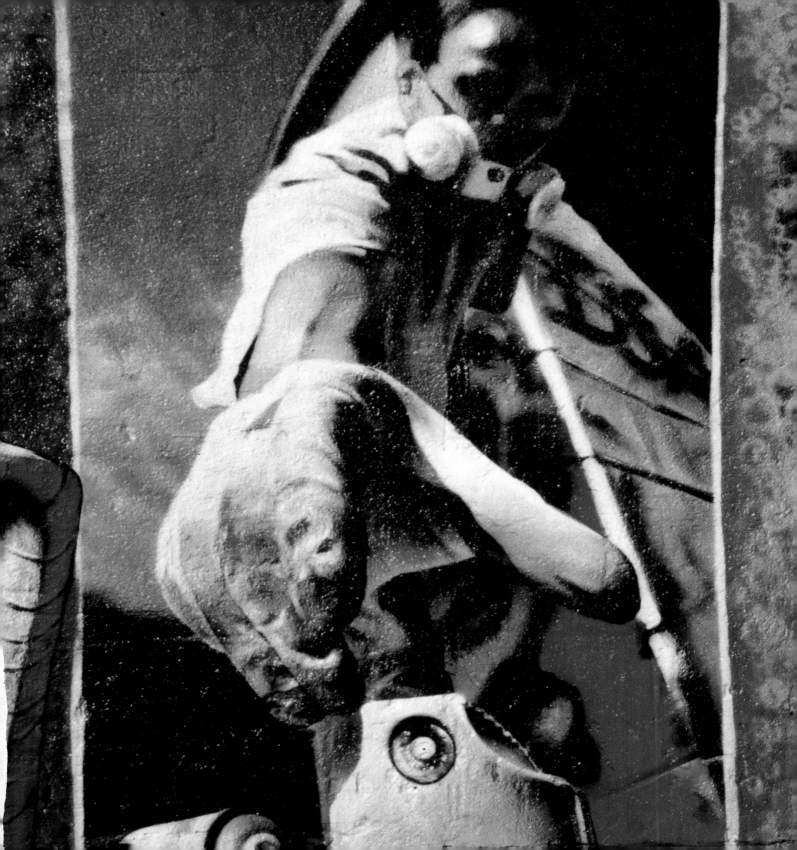

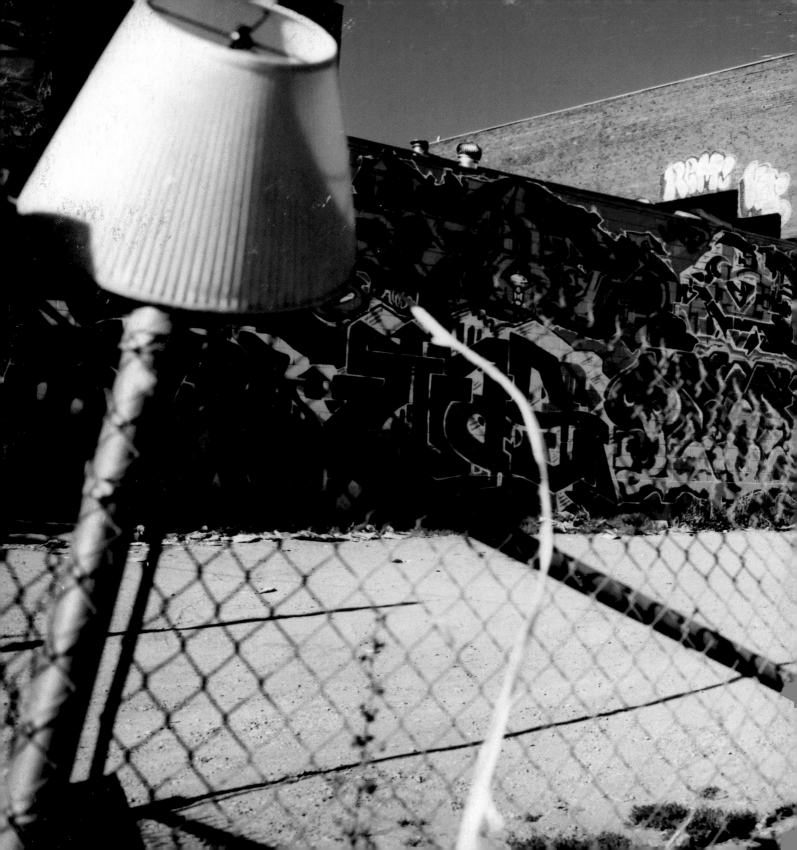

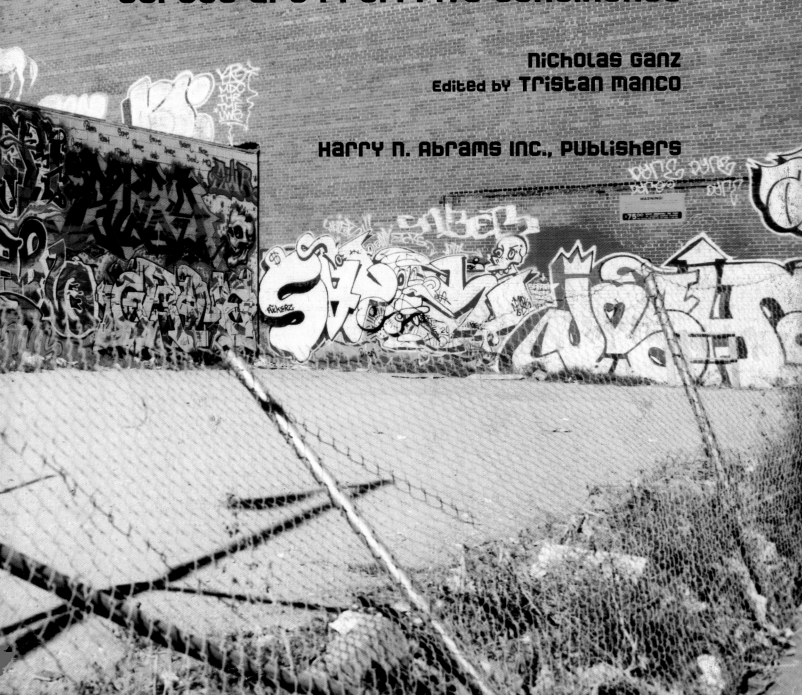

Graffiti World
Street Art from Five Continents

Nicholas Ganz
Edited by Tristan Manco

Harry N. Abrams Inc., Publishers

Library of Congress Cataloging-in-Publication Data

Ganz, Nicholas.
 Graffiti world: street art from five continents / by Nicholas Ganz.
 p. cm.
 Includes bibliographical references.
 ISBN 0–8109–4979–2 (hardcover)
 1. Street art. 2. Mural painting and decoration —20th century.
3. Graffiti. I. Title.

ND2590.G35 2004
751.7'3—dc22
 2004004248

Printed and bound in Singapore

10 9 8 7 6 5 4 3 2 1

Harry N. Abrams, Inc.
100 Fifth Avenue
New York, N.Y. 10011
www.abramsbooks.com

Abrams is a subsidiary of

LA MARTINIÈRE
GROUPE

Page 1
El Kitsch Tasso, Wiesbaden, Germany, 2001
Pages 2–3
South of Market, San Francisco, USA, 2000
Pages 4–5
El Kitsch Tasso: for the flood victims
in Saxony, Glauchau, Germany, 2002

contents

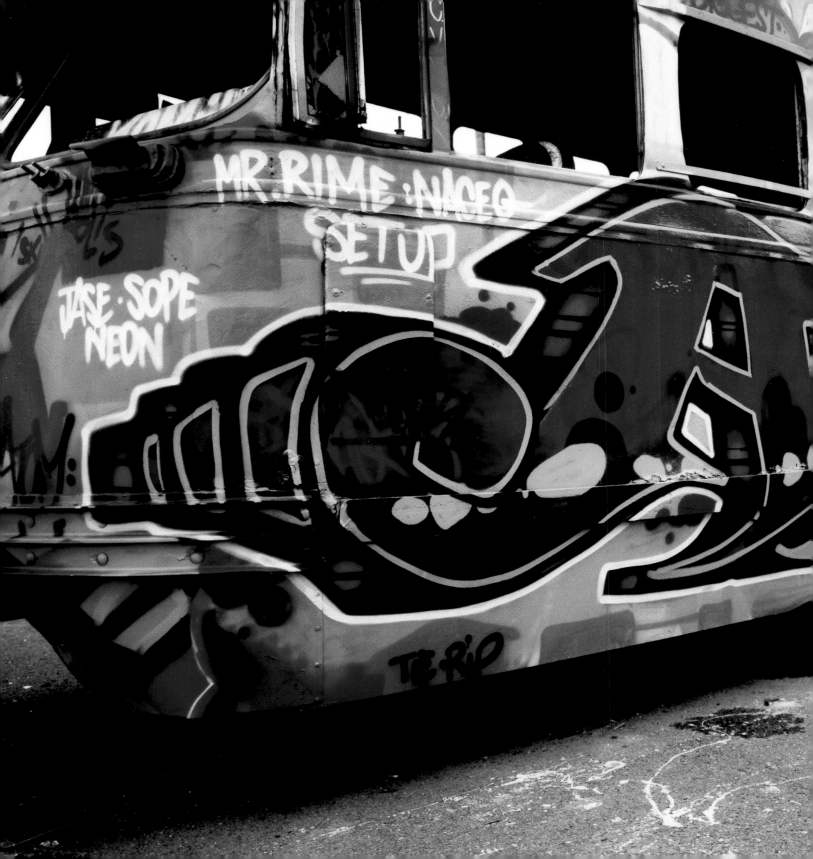

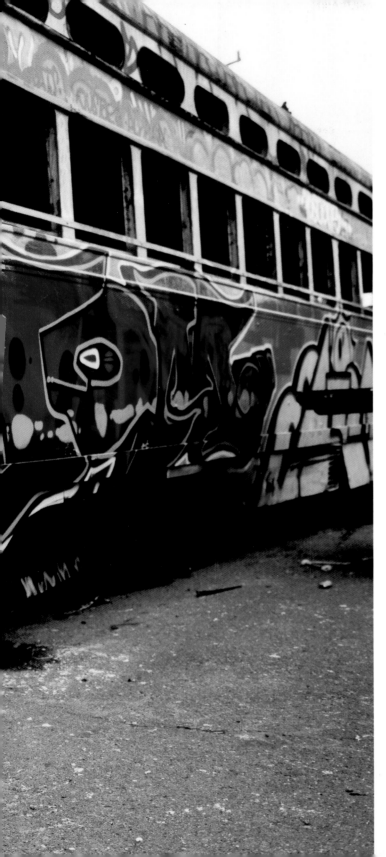

Foreword

Graffiti as we know it today may have a relatively short history but it has managed to touch almost every corner of the globe. In this book, I have attempted the most comprehensive presentation ever published of the most interesting and influential artists in individual countries. I have roamed the world – literally, but also via the Internet and a huge range of contacts – to provide a truly unique perspective.

Letters used to dominate but today the culture has expanded: new forms are explored, and characters, symbols and abstractions have begun to proliferate. Over the past few years, graffiti artists have been using a wider scope of expression. Personal style is free to develop without any constraints, and stickers, posters, stencils, airbrush, oil-based chalk, all varieties of paint and even sculpture are used. Most artists have been liberated from relying solely on the spraycan.

As a result, many now refer to a post-graffiti movement, characterized by more innovative approaches to form and technique that go beyond traditional perceptions of the classic graffiti style. To reflect these changes in the graffiti world, these new directions have become a focus of this book. I have deliberately not divided the contents by country, deciding instead to order artists largely alphabetically by continent. This is because nationality, race and sex have no bearing on the graffiti scene.

Nicholas Ganz

Atom, USA, 1999

7

WORLDWIDE HISTORY OF GRAFFITI

Derived from the Italian *sgraffio*, meaning 'scratch', graffiti has been around since the beginning of mankind. Pictures, such as those at the Lascaux Caves in France, were mostly carved into the cave walls with bones or stones, but early man also anticipated the stencil and spray technique, blowing coloured powder through hollow bones around his hands to make silhouettes. In ancient Greece, fragments of clay were found on which notes had been carved, while excavations in Pompeii brought to light a wealth of graffiti, including election slogans, drawings and obscenities.

In 1904, the first magazine to focus on toilet graffiti was launched: *Anthropophyteia*. Later on, during the Second World War, the Nazis used writing on walls for their propaganda machines to stir up hatred towards Jews and dissidents. However, graffiti was also important for resistance movements as a way of publicizing their protests to the general public. One example is 'The White Rose', a group of German nonconformists who spoke out against Hitler and his regime in 1942 through leaflets and painted slogans, until their capture in 1943. During the student revolts in the 1960s and 1970s, protesters made their views public with posters and painted words. French students often turned to the *pochoir* (the French word for stencil graffiti) technique, the precursor of the present-day stencil movement.

Today's graffiti developed towards the end of the 1970s in New York and Philadelphia, where artists such as Taki 183, Julio 204, Cat 161 and Cornbread painted their names on walls or in subway stations around Manhattan. The unique make-up of New York City – in which the Harlem slums and the glamorous world of Broadway stand side by side – seems to have been a breeding-ground for the first graffiti artists, bringing together many different cultures and class issues in one single place. This environment fuelled an artistic battle against the power brokers in society, and a breakaway from poverty and the ghetto. Cornbread, for example, became notorious by spray-painting his 'tag' (the striking signature of a graffiti artist) on an elephant in a zoo. Through these pioneers, American graffiti was born, sweeping

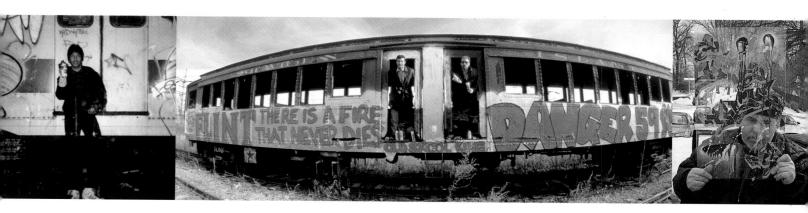

Dave Chino, New York, USA ✳ Flint... & Danger 59, New York, USA, 2002 ✳ Tracy 168, with acrylic plate, New York, USA, 2003

through the world and drawing thousands of youngsters under its spell.

Initially graffiti artists often used either their real names or nicknames, but soon the first pseudonyms started to appear. The glut of new graffiti artists brandishing their names across the whole city inspired writers to find new ways to make their work stand out. Tags got bigger and bigger until the first 'pieces' (short for 'masterpieces') appeared on New York trains. Many artists sought recognition, either by spray-painting the most trains or the best pieces. Stencil and street artists, meanwhile, wanted to communicate with the passer-by or shape their environment without any constraints.

Seen, Lee, Dondi (RIP), Stayhigh 149, Zephyr, Blade and Iz the Wiz became heroes through the sheer quantity and quality of their work. Artists initially targeted trains because they often travelled through the whole city and were seen by millions of people. By the mid-1980s, it was claimed, there was not a single train that had not at one time been spray-painted from top to bottom.

This changed in around 1986, when the New York authorities took steps to protect their property from graffiti by putting up fences around station yards and buffing trains regularly.

As the New York writers travelled around, the graffiti phenomenon spread throughout the whole of the USA, and soon trains became targets in Europe. At the same time, the first exhibitions took place in Amsterdam and Antwerp. Pieces started to appear in almost every European city from the early 1980s, although Amsterdam and Madrid had fostered an earlier graffiti movement that had its roots in punk.

However, it was only really with the arrival of hip-hop that the European graffiti scene took off. The majority of graffiti in Europe was based on the American model, which remains the most popular to this day. With hip-hop, graffiti entered almost every Western and Western-influenced country and then started to edge out further afield. Asia and South America caught on later, but their graffiti culture is now growing at a phenomenal rate and has already reached a high standard, particularly in South America.

Iz the Wiz & Mickey, New York, USA ✏ La Mano, Barcelona, Spain, 2003 ➡ Miss Van, Supakitch & Koralie, Montpellier, France, 2004

The Here and now

The New York model of graffiti centred around the distortion of letters, but many new approaches have since emerged – pushing the boundaries of graffiti culture. Over the years, the original letter style has developed to encompass a whole range of different typographic forms: the legible 'blockletter', the distorted and intertwined 'wildstyle', the familiar 'bubble style' and '3D'. Characters, which started off as ancillaries to letters, now form their own graffiti group and range from comical figures to those of perfect photorealism. Logo and iconic graffiti, on the other hand, specialize in striking emblems or figures respectively.

Although the spraycan, the traditional graffiti tool, remains key to writers worldwide, the choice of material available these days – oil or acrylic paint, airbrush, oil-based chalk, posters and stickers, to name a few – is extensive and has widened the scope artistically. The stencil technique (which involves using a paintbrush or spraycan to paint images or words through a template) has recently brought to the fore some of the most recognizable graffiti artists – such as English artist Banksy, with his mix of ironic and politically motivated pictures, and German 'Bananensprayer' Thomas Baumgärtel, who has stencilled his bananas on countless galleries and museums.

The emergence of the Internet has also played an interesting role in the evolution of graffiti. Although some artists shun this new medium, arguing that the direct experience of the art form is crucial, many graffiti artists and their followers have welcomed it with open arms as an additional field of action. Massive archives have been set up by enthusiasts and artists. One example is 'Art Crimes', which has become the definitive worldwide site for highlighting the talent of many writers for a wider audience. In many countries, these banks of pictures and information data are an important means of access to influences from other parts of the world. Before the Internet revolution, different continents, cities and even districts had their own distinctive graffiti cultures. Today, those local differences still exist to some extent but have been inspired by styles from all over the world. For countries such as South Africa and Russia, which artists have tended to neglect on their travels, and where it is often impossible to get hold of graffiti magazines and books, good-quality spraycans and caps (the spraycan nozzle, which determines the spray width), the Internet can offer invaluable possibilities.

The various historical aspects of graffiti brought together in this book, and the different forms and techniques that are around today, have made it necessary to group all of the style branches under the word 'graffiti'. Many artists tend to distance themselves from this word because they think that it is no longer contemporary. Moreover, it often conjures up images of vandalism and defacement, or is treated as a generic term for street art. As a result, a lot of artists prefer to label their work as 'aerosol art', 'post-graffiti', 'neo-graffiti' and 'street art' in order to differentiate themselves. I do not wish to make any reference to vandalism by using the term 'graffiti' but, rather, to include and present as many graffiti styles as I can, along with their most interesting pioneers.

Unknown artist, *Dog*, Paris, France, 2003
Following pages: Dicy, Sickboy & Xenz, Bristol, England, 2001

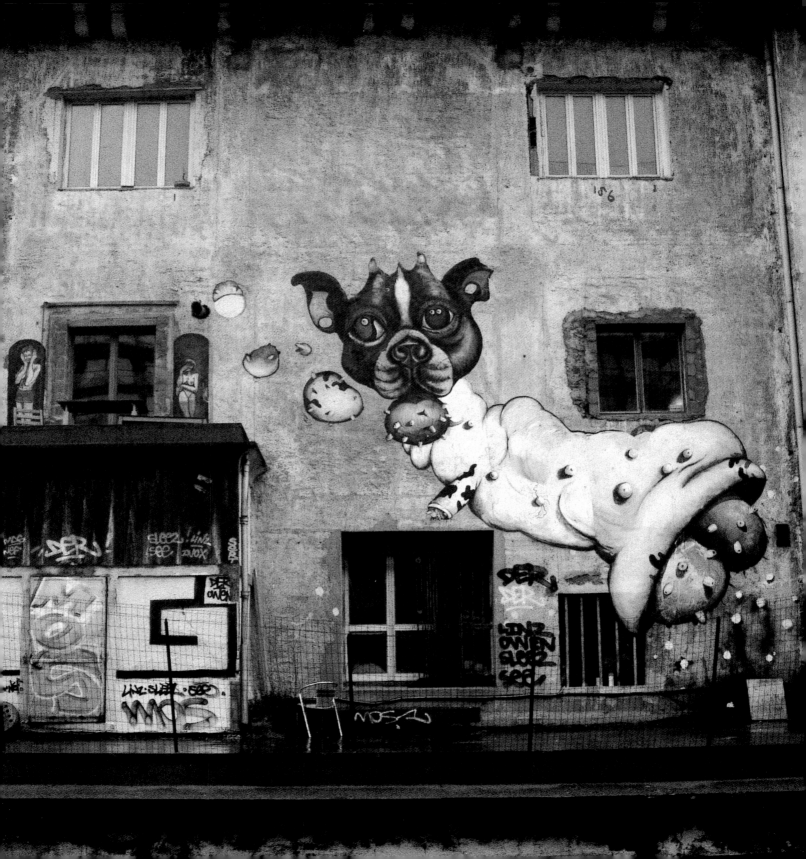

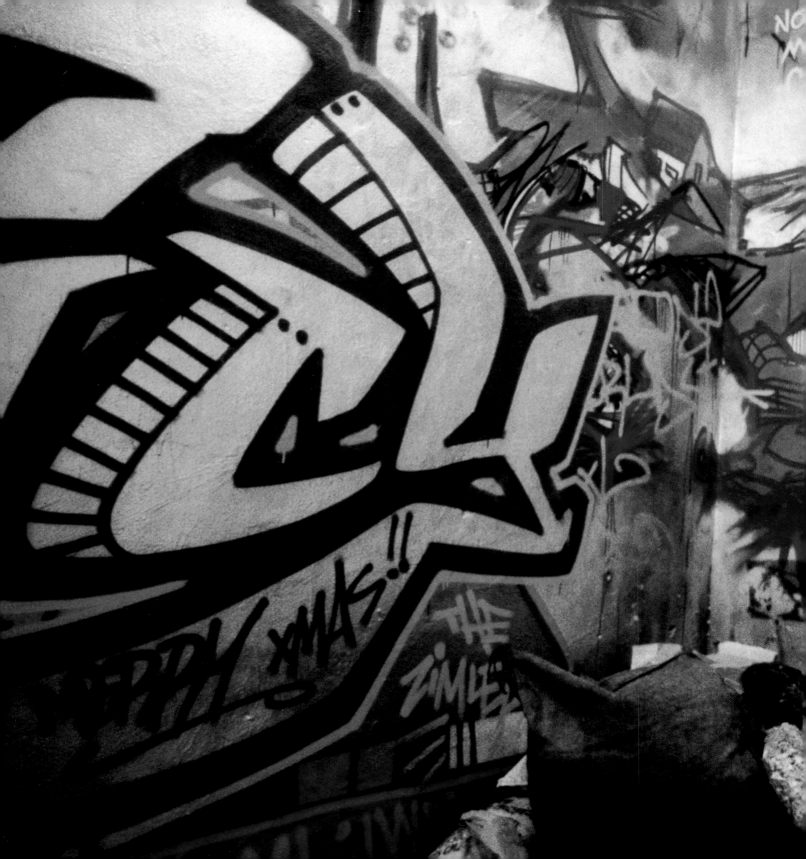

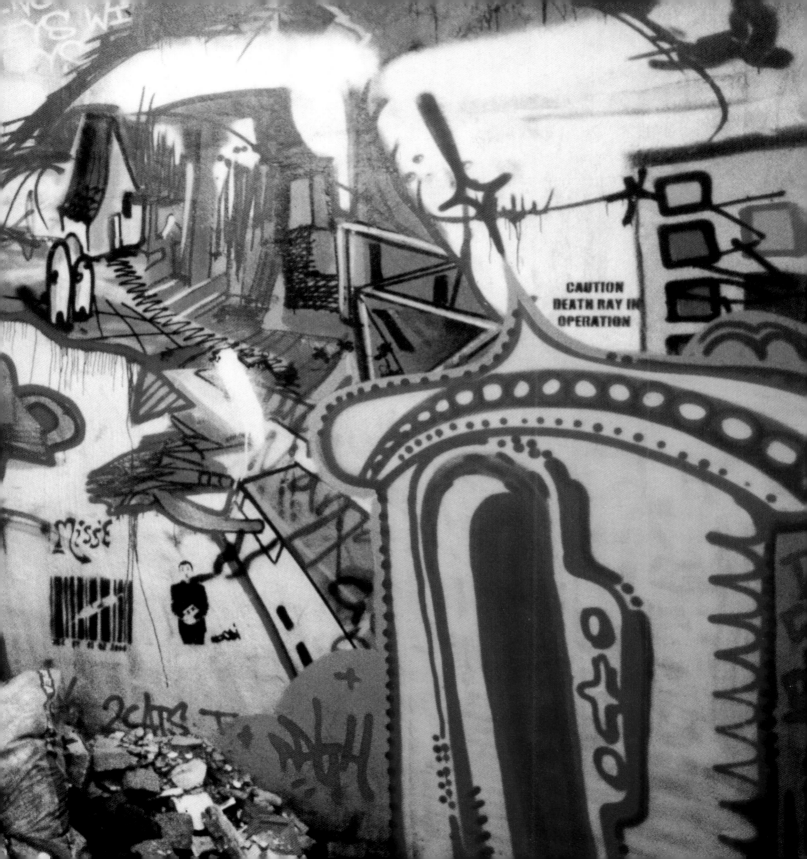

CAUTION
DEATH RAY IN
OPERATION

The USA

The USA was the birthplace of graffiti, which spread like wildfire from cities such as New York or Philadelphia throughout the whole country – and later throughout the whole world. As a result, it has united a raft of different character and letter styles and post-graffiti artists. Some try to put across a message; others simply want to add an element of art to a wall or an entire city.

In New York, pieces that are reminiscent of the early 1980s stand alongside images inspired by the modern trends of street art culture – such as Reas with his plaques, Shepard Fairey with his international 'Obey Giant' campaign and Michael De Feo, known as the 'Flower Guy' after the hundreds of flower posters he has put up across the city.

The quality of both lettering and figurative work has risen to amazing heights, and artists such as Dalek and Craola have created completely new worlds around their characters. Many of the early writers are now freelance artists or work for key companies in the clothing industry as designers. Murals have become particularly popular as they often help American artists to secure paid work.

The Puerto Rican scene began to emerge at around the same time as New York's because many of the first graffiti artists were born in Puerto Rico or had Puerto Rican blood. In sharp contrast to New York, however, writing started off on walls as opposed to trains. MTR, the island's most noteworthy crew, was one of the first to be founded by Puerto Rican writers.

South America

Although still at an early stage in its development, South America has risen to worldwide prominence over the past few years through its naive and exemplary figurative drawings. The social and economic problems, drug abuse and gang conflicts that have existed in this part of the world have had a huge impact on the South American graffiti scene; and, like the early days in New York, graffiti reflects strong opposition towards the rich upper classes from people living in the ghettos. Spraycans can be difficult to come by, often forcing artists to diversify.

São Paulo and Rio de Janeiro are at the centre of Brazil's graffiti movement, boasting a whole host of internationally

Canada

Despite its proximity to the USA, Canada had a late start in around 1984. Initially there was a huge boom in graffiti artists but this soon subsided, only to re-emerge in the early 1990s. Artists tended to gather in large cities such as Montreal, Toronto and Vancouver, but talent also flourished undetected for a long time in many other, smaller places.

Canada was also able to make its mark on a worldwide level through the tradition of 'monikers' (figures and pictures depicted on goods trains, created with oil-based chalk), which is still very much alive today. The monikers have a long history stretching back to the Depression of the 1930s, when people jumped on trains without any particular plans and travelled from town to town looking for work. Over the years, they created their own form of communication with chalk to express opinions and exchange views. These days, goods trains are very easy to spray-paint and are attractive targets because they tend to be seen by a lot of people. Often the artist will never see his artwork again, or not until months later.

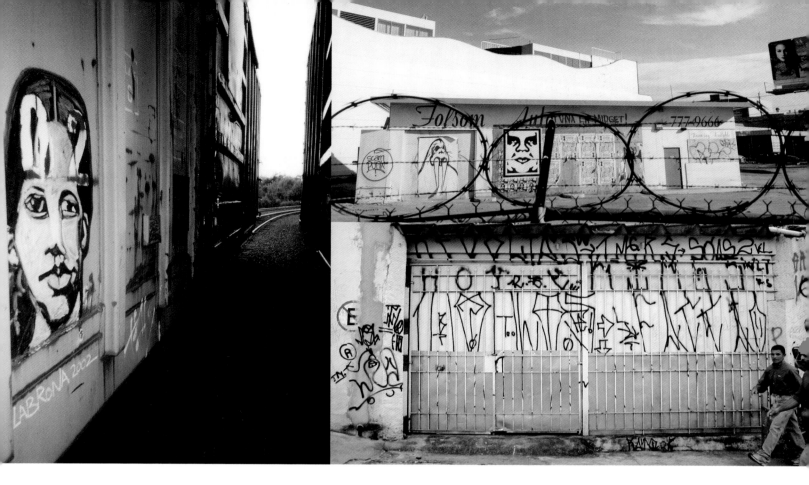

lauded character artists. Despite its fledgling status, this scene has had the most significant influence on worldwide graffiti styles over the past few years. It has introduced a completely new type of bubble letter, which characteristically is not painted over work out of respect. Rather, it is executed above or around other throw-ups (simple letters, often only with an outline or a single-colour fill-in, generally painted very quickly), in recognition of the cost of paint, to create vast colourful patchworks in an exuberant style. Brazil is also famed for its *pixacao*, a cryptic and elongated writing style that originated in São Paulo. Its practitioners – known as

pixadores – risk life and limb reaching the very tops of the city's buildings, and no surfaces go uncovered. Brazilian graffiti artists are now striving to gain recognition worldwide.

The Os Gemeos twins and artists Nina, Vitché and Herbert are all well known and take part in international productions and exhibitions. In fact, Os Gemeos have become two of the most talked about graffiti artists. Their pictures are reminiscent of drawings and illustrations from children's books and are plastered in every possible – and impossible – place. Small groups of estimable artists are also emerging from Argentina and Chile.

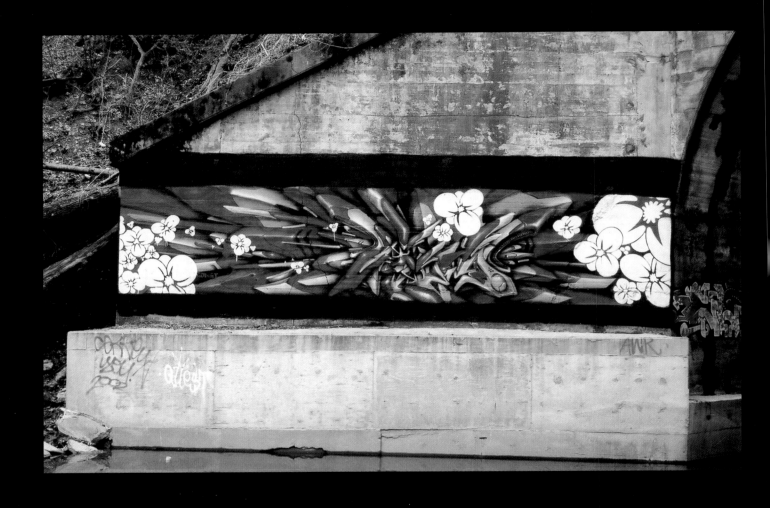

3A CREW

Graffiti writer Ges decided to set up USA-based 3A in 1995 after the motivation in his old crew lost momentum. He has been working with core member Kem 5 since 1997, and they have had a clear artistic influence on each other: both have an abstract wildstyle, often creating uncomplicated fill-ins (areas inside the letters that are coloured in) on a simple, toned-down background. Totem 2, another important 3A figure, has given the crew a whole new flair with his innovative characters, which have been inspired by Japanese martial arts, robots and comic books. 'The international connection of writers is one of the many aspects of the culture that seems to be exclusive to graffiti,' says Ges. 'Only in the graffiti world can you get off a plane in another continent, and end up staying in a random person's house.'

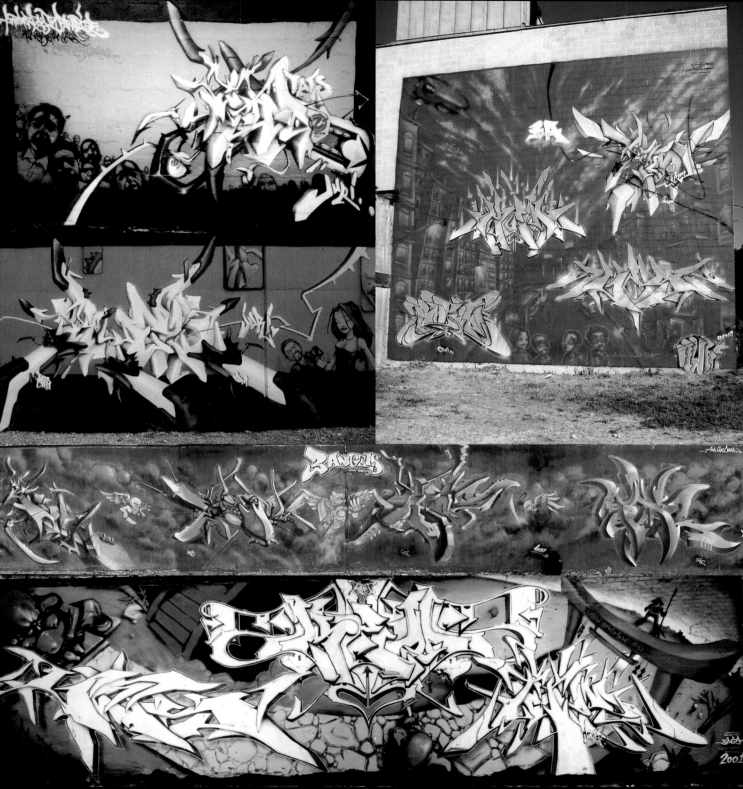

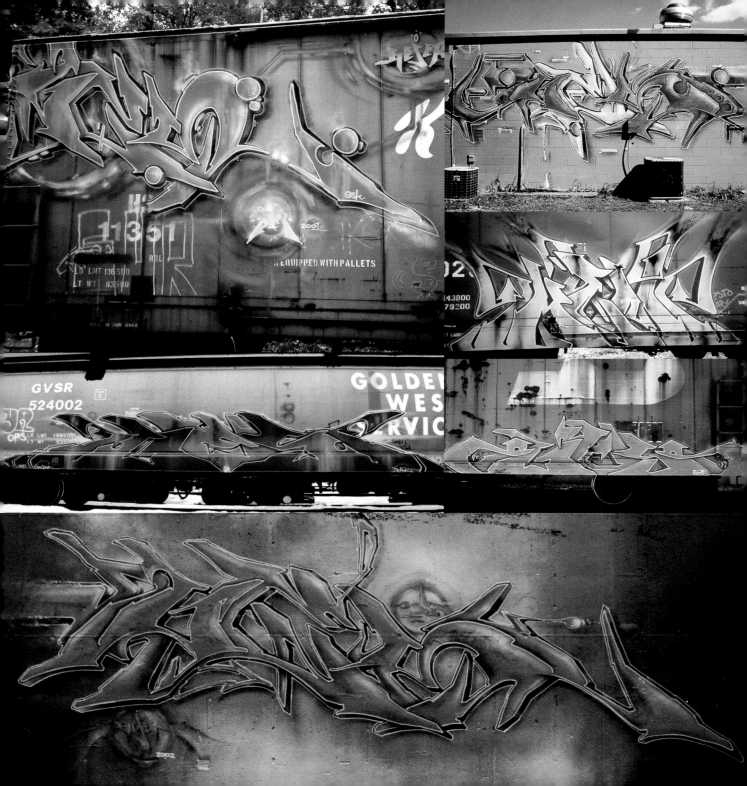

3A CREW 23

ABOVE

'Everyone's seen an arrow pointing up before without thinking much of it, but when you're confronted with a painted arrow on the wall, or moving down the street on a truck…you start to wonder what it all means.' Above started off spray-painting his name on goods trains in California. As a student in Paris, he covered the city with his arrows, using a variety of techniques, including stickers, stencils, wood and stamps. Back in the USA, he hangs arrows on cables in his town like old shoes, hoping 'to represent the power and energy that you're capable of unlocking within yourself'.

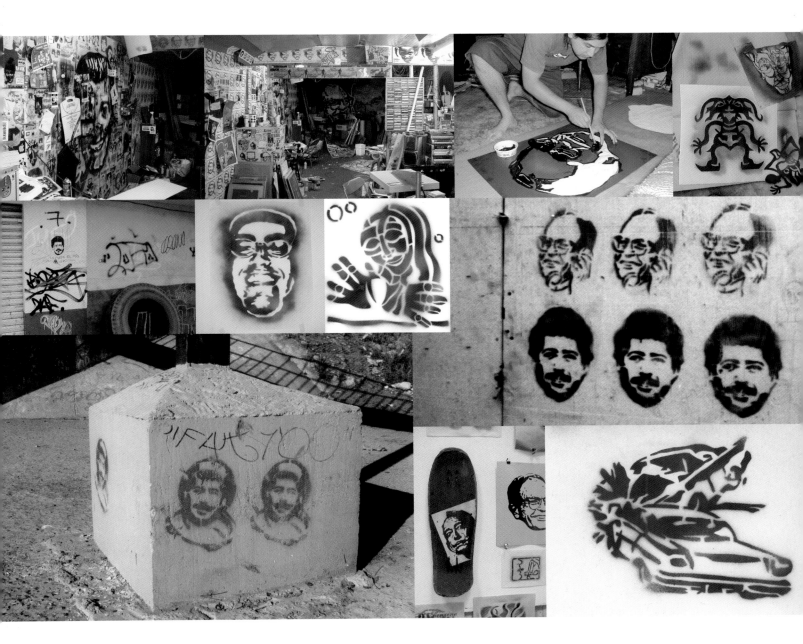

ACAMONCHI

Acamonchi's pictures were inspired by the underground culture on the borders of northern Mexico and America, as well as the punk scene. The man behind it, Mexican-born Gerardo Yepiz, started off working with Shepard Fairey and together they produced the first stencils. These days, his work includes propaganda projects and mail art, which he uses to comment on Mexican popular culture. 'I've been an underground artist since the mid-1980s, when I was really into fanzines and skateboard punk counter-cultures,' says Yepiz. 'Punk rock gave me the socio-political awareness at the same time that fanzines introduced me to the mail art movement…. For me, Acamonchi would be mail art meets graffiti with a twist of Mexican urban kitsch. You can't beat that!'

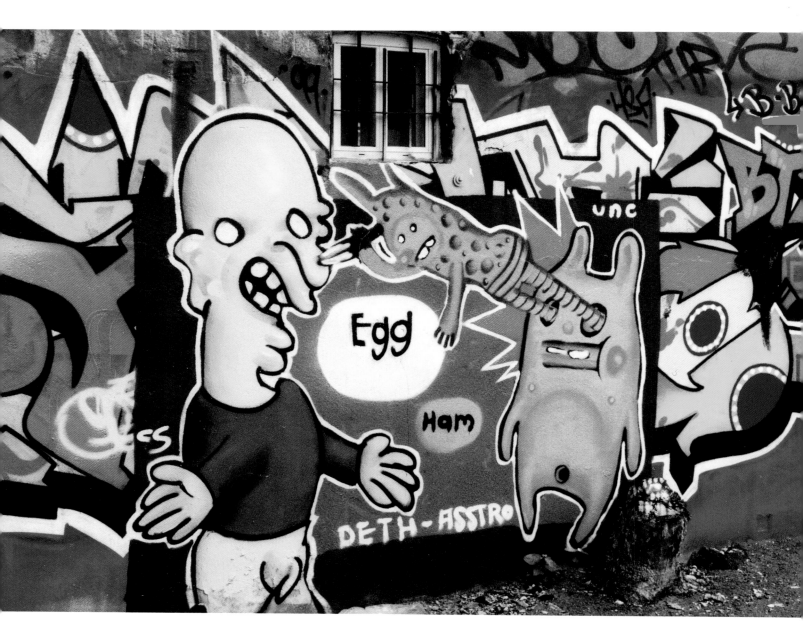

ASSTRO

Asstro (also known as Eggs) grew up in Chinatown in downtown Toronto. His first street artworks were symbols of anarchy, which he spray-painted when he was just six without really understanding their true meaning. These days, he is known for his surreal figures, which he plasters across walls and trains with spray-paint or chalk. His work also includes puppets (made out of socks), murals and illustrations.

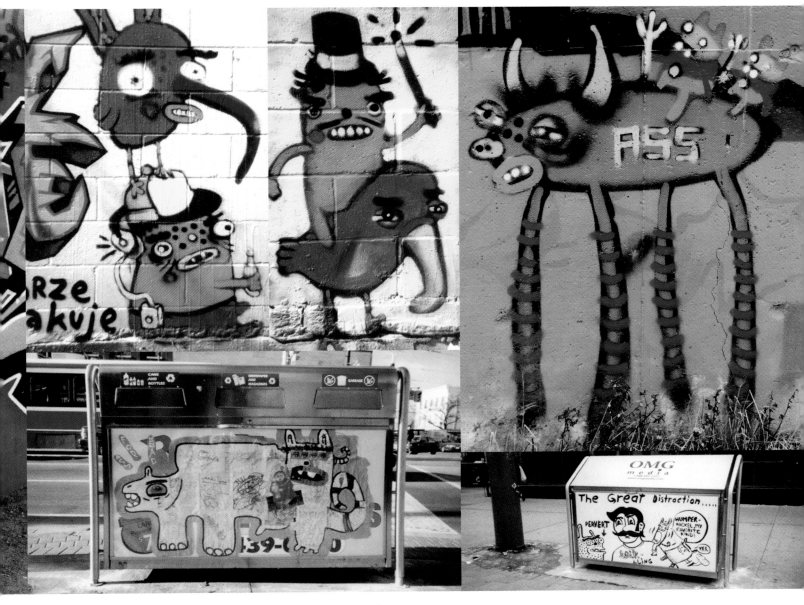

27

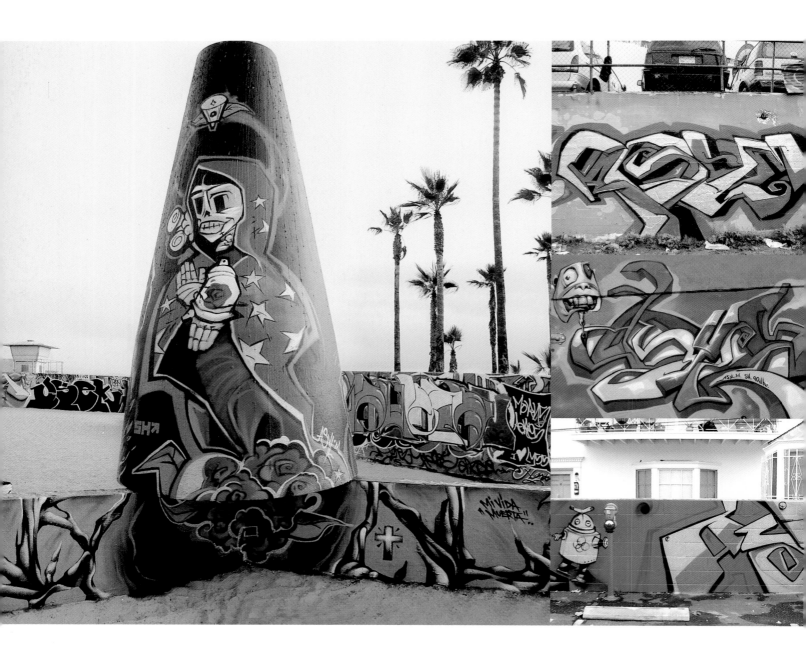

ASYLM

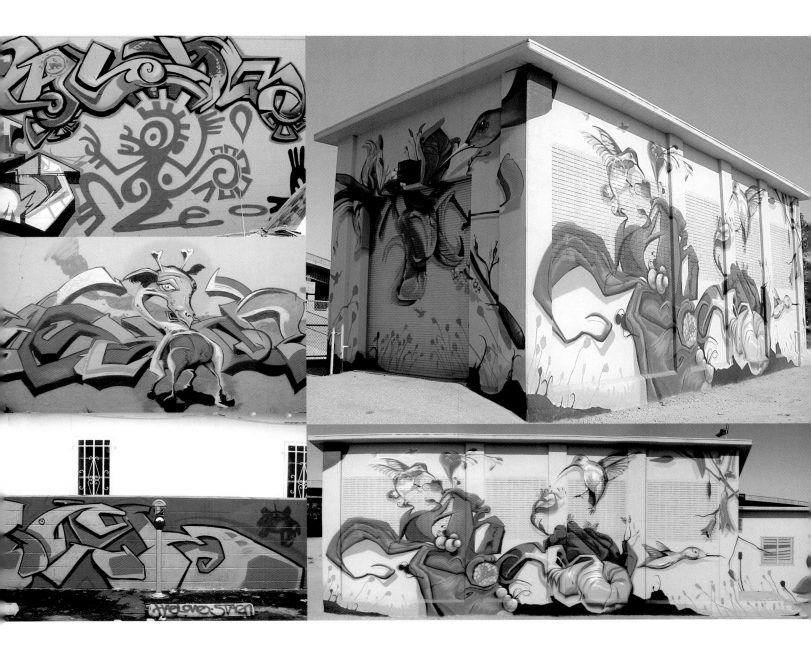

Asylm started off spray-painting concrete walls in Los Angeles in 1989 but moved on to develop characters, blending traditional graffiti techniques to create his own comical world. He often paints lavish pieces with crew partner Man One, although he also works on canvas-based fine art.

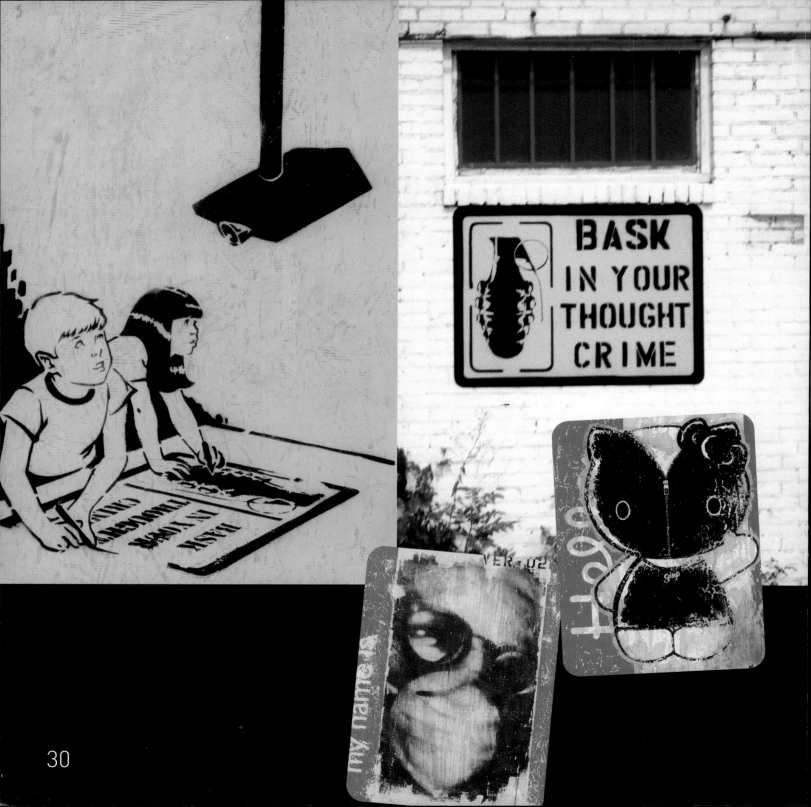

BASK

When he was eight, Czech-born Bask fled from the Communist regime to the USA with his parents. He belongs to a group of artists – including Barry McGee (also known as Twist) and Shepard Fairey – who were inspired by urban landscapes and cultures and adopted ideas from mainstream artists to create their own style of post-graffiti.

Using paint drips, thick textures and stencils, Bask creates characters, child-like sketches and collages on canvases and walls. His pictures often have a political or social element, and he tries to make the passer-by think with his humorous black metaphors, deconstructed popular logos, and self-analysis.

31

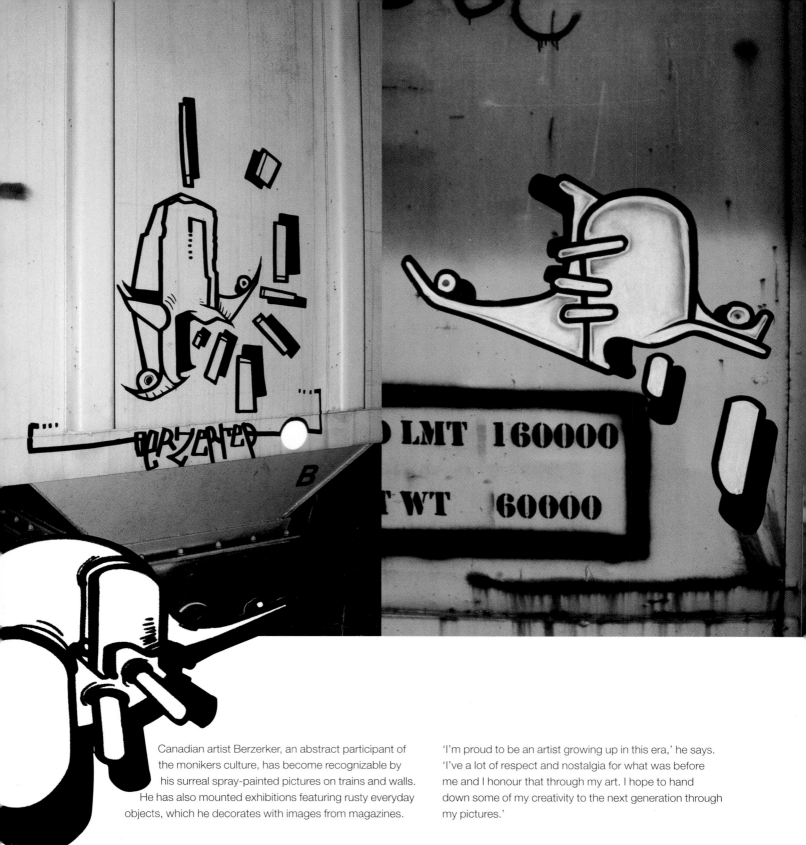

Canadian artist Berzerker, an abstract participant of the monikers culture, has become recognizable by his surreal spray-painted pictures on trains and walls. He has also mounted exhibitions featuring rusty everyday objects, which he decorates with images from magazines.

'I'm proud to be an artist growing up in this era,' he says. 'I've a lot of respect and nostalgia for what was before me and I honour that through my art. I hope to hand down some of my creativity to the next generation through my pictures.'

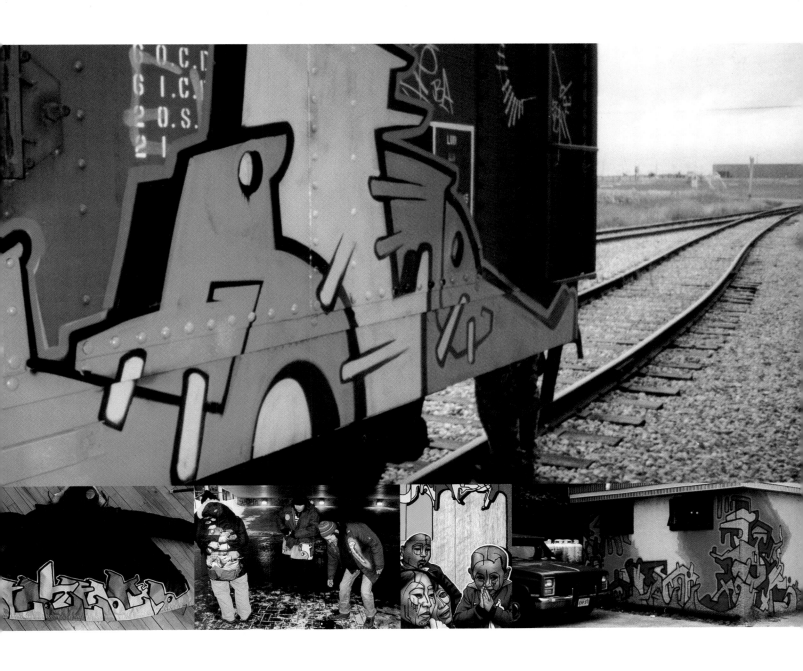

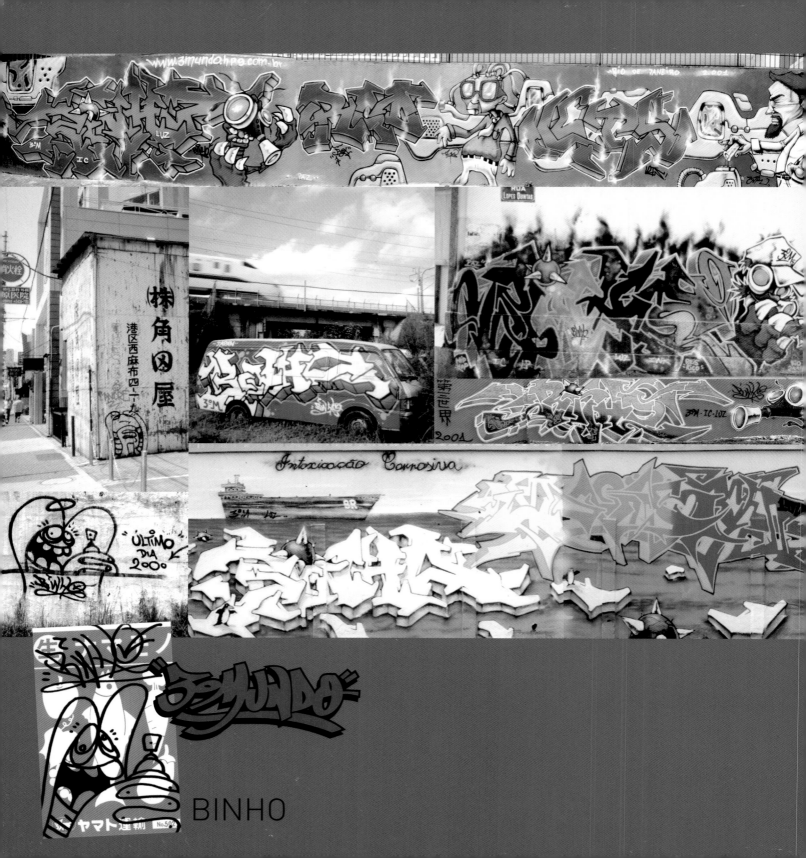

BINHO

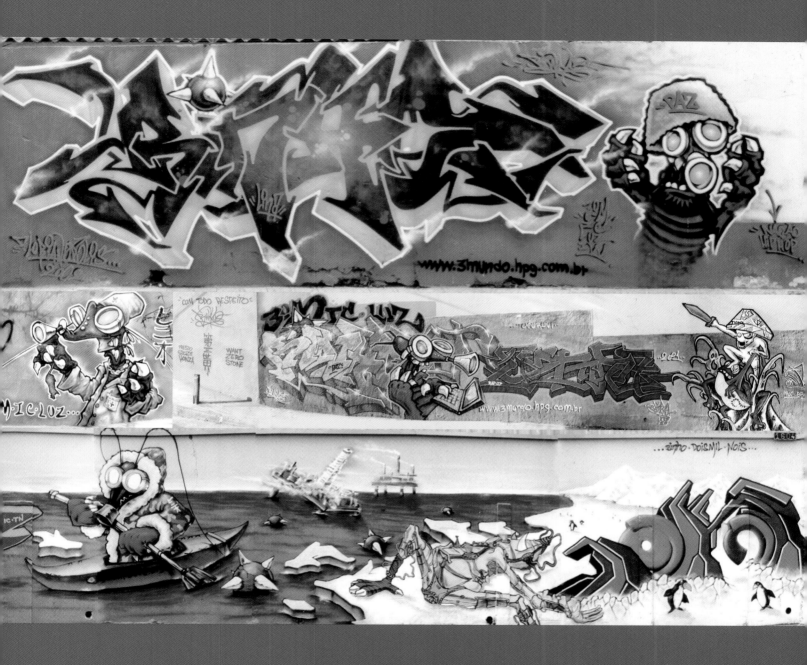

Binho, one of Latin America's first graffiti artists, has been writing since 1984. His traditional old-school style features a cockroach, highlighting the prejudices against and resistance to graffiti in the Third World. He also publishes a graffiti magazine, *Documento Grafite*, and has his own clothing line, 3ºMundo. 'We [in the Third World] have a lot of drive and culture behind us,' he says. 'We've been taken for granted for a long time, but when we finally break down those barriers, we will get the respect and peace we deserve.'

'I started writing 35 years ago for the sheer love of the night and the simple beauty of letters,' Chaz explains. 'The letters were "Cholo" east Los Angeles style and made me proud of my Latino culture and my place in the world graffiti movement….' Cholo is a territory-driven squarish typeface that the Latino 'Zootsuiters' developed in the 1940s in reaction to the position and treatment of Mexicans in American society. 'I paint graffiti on canvas now, because I need to spend more time with letters. Instead of a couple of hours on the streets, I now need three to four months and sometimes up to two years working on one painting. You need to spend whatever time it takes to "listen" to your painting.'

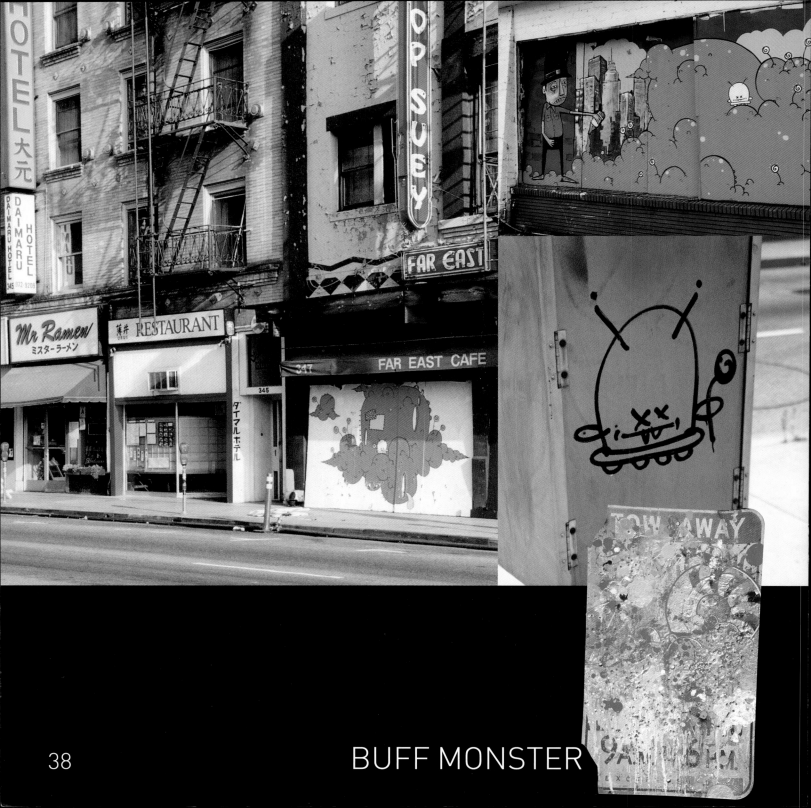

BUFF MONSTER

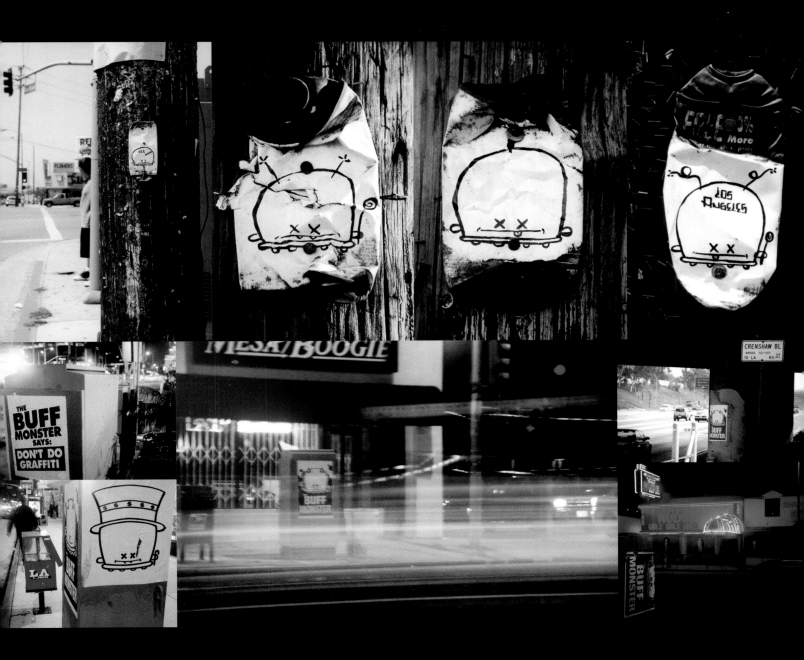

Random got into spray-painting when he was sixteen and now uses his poster campaigns, stickers and pictures to inspire people to do the same. He has become recognizable by his elusive and mischievous Buff Monster, which emerged from Los Angeles' 'inhospitable streets' and appears in various forms, each with the same focus: the buff, or the destruction of the picture. The unmistakable little monster initially infiltrated areas on old, flattened spraycans nailed to electricity pylons, but now appears throughout the city.

'The paramount irony of graffiti is that you use paint and permanent ink to make work that is anything but permanent,' says Random. 'That's just as frustrating as it is funny. So being fully aware of that reality, I created something that got a lot closer to that elusive permanence that we're all seeking.'

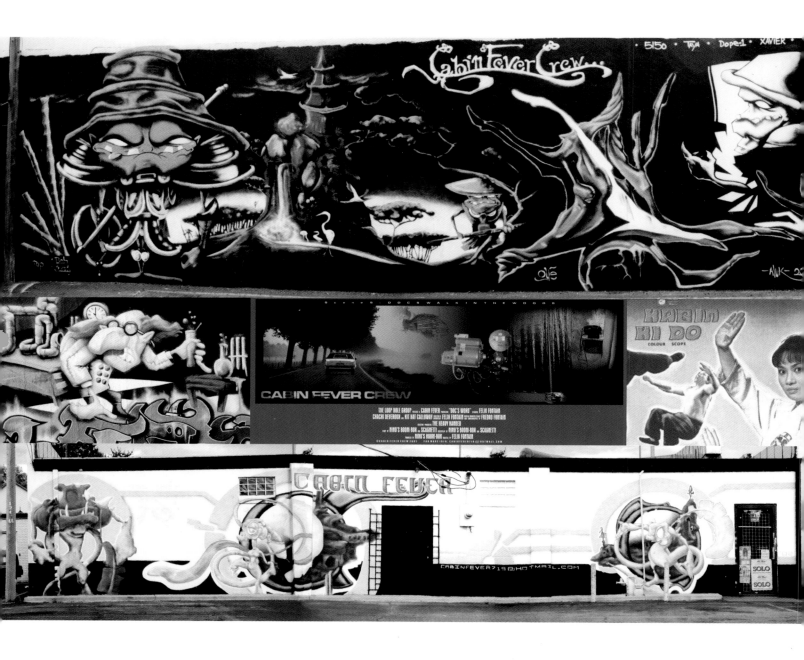

40 CABIN FEVER CREW

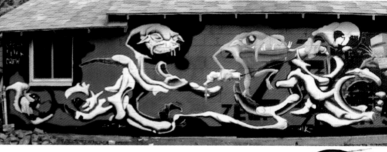

Cabin Fever Crew was established in 1998, although founder Ninos Boom Box got into graffiti as early as 1992. 'We [Cabin Fever Crew] are considered artists by our peers, but they do not realize that we serve our demons – that is, our feelings or emotions,' he says. 'We have to express ourselves artistically, to calm this demon inside of us. If we did not do what we do, I would have done myself an injury by now.'

The crew is actually a collection of musicians, DJs and actors, who produce records and work on acoustic plays or short films. In 2003, they brought out their first album, *Phantom Limb Syndrome: Docs Word*, featuring music and an auditory theatre. It tells the story of a mad doctor who has developed a deadly virus. Members of the Cabin Fever Crew are enlisted to rescue his assistant from a dangerous gang.

41

CASE

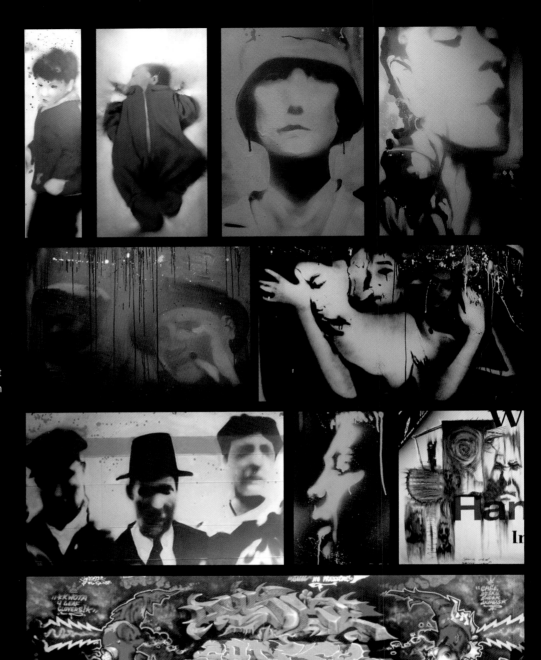

It was fellow graffiti artists Alone and Chrome who first encouraged Canadian-born Case to experiment with a spraycan, which remains his preferred tool to this day. His work has a varied, progressive style and is produced with a great deal of care. Case's canvases have a particular edge – realistic portraits, children or pictures that seem to come from another time – but his multifaceted work also includes comic figures and programming animations. 'It's personal and different from graffiti,' he explains. 'I look at my paintings as art with spray-paint, and my walls or trains as graffiti. Art is for galleries. Graffiti is for trains.' Case also continues to use goods trains and walls as artistic platforms.

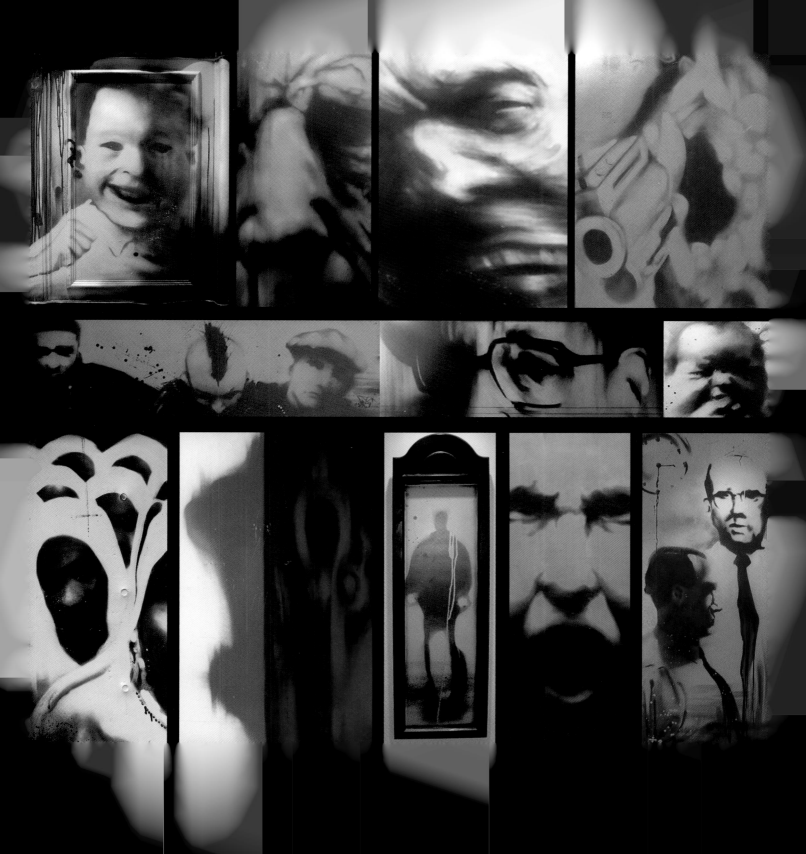

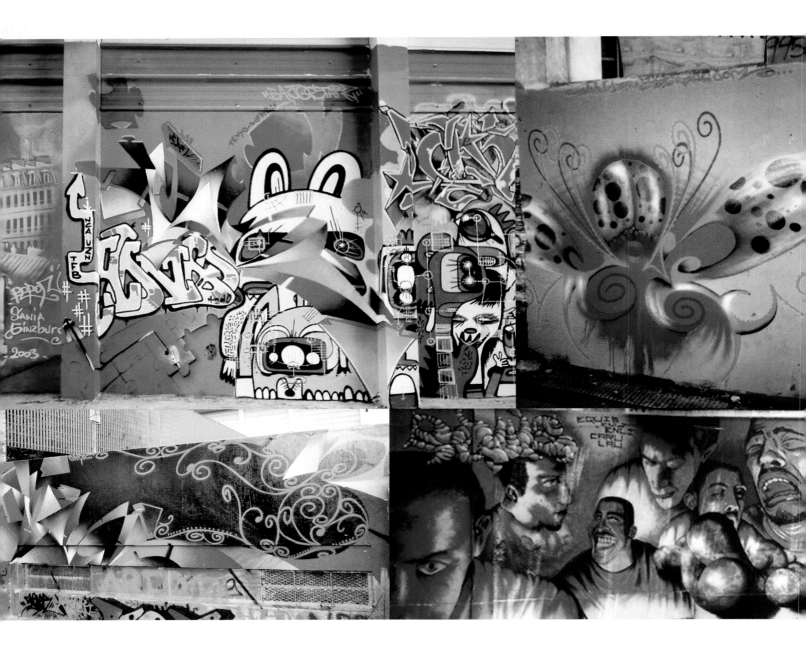

CARU

Caru is from Buenos Aires but now lives in France, where he has become an integral part of the local scene. His pictures play with abstract shapes and plastic letters, and often look like moulded balloons.

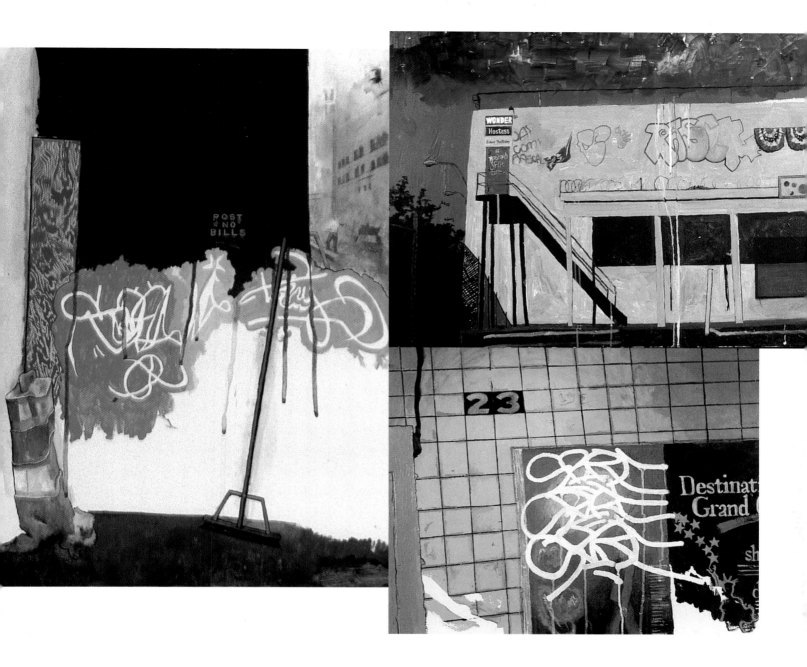

CATTLE

Cattle (also known as Constance Brady) paints her canvases in acrylic, drawing inspiration from subjects she used to photograph on the streets of New York. She is particularly keen on documenting homeowners' attempts to cover up throw-ups or tags on their walls. 'Graffiti, like disease, is metastatic,' she explains. 'Writing on walls highlights a building's ageing process; with landlords actively opposed to graffiti, their attempts to cover the marks with bad colour swatches actually highlight the existence of graffiti…. Graffiti is like lush green ivy on a wall…. By painting graffiti – the activity, anger and response – on canvas, I am documenting these beautified landmarks of civilization.'

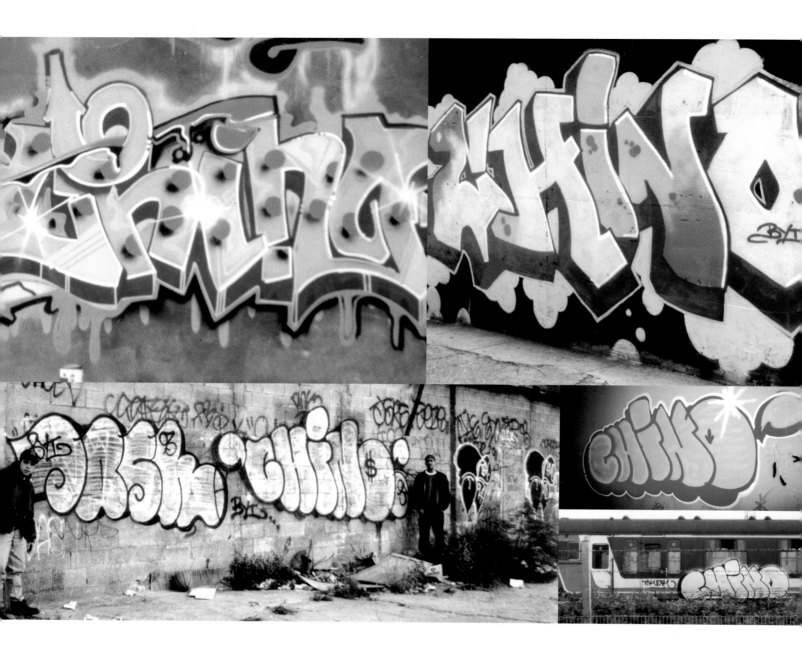

DAVE CHINO

Dave Chino belongs to the old generation of graffiti artists.
Based in New York, he bears testament to the importance
of the graffiti movement.

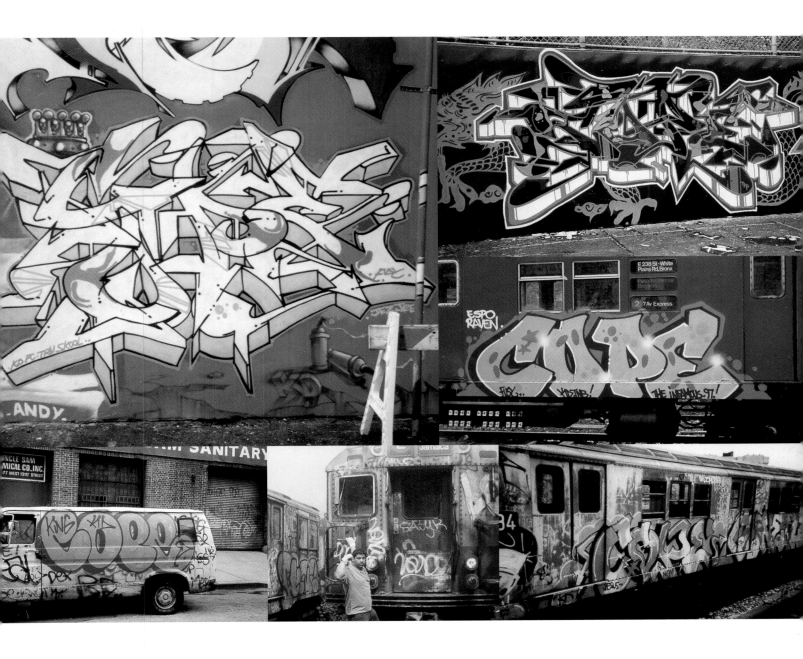

COPE 2

Cope 2, one of the hard-core train bombers, founded the international crew KD – initially called Kids Destroy but now known as Kings Destroy or Killa Dogs – and also works with the TATS and FX crews. He has been on the scene since 1979 and has covered huge swathes of the New York subway with his memorable throw-ups and his typical wildstyle. From his apartment, he looks down at the clean trains that whizz past his block; for him, trains are graffiti. He went through a rough patch when the Vandal Squad, the police's special unit for graffiti, put him under surveillance and searched his house.

47

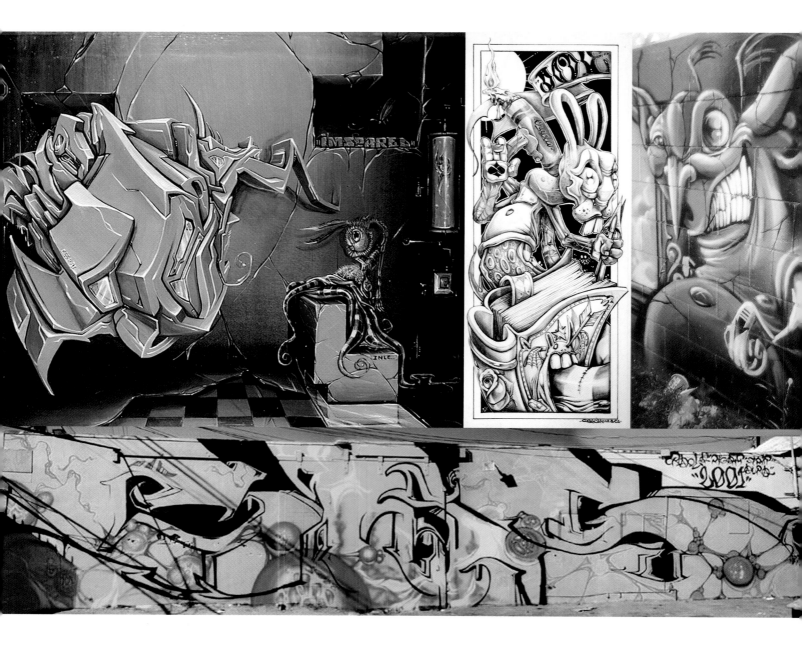

CRAOLA

Craola is from Los Angeles' South Bay area, where there is hardly any graffiti. Although he has been painting since he was a child and has taken a lot of influences from that period of his life, he only got into graffiti when he was seventeen. Initially he worked with Natoe and Plek, who gave him a lot of technical help as well as guiding his style. He describes his picture

stories as 'cartoon realism, creepy bed-time stories, organic meets tech': 'A lot of of the personal paintings these days depict a world that I still have no name for. There are crazy bunnies, lots of birds, and kids taking over the place in flying contraptions. There are nightmares being conquered in this world by brave kids….'

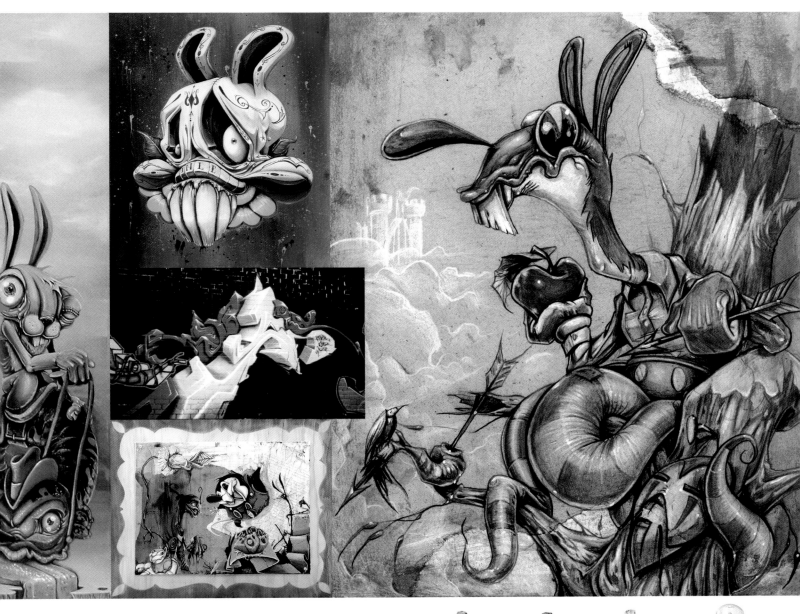

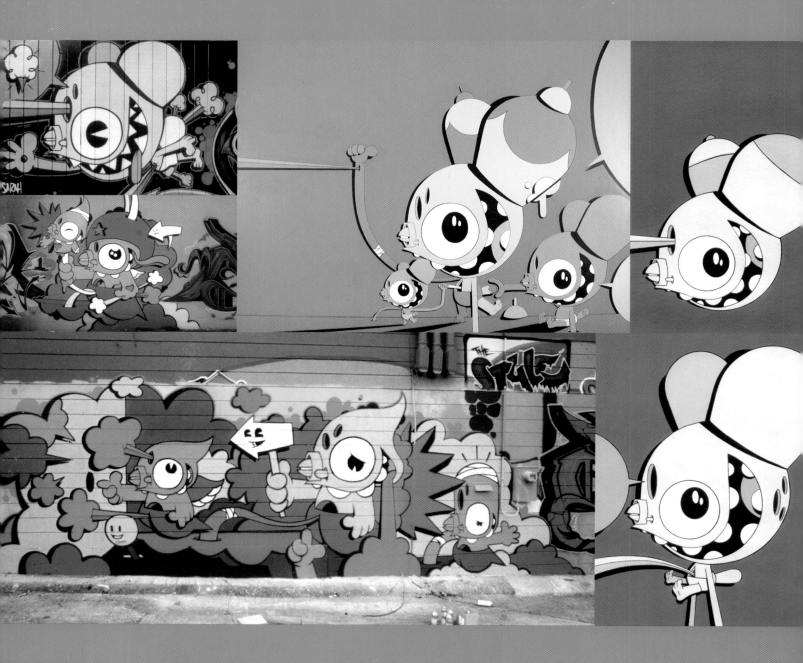

Based in New York, Dalek is actually a modern character designer but was strongly influenced by graffiti. Because his dad worked in the navy and the family moved around a lot, he has spent several years in both Japan and Hawaii. He started to spray-paint around Chicago in 1993, but nowadays you are more likely to see his work on paper and skateboards or in galleries. Dalek is probably best known for his Space Monkeys: clearly drawn characters reminiscent of comic strips, which he creates using stencil and freehand techniques.

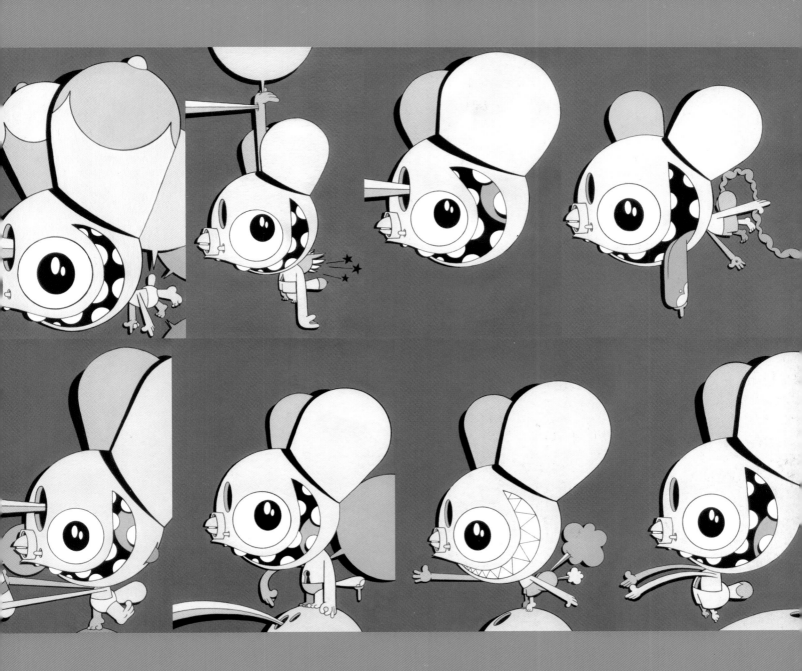

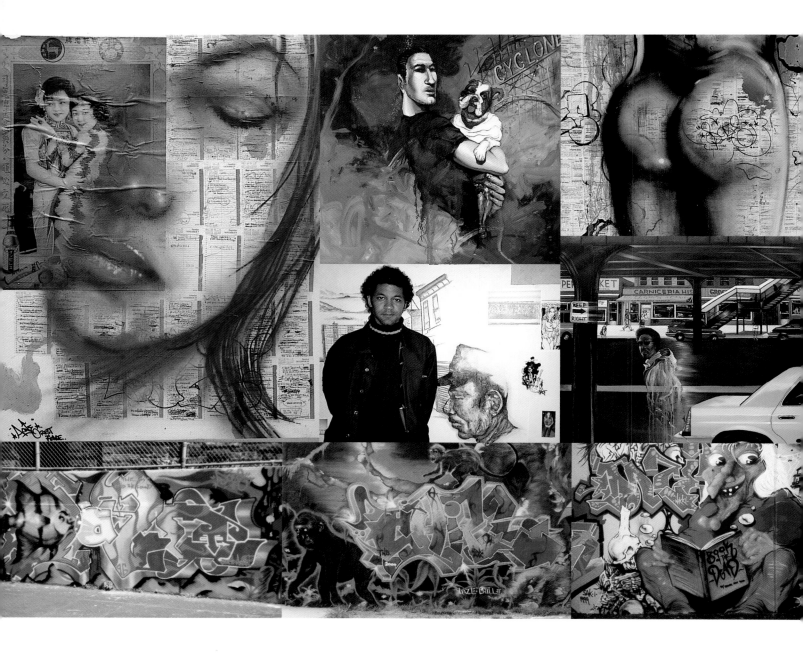

DAZE

Friends at the School of Art and Design got Daze into graffiti in around 1976. Working with the likes of Cope 2, Zephyr, Crash and Tkid, he covered New York with his styles and characters. In the early 1980s, he discovered oil painting and created realistic, independent pictures about life in the Big Apple.

He became one of the first writers to exhibit abroad with a show at the Pitekin Thropus Gallery in Tokyo, Japan, and has since sold his works at countless venues worldwide. Over the years, graffiti has become more than a hobby for Daze, he says: the pictures have gained the upper hand.

MICHAEL DE FEO

Michael De Feo, or the 'Flower Guy' as he is widely known, started off spray-painting stencils on pavements in New York. He came up with his infamous flower design in 1993, printing it on paper using the silk-screen technique, and has not stopped since. Over the years, he has plastered hundreds of his flowers across the city and even further afield, including San Francisco, Seattle, Boston and even Amsterdam. His TV stickers – adults and kids with TV heads – have also gained notoriety through their comment on the role and influence of television in today's society.

53

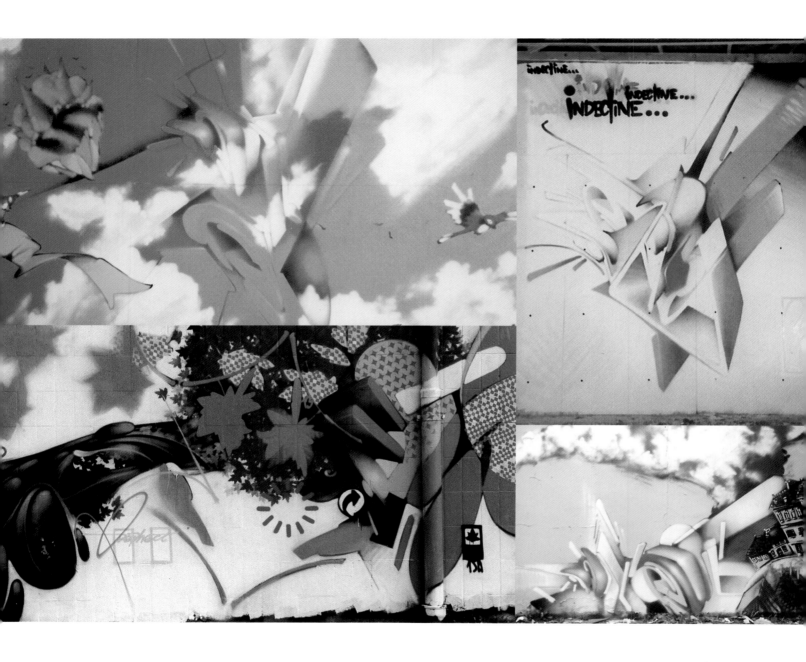

American-born Dephect has lived in both Italy and Germany. His early spray-painted pictures were abstract, a combination of 3D elements and 2D surfaces and lines. Oil painting has given Dephect a new way of expressing his personal experiences and thoughts. Many of his pictures often seem quite rough in style, and if he does not like something he paints over it or crosses it out to achieve a new form of aesthetics. 'The struggle to create is very important for me, not only as an artist, but as a person,' he says. 'Progress comes from struggle, and we learn from our mistakes. I tend to look for the mistake, rather than search for technical perfection. It's a hard habit to break.'

DEPHECT

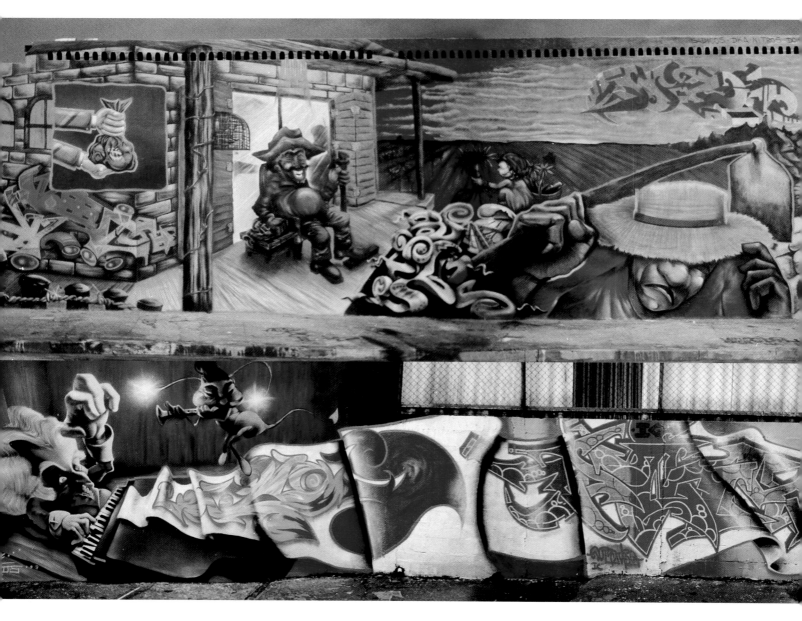

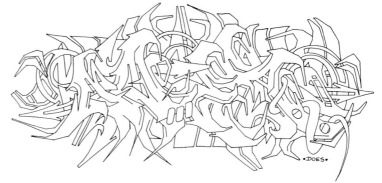

56 DOES

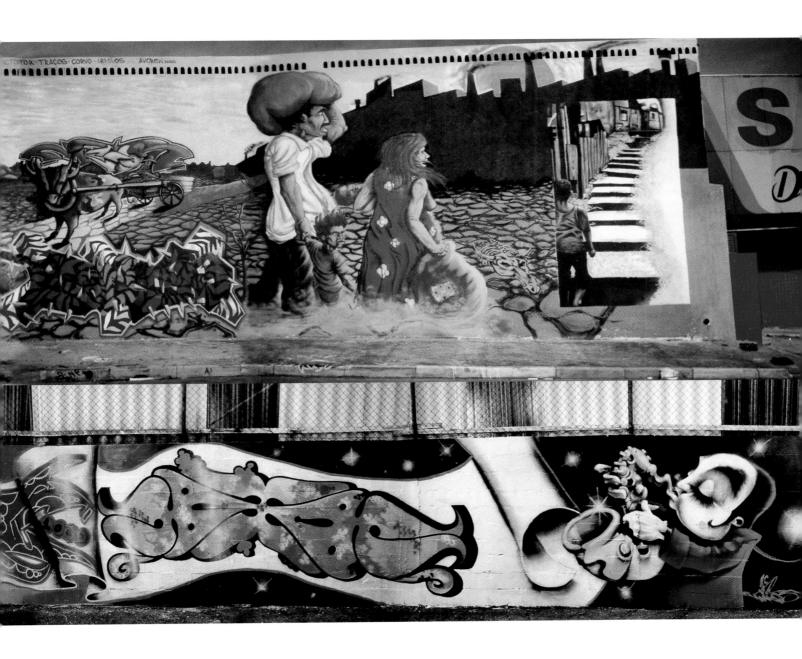

Does comes from São Paulo and began spray-painting with stencils in 1988. He moved onto letters after seeing a video of bombed trains running through New York.

These days, he has his own wildstyle, which combines elements of the Brazilian artesanato, an Indian script and Arabic decorations.

57

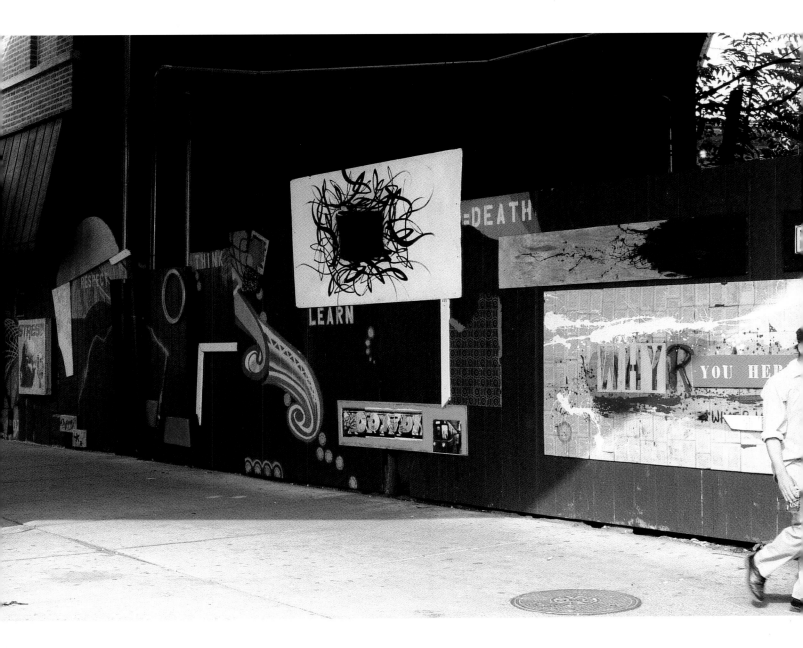

DZINE

Carlos 'Dzine' Rolon discovered graffiti in one of the early documented accounts of the first New York graffiti movement. Initially his work focused on textures and the superposition of pictures on walls, but his style has become increasingly abstract – a shift influenced significantly by Dzine's study of neo-abstract expressionists. Music has frequently played a role in his work, encouraging him to undertake projects that unite pictures and music. For example, he has designed record covers and founded his own record label, Lala Records. He has also exhibited his work.

59

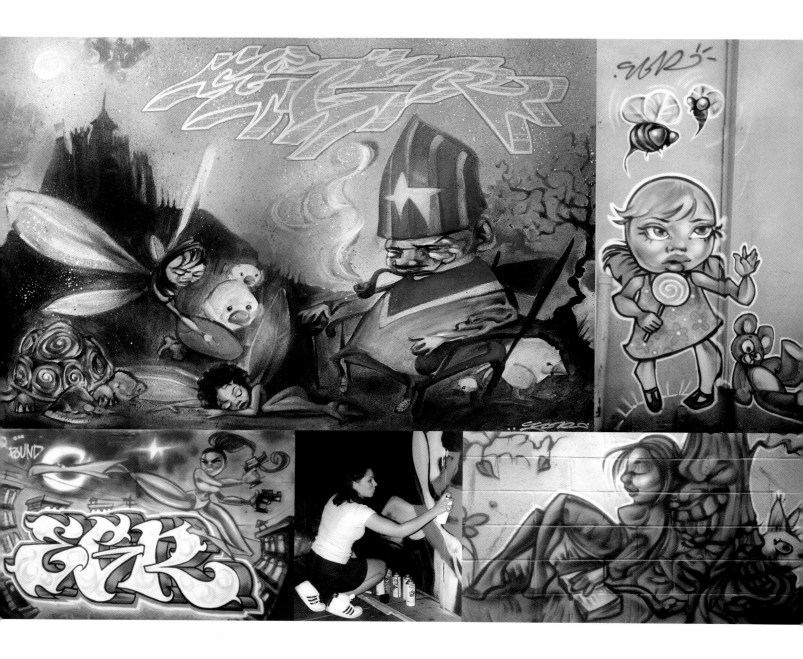

EGR

As a small child, Canadian artist EGR sat in front of the TV and painted pictures of the characters from *Sesame Street*. Drawing became a passion, but it was Clew that got her interested in graffiti, before she moved to Toronto. Nowadays, she has cut down on illegal spray-painting, presenting her work on canvases using oil paint or mixing techniques.

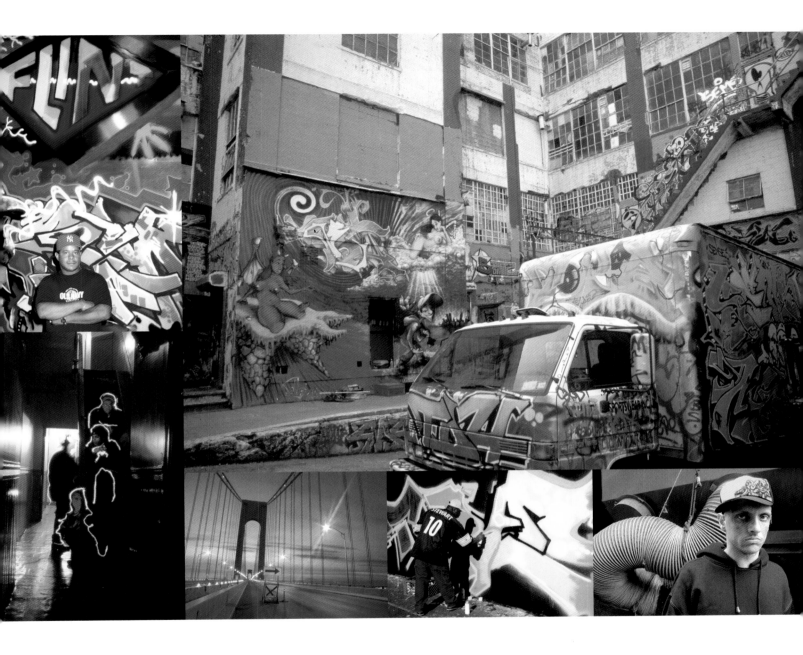

FLINT...

Flint Gennari got into graffiti before aerosol art really took off in New York and the first 'whole cars' (trains that are covered from top to bottom) or panels came onto the scene. Tagging up subway stations and trains on the D-Line, he became known for his slogans – including 'For those who dare',

'For ladies only' and 'Bad but not evil'. Early comics encouraged him to create an anonymous, mysterious identity, which inspired subsequent artists such as Futura 2000. Now he makes his living as a professional photographer, taking photos of graffiti and other artists, and experimenting with light.

heavyweight®

There are many artists in the graffiti world who started off using a spraycan but now work as fine artists or designers. The Heavyweight crew is one such collective from Montreal, comprising Dan Buller, Tyler Gibney and Gene Pendon.

Founded in 1998 as Heavyweight Art Installations, the crew specializes in colourful canvases, and its paintings often feature life-size thematic portraits of musicians or political activists on an abstract and quite complex background.

63

HERBERT

Brazilian-born Herbert started to paint in 1992 in São Paulo and has since taken part in a raft of events and exhibitions. Using various techniques to create a background, he constantly develops his characters and compositions through experimentation. Offering an enigmatic insight into his world, he says: 'While I was awake, I could see the fins scattered on the beach…. Every time that the sky goes dark, and the moon lights up the sand, I go into the sea and I know that in a short time I will disappear, and that what will be born is a wish to be something that is not just flesh and bone…. I don't swim, and the sensation that I am drowning comes every day for a few brief seconds, and then it goes away again, and suddenly it brings the wish to be something that has no blood or sweat….'

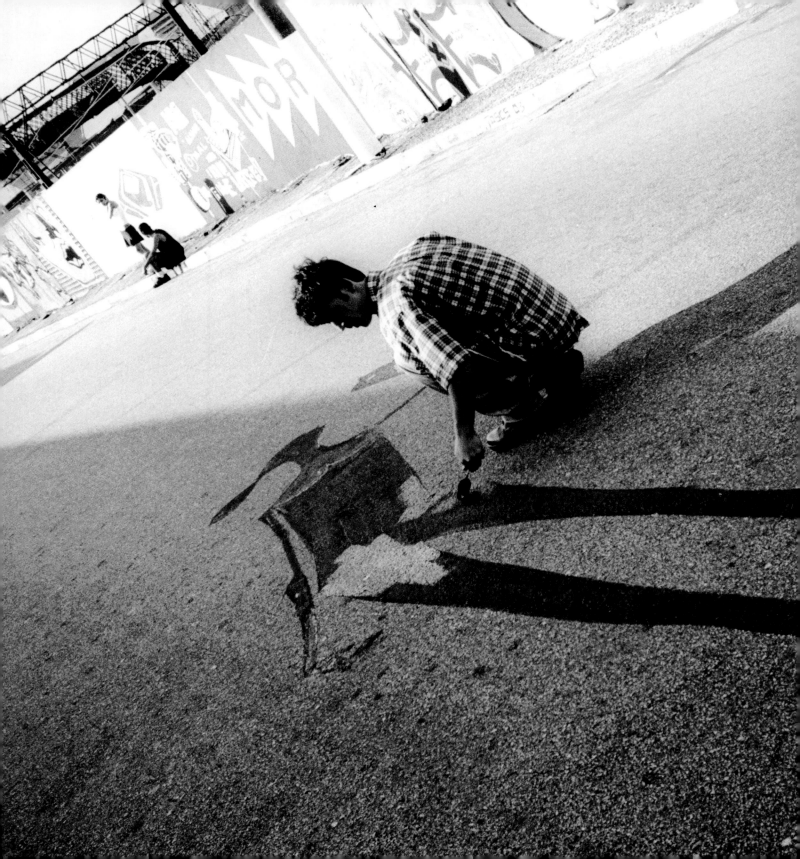

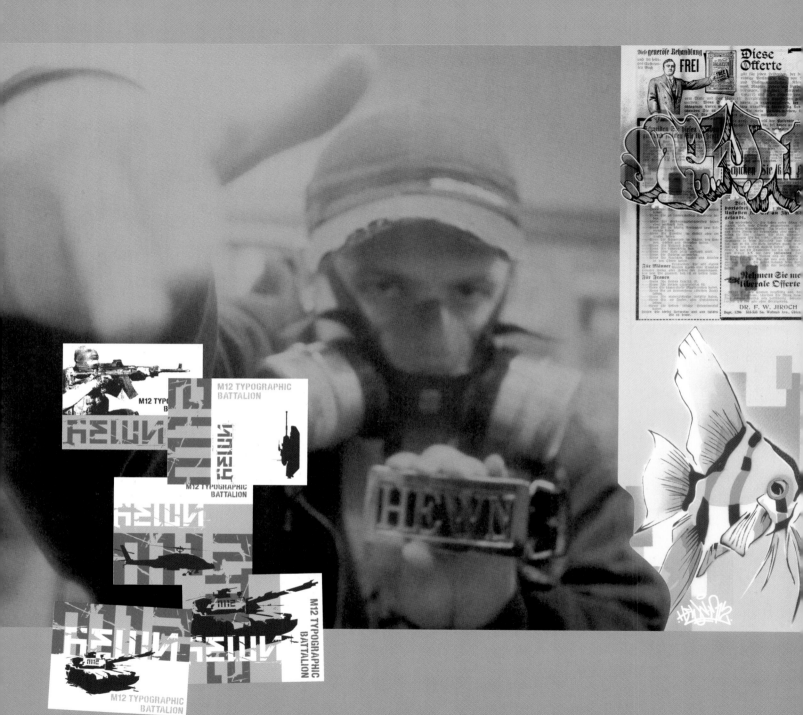

HEWN studied graphic design and now lives in Wisconsin. Regularly working on new projects, he spray-paints or draws on walls, books and objects he has found. 'My art expresses my feeling or mood at the time,' he says. 'If it's my older calligraphy, then I'm in a dark and medieval mood. If the pieces are colourful and bubbly, then I'm feeling fly.' He works with acrylic glass and adhesive film. Using coloured layers and splashes on clear, rough, acrylic panes, he creates a background for his artwork on the pane's reverse side, and then works with adhesive film or stencils to bring out the letters or pictures on the front.

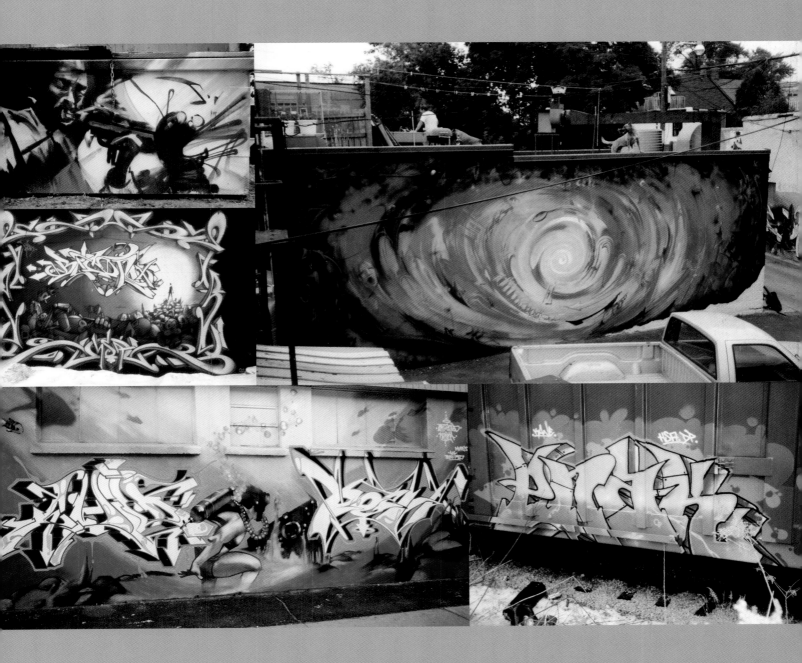

HSA CREW

HSA crew pioneered Canadian graffiti, and many of the large murals that its members produced are still around today. The crew comprises a number of very different, high-quality artists with their own individual styles, including graffiti writers Bacon and Kane.

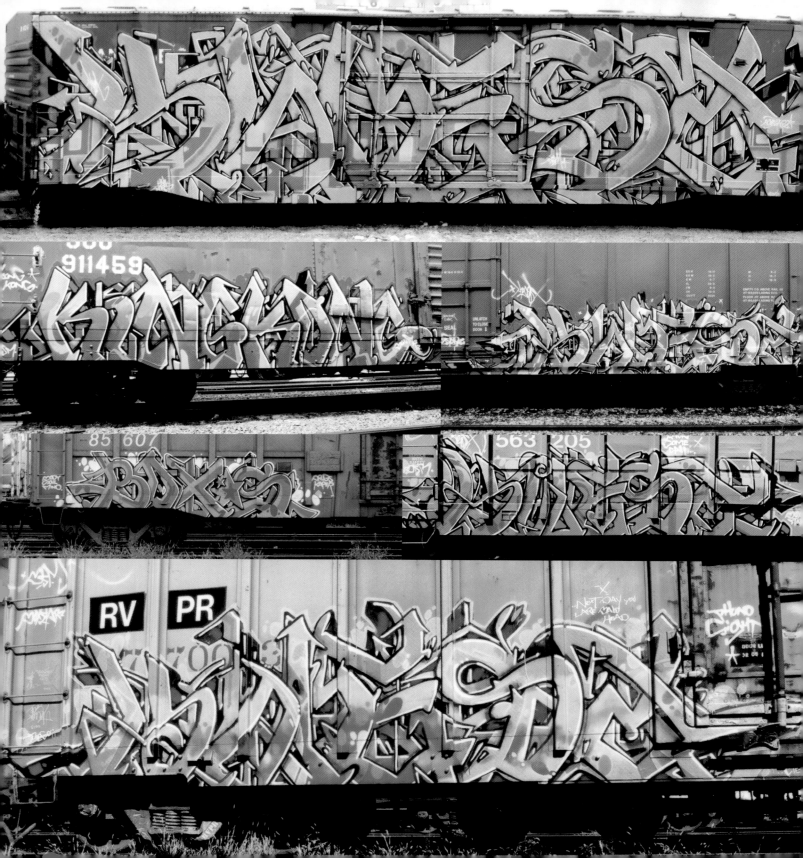

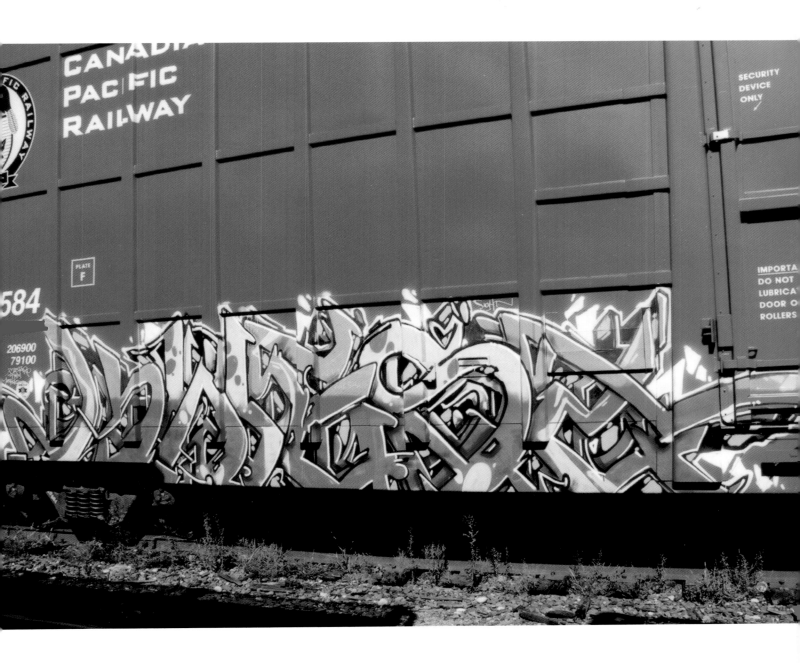

KWEST

Canadian-born Kwest is a member of Boxstars crew and generally paints his wild letters on freight trains, blending the colours of his pieces with the background of the trains.

He has always thought that art is a powerful means through which to voice issues and change society for the better, and his intense, spray-painted pictures are laden with messages.

69

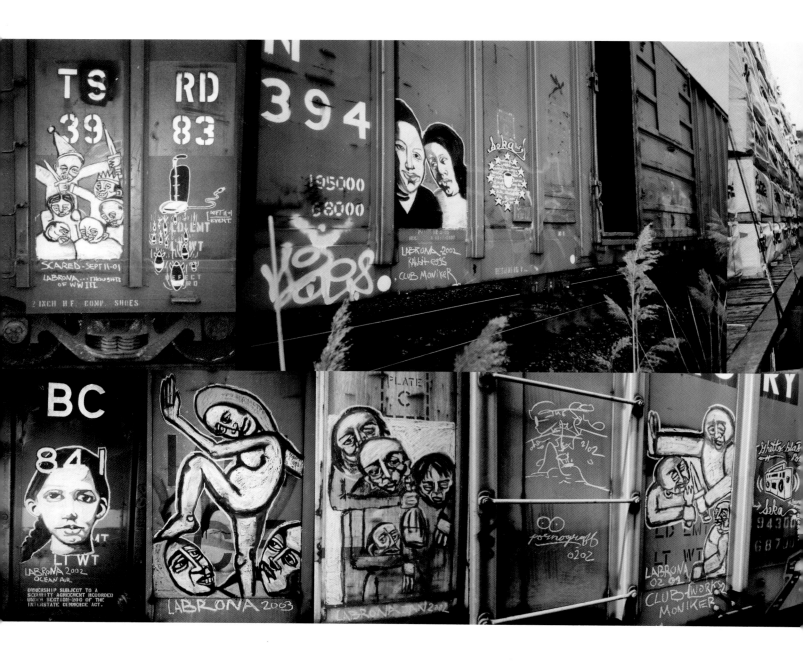

70

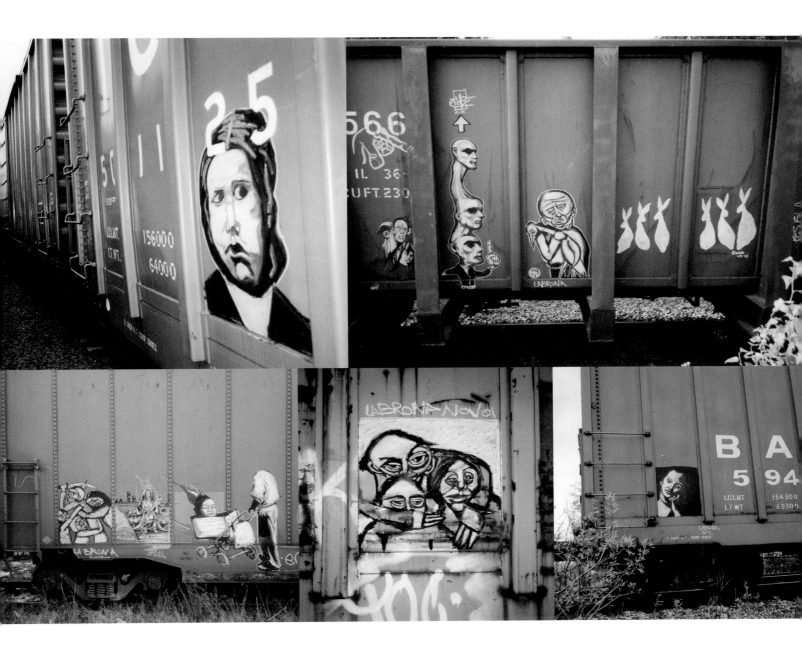

Although Labrona has been drawing and painting for quite some time, it was Other who inspired him to start using goods trains as an artistic platform when they both shared a flat in Montreal. He tries to find a connection between his realistic portraits and scenes and the environment and make-up of the train, using existing graffiti, writing or rust as an independent part of his compositions. The artist also aims to incorporate feelings, thoughts, anxieties and longings in his pictures. Oil-based chalk is his preferred medium, but he often also uses a spraycan before colouring the background.

71

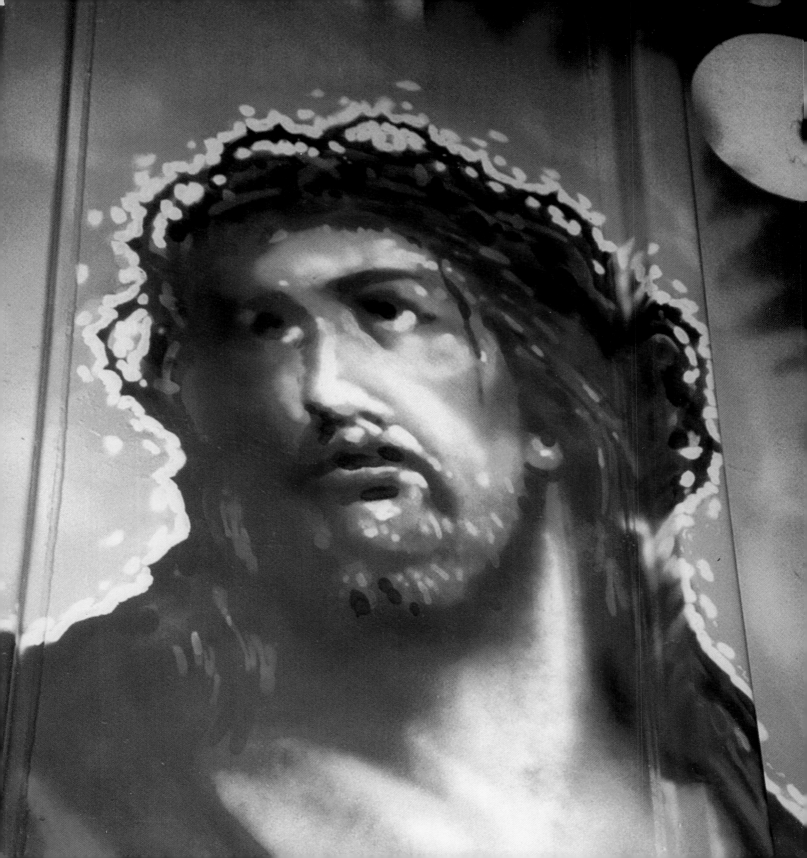

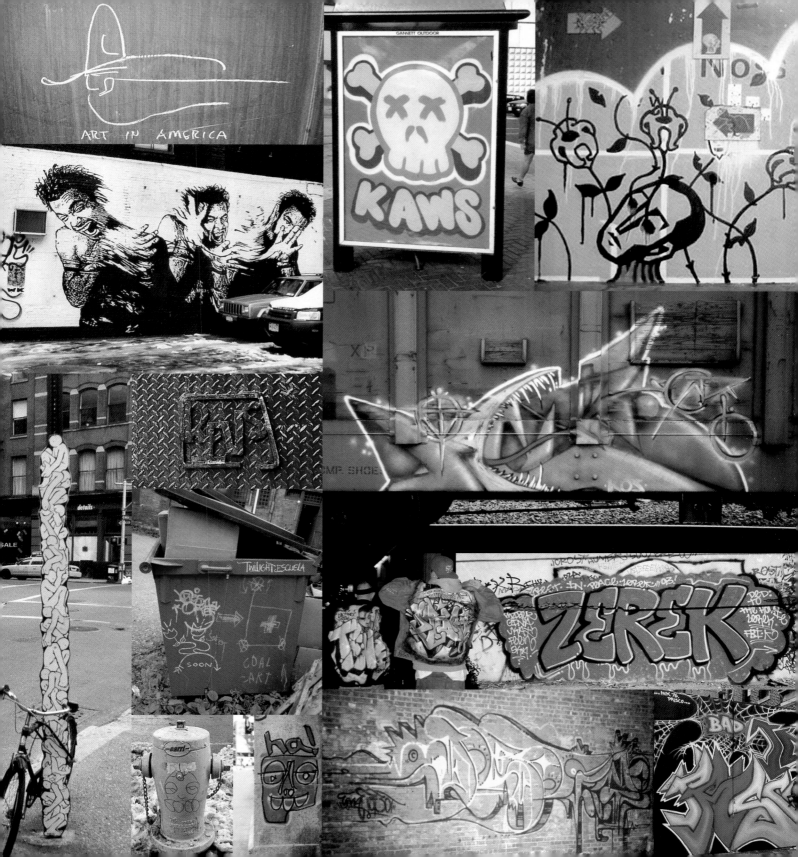

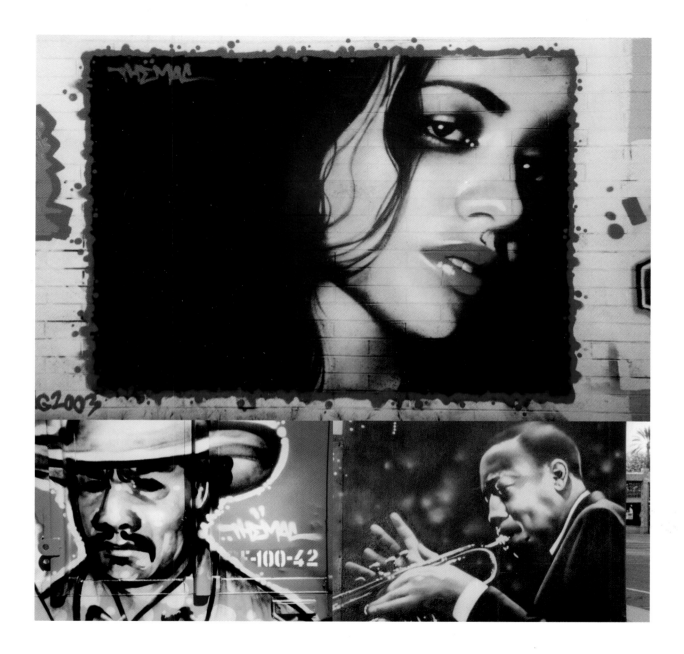

MAC

Mac is from Phoenix, where Mexicans form a large proportion of the population – an influence that is clear to see in his artistic development. His colourful, realistic and, at times, very personal and religious pictures have been inspired by a combination of factors: his home town; his mother; the Catholic Church; other artists; and his preference for characters and portraits. Although he tries out other techniques, he prefers to spray-paint. 'Graffiti is an adventurous art,' he says. 'You do it because you want to do it, sometimes taking a lot of risks. It's not about making money and there aren't any rules. It's true freedom of expression.'

73

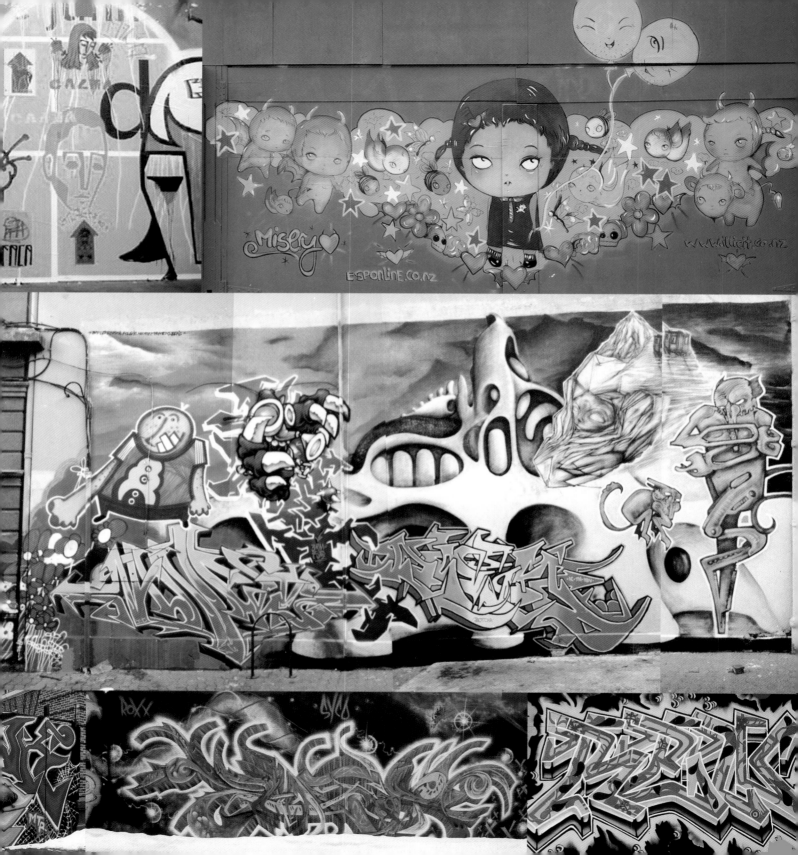

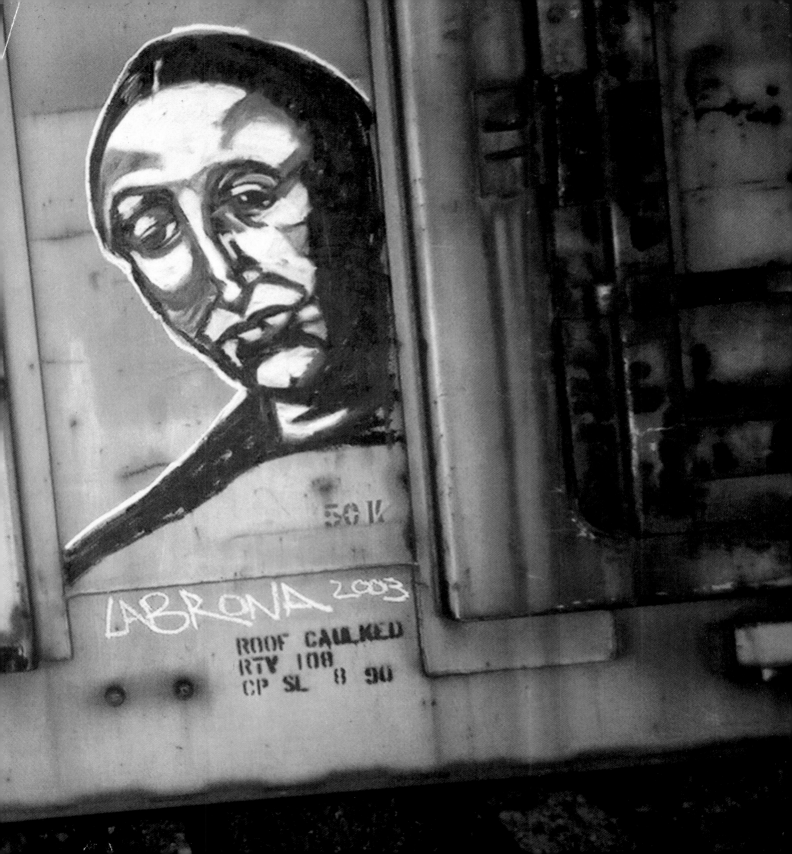

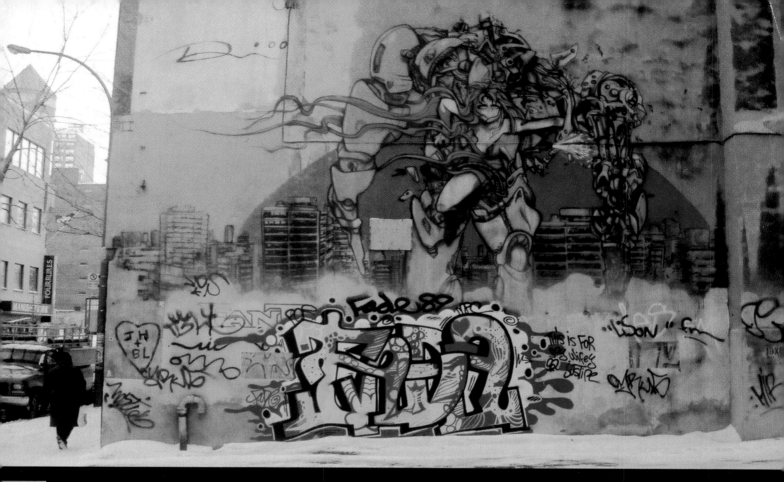

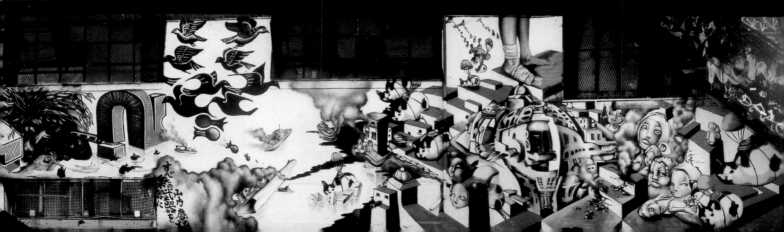

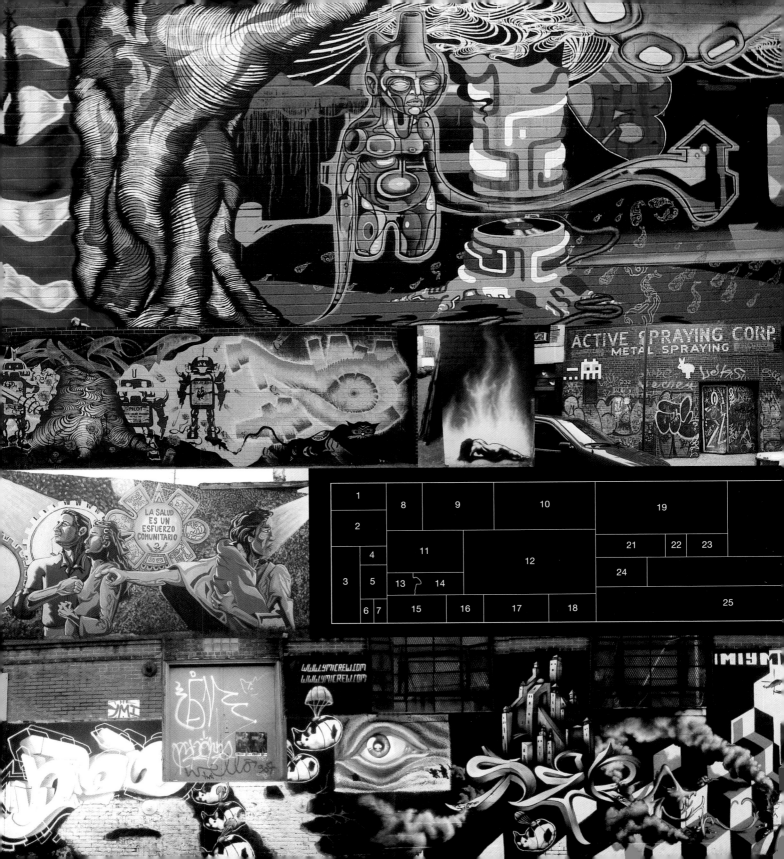

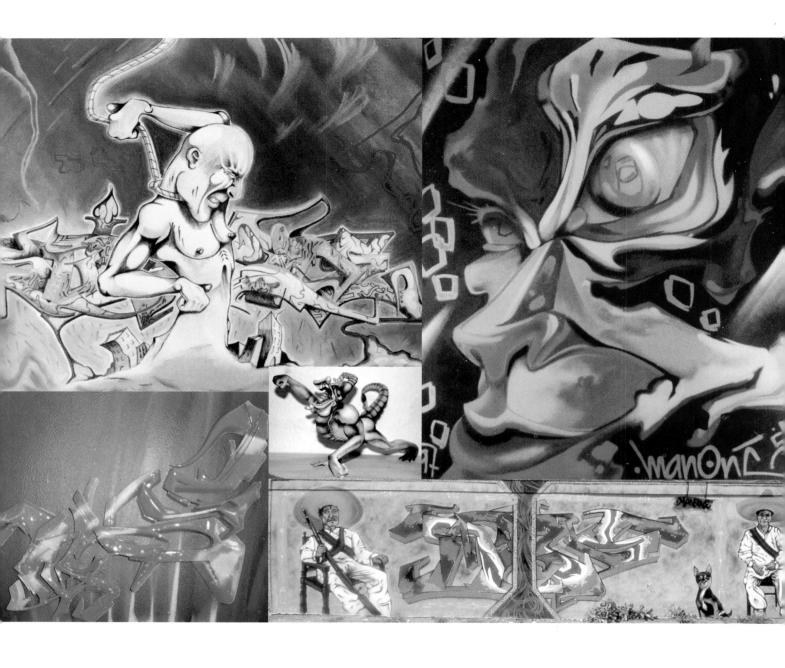

Since painting his first pieces in 1987 (when he was just sixteen), Los Angeles-based Man One has been using many different techniques, from oil and acrylic paint to ink and pens. 'The more tools you can handle, the wider your choices to make an impression,' he says. 'I tend to be political in a lot of my work. I think we live in a time when there are a lot of evil things going on in our world. Graffiti art is a way to reach the masses and change people's minds. I enjoy trying to do that.'

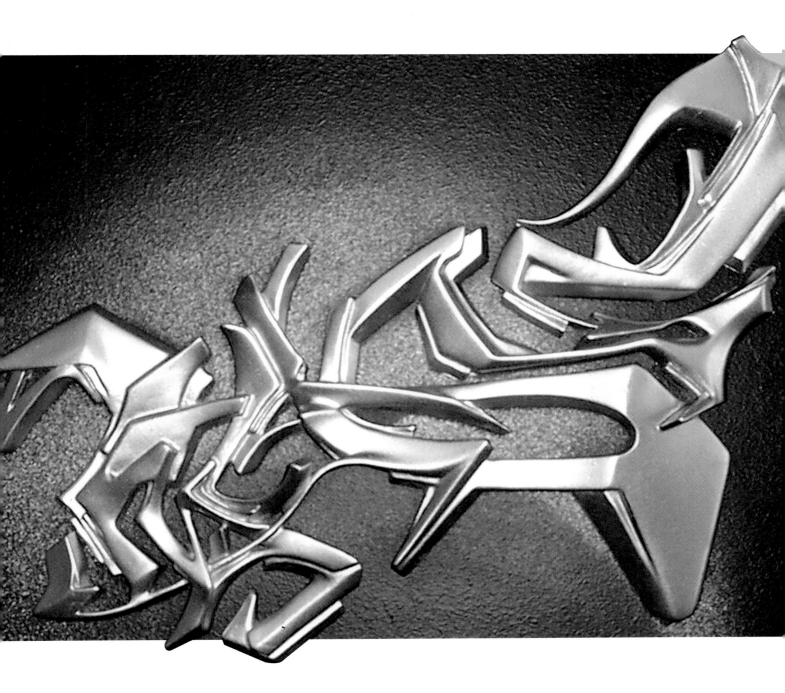

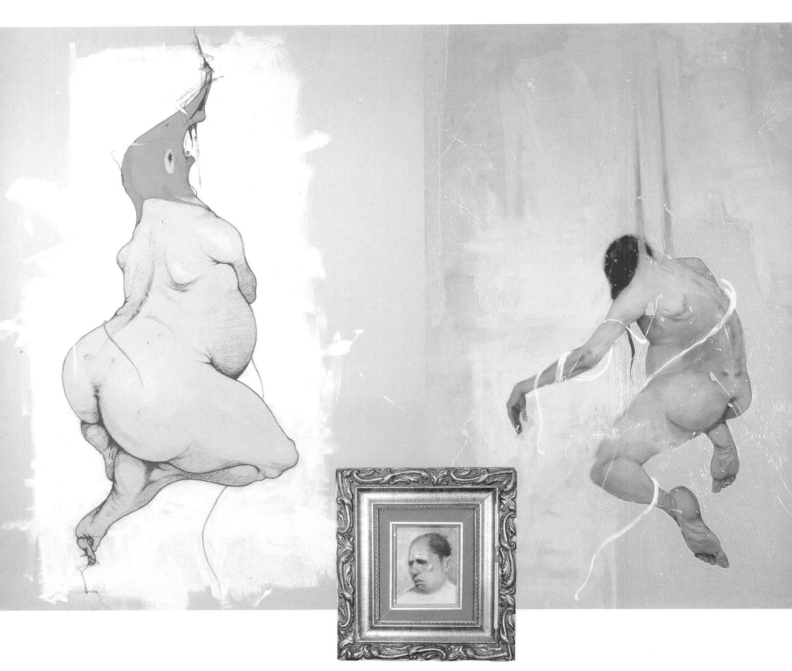

Merz, from Ohio, now lives in New York and is a partner of fellow writer Dalek. He has been painting and drawing since he was little, but these days he generally composes his pictures with oil paints or by mixing techniques on canvas or cardboard. The result is a combination of traditional oil painting and graffiti elements.

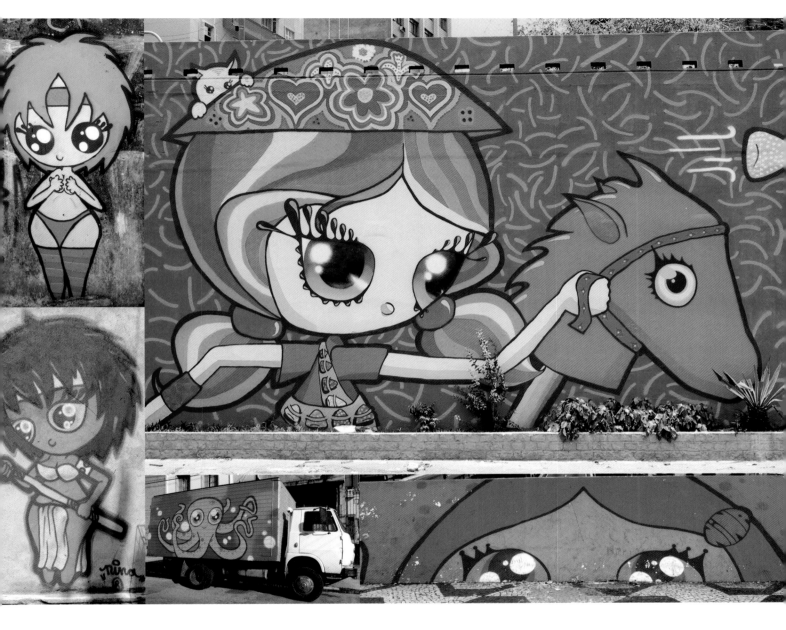

NINA

Born in São Paulo, Nina started to get into graffiti in 1990 and is one of Brazil's pioneer female writers. Her pictures, which often depict animals, insects or other forms of nature, have a deliberate childish element, which she uses to emphasize the beauty and value of the objects she paints. Together with the twins Os Gemeos, she travels all over the world painting her fantastic pictures.

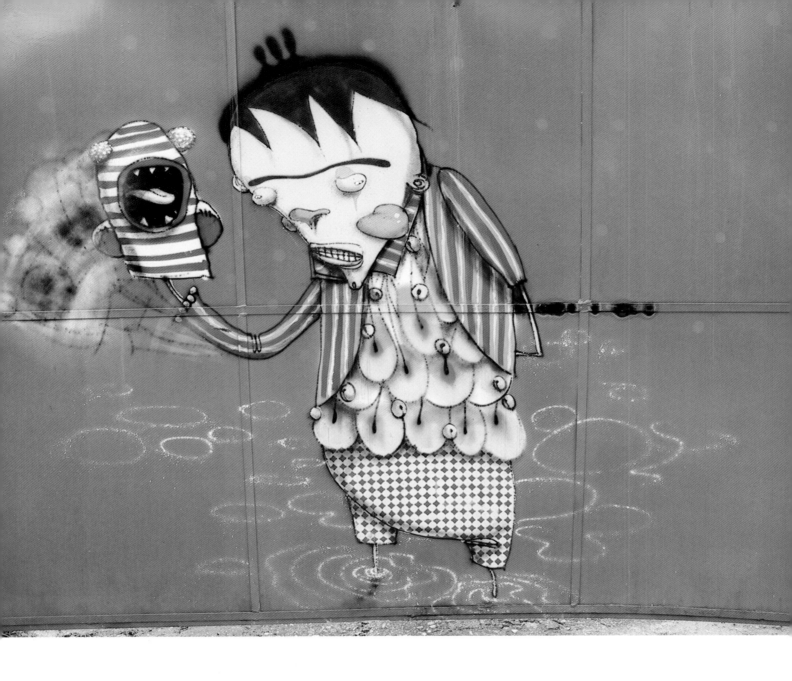

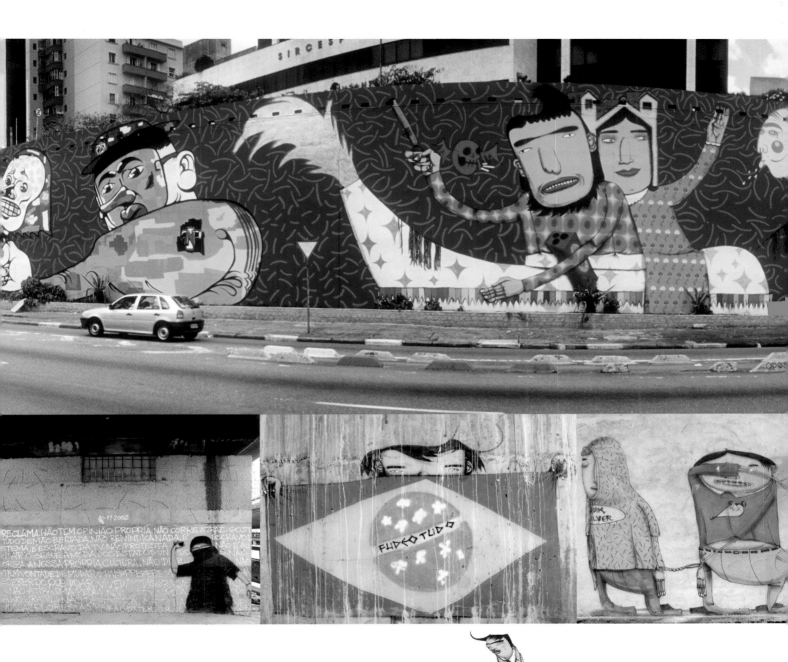

Os Gemeos are twins from São Paulo (Gemeos meaning twins in Portuguese). Since discovering spray-paint in 1986, they have not only participated in countless graffiti-orientated events and competitions, but have also pioneered Brazilian street art. Renowned for spray-painting with a kind of intuitive understanding, they have their fantastic characters, a distorted, comic-book their works tends to reflect and emotions. also gained recognition for which are often composed using style. They are improvisers, and their personalities, experiences

85

OTHER

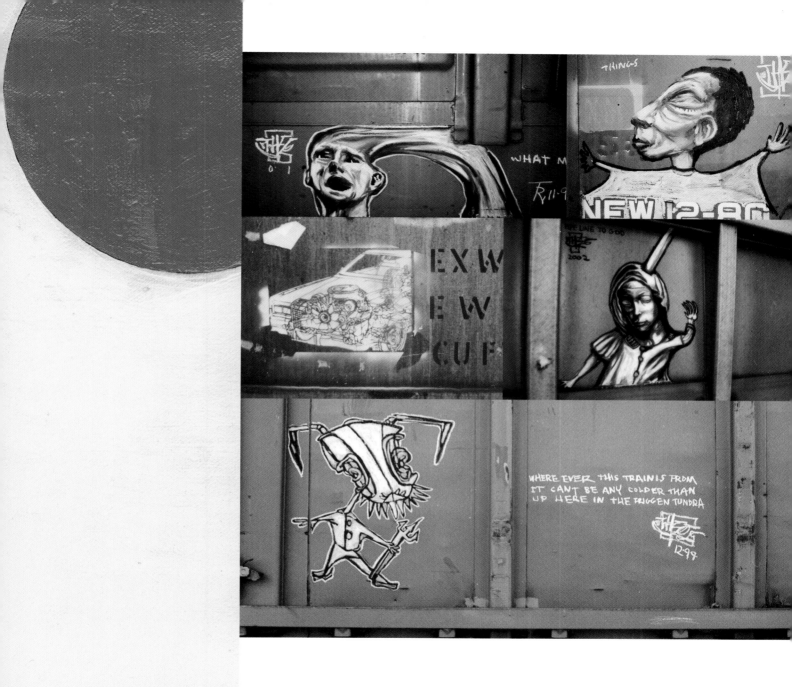

Through his travels, Other has managed to paint his realistic pictures, imaginative compositions and poems on goods trains throughout Asia, Europe and North America. 'I paint maybe a couple of walls a year,' he explains. 'Freight trains and their international / time zone movements are all that matters to me…rusty, heavy, slow-moving blindness…. I can't explain the feeling of painting in a train yard during a thick snowstorm…the lighting, the fresh air…it's a real lifesaver….' Like many others, he started off tagging, but turned his back on spray-painting in 1993 when he switched to oil-based chalk. Safety and convenience ended up influencing this decision: Other wanted to avoid breathing in the fumes from spraycans and was fed up with lugging cans around in bags.

87

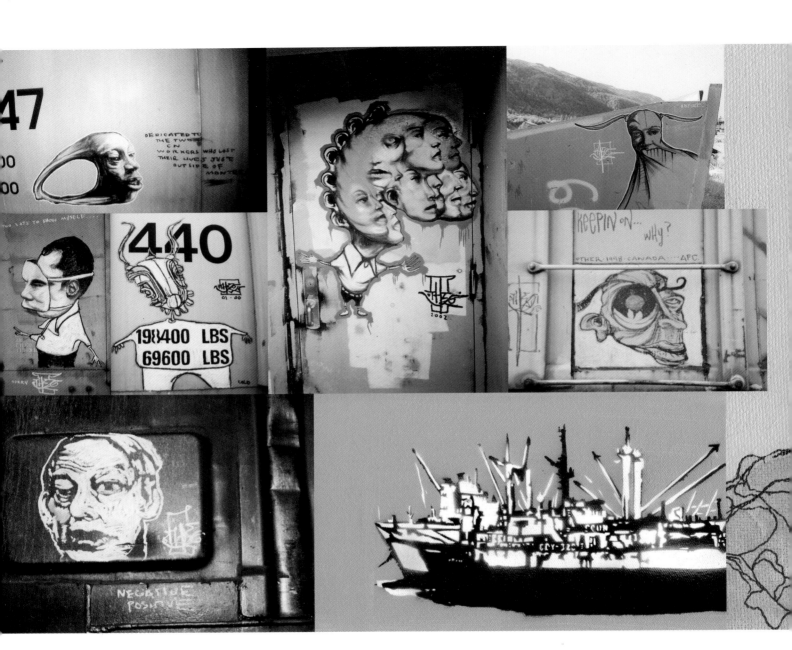

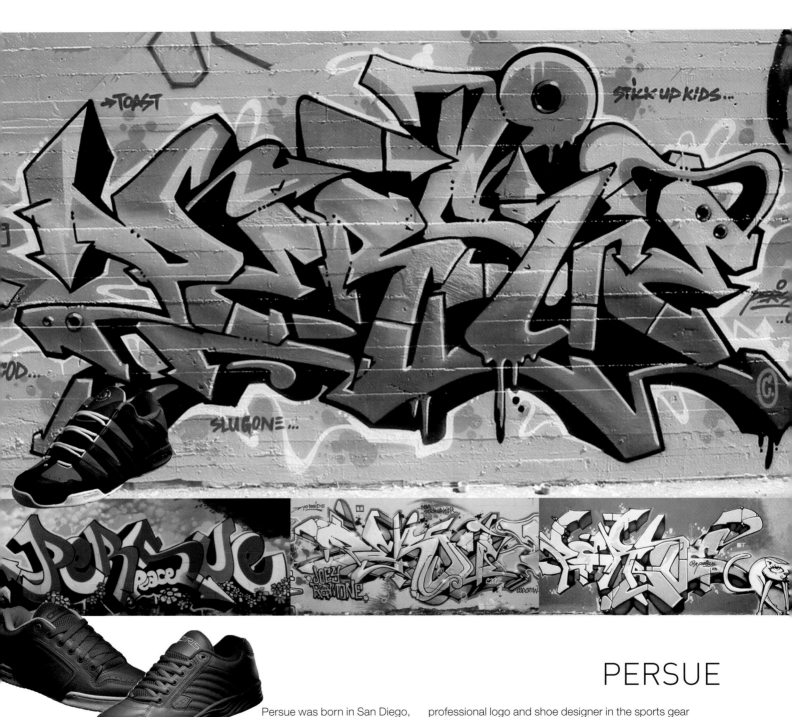

PERSUE

Persue was born in San Diego, where he still lives. He got the graffiti bug when his former teacher, Xpek 1, showed him his blackbook (a collection of sketches in a bound book). Although never officially trained in graphics, Persue's fellow artists taught him so much that he now works as a professional logo and shoe designer in the sports gear industry. Initially he worked as a freelancer at firms such as Eightball (now DC Shoes), where he caught the public's eye with the brands Osiris or Circa. For a while now, he has also been co-organizing exhibitions with other American artists such as Joker and Giant.

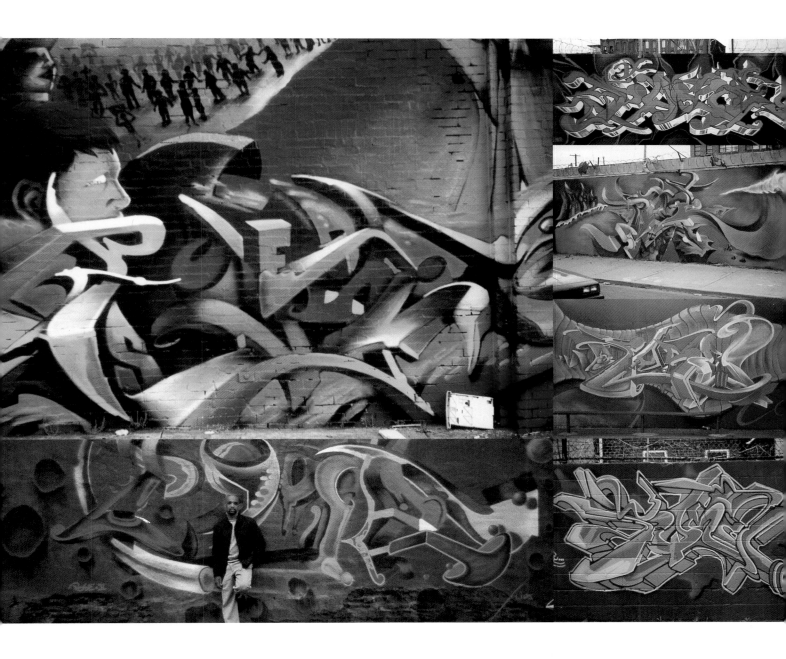

Pose 2 grew up in Philadelphia, which is better known for its legal graffiti than for bombings. Since getting into graffiti at the age of fourteen, Pose 2 has experimented with all sorts of styles, covering his walls with abstract compositions, flat outlines or 3D letters.

'For me, graffiti has always been a personal expression of who I am,' he explains. 'A nonconformist, I have my own set of rules, my own style, my own business, my own ideas of life…it's a struggle but it's a challenge to be free.'

POSE 2

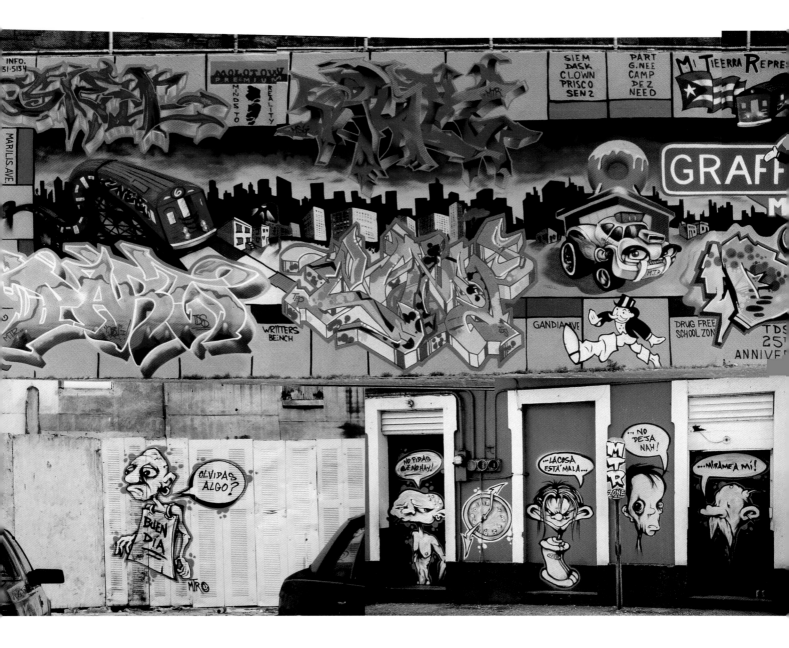

PRISCO

It was Prisco's mother who influenced his style. When he was young, she used to design T-shirts, painting names and words in different styles and colours across the front, or using adhesive letters.

Under this influence, Prisco ended up drawing his name non-stop – particularly on his grandfather's garage using a metallic spray. Without any knowledge of tagging, soon his name began to appear all over Puerto Rico.

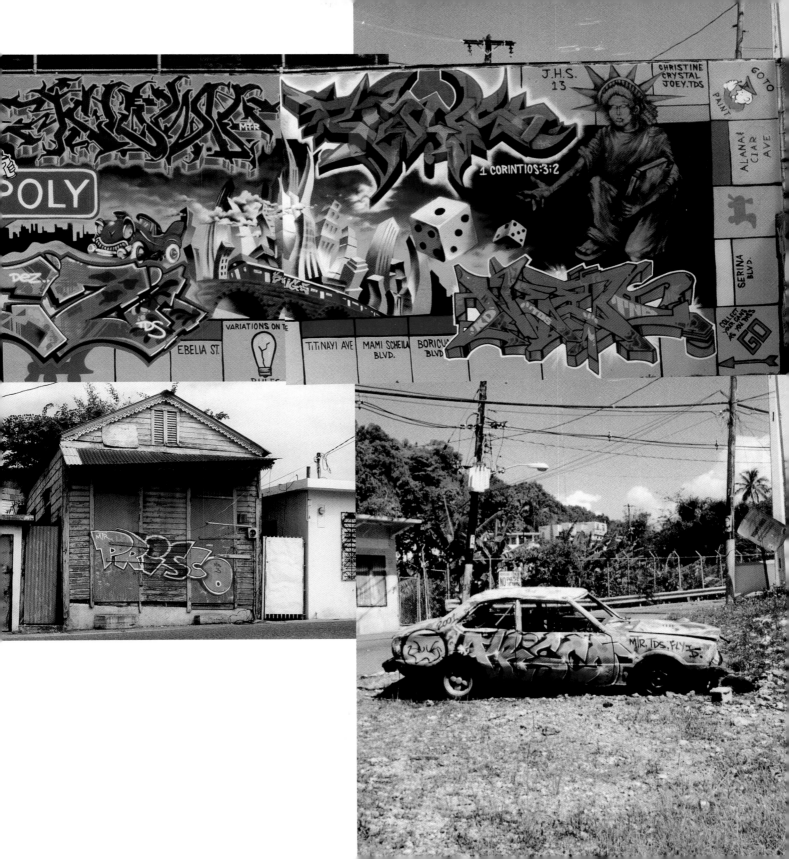

PRISM

Prism got the graffiti bug in 1988–89, while helping local graffiti artist Force One to paint a piece in an alley in Pittsburgh. From that point on, under many different names, he pursued the craft adamently. In around 1995, he chose the name Prism and started pursuing his on-going passion for painting freight trains. The artist's independent and lavish style, coupled with the huge colour spectrum he taps into, are the qualities that make his works stand out as a unique statement.

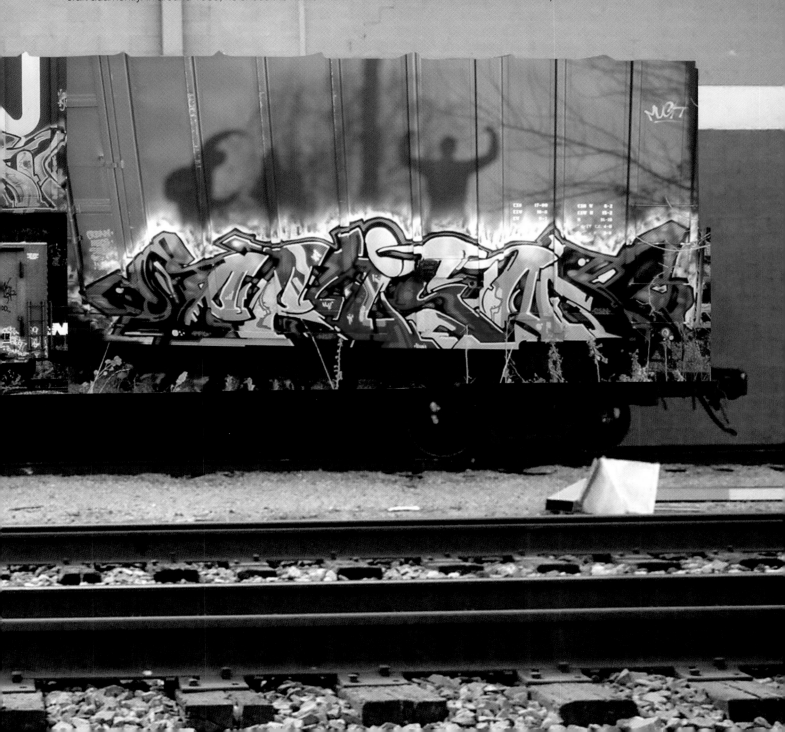

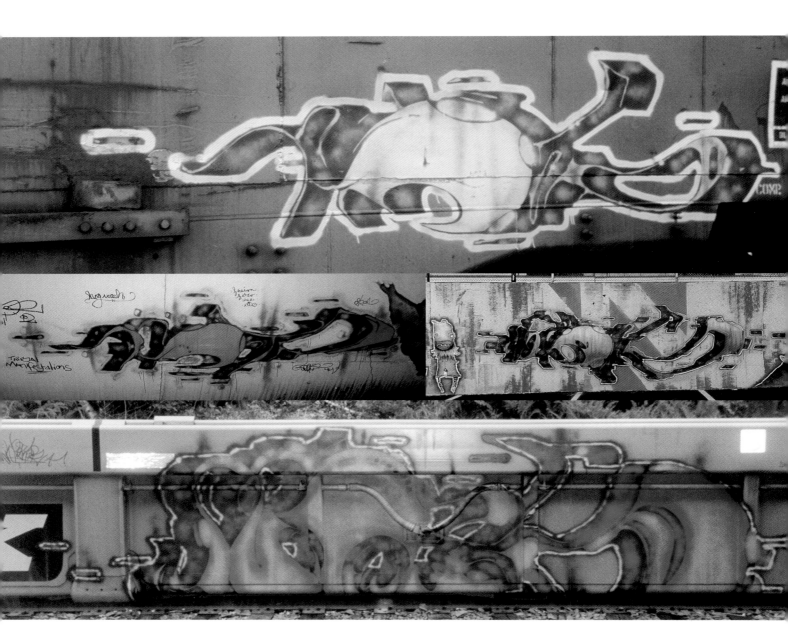

SECTR

Canadian-born Sectr has been spray-painting since 1995, targeting American goods and passenger trains that travel throughout the whole of North America with his abstract and compact style. To give his creative energy as wide a scope as possible, he uses various tools, combining a marker, spraycan and even scraps of rubbish. 'I don't know and I never really stopped to think about my own style or analyse it, it just happens,' he explains. 'Planet Earth is the most intricate life form I'm currently aware of, and I find it fascinating. I try to incorporate it into my work. My work is organic chaos, with a hint of technology thrown into the mess.'

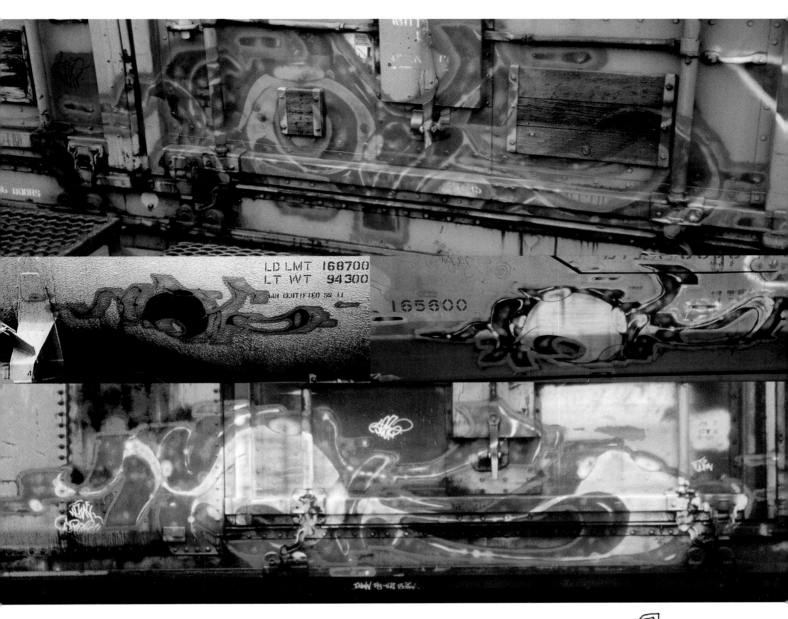

LD LMT 168700
LT WT 94300

165600

97

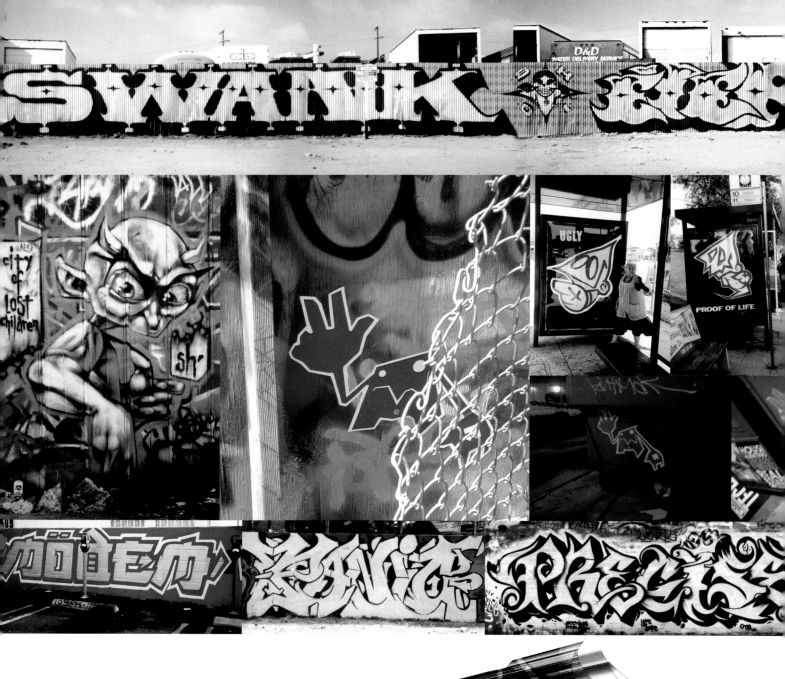

SEEKING HEAVEN CREW

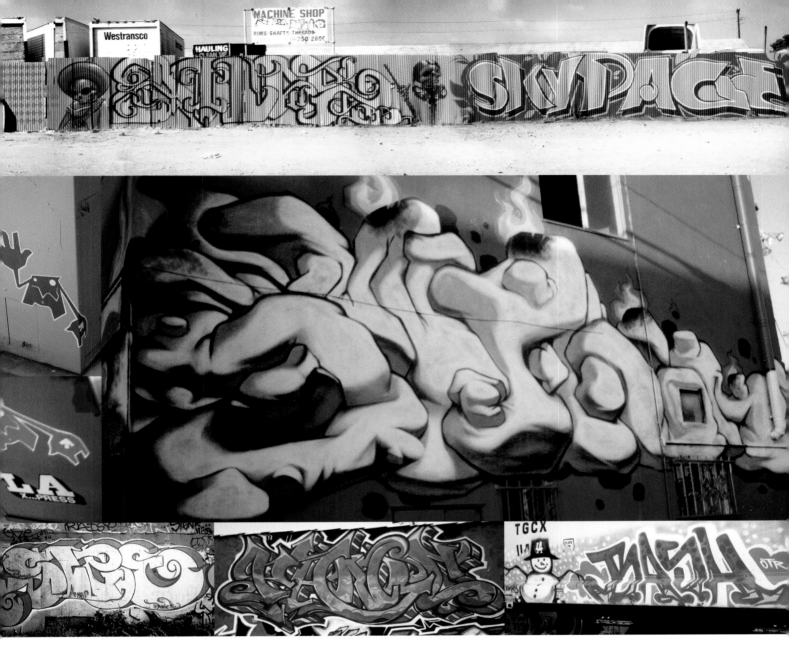

Founded in 1989 by original gangster graffiti artist Precise 1, Seeking Heaven crew now has a large number of members based in Los Angeles. 'The name comes from always looking higher,' explains member artist Eye. 'Our style is synonymous with the north-east of the city.' The crew's experimental, native style knows no boundaries, and its members are constantly trying out new modes of expression. *Lost*, a magazine published by Seeking Heaven, provides a platform for local graffiti artists, and some members also work as freelance artists or designers.

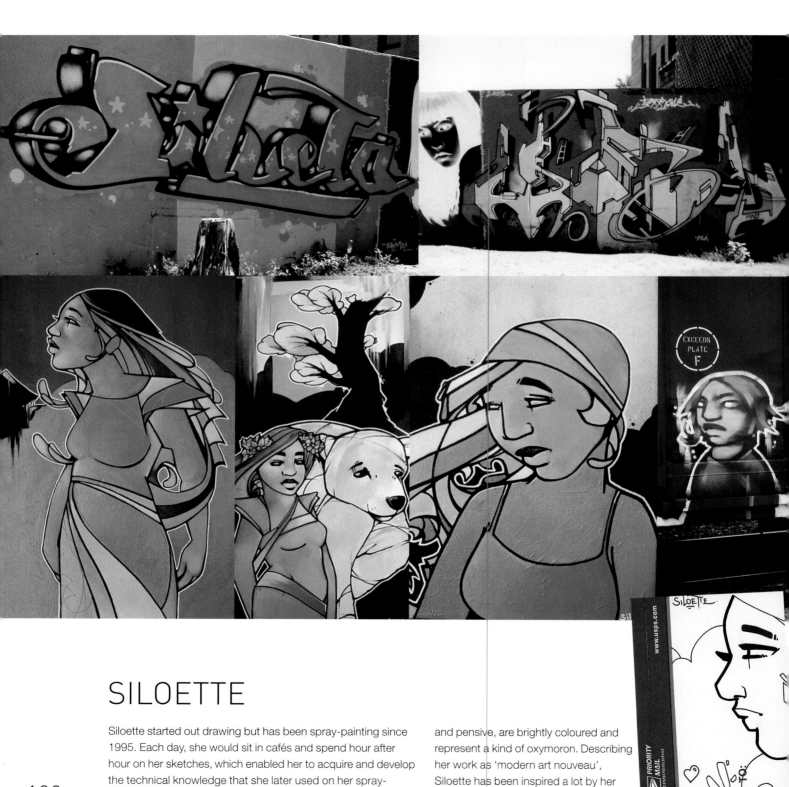

SILOETTE

Siloette started out drawing but has been spray-painting since 1995. Each day, she would sit in cafés and spend hour after hour on her sketches, which enabled her to acquire and develop the technical knowledge that she later used on her spray-painted pictures. The faces she depicts, often melancholic and pensive, are brightly coloured and represent a kind of oxymoron. Describing her work as 'modern art nouveau', Siloette has been inspired a lot by her younger brothers and family.

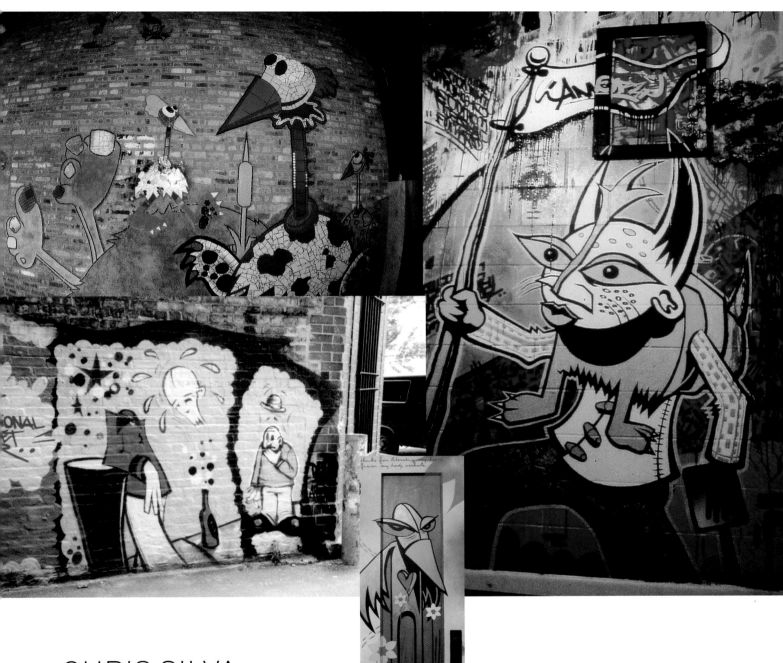

CHRIS SILVA

Chris Silva was born in Puerto Rico and now lives in Chicago. With his positive, autobiographical pictures – through which he tries to process his personal thoughts and emotions in the form of a visual diary, and to form a relationship between himself and others – he tries to create an alternative to the glut of soulless advertising posters he sees around. The range of tools and techniques he uses is extensive including spray-painting, mosaics, acrylic paint, ink, cement and different kinds of paper.

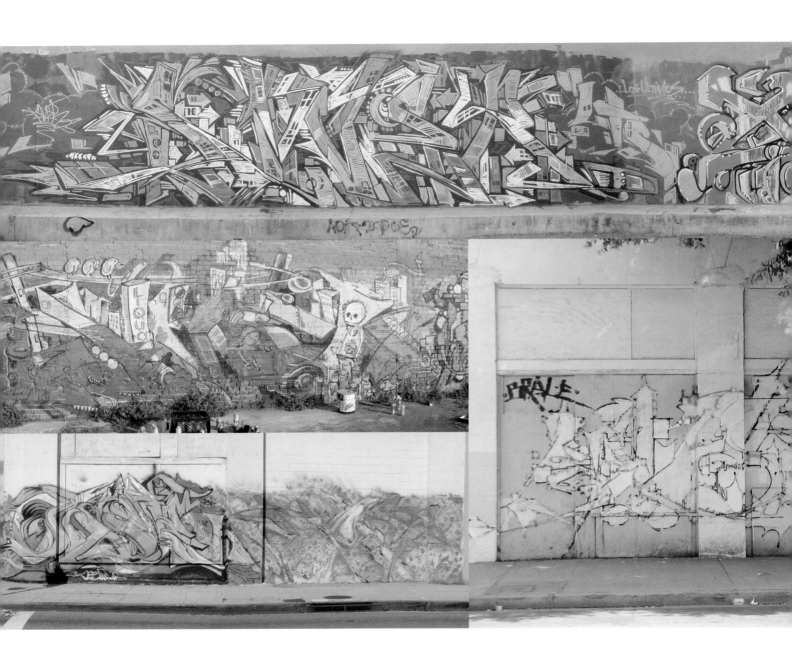

SINER

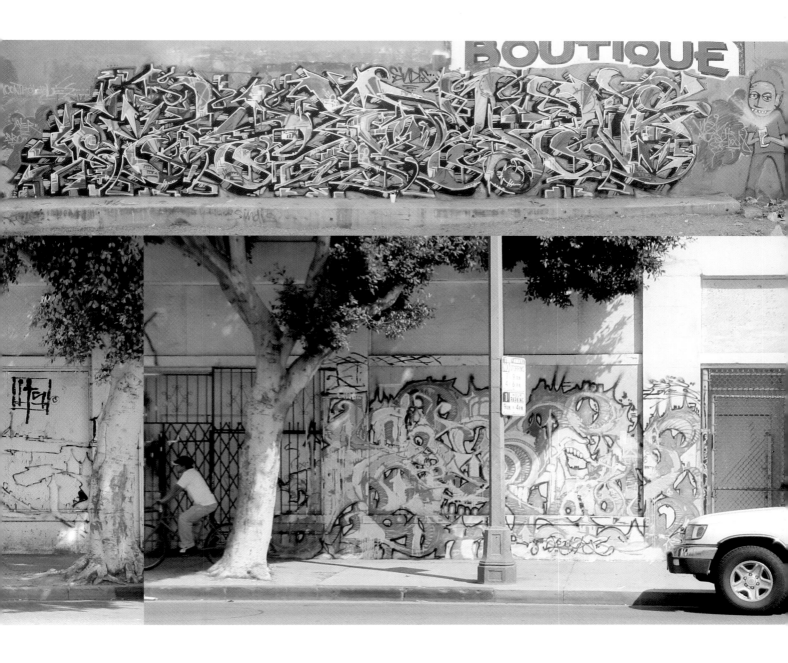

Siner comes from Los Angeles and represents a particular form of wildstyle for which this region is famous. His letters are twisted and entwined, with a lot of decorations and a complex choice of colours.

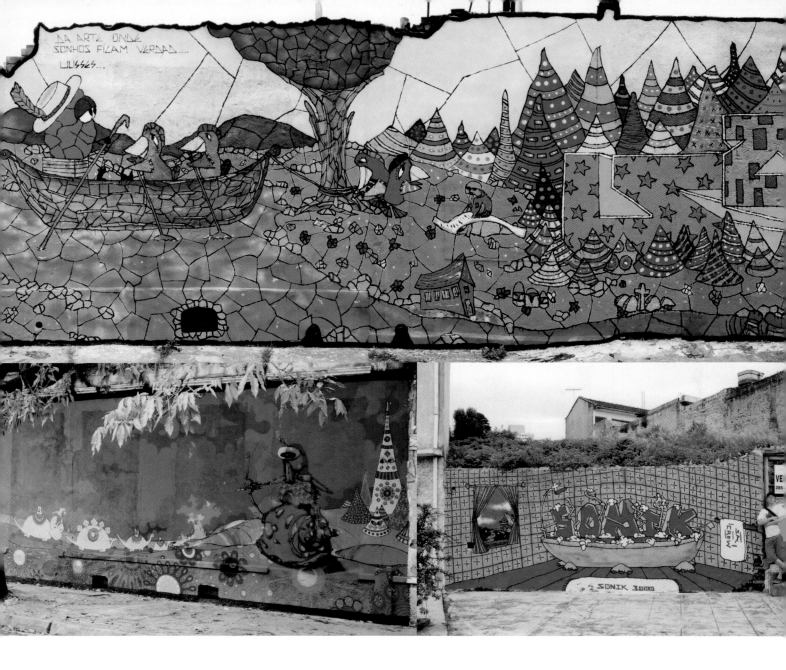

104 SONIK

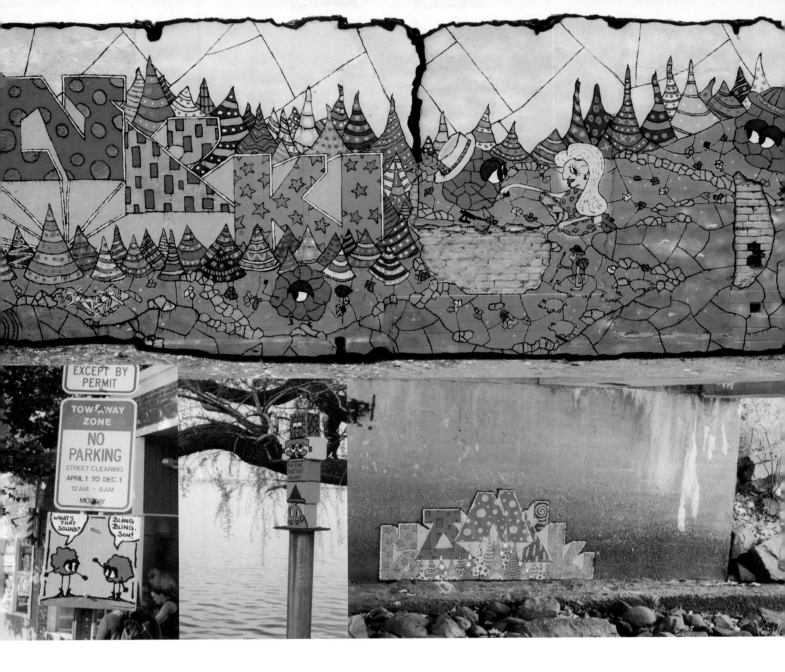

Sonik (also known as Caleb Neelon) is based in Cambridge, Massachusetts, although his simple characters often have strong Brazilian influences. He is especially fond of humorous signs, characters and texts, which are specifically designed to catch people's attention and target children. The artist believes that his works have political elements because they are painted illegally and remain anonymous. Over the years, his travels have enabled him to take his art to many parts of the world. Moreover, when he journeyed through Brazil, Nepal, Iceland and the USA, he worked out individual projects for each country, taking account of differences in language and conditions.

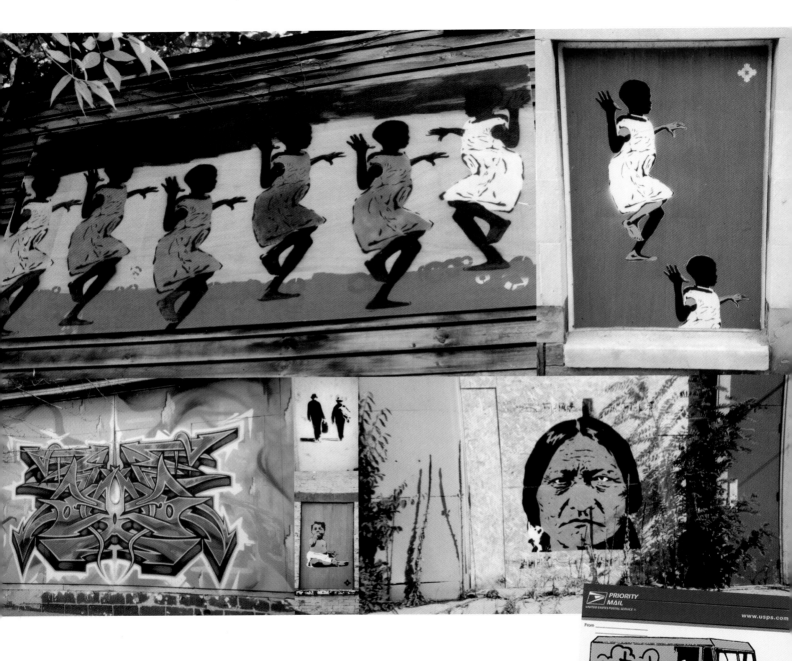

STAIN & SCOUT

Stain and Scout are based in New York. Stain, originally from
Baltimore, started to use stencils because he was unable to
afford screen-printing equipment. The artist's pictures have
a subjective quality, documenting aspects of his personal life
and family history. Both artists stencil and screen-print posters
and stickers, which often contain political or social statements.

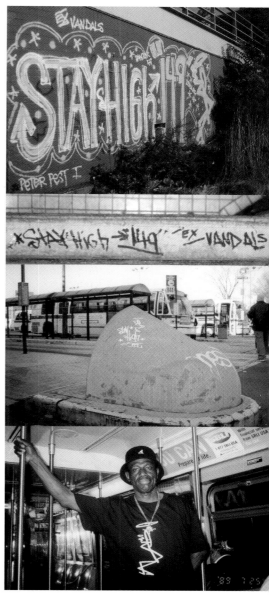

STAYHIGH 149

Stayhigh 149 is one of New York's old-school pioneers and has been painting since around 1969. He became known for his striking character, borrowed from the TV series *The Saint*, which he adapted to incorporate a joint, elements of which

have often been copied by other writers in their tags. His well-known slogan, 'Voice of the Ghetto', also emerged early on. After almost twenty years' absence, his striking figures have started to reappear on the streets of New York.

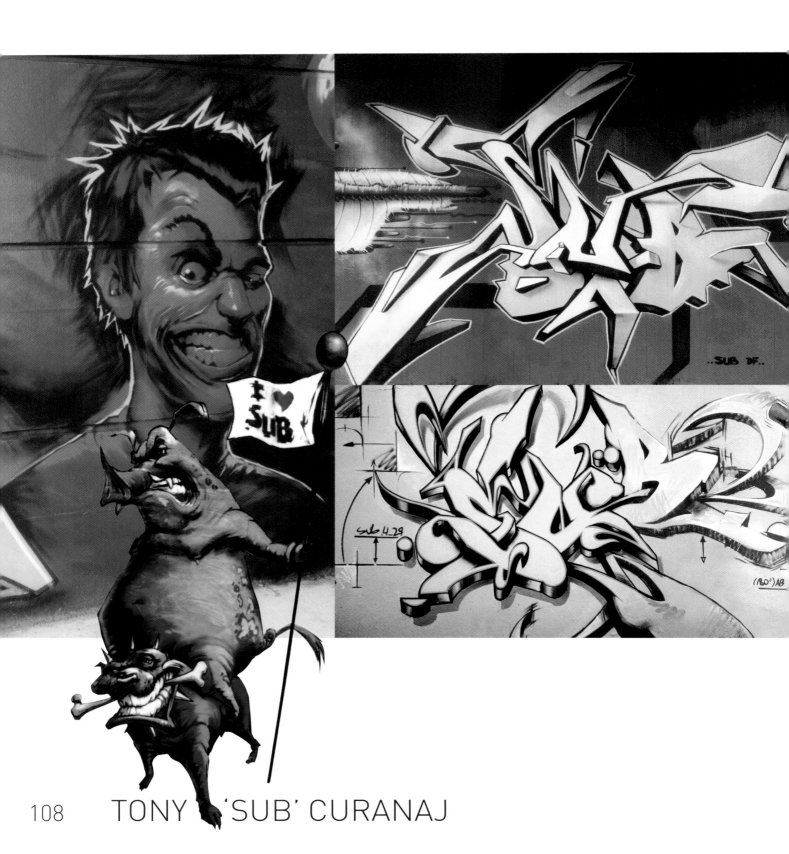

108 TONY 'SUB' CURANAJ

New Yorker Sub is an influential artist who takes elements of 1990s graffiti and combines them with present-day technical skills. He first got into graffiti in the late 1980s, and soon got credit for his technical skill and creativity.

His love of the classical, realistic painting and drawing techniques of the 19th-century masters prompted him to study drawing and fine art. Along with other like-minded graffiti artists, he began to develop his graffiti using a combination of letters, an integrated background and figures. Today, he is a successful illustrator and paints murals in the USA and Europe. His passion, however, remains classically inspired oil paintings.

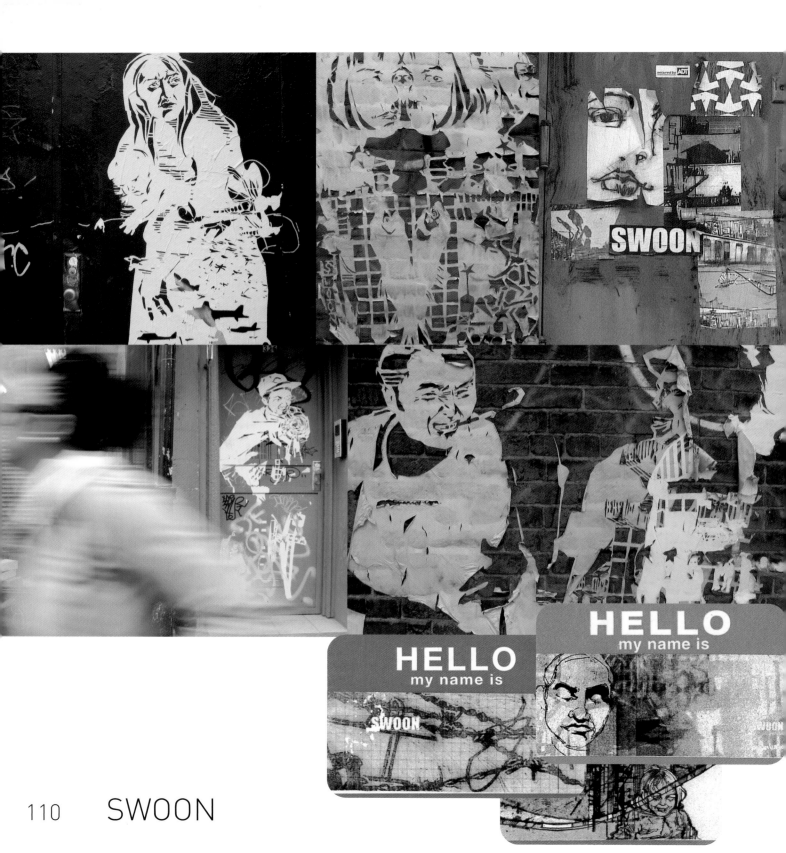

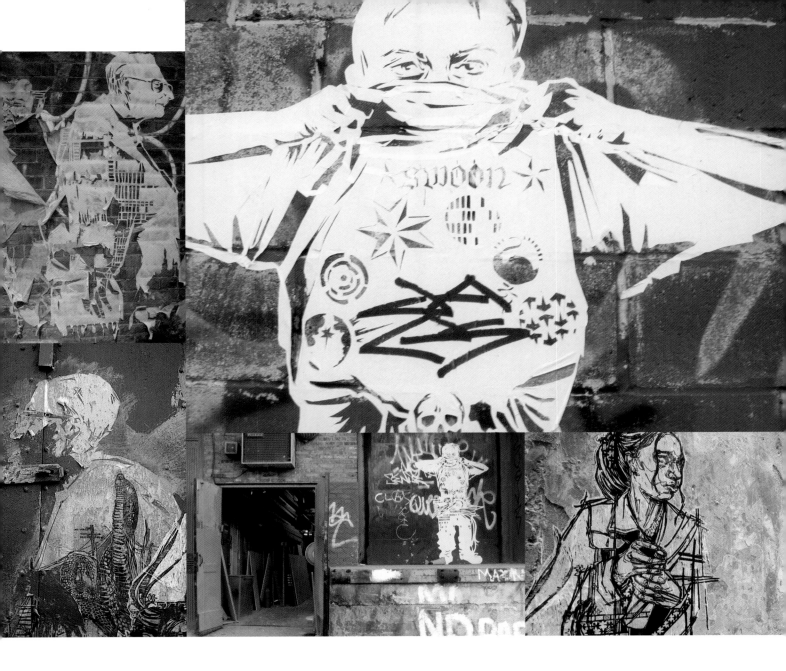

Swoon's cut-out posters are plastered around Brooklyn, but she has also worked in London, Berlin and other cities. Building on her knowledge of fine art and oil painting, her paper cut-outs are often portraits of the city's inhabitants and architecture. These silhouettes are sometimes cut with fine details or otherwise include elements of printmaking.

She also plays with the textures and colours of the wall. 'I usually don't express specifically political things, unless they just come out in my work,' she says. 'While the USA was first invading Iraq, I found myself making a cut-out of a woman and child running from bombs being dropped, but it wasn't my intention to make that kind of image at first….'

111

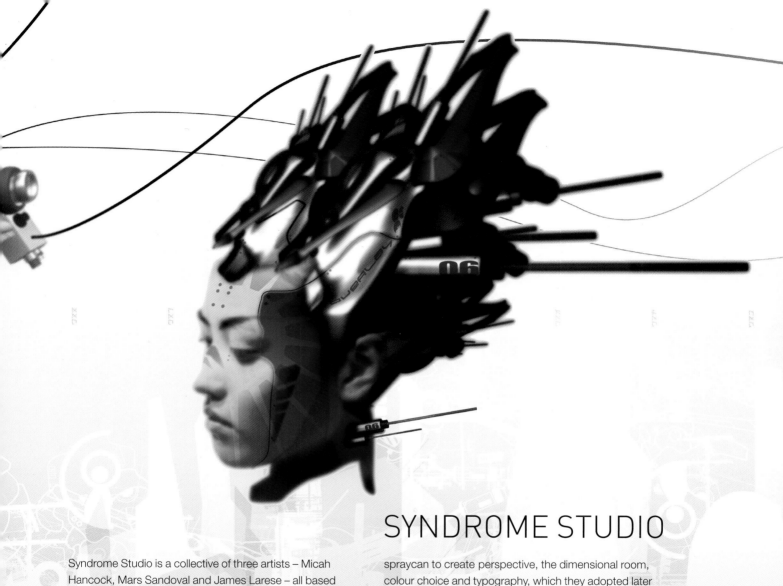

SYNDROME STUDIO

Syndrome Studio is a collective of three artists – Micah Hancock, Mars Sandoval and James Larese – all based in Los Angeles. All members of the studio have been influenced by graffiti, and their pictures have clear hip-hop and graffiti art elements. In their early days, they used the spraycan to create perspective, the dimensional room, colour choice and typography, which they adopted later in their digital designs. They all work in quite different fields but have formed a collective to create collages on canvases, prints or video screens through digital tools.

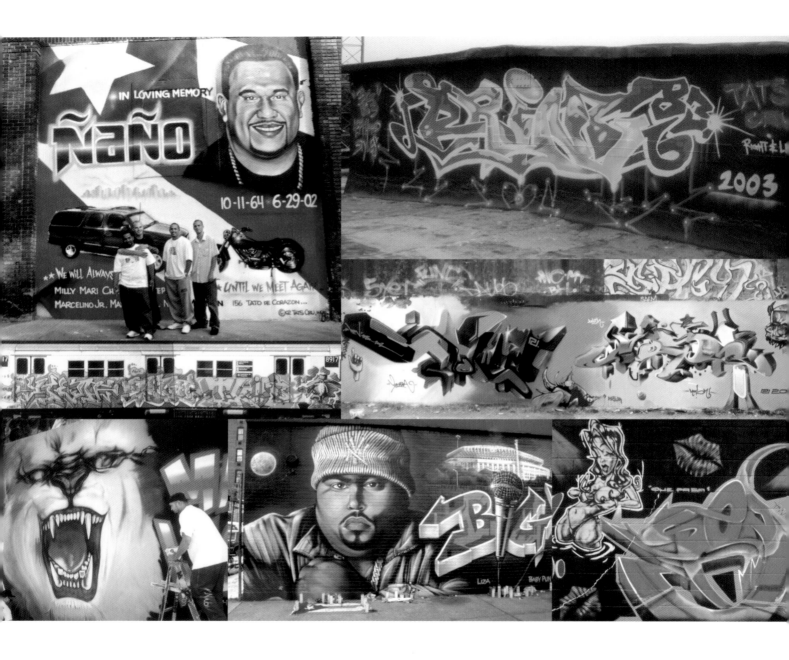

TATS CRU

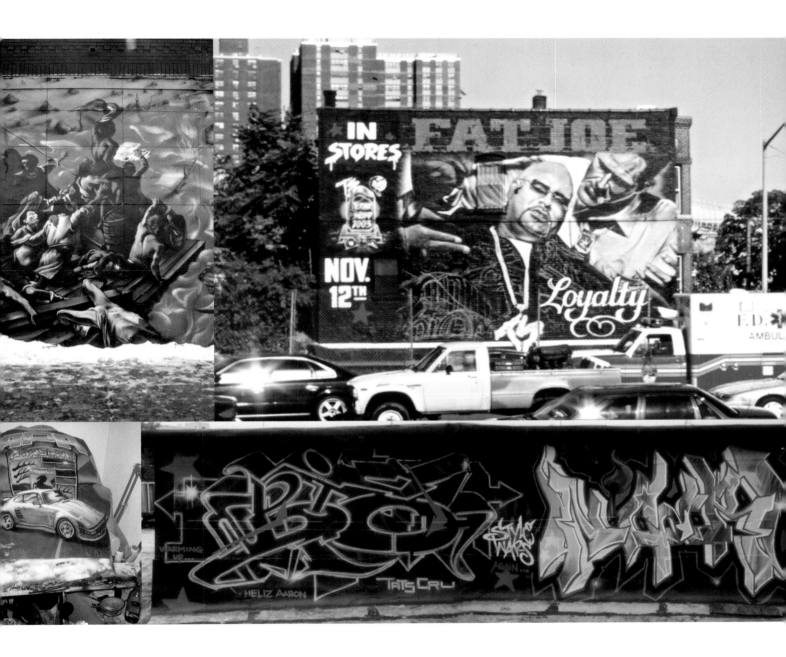

Like many of TATS CRU's long-standing members, founders Bio, Nicer, BG 183 and Brim started off doing graffiti in New York subways over twenty years ago, after seeing the work of early writers such as Seen, Stayhigh 149 and Tkid.

They have since become professional muralists, promoting graffiti as a viable art form to businesses looking for fresh, innovative and eye-catching ways to represent their products or services to the public.

TS5 CREW

The Spanish Five (TS5 / TSF) was around from the 1970s until 1984, controlling an area that stretched from downtown Manhattan to uptown Harlem. Targeting many trains, above all the IRT#1 Line, their work is typical of the bombing periods of New York's early graffiti scene. When the crew started to break up at the end of the 1970s, only three of the original members remained: Stan, Prism and Deadly-Done.

UNC

Toronto-based Urban Nightmares Crew was formed in 1997 by Mine, Cinder, Deth, Jesp and Asstro. The thirty-strong crew includes artists with a huge variety of talents, many of whom are no longer active on the street. 'The landscape of suburbia was grey and boring. I felt it was time for a change,' says Mine. 'I didn't use graffiti as an excuse to break shit. I just wanted to cover everything I saw with paint in order to cause static in everyday life – you know, make people stop and smell the roses. Unfortunately, some think that the graffiti rose stinks!'

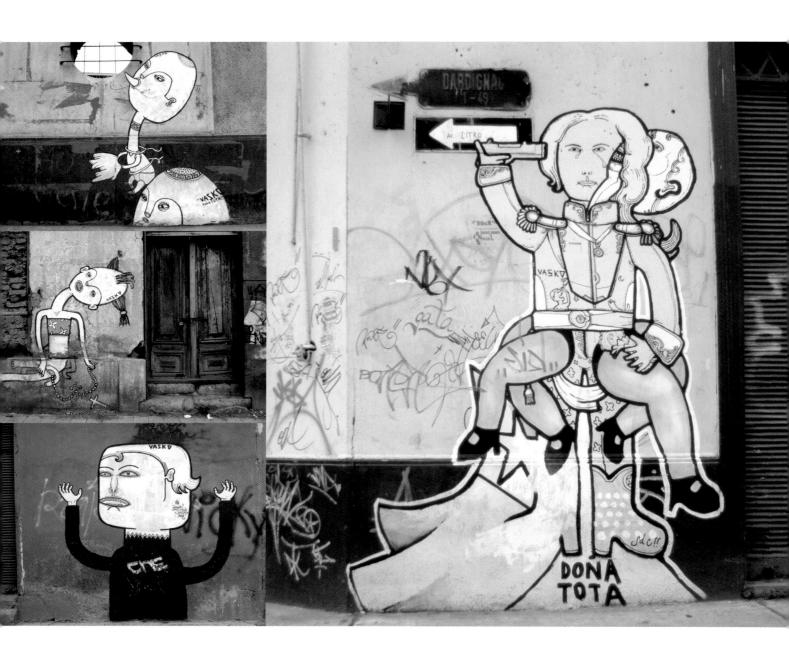

VASKO

Chilean artist Vasko comes from Santiago and is an impressive representative of the local graffiti culture. His pictures include menacing, fantastic characters.

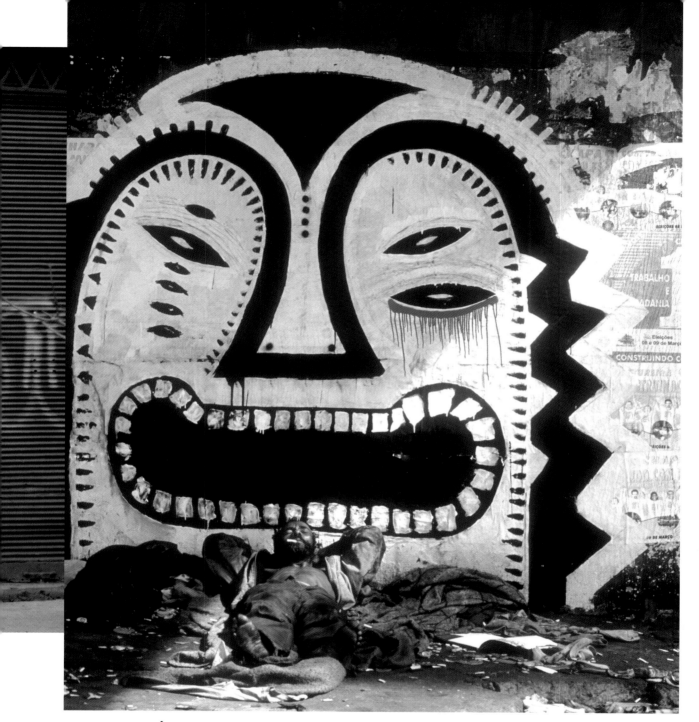

VITCHÉ

is another pioneer of the Brazilian spray-painting scene and became actively involved in 1987. He wants to make the passer-by think with his pictures, and invites him or her on a journey through his artworks. Personal experience and Brazilian culture have been important influences on his work, which often features masks – generally used to symbolize the superficiality of people. Gauging the artist's use of colours is also key to understanding the message of his pictures. Red, for example, is often used to reflect hatred, although lately it has become a more positive element in his compositions.

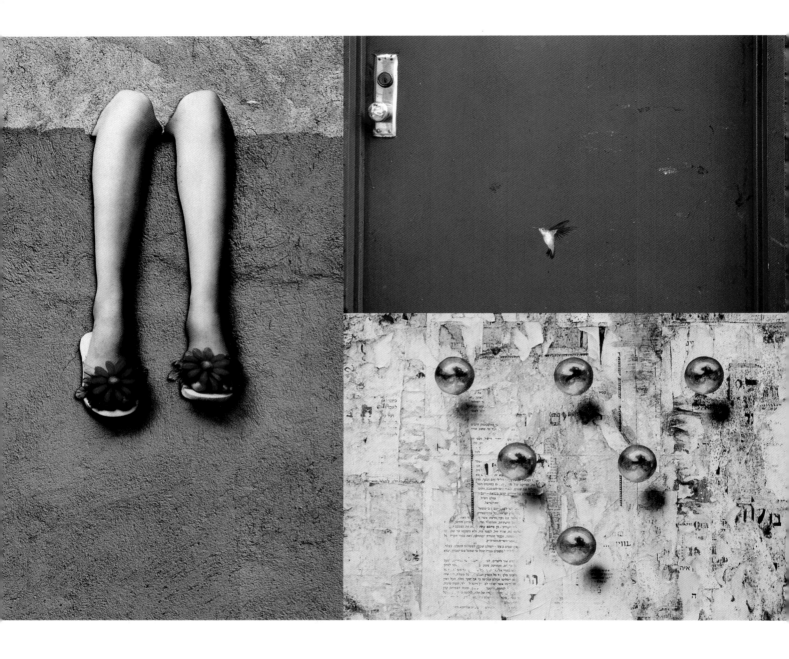

DAN WITZ

Dan Witz began his career as a street artist in the late 1970s, when there were loads of paintable panels on trains and breakdance was popular on the streets. Probably his most striking project was *Hummingbirds*, which he first started to paint in May 1979. He returned to the idea in 2000 with a new series of pictures of the shimmering birds. Throughout the many years he has worked on the streets, he has caught the passer-by's eye with objects that seem to come out of the wall – the still candles and pictures of saints that he has been painting since 11 September 2001, for example.

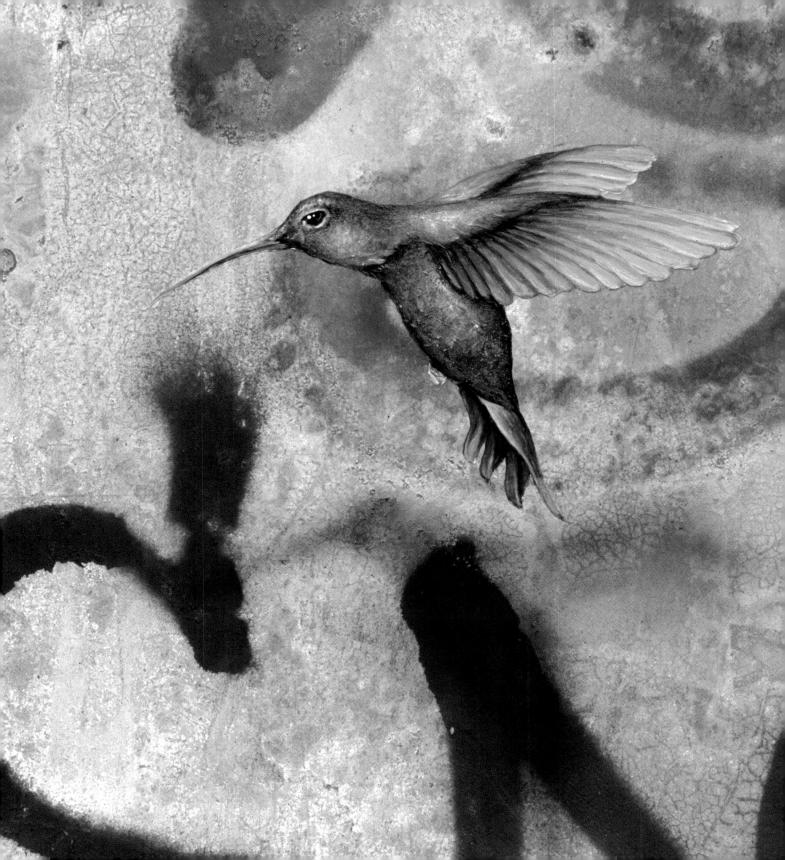

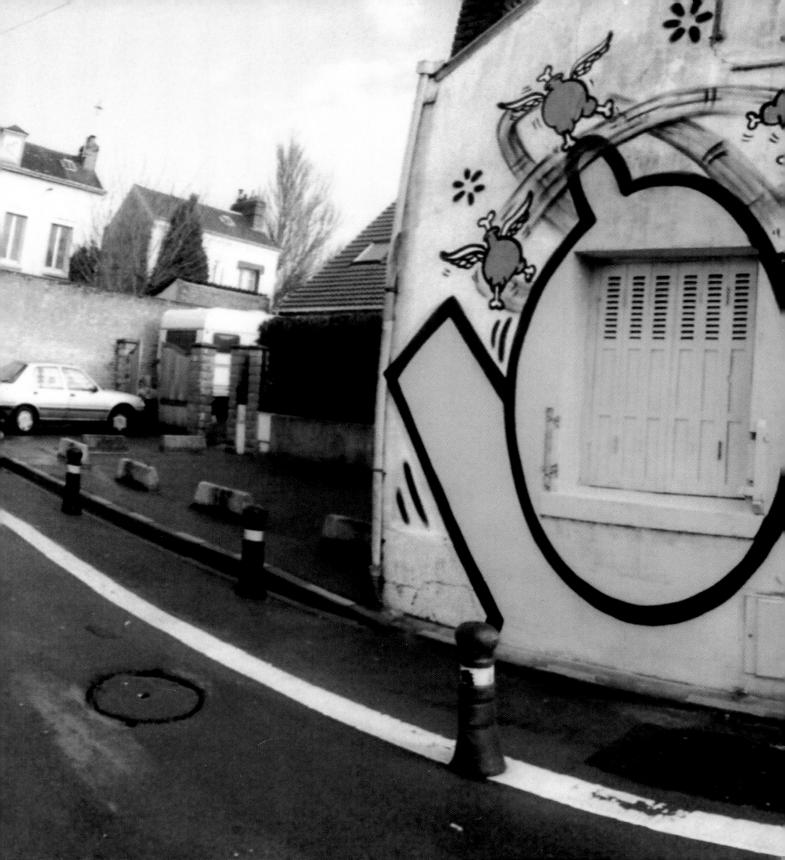

EUROPE

Europe

There were pieces in Europe before the arrival of American graffiti, and stencil artists were active in Paris long before the first tags and styles emerged. An independent stencil scene also emerged in the 1980s, which is unconnected to hip-hop graffiti and is often associated with the punk rock scene. Cities such as Paris or Madrid brought their own special style to stencil graffiti, and graffiti artists used the technique as a counter-movement to hip-hop. But graffiti did not really take off until the mid-1980s, when hip-hop appeared on the scene and whole urban areas succumbed to creative assaults by artists.

In turn, the European scene is now influencing the graffiti world through the work of its more progressive artists. They have introduced many new concepts and levels of thinking, including logo and iconic graffiti, innovations in character art, sculptural graffiti and new approaches to art in urban spaces. Many artists of this genre are French, such as Akroe, KRSN, Monsieur André, HNT, Stak and Alëxone, to name a few, but there are also new graffiti movements in England, the Netherlands, Germany, Italy and Spain, pioneered by the likes of The London Police, Flying Fortress, Viagrafik and Sickboy.

Sweden

Somewhat cut off from the rest of Europe by its geographical position, Sweden – along with its Scandinavian neighbours – has been able to develop its own style. The majority of graffiti is in Stockholm and the large cities, but it has also managed to penetrate further afield into more rural settings.

Denmark

The Danish graffiti culture developed in around 1983, when TV stations broadcast *Style Wars*. Subsequently, it became known for its different letter styles – including the wildstyle, which is used by respected writers Swet and Bates. Denmark boasts a number of old-school spray artists, including Shame, Sketzh, Cres and Sabe, who tend to have altered their style very little over the years.

Great Britain

In the early years, British artists began creating pieces, influenced by the New York scene. A large community of spray artists developed in around 1983, particularly in London, Wolverhampton and Bristol. Recently, it has proved very difficult to carry out illegal artwork in London, which is under constant surveillance, but a talented and independent culture thrives in other cities such as Sheffield, Hull, Brighton and Bristol, to name a few. Techniques have changed a lot over time, particularly with the increased popularity of stencils and posters. A typical example is Bristol-raised Banksy, who spray-painted politically inspired pieces before his renowned stencils.

The Netherlands

The Dutch scene developed out of the punk movement and – next to France and Germany – is one of the most important in the history of European graffiti. Amsterdam was one of the first developers and started to make its mark in the early 1970s. Some of the first graffiti exhibitions outside the USA were held as collectors brought NY artists like Dondi (RIP) to the Netherlands. With the country's liberal graffiti policy, graffiti on trains or walls is hardly ever buffed. However, even in the early days, trains were used far less than in America, as pieces on walls generally last a lot longer. In fact, it was not until around 1988 that painting trains became fashionable.

Loomit, Magic, How & Nosm, Düsseldorf, Germany, 1997

Germany

Germany's graffiti culture developed in the early 1980s, influenced by films such as *Wild Style* and *Style Wars*, especially in Berlin, Munich, Hamburg and the whole of the Ruhr valley. Berlin, which was seen as 'Europe's style metropolis', played a particularly important role at this time through the likes of graffiti artist Odem, who brought an independent Berlin wildstyle to the fore. There was also a spray-painting trend in the former East Germany, but the government quashed it by banning the use of spraycans and removing them from shops.

France

There are many fascinating French artists, but the most innovative tend to come from Toulouse and Paris. Paris has seen a lot of changes in street culture throughout its history, from stencil artists such as Blek Le Rat and Miss Tic at the beginning of 1984 to the tide of tags and throw-ups that appeared all over the city some years later. Nowadays, there are lots of characters and logos or huge photorealistic wall creations, like those of the MAC crew, and a new generation of character and icon graffiti artists has formed. Toulouse provides tough competition, however, with the paintbrush characters of Miss Van, Fafi and Lus, the complex styles of Ceet, and the striking throw-ups of Tilt.

Portugal

Portugal's graffiti culture has been developing since the beginning of the 1990s. Although primarily concentrated in Lisbon, graffiti has also infiltrated smaller towns.

Spain

The Spanish scene boasts countless character artists scattered throughout the country, but Madrid, Barcelona and Granada are the hotspots of modern graffiti. The scene in Madrid predated the hip-hop movement but, as tags took off, it developed a particular tag style – a rounded signature with arrows. El Muelle became legendary for this style, but various other artists such as Glub also went on to develop it. Along with figurative graffiti, like that of Done, Sex and the Pornostars, a significant stencil movement has also developed in Madrid. Barcelona attracts writers from around the world to its high-quality and exuberant Halls of Fame.

Italy

Italy is renowned for its trainbombing. Not only was it particularly easy for many years, but it had the added advantage that trains generally had a long life and travelled throughout the country. The scene started in Milan, but it was Rome that put Italy on the map when it became one of the most bombed cities in the world. Nowadays, it is decidedly

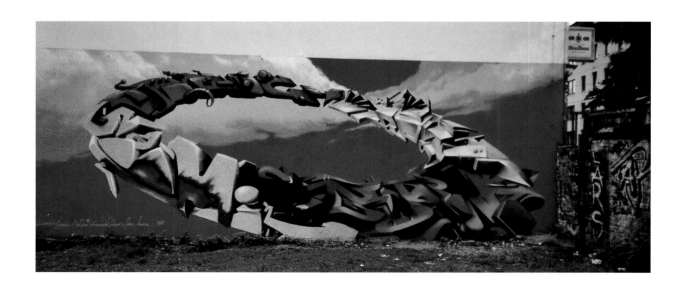

more difficult to paint trains: because of safety staff, artists no longer have as much time as they used to, and trains tend to be buffed quickly. Italy is also well known for championing contemporary arts. In the 1980s, important shows of graffiti-inspired artists such as Jean Michel Basquiat were staged in Modena, and more recently Barry McGee's 2003 show at Fondazione Prada in Milan.

Switzerland

Switzerland's early pieces were often strongly influenced by those in internationally renowned books. Naturally here, like elsewhere, the New York letter style was a model. As the scene became more original, artists like Dare put their own stamp on it and came to international recognition. Graffiti is often concentrated in the cities and, although the scene is not huge, it has nurtured many talents over the years.

Austria

Austria's graffiti scene is small compared to that of its neighbours and, as a result, it has become difficult to paint illegally. This has not deterred some artists, however, who continue to paint trains even though their work is buffed very quickly. The majority of graffiti artists are based in Vienna, but there are also small clusters in Linz and Innsbruck who tend to have been influenced by hip-hop. Many writers are also MCs or DJs. Graffiti culture is only just beginning to develop.

Croatia

The Croatian scene started to develop in 1984, influenced by foreign media and films such as *Beat Street* and *Wild Style*, and graffiti can now be found throughout the country. YCP crew is among its key representatives.

Greece

Greece and its local activists were thrust into the limelight through the *Chromopolis* project. Concentrated in Athens and Thessaloniki, the movement is enjoying a boom, particularly in pieces. Over the past few years, pioneers such as Bizare or Woozy have continued to make their mark, and new artists are emerging, often working with stencils or characters.

Bulgaria

Strongly influenced by socialism, the Bulgarian graffiti scene was only really able to develop from the mid-1990s onwards. In contrast to other countries, Bulgaria's capital city, Sofia, played little part in the early years, when artists generally spray-painted in areas such as Varna. An individual hip-hop culture developed alongside the graffiti movement, and both soon gained popularity.

Russia

Although political slogans or toilet graffiti have been around in Russia for quite some time, the graffiti scene developed late. After the collapse of the USSR, the lives of graffiti artists changed unrecognizably, and pieces started to appear. A few of the first graffiti artists are still active today. The past few years have seen a graffiti movement of astonishingly high calibre develop, moving out from Moscow and St Petersburg to every corner of the country.

Belarus

The Belarusian scene has centred around Minsk since 1997. Prior to 1997, there were pockets of graffiti activity, but they were quickly quashed by the government. Even in the late 1990s, spraycans, caps and graffiti magazines were in short supply, which may explain the important role that the Internet has played in the artistic development of many enthusiasts here. Nowadays, the situation has improved somewhat: there are graffiti books and jams, and the True Stilo crew, which has pioneered the country's street art, has become increasingly prominent through a contract with Montana.

Estonia

A young graffiti culture has emerged in Estonia, influenced primarily by external factors. For many years, spraycans were not available here and, as a result, the first graffiti only really started to emerge in the early 1990s. The scene is largely based in the capital Tallinn, where the CAPO crew is active. Thanks to the efforts of this crew and others, a lively graffiti environment is developing. Many Estonian artists also work as designers or sell their canvases.

El Tono, Madrid, Spain, 2003

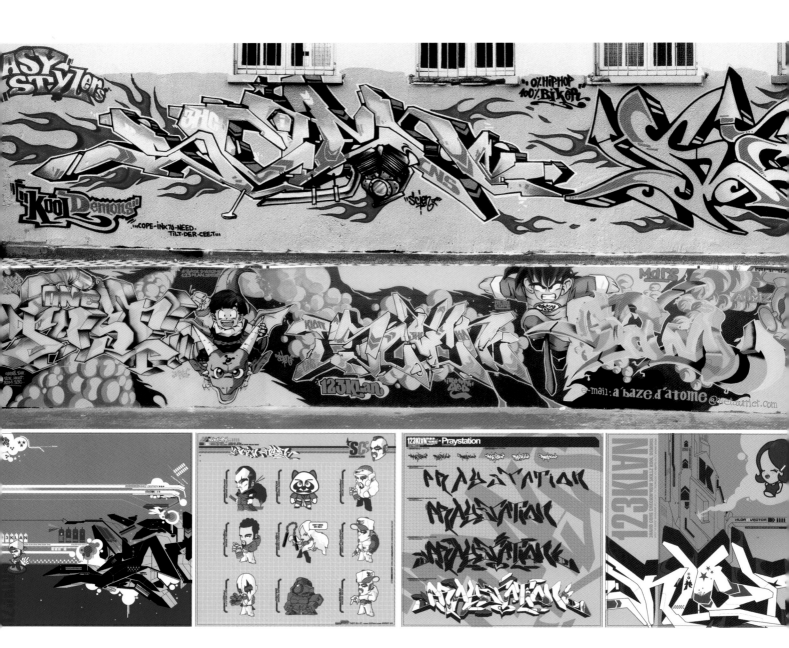

123 KLAN

French crew 123 Klan was founded in 1992 by husband and wife team Scien and Klor. In 1994, they got into graphic design through the work of Neville Brody and started to apply it to their graffiti (and vice versa). They describe their art as 'when street knowledge meets technology and graffiti melds with graphic design'. One of the great things about graffiti is the opportunities it gives you to travel around and paint with different people, and the pair have shown off their pictures at venues around the globe – from London to Singapore. Dean, Sper, Skam, Meric and Reso 1 are the other crew members.

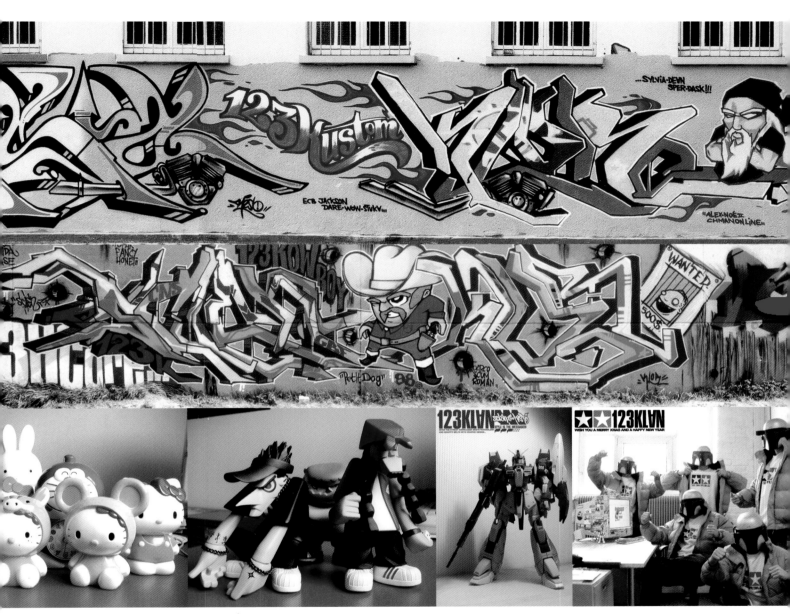

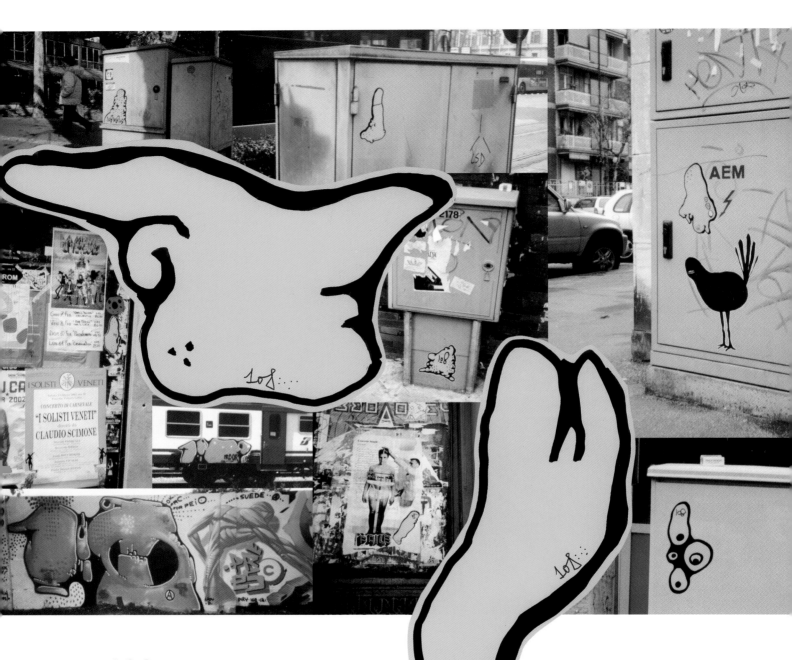

108 comes from Alessandria, where Italian street art began. This innovative, evolving artist picked up graffiti in 1990, but has minimalized his style increasingly over the course of his career. This is even true of his name (he used to call himself Form or Enom). One of his most recognizable works is his yellow amoeba, which he has plastered in the form of stickers across New York, London, Paris and San Francisco. 'I like minimal and rotten stuff,' he explains.

'At the moment I do my yellow stickers too. Over the years, I have done trains, walls and a lot of silver pieces, but the location is the most important aspect. Probably my favourite thing is silver pieces on old walls…. Finally I can tell you – writing is too boring for me…the most interesting thing is experimentation!'

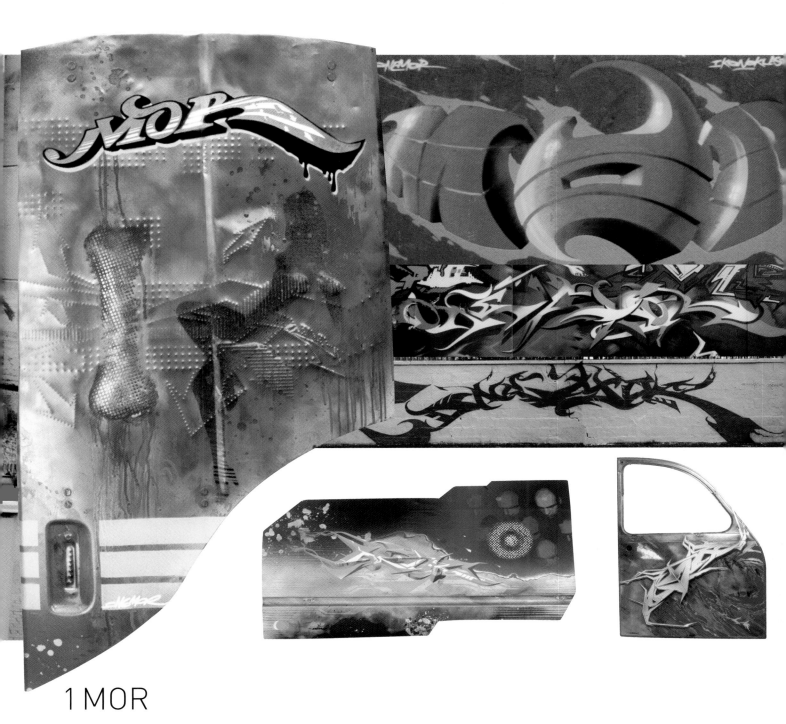

1 MOR

1 Mor, a Scottish graffiti artist who worked with Fallen Angelz Productions until 2000, has painted alongside Rough, Arcae and the Ikonoklast Movement. These days, he lives in New Zealand. He has got his own particular letter-based style, which he has been developing to experiment with new ideas. 'The challenging nature of graffiti forces me to paint with creative integrity,' he says. 'I strive to find a balance between order and chaos – the order being the pre-planned structuring and technical finesse, and the chaos being the spontaneous elements. Finding this balance is what gives graffiti its energy. Sometimes it works, sometimes it fucks up. This is the challenge that keeps me motivated.'

133

akroe

French-born Akroe started doing graffiti on the streets in 1990 and then turned his attention to an old empty cheese factory. His passion for mixing drawing and graphic design drove him to study applied art in 1993, and he specialized in graphic design for two years. In 1998, he moved to Paris and worked as a graphic designer in different companies before becoming a freelance graphic designer, illustrator and artist.

A shortage of large-scale, forgotten spaces and factories prompted him to paint on the streets again, where he was particularly interested in seeing people's reactions. By painting angles, forsaken objects, windows and strange surfaces, he discovered that he could play with the way pictures are read. Most of his artistic work now is based on the link and interaction between the picture and its medium.

Alëxone (also known as Oedipe) is an interesting pioneer of the Parisian character graffiti movement. He started spray-painting in 1988 and, after trying out endless techniques, learnt how to be an illustrator and graphic designer, although the spraycan remains his favourite tool. He often puts his humorous, thoughtful and clear figures and his letter styles in context with the background in order to give his paintings a certain edge. The colour choice and location are therefore crucial. His works have appeared all over Paris as stickers and posters or on advertising billboards.

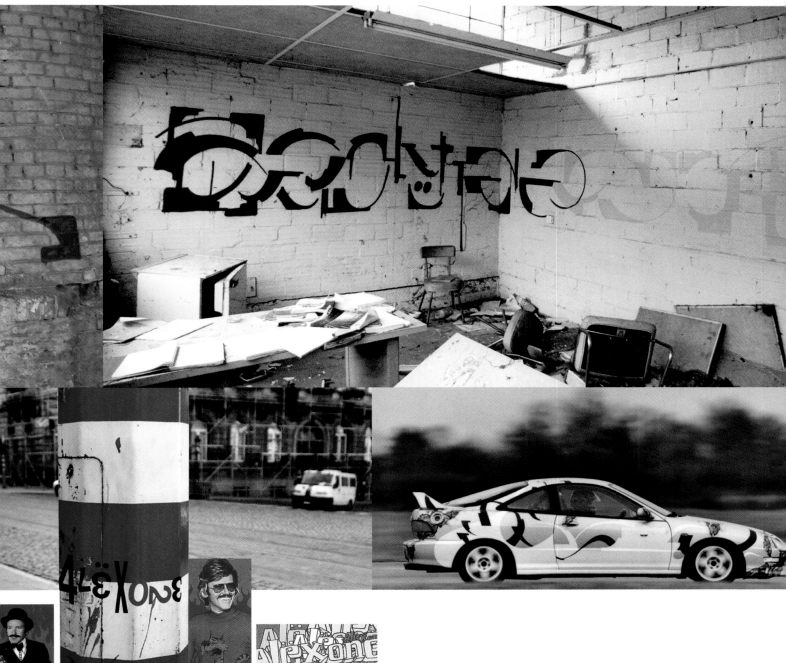

ALËXoNE

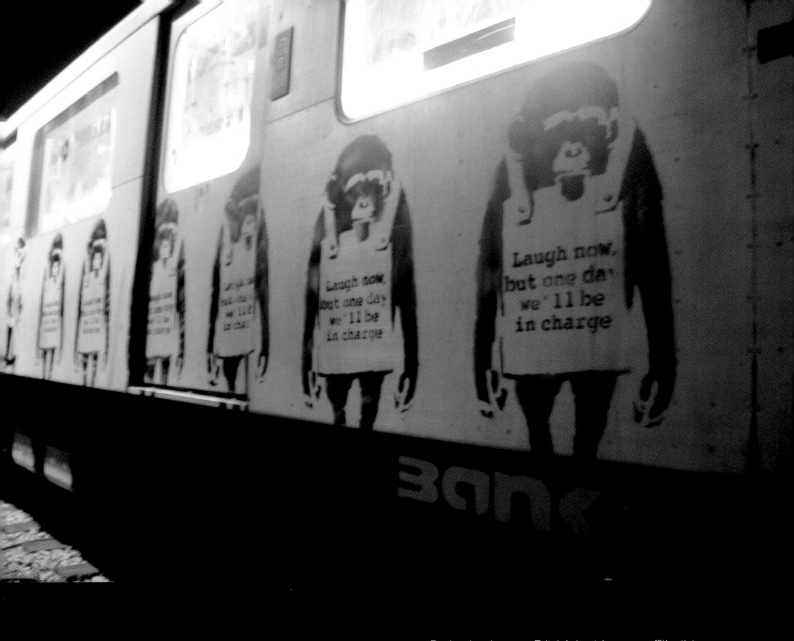

Banksy has become Britain's best-known graffiti artist. Growing up in Bristol, he became involved in the city's long-standing graffiti scene at the end of the 80s boom. Originally painting in the classic graffiti style, he turned to stencils after an embarrassing incident in which, abandoned by the rest of his crew because he painted too slowly, he had to hide from the authorities for six hours beneath a train. With stencils he was able to filter his humour and irreverence into a powerful

visual punch. His notoriety is such that the national media avidly follows his more spectacular exploits. Recently, his paintings were spotted and hurriedly removed from both Tate Britain and the Louvre. These personal donations were described as 'shortcuts'. According to Banksy, 'to actually go through the process of having a painting selected must be quite boring. It's a lot more fun to go and put your own one up.' Other stunts have included the production of

animal protest graffiti on behalf of the inmates of several international zoos.

Banksy's 'DIY' ethos has been applied to his own best-selling books – *Existencilism* and *Banging Your Head Against A Brick Wall* – and to self-staged exhibitions such as his 2003 London show 'Brandalism'. Through his 'lyrics', actions and artworks, he has managed to keep his political edge while making sure we still get the joke.

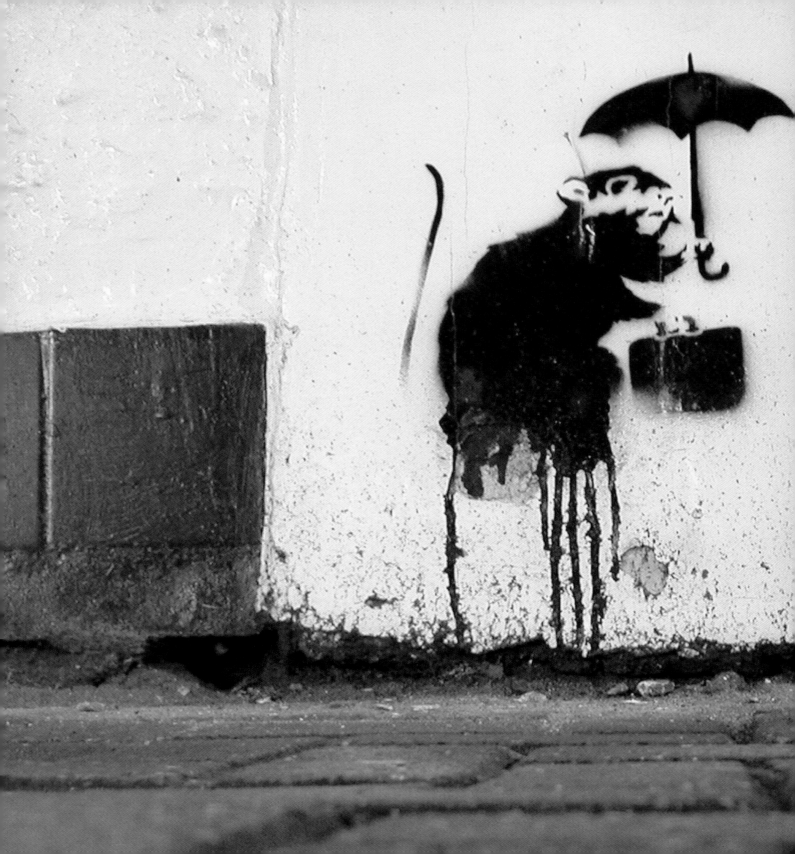

142　BESOK

During his career as a graffiti artist and illustrator, German artist Besok has explored many different ways to express himself through the spraycan, often in conjunction with markers and acrylics. He says: 'I like to take time on my paintings, to work without pressure, although sometimes you can produce the best pictures under pressure. Nevertheless, most of my spray-painted works are done on canvas.' Inspired by dreams, travelling, and daily life and its emotional fluctuations, he wants to get the public's attention, make the onlooker think, and provoke criticism through his works.

143

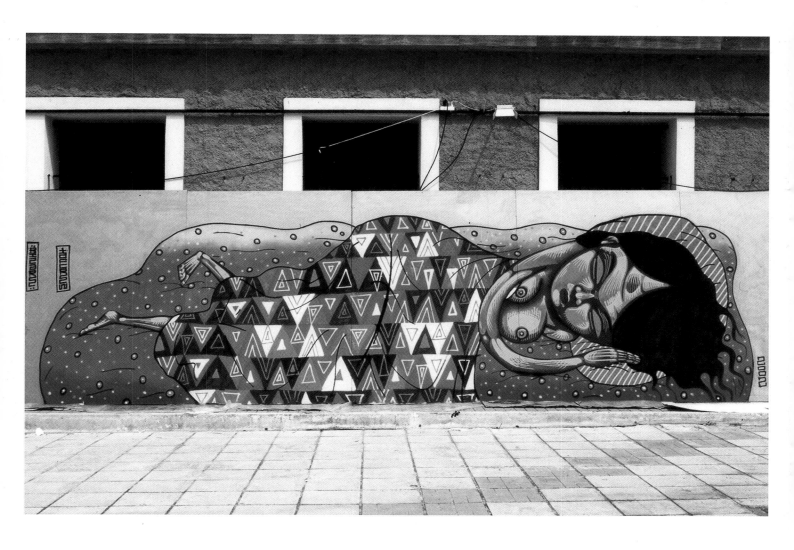

Bizare is a character artist from Athens. Along with fellow
team mates Besok, Codeak and Os Gemeos, he took part in
the Greek *Chromopolis* project in 2002. His most noteworthy
works include a mural he painted in Wiesbaden and a
monument to honour reggae musicians.

BIZARE 145

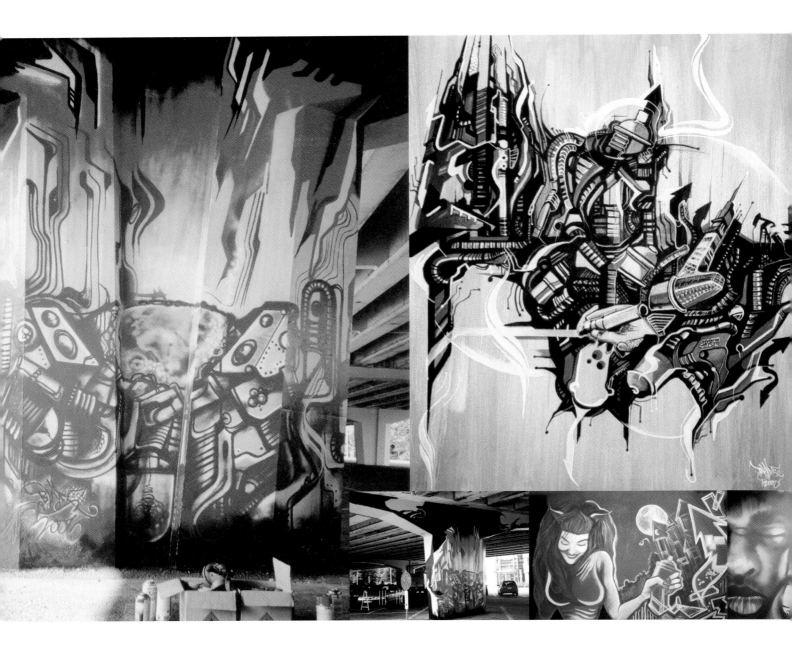

BLADE

Blade grew up in the Parisian suburbs but also lived in New York for many years before moving to Bordeaux. He picked up graffiti in 1984, inspired by Tkid and the BBC crew (Jone One, Jay One and Aone [RIP]). Over the years, he created his own style, combining traditional and oriental letters, and he also came up with his own way of drawing figures. Nowadays, he works as a designer in Blade Graphics Studio, paints canvases and draws.

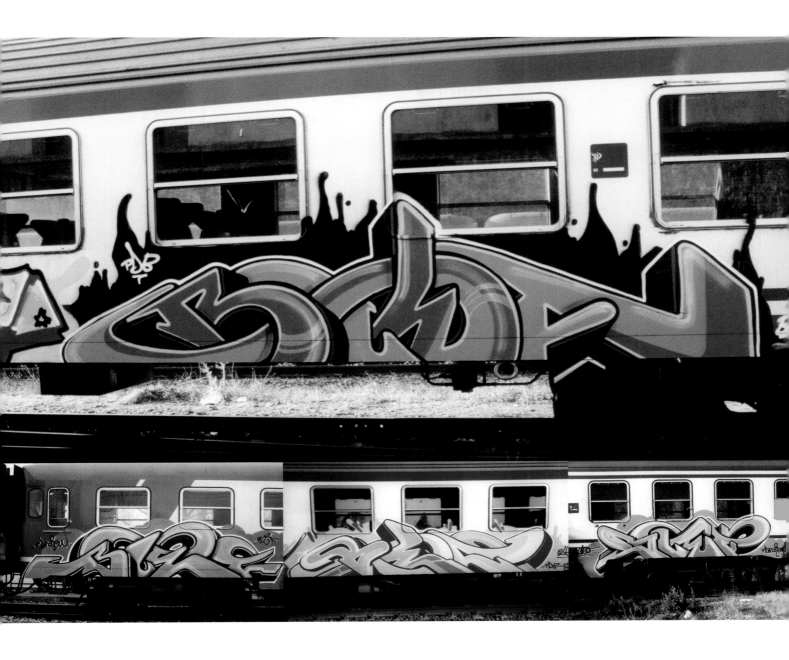

BLEF

Italian-born Blef has become known for his use of pseudonyms. He has been drawing since he was little, but the turning point came in the early 1990s when he painted his first outline. He has not stopped since! Blef tagged up his first trains in the mid-1990s and won fame throughout northern Italy for the countless red interregional trains that he painted in his own dynamic style. He emerged in Italy's Golden Age, when trains were hardly ever buffed.

147

BLEK LE RAT

Blek studied graphics and fine art at the Ecole des Beaux-Arts in Paris, but it was in New York that he first saw graffiti – in 1971 to be precise, when the first letters began to appear on trains. In the early 1980s, he and his friend Gérard were working at an adventure playground when they saw some aerosol art and felt inspired to give the spraycan a shot. They soon tried out stencilling (Blek had recalled some images he had seen of Mussolini in Italy when he was a child) and they chose the name 'Blek'. After they went their separate ways in 1983, Blek took the name for himself.

The nickname 'Le Rat' refers to some of Blek's earliest stencils of rats, but his work developed into impressive, life-size figures, which he has spray-painted in specific sites around Paris, as well as abroad.

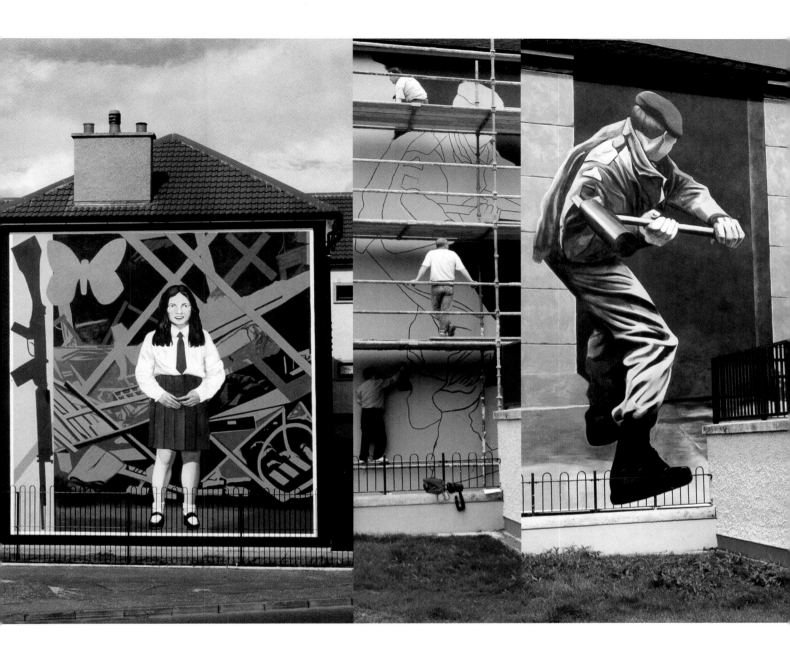

BOGSIDE ARTISTS

Murals have their own worldwide history, influenced by cultural and political trends. They have played a particularly important role in Northern Ireland. Tom Kelly, William Kelly and Kevin Masson are from Bogside, Derry, which is known for its huge and detailed murals in the part of the town known as 'Free Derry Corner'. The Bogside Artists use a paintbrush to create their artworks, which refer to events that have happened in the town, and they put a lot of themselves into their compositions – not only their own experiences and time but also money.

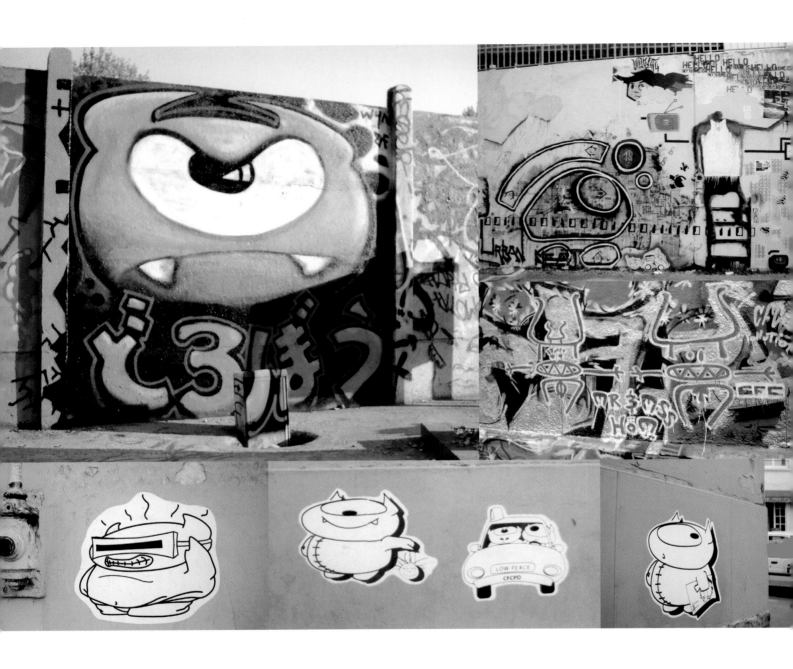

BURGLAR

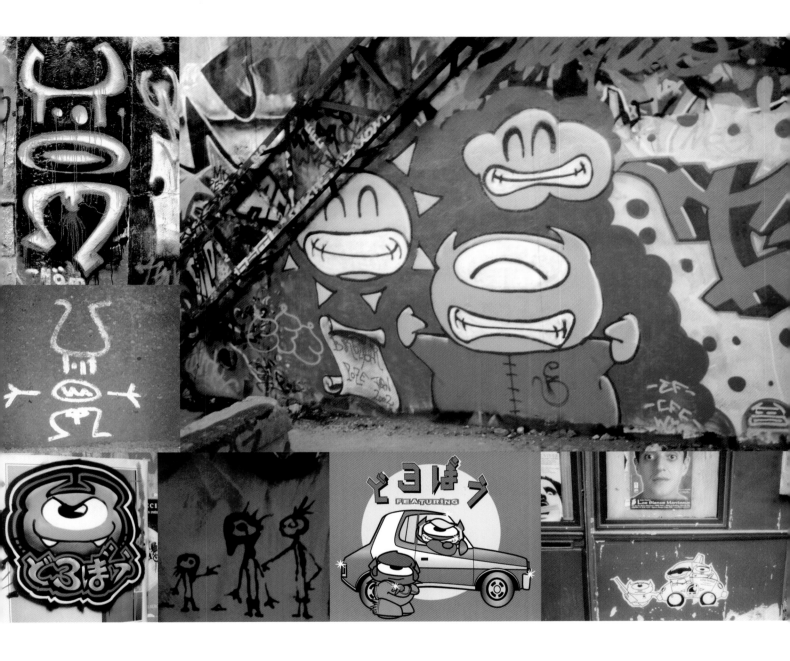

Burglar first emerged in Paris in around 2001 and has created an entirely new world around himself with towns, jobs and police. The one-eyed figures that he portrays speak English and have also been trying out some Japanese and Spanish of late. They often appear on posters, stickers or plaques on the street and tend to have concrete – if somewhat amusing – messages, spreading their word by night.

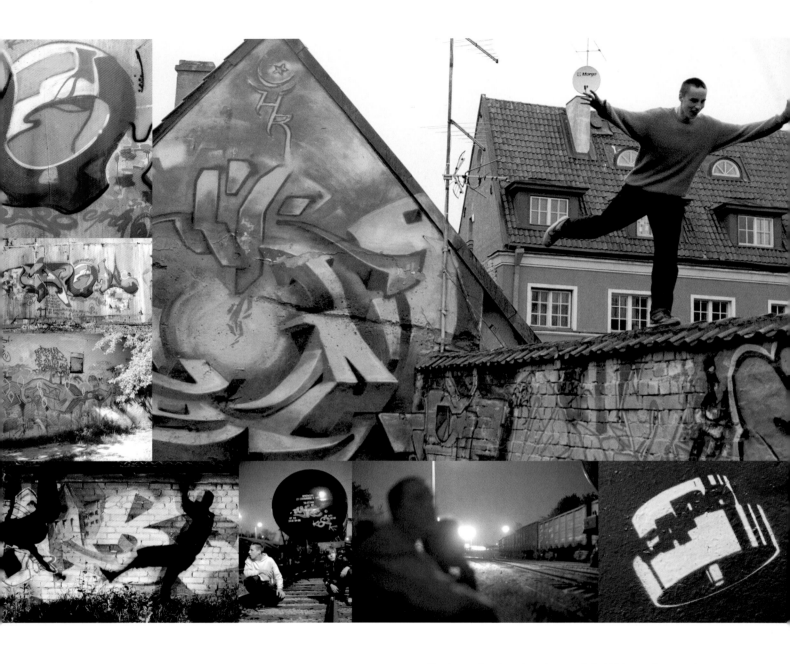

CAPO CREW

'I've been drawing since I was a little kid,' says Anton, who founded the CAPO (Crime Art Public Organization) crew with Click in 2000. 'Before I got involved with graffiti, I used old Soviet nitropaint to scribble things on walls and found it a good way to paint and express myself....' CAPO is one of the most ambitious and active crews in Estonia and has been influenced by Daim's 3D letters. Its members have also been known to paint collaborative artworks – with fellow Estonian crew SEK, for example.

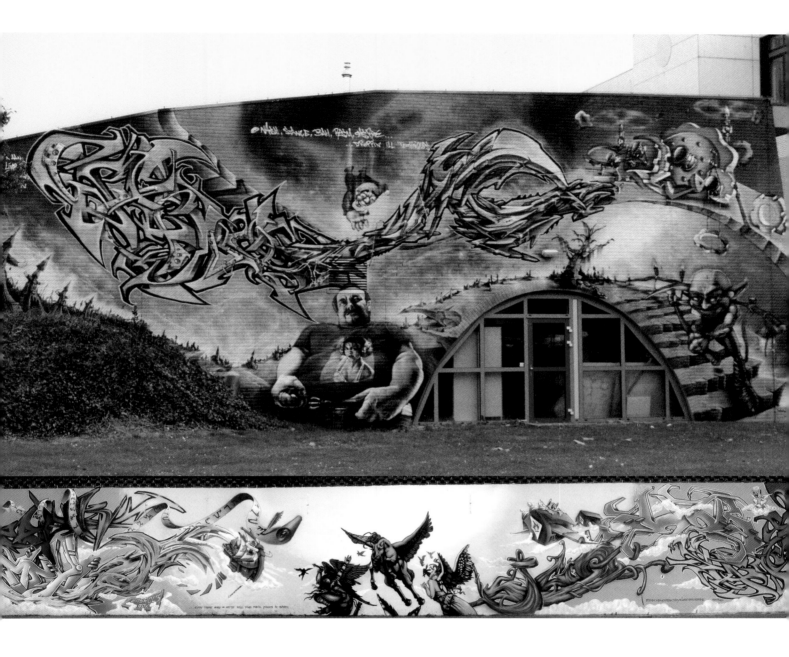

CASROC

Casroc was born in Limburg (the Netherlands) and now lives in Antwerp. He has been drawing since he was a child but had a slow start in graffiti. His pictures are complex and abstract – a mixture of 3D styles, which he distorts or blends into a landscape as an individual part of the background. Casroc's passion for graffiti has led him to realize a few larger projects in Belgium, Germany and Italy, working together with local schools and authorities.

153

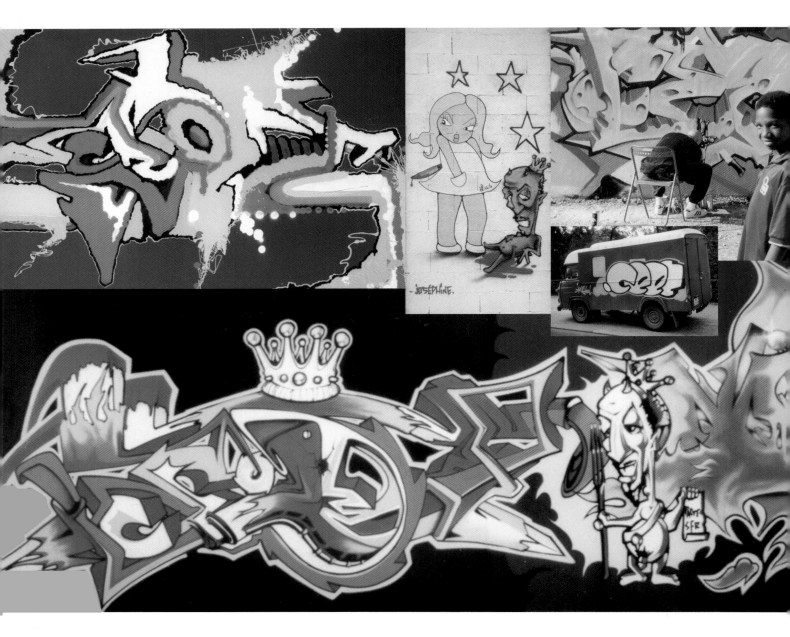

CEET

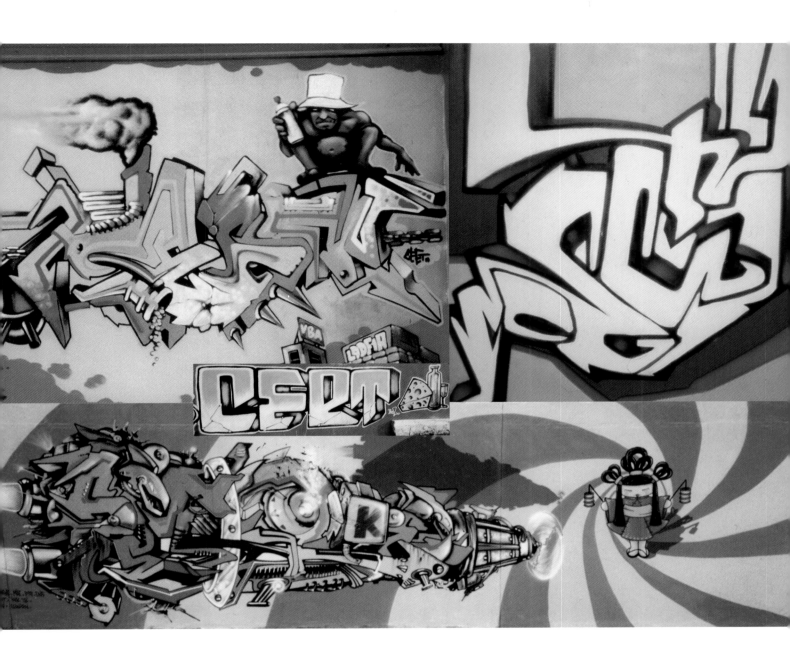

Algerian-born Ceet, now based in France, took up aerosol art in 1988, after trying to make his way as a breakdancer. Travelling has put him in touch with a huge variety of graffiti artists, and he has developed his own unique style of lettering:

'First I like to play with the colours and destroy the letters. I like it when people can't understand what I write, when they try to imagine what my letters might be. It's a kind of game between me and the passer-by.'

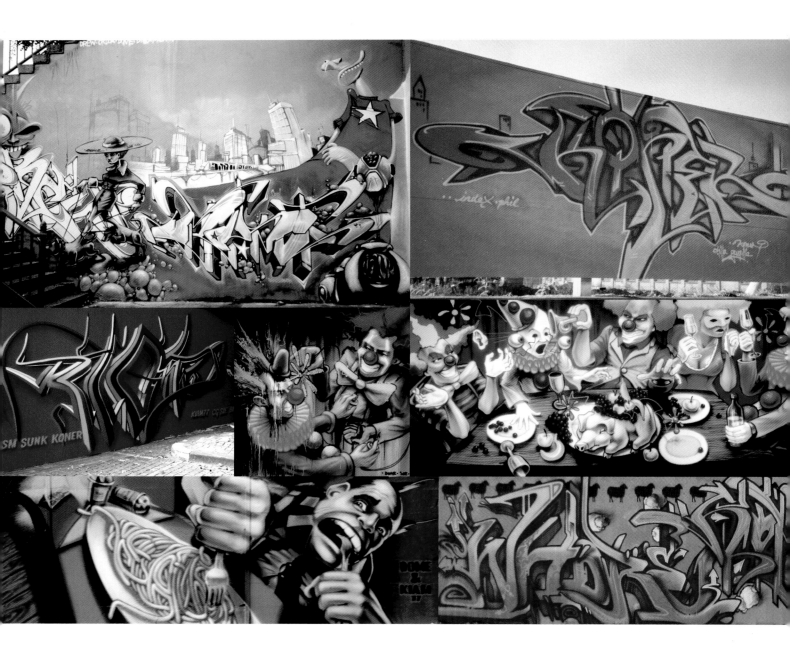

CG CREW

Germany-based Chilla Guerilla crew combines a variety of styles by different artists – such as Dome with his comic-like characters, or Kiam 77 who is recognizable by his 3D styles with interrupted lines. 'The more you experiment, the further you come,' says crew member Index. 'Every technique has a specific expression that can be used on its own. Particularly with canvases, you often push the spraycan to its limits because of its format. At the moment, I like to paint bottles with different colours – a process that has similarities to Jackson Pollock's action painting.'

157

Barcelona is renowned for its colourful graffiti culture. Cha's naive and comical drawings look like colourful narratives from children's books. Cha – or sometimes Chanoir, the black cat – takes some influence from painters such as Marc Chagall and Joan Miró, as well as early 80s graffiti.

THE CHROME ANGELZ

The Chrome Angelz is probably one of the most famous European crews, and it still has a great deal of clout on the worldwide graffiti scene. Covent Garden in central London – where the crew's founders Zaki 163, Mode 2, Scribbla and Pride would all meet up – used to be the Mecca of the city's hip-hop scene. 'We wanted to form a crew of like-minded individual artists, who we all considered to have the same outlook on graffiti,' says Zaki 163. 'A lot of our influences came from our contact with each other and our mutual interest in all art forms – not just graffiti, but history of art, both old and modern. We wanted to bring all our influences and styles to T. C. A., and make it the best crew in England.'

159

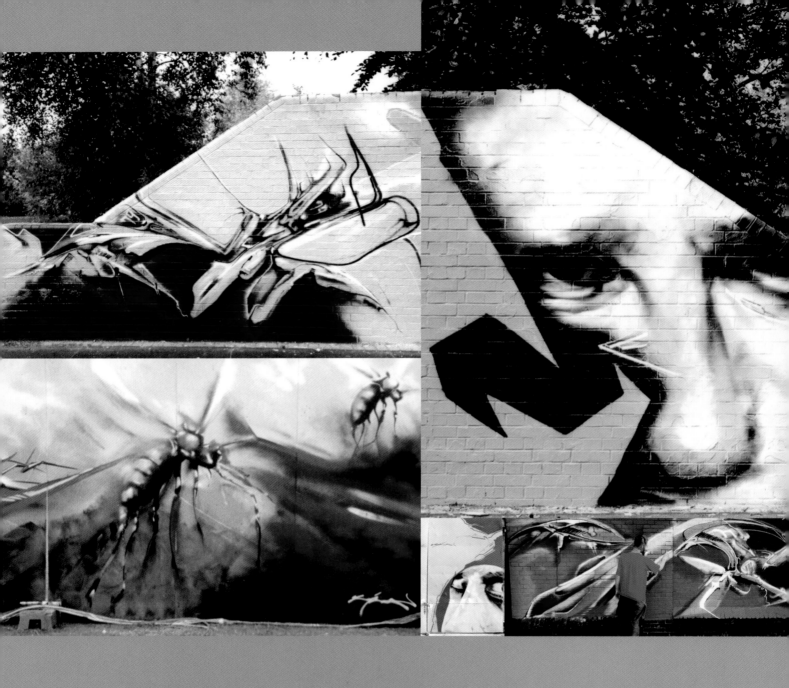

CHINA

English graffiti artist China is known for his abstract compositions, with high-impact colour clashes and technical detail. He also publishes *Fold* magazine.

CHEBA

Cheba, a young pioneer
of the modern poster
and sticker culture,
comes from Bristol.
In 2001, he began
to use stencils and
stickers to plaster
his simple but striking
figures on the streets,
but he also likes to
paint figures on walls
with crayons. He
is now moving into
the legal world of
commissions.

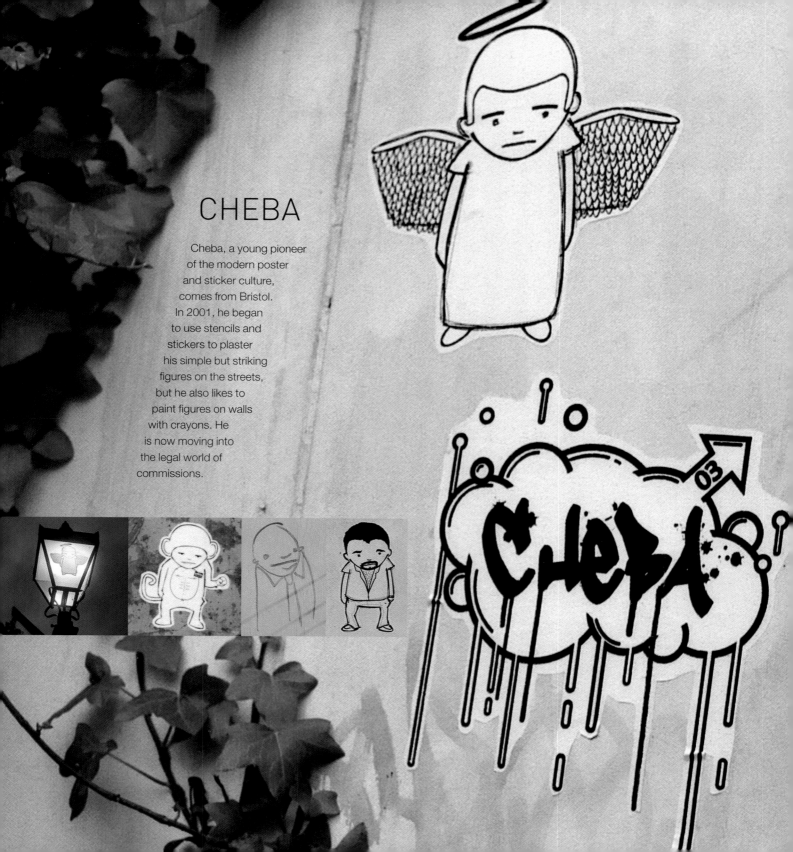

CHROMOPOLIS

Organized by *Carpe Diem* magazine, with the support of the Greek Ministry of Culture, *Chromopolis* brought sixteen international graffiti artists to Greece in the summer of 2002. This important project was developed to promote graffiti as an art form, and formed part of a government-led initiative called 'Cultural Olympiad 2000–4' to mark the 2004 Olympic Games in Athens. Working in two teams, the artists travelled to ten different towns and cities and created striking, large-scale compositions on walls. Os Gemeos, Besok, Codeak, Bizare, Mak 1 and Loomit were among those who took part.

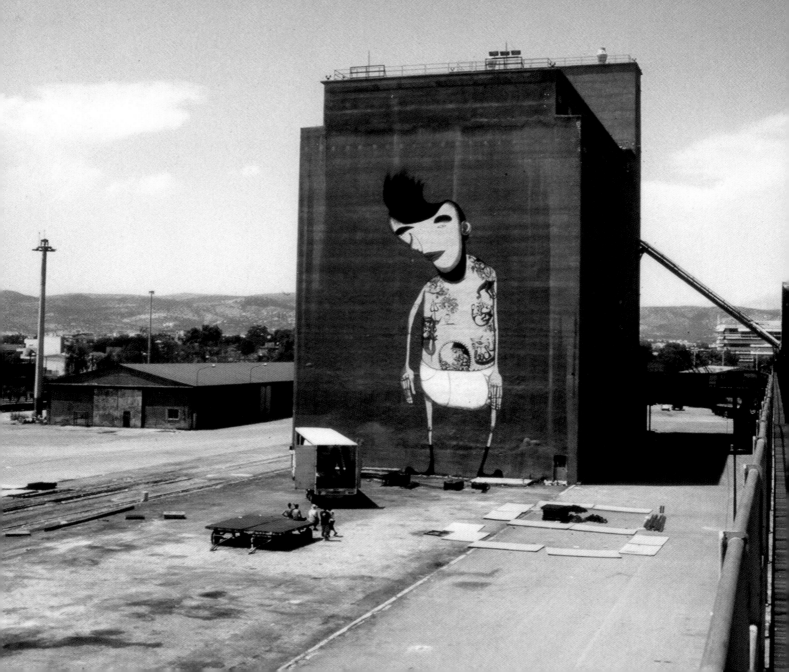

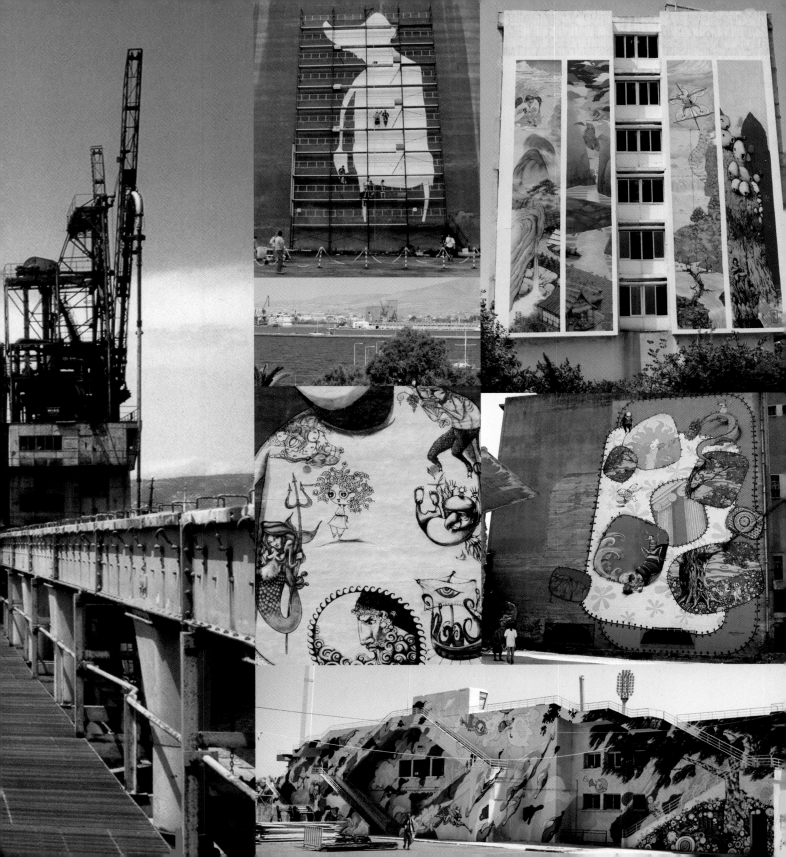

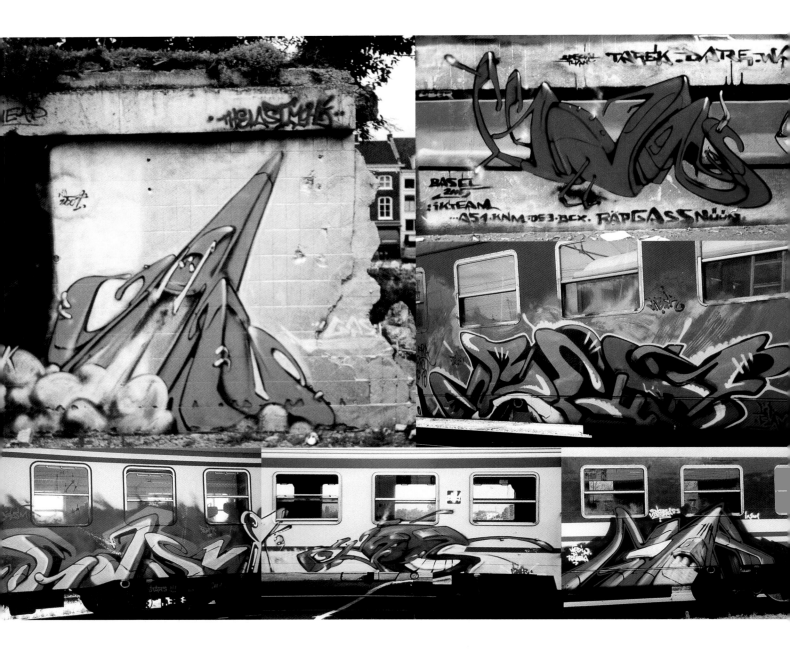

CIBER STARGASS

Originally from Italy, Ciber Stargass now lives and works
in Washington DC. Like many other Italian graffiti artists, he
initially used trains as an artistic platform, covering them with
his name. The artist tends to distort his letters to create his
own 3D shapes, although he also works with traditional styles.

CMP

Danish-born Claus M. Pederson had his first writing experience with fellow graffiti artist Spin 05 in 1984. He started off with traditional letters, but later chose to focus on a different type of picture, depicting stations, lights and street life. His work is characterized by intense colours and lively scenes. In 1989, he launched Denmark's first graffiti magazine, *Fantazie*, with Spin 05 and he has had several commissions since those early years, as well as a cluster of exhibitions. Recently, he has been working as a draughtsman in the media world.

165

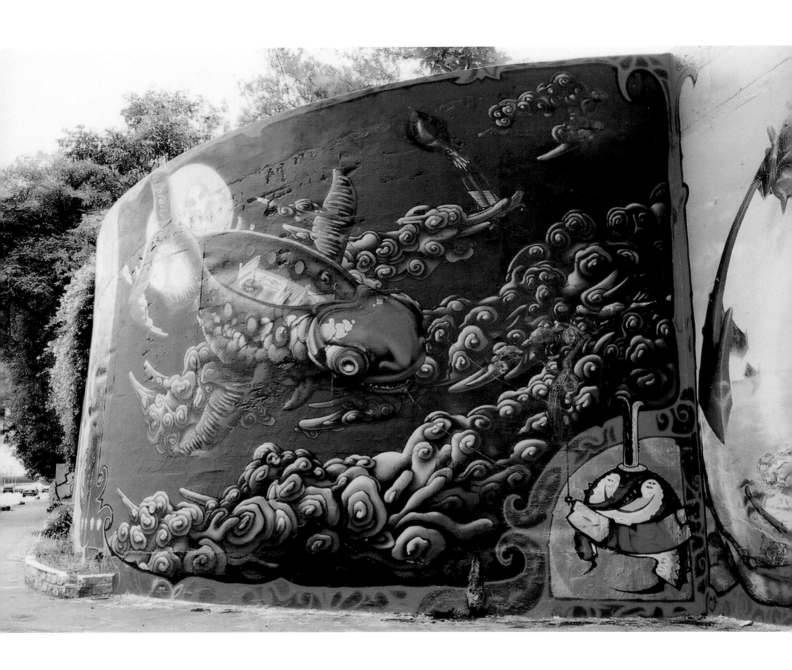

166 CODEAK

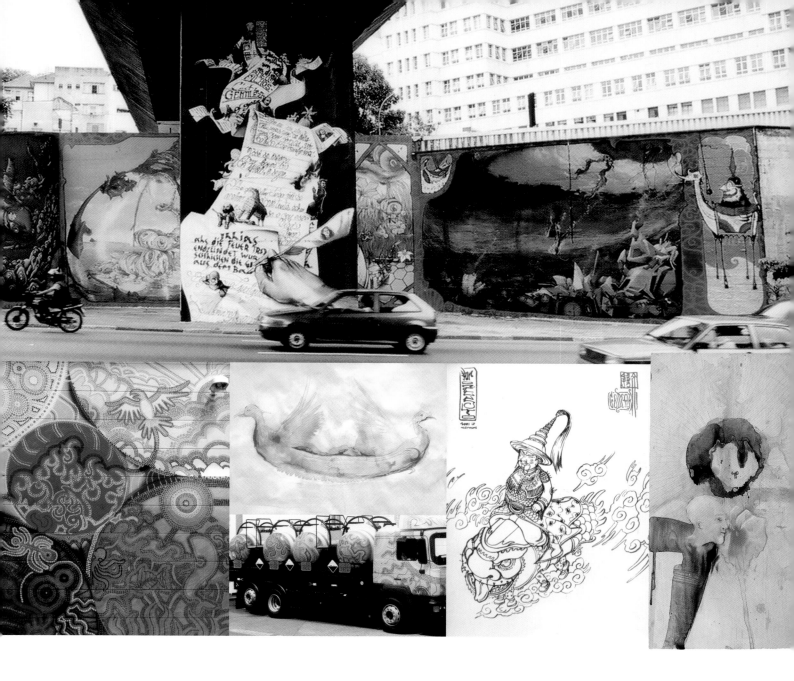

Codeak was born in London but now lives in Augsburg in Germany. He was introduced to graffiti in 1984 when he read an article in youth magazine *Bravo*. 'First of all, I mark out a thematically broad field,' he explains. 'For me, at the moment it's German–Chinese culture. I cultivate and experiment with this cultural field, using particular approaches. For instance, I leave many of my present works to emerge through technical chance. During the creative process, communication with my works is essential. Sometimes this communication can even take the form of war between me and the work. The picture wants something harmonious, but I'm against that. The battle is fought until we reach a consensus, and that's the announcement that the work is finished....'

167

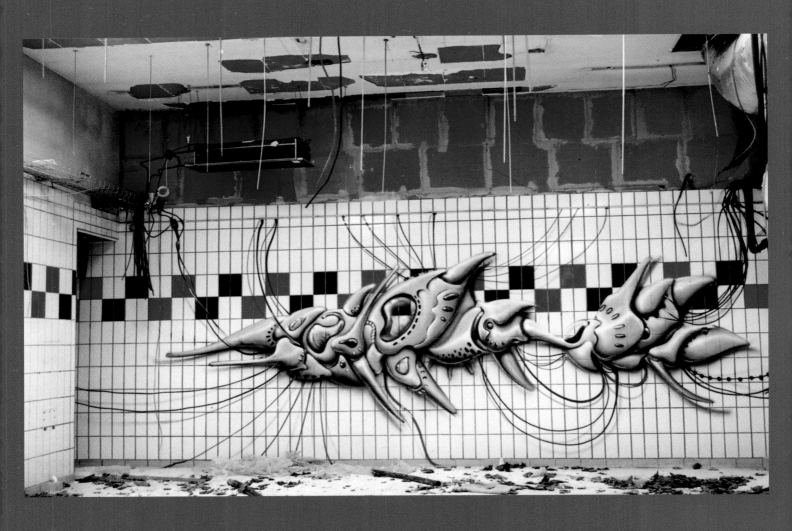

CORAIL

Japanese *manga* artist Masamune Shirow and the ocean's huge variety of unusual life forms were key influences on Corail's work, which combines biological elements and mechanical objects or robots. He has been spray-painting in his home town of Toulouse since 1996 and tries to start up a dialogue between the background (the wall) and his picture. Through his use of colour, his pictures often blend with the background and tend to be linked to features of the wall, creating a perfect illusion – to such a degree that it can be difficult to differentiate between what is real and what is not.

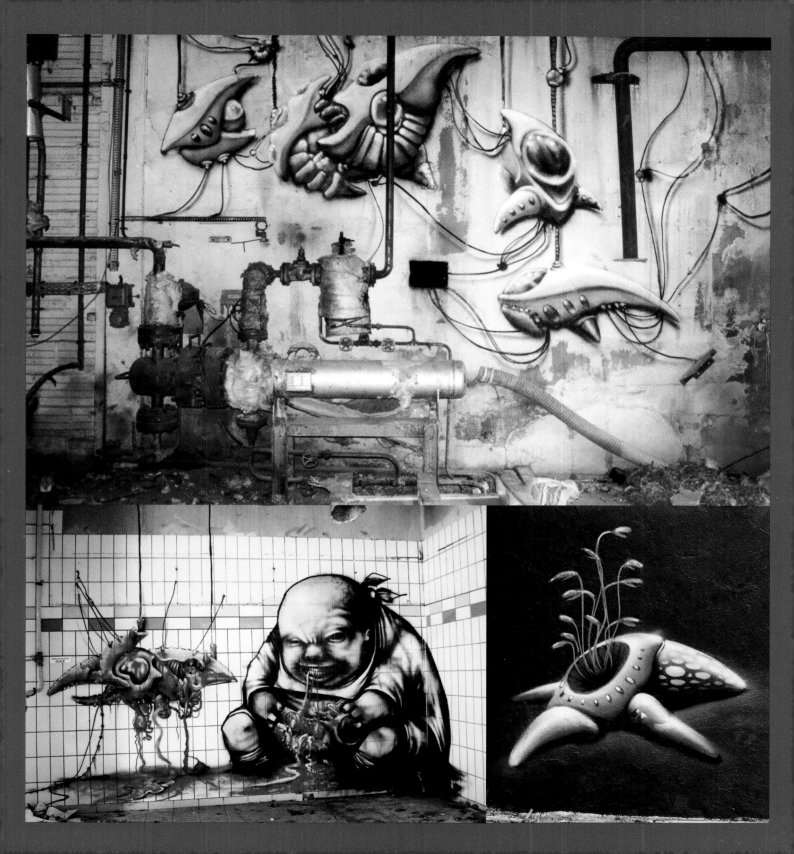

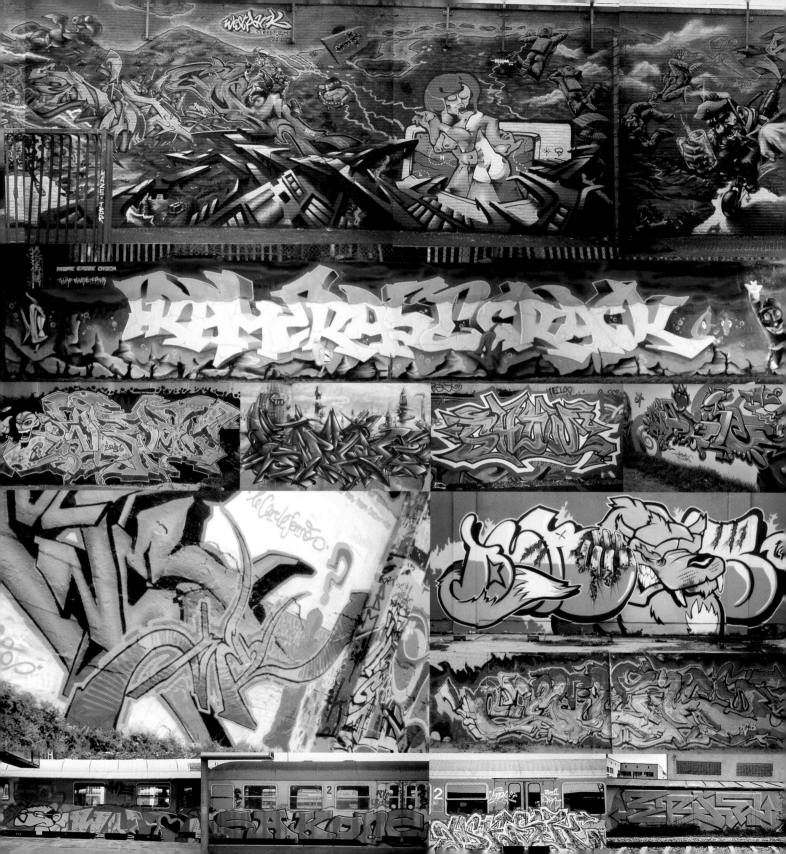

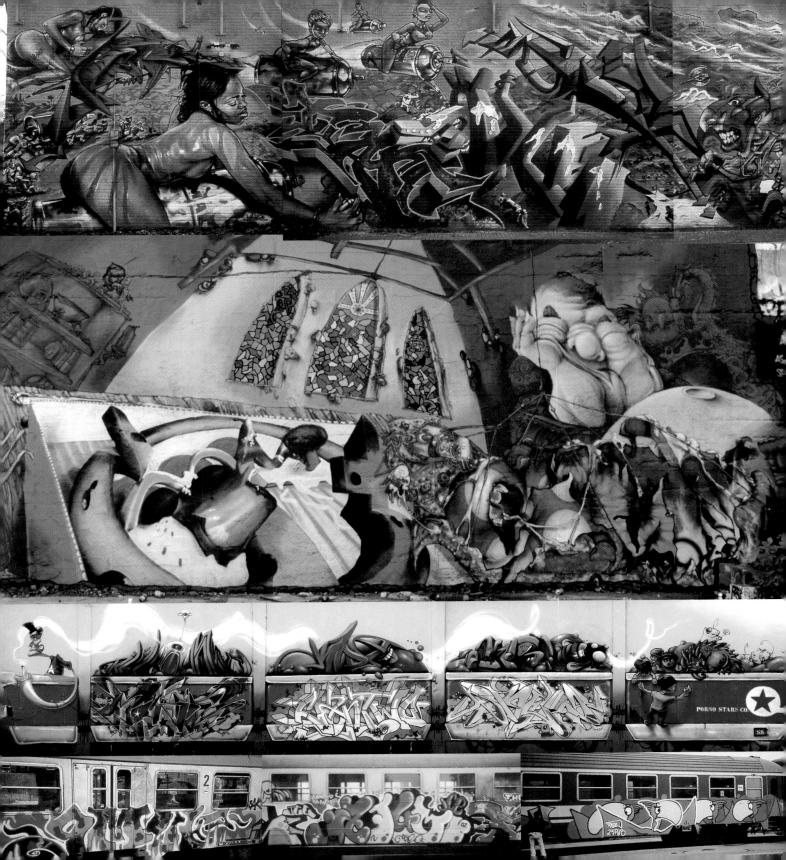

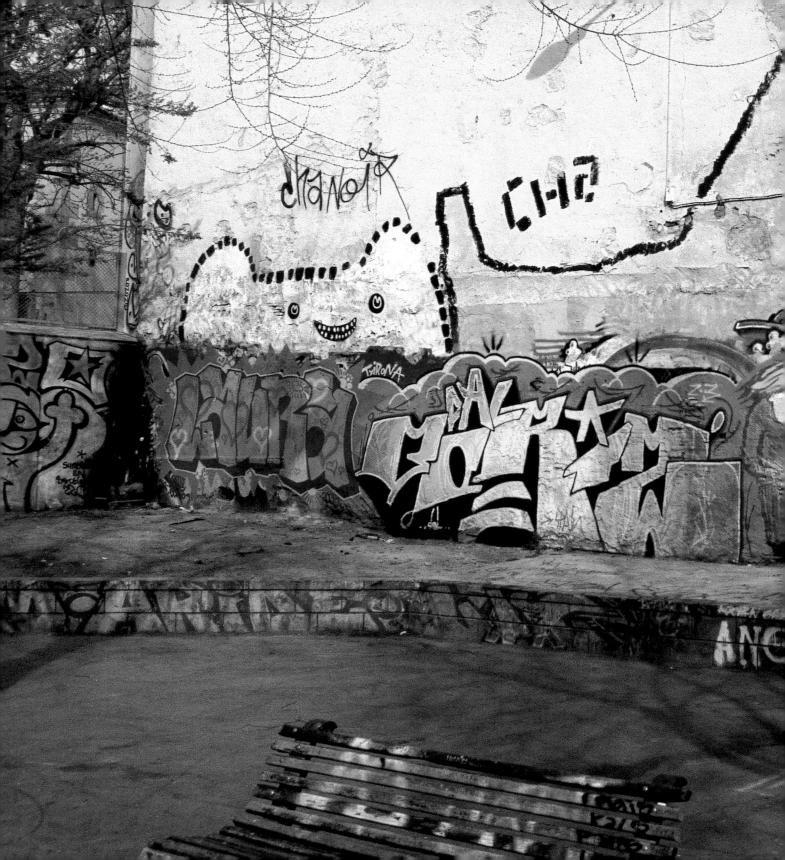

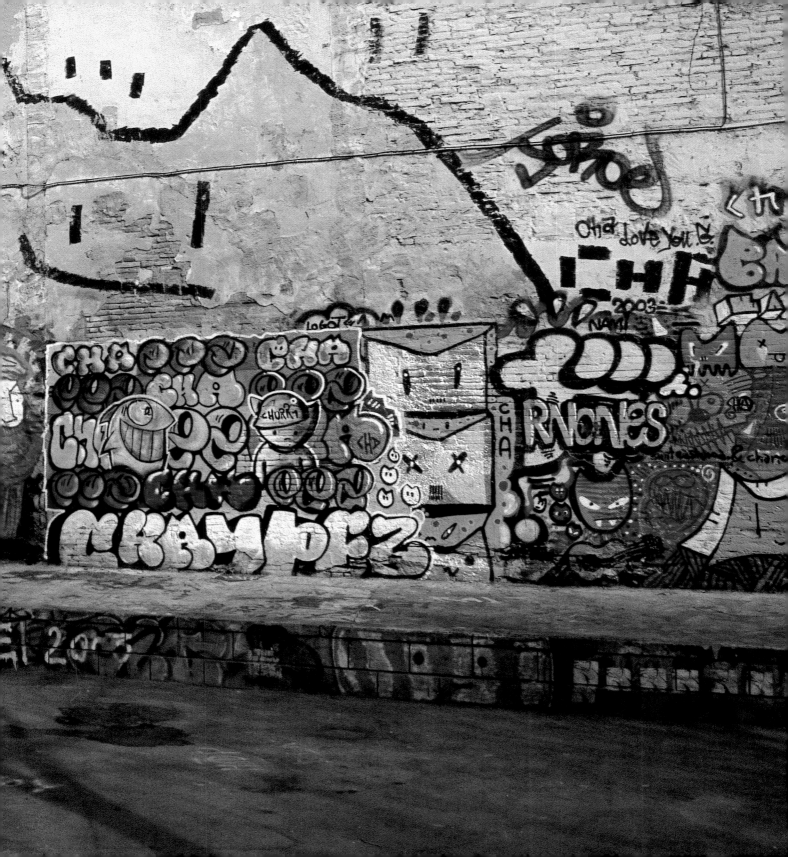

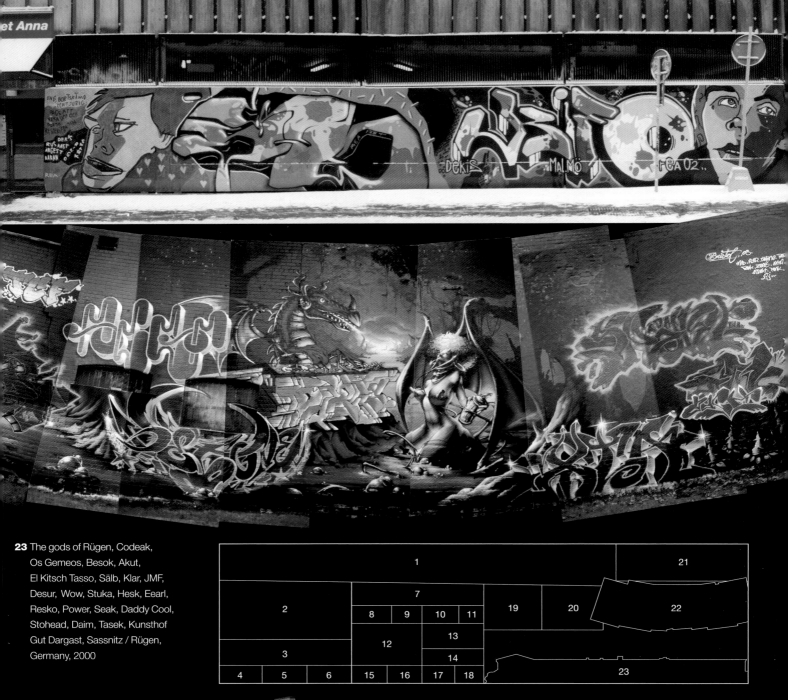

23 The gods of Rügen, Codeak,
Os Gemeos, Besok, Akut,
El Kitsch Tasso, Sälb, Klar, JMF,
Desur, Wow, Stuka, Hesk, Eearl,
Resko, Power, Seak, Daddy Cool,
Stohead, Daim, Tasek, Kunsthof
Gut Dargast, Sassnitz / Rügen,
Germany, 2000

1							21
2	7				19	20	22
	8	9	10	11			
	12		13				
3			14				
4	5	6	15	16	17	18	23

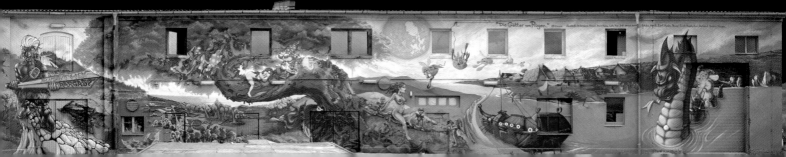

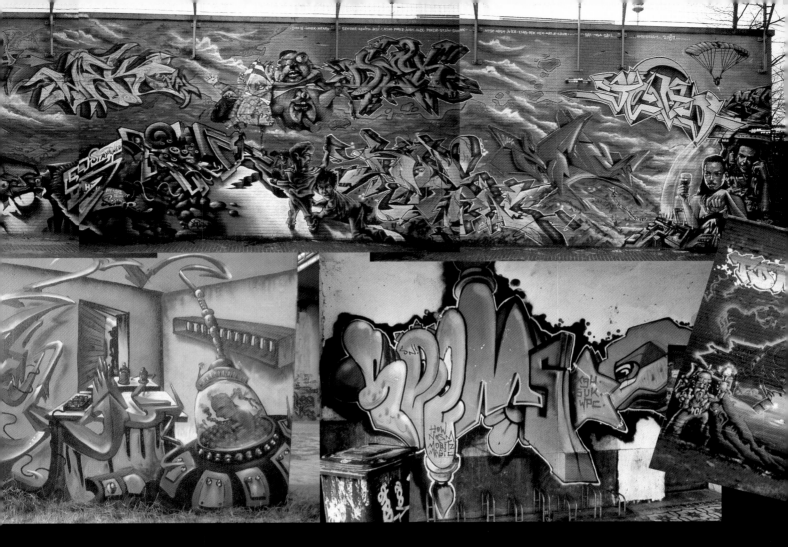

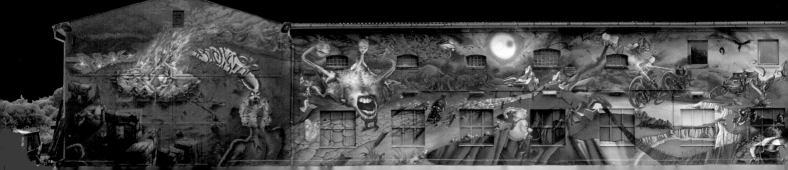

German artist Daim started spray-painting in 1989 and has raised 3D letters to a whole new level. The inspiration for his vivid paintings came to him during his studies on photorealism, and from Salvador Dalí's surrealistic works and Van Gogh's play on light and shade. 'This is what I later tried to include in my pieces,' he says. 'My aim was to make the letters more realistic, more plastic. After that, I attempted to do my styles in real 3D.' After studying the liberal arts for two years in Lucerne, Switzerland, he returned to his home town and founded the Getting-Up Studio in 1999 with fellow graffiti artists Tasek, Stohead and Daddy Cool. Nowadays, he concentrates on canvases and collaborative murals.

DAIM

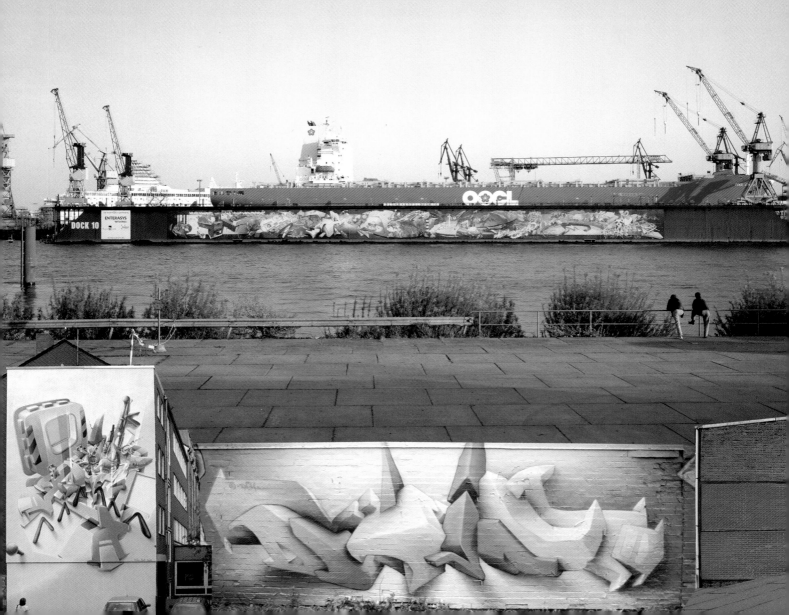

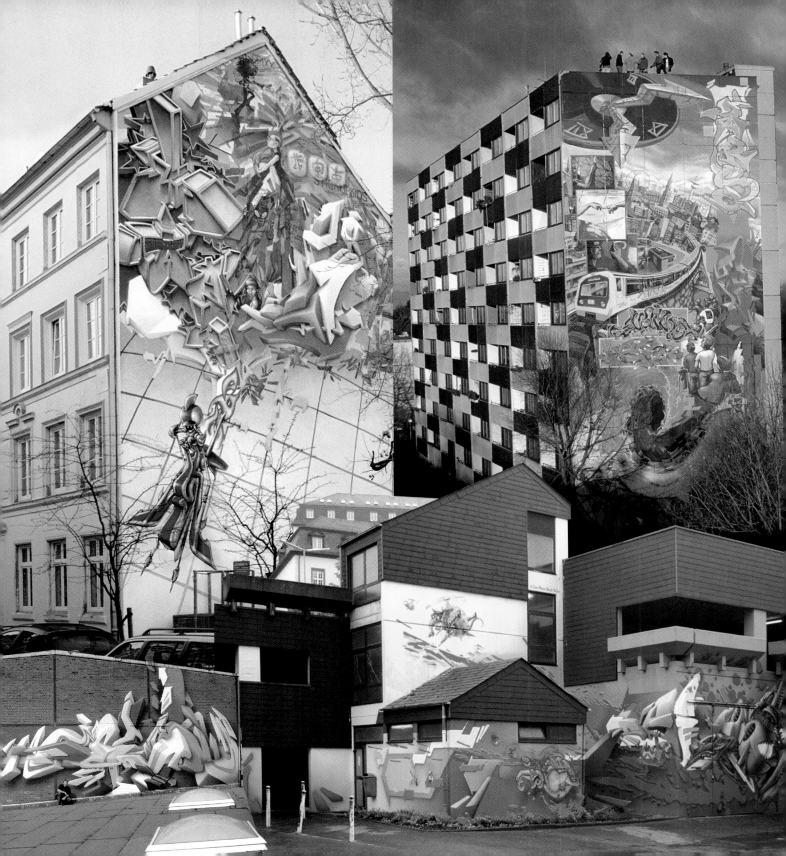

DFM CREW

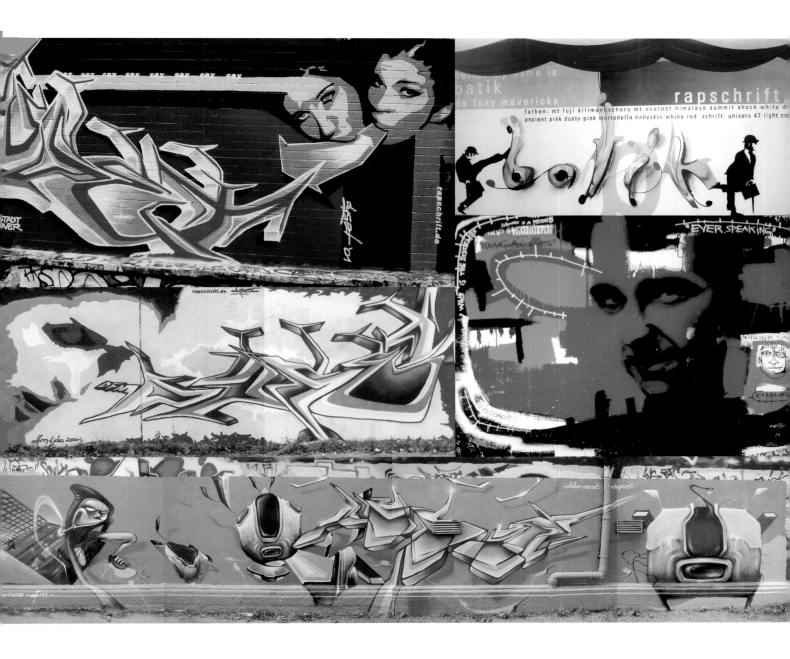

DFM is a young, innovative German crew. Its members began to develop their precise style in 1998, but their pictures show a wide variety of influences. These days, they try to incorporate graphic and design techniques into their conceptual work. Using a computer to develop ideas, they then employ stencils and acrylic paint to spray-paint the results onto a wall or canvas.

'Our aims now are different from earlier, in the sense that we want to extend our range – for instance, in the sphere of graphics and design,' they explain. 'This is also reflected in our walls, but in addition we want to work innovatively, not just adding styles continuously, perhaps with a bit of character in the middle; we want to remain flexible, which unfortunately doesn't happen often enough.'

181

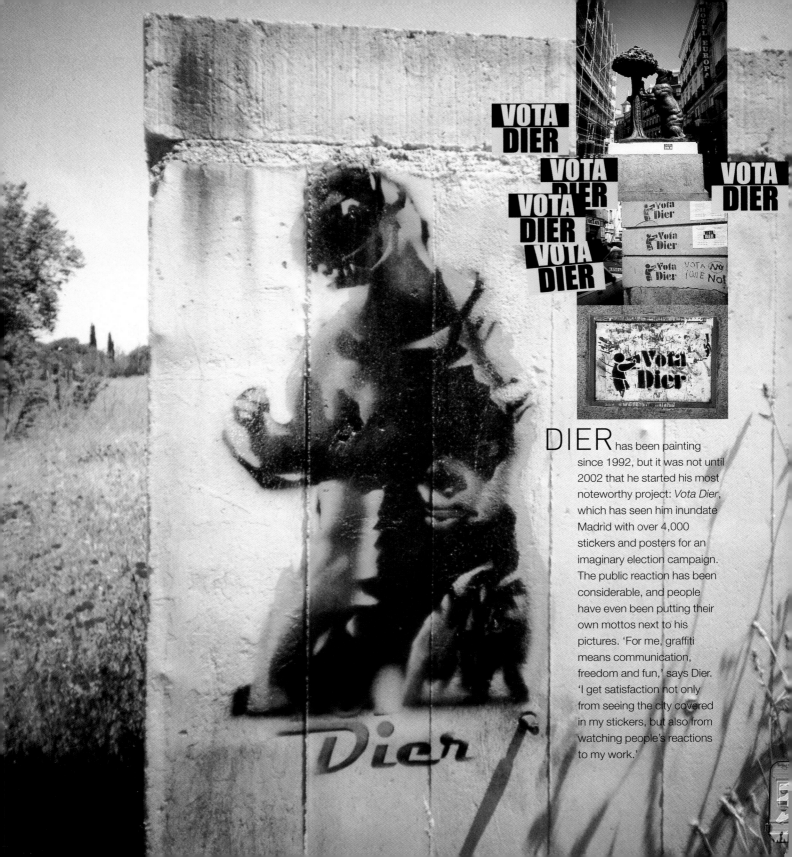

VOTA DIER

VOTA DIER

VOTA DIER

VOTA DIER

DIER has been painting since 1992, but it was not until 2002 that he started his most noteworthy project: *Vota Dier*, which has seen him inundate Madrid with over 4,000 stickers and posters for an imaginary election campaign. The public reaction has been considerable, and people have even been putting their own mottos next to his pictures. 'For me, graffiti means communication, freedom and fun,' says Dier. 'I get satisfaction not only from seeing the city covered in my stickers, but also from watching people's reactions to my work.'

DNS CREW

Daddies Nasty Sons are from the northern part of the Netherlands. They had little competition on their patch when the crew was founded in 1988, and tended to model their pictures on those from Amsterdam. Romeo, Mega and Mark – the original founders – travel around together painting and were joined by Sperm in 2002, who has his own photorealistic style. Mega is now working as a professional graphic designer, and Romeo has brought out a number of records with his rap group, L-West Productions.

183

DONE

Done grew up in Barcelona and has been drawing since he was a child. An interesting pioneer of the Spanish character culture, he has developed his own imaginative style, produced cartoons and now works as a 3D designer in an advertising firm.

'The most noteworthy thing about my style is the way I use characters to express myself,' he writes. 'I like to give them expression, playing with the bumps, trying to convey some feelings with the colours, playing with lights.... I like letters but I really love painting characters.'

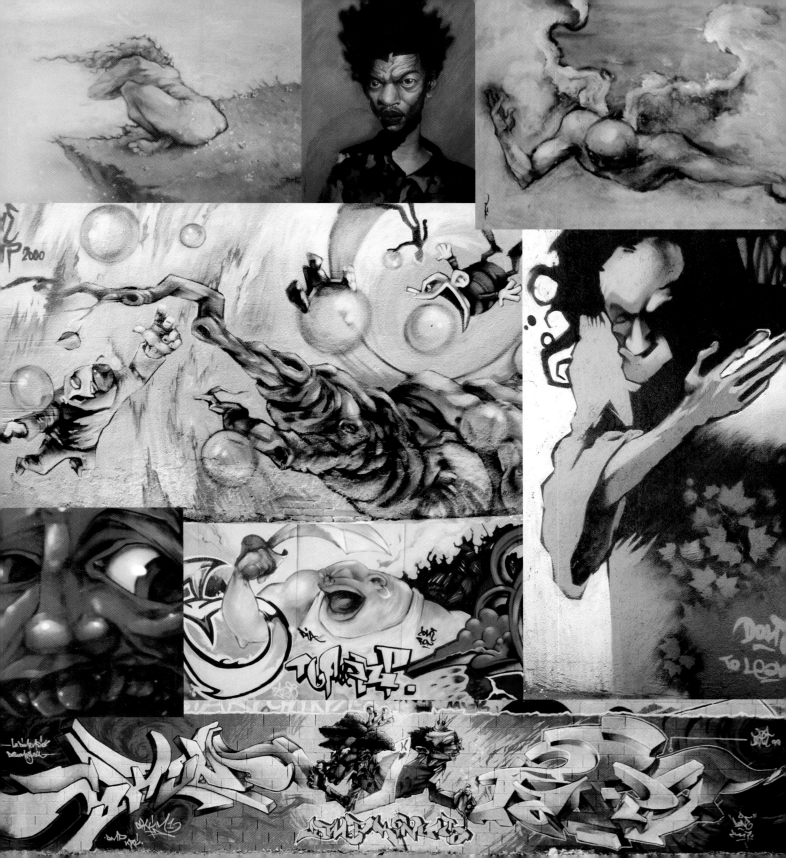

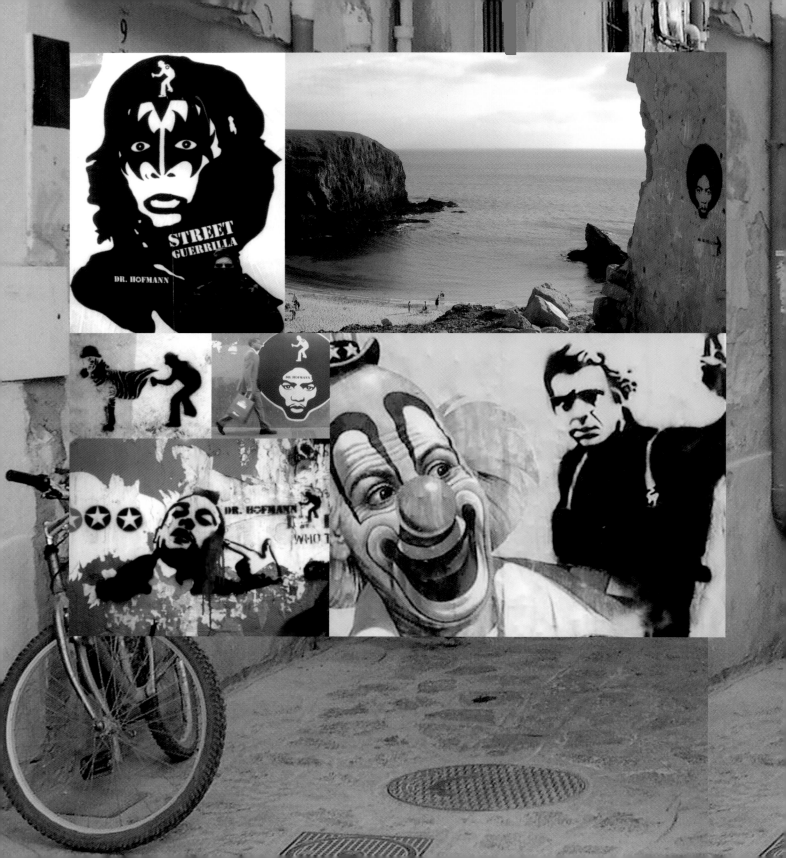

VOLANDO VOY

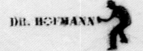

DR. HOFMANN

DR. HOFMANN

Spanish-born Dr. Hofmann
was one of the earliest
practitioners of Madrid's
unconventional graffiti
culture, working with
different letter styles
that resemble signatures.
He pioneered the use
of stencils with his stylish
and striking work.

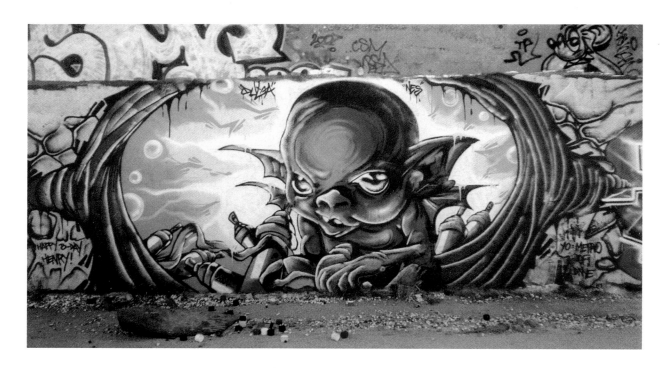

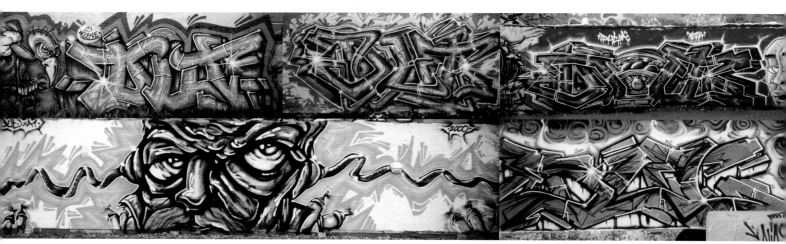

DUT

Dut has become recognizable by his hip-hop-inspired characters and compact styles. Based in Copenhagen, he has been drawing figures since 1986, but it was two years later that he started using a spraycan. His broad range of styles encompasses complex fill-ins.

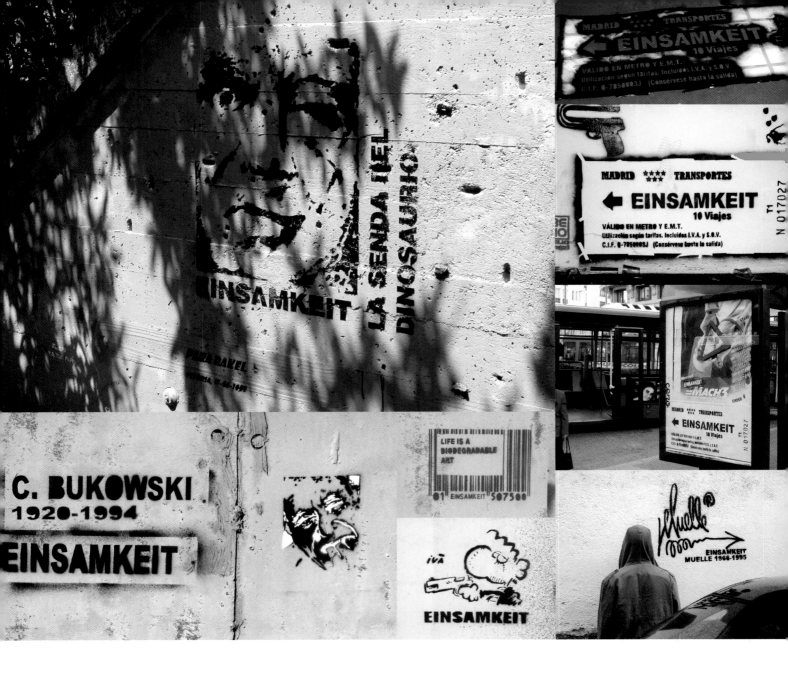

EINSAMKEIT

Although he has only been working with stencils since 2003, Einsamkeit is typical of Madrid's stencil artists. He took a break from the graffiti scene between 1990 and 2003 to compose poems. Early street artists such as Blek Le Rat encouraged him to start spray-painting again, using figures.

EL KITSCH TASSO

Before the Berlin Wall came down, there was very little opportunity in East Germany to spray-paint. In fact, in the early 1980s, the authorities actually put a ban on the sale and use of spraycans because it was far too easy to write politically motivated slogans with them. At around this time, Tasso used chalk and aerosols to try out some graffiti under the Meerane Bridge. He was unable to spray-paint another picture until 1991, when markers and other materials became available again. His photorealistic figures, animals, landscapes and portraits are very impressive, and his skills have given him the opportunity to work freelance in a professional capacity, painting facades and canvases. 'I'm not afraid of diversifying my techniques and developing from the brush and the airbrush,' he says. 'All that matters in the end is the quality of the picture.'

191

192	EL TONO & NURIA

El Tono comes from Paris and got into graffiti in 1993. Since the late 1990s, he has been working on printed captions on posters and stickers, at a time when other graffiti artists were still hand-painting their tags. Madrid inspired him to try something new – he began to paint striking lines on old houses that had not been tagged. The shape he paints is a loose interpretation of a 'tuning fork', while girlfriend Nuria paints a 'key'. 'My interest is to catch the eye of passers-by and educate them – I want them to realize exactly what people can do out on the streets,' says El Tono. 'The street is the most direct and accessible way of expressing myself that I know…. The story relies not only on the paint but on all of its shapes and motions, the building, the wall, the neighbourhood….'

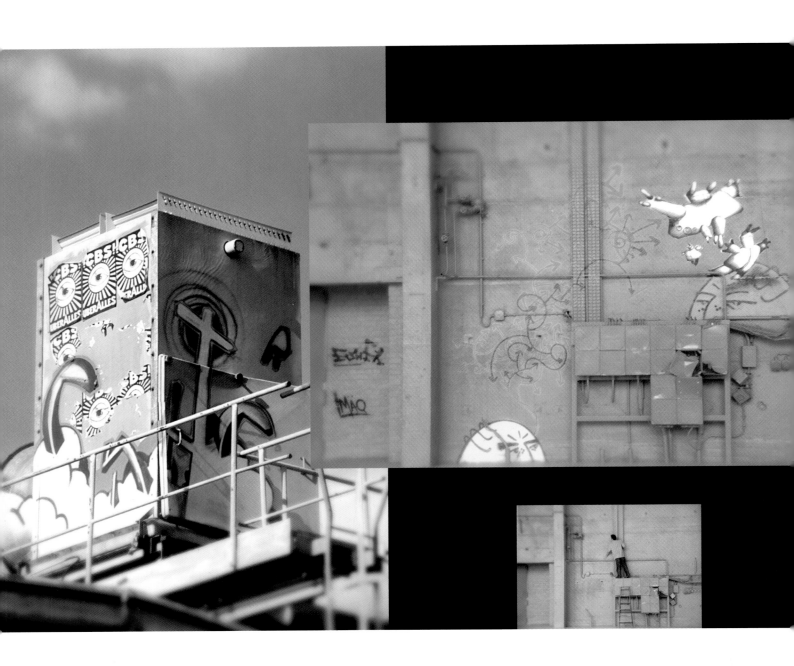

194 ESHER

Esher was born in Frankfurt but grew up in Berlin, where he taught himself graphic design and photography, and got into graffiti in 1990. He likes to experiment with different abstract elements, and works with happenings or creates rooms for fashion shoots. You can always expect something new and unique from him. He has also designed his own font.

ETNIK

Etnik became interested in graffiti after moving north of Florence. Travelling through Tuscany, he paints walls and trains using a wide range of techniques. He was also a co-founder of the KNM crew.

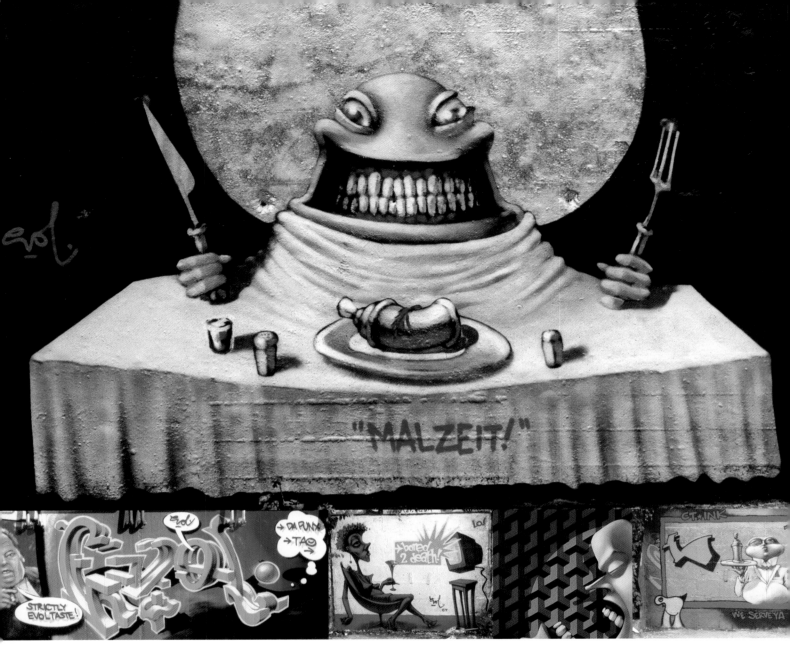

EVOL

Evol comes from Berlin and draws characters using a varied, nontraditional style. Through his work as a freelance designer, new influences have come into his pictures – prompting him to try out stencils, for example, and encouraging him to create T-shirts and canvases. For him, graffiti has 'developed into a public "art"'.

197

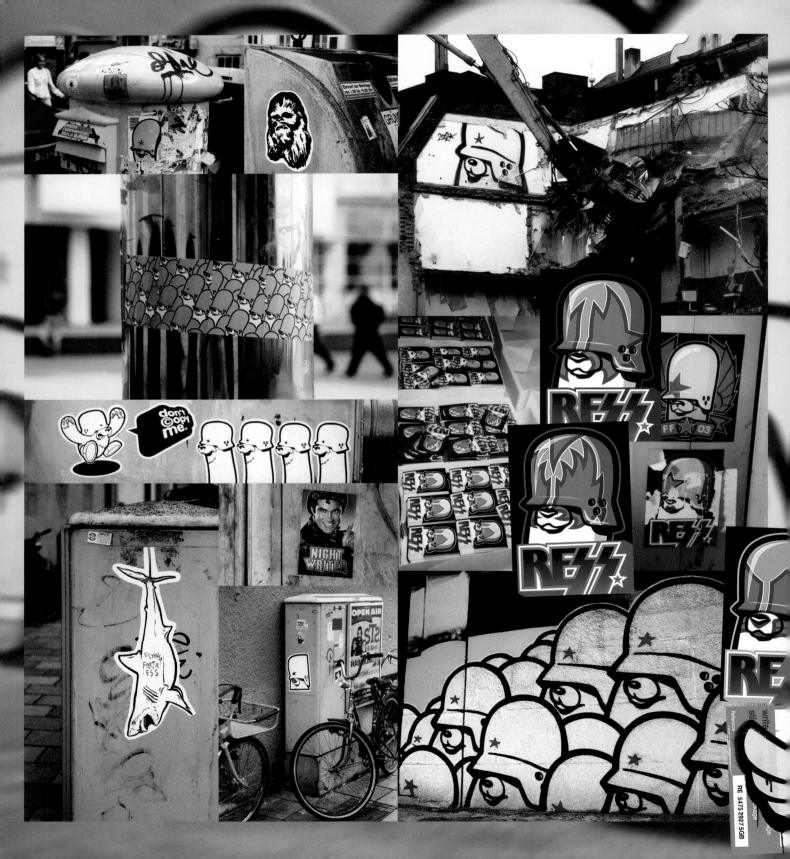

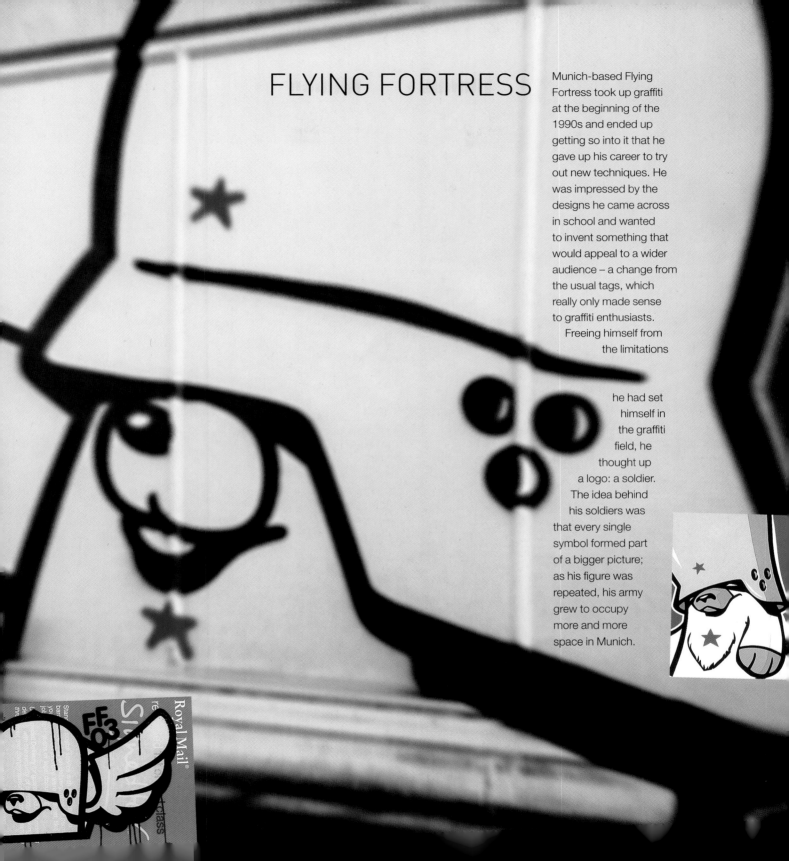

FLYING FORTRESS

Munich-based Flying Fortress took up graffiti at the beginning of the 1990s and ended up getting so into it that he gave up his career to try out new techniques. He was impressed by the designs he came across in school and wanted to invent something that would appeal to a wider audience – a change from the usual tags, which really only made sense to graffiti enthusiasts.

Freeing himself from the limitations he had set himself in the graffiti field, he thought up a logo: a soldier. The idea behind his soldiers was that every single symbol formed part of a bigger picture; as his figure was repeated, his army grew to occupy more and more space in Munich.

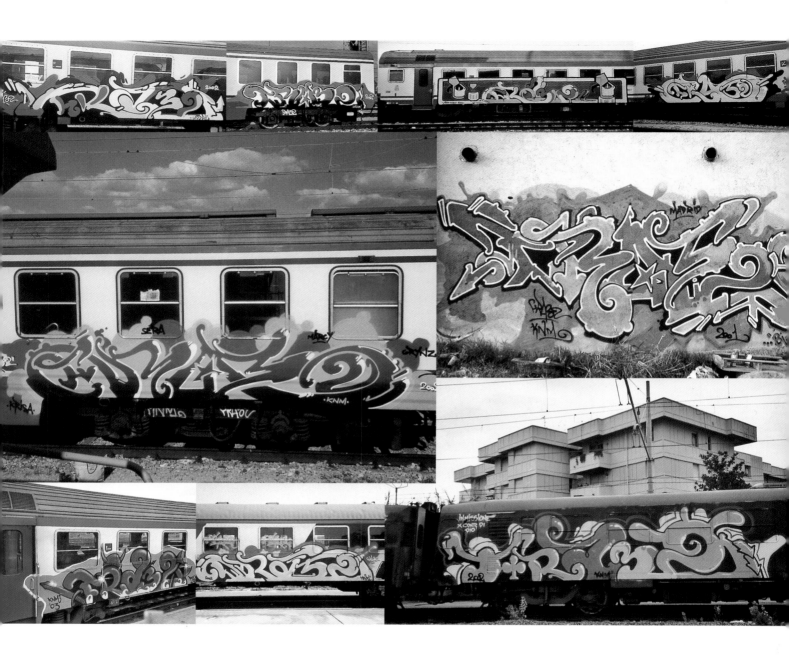

Fra 32's graffiti started to emerge in Pisa in around 1995, and it was not long before he painted his first train. Panels on trains became the preferred medium among many Italian artists but have since lost some of their appeal – these days carriages are covered with special films for easy buffing. Fra 32 also lived in Madrid for a year, where pieces tend to be buffed more quickly. This taught him to work more efficiently, and he used his experience abroad to spray-paint countless panels on his return to Italy. His style varies a lot, from letters inspired by New York to experimental pieces. He and Etnik have created some of the most impressive train work in Pisa and Italy as a whole.

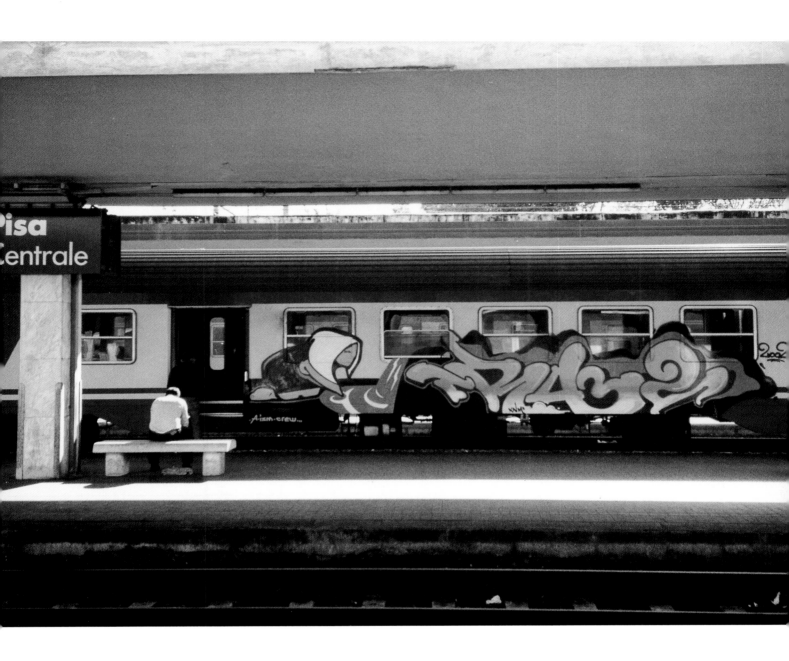

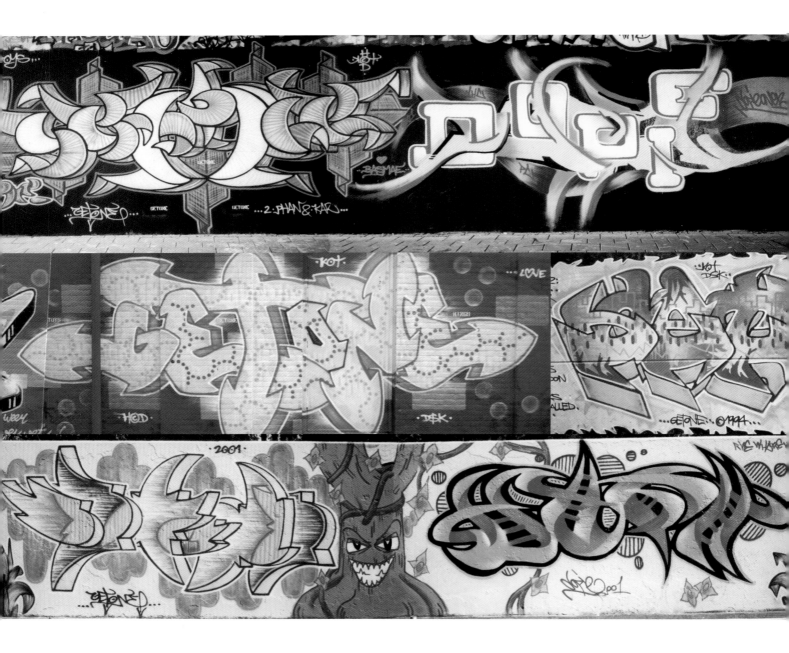

GET 1

Get 1 is a pioneer of the Dutch graffiti culture and has been spray-painting train lines across the whole country since the early 1980s. He is a typical representative of the old-school styles, continually developing with individual and abstract elements.

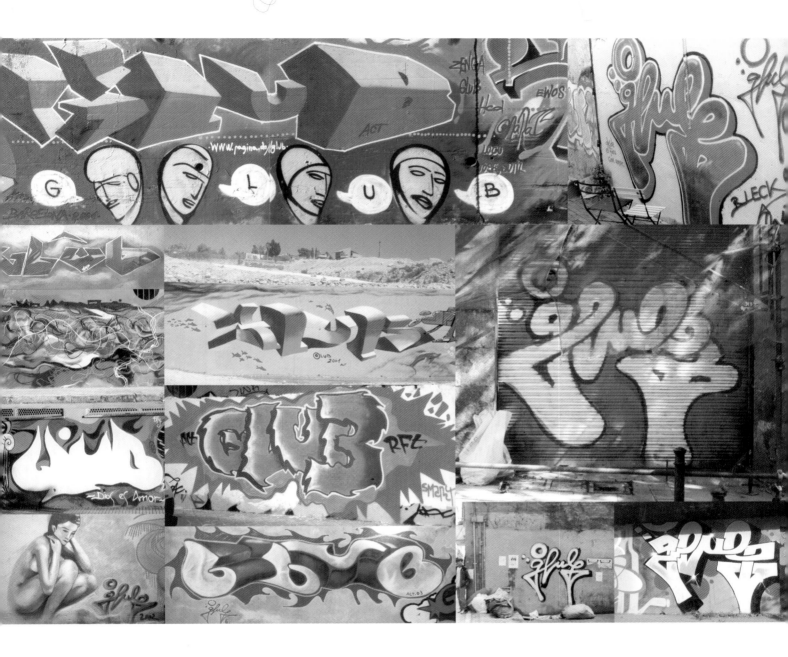

GLUB

Glub has had a great impact on Madrid's scene with his countless tags and pieces. He belongs to a special group of writers who emerged in the mid-1980s and concentrated on the American style letters. He specializes in a variety of tags and tries to vary his style, including flat styles or old letters influenced by New York, and highly experimental pictures.

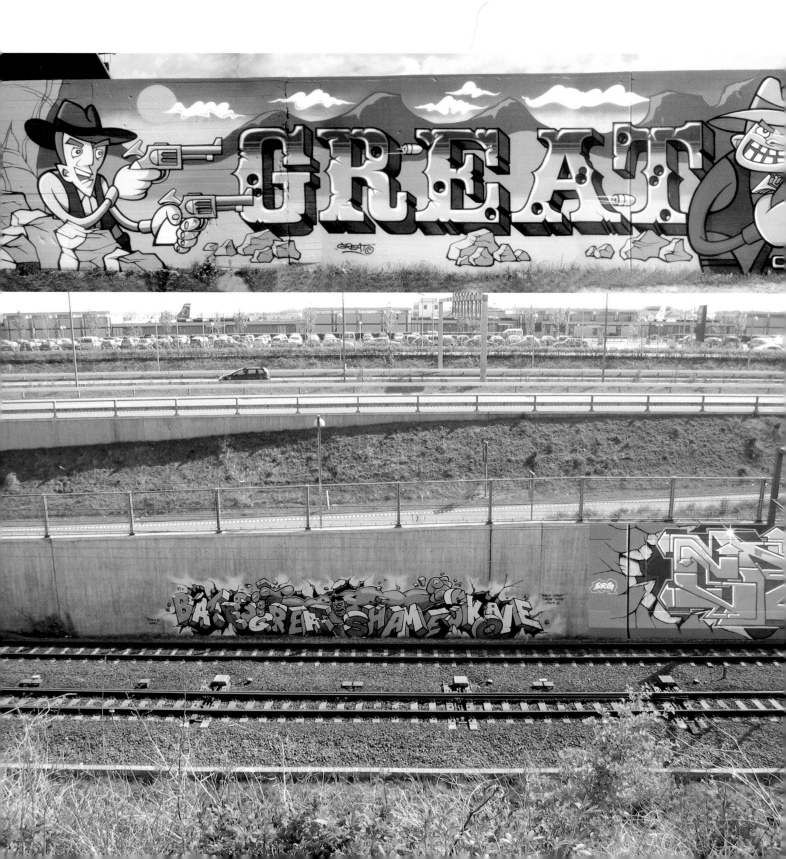

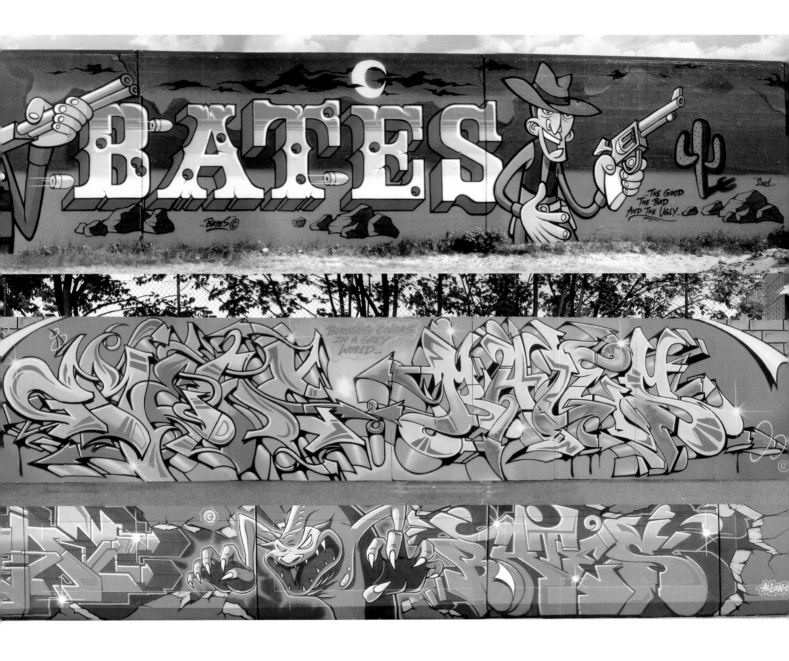

Great and Bates are two graffiti artists from Copenhagen who stand out through the richness of their pieces. Bates is arguably one of the most influential graffiti artists in Europe; his extensive travels have won him international recognition, although fame is not what spurs him on. Great and Bates plan their pictures very precisely, driven by a determination to move forward artistically. Although their letters tend to adhere to traditional styles, they do not allow anything to get in the way of their natural exuberance.

GREAT & BATES

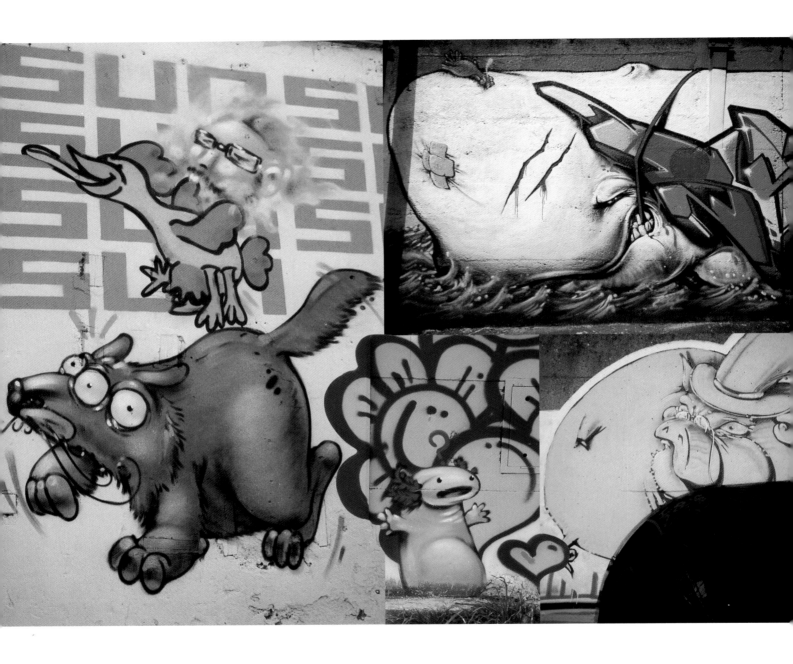

HITNES

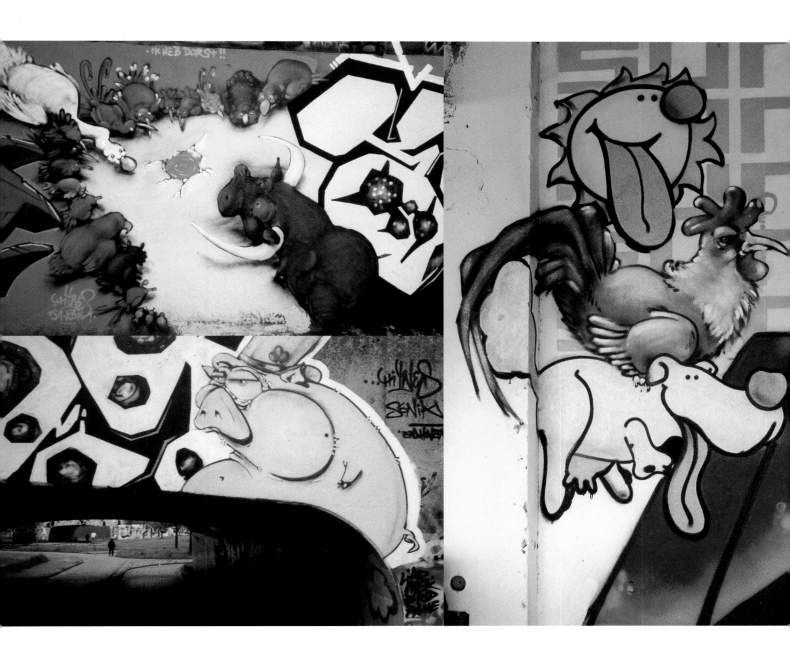

Hitnes is not a typical representative of the Roman train scene. He has specialized in drawing animals since 1999, with the aim of depicting nature's beauty: 'The beauty of nature is something amazing, and I always try to get this across. I mean, you could compare the curves of a mountain to the smooth back of a fish, or you could compare the back of a cat to that of a girl…it's wonderful.' He works on paper or canvas with markers and acrylic paints to create illustrations or paint images for vegetarian businesses or vegetable stores, and has also taken part in exhibitions.

207

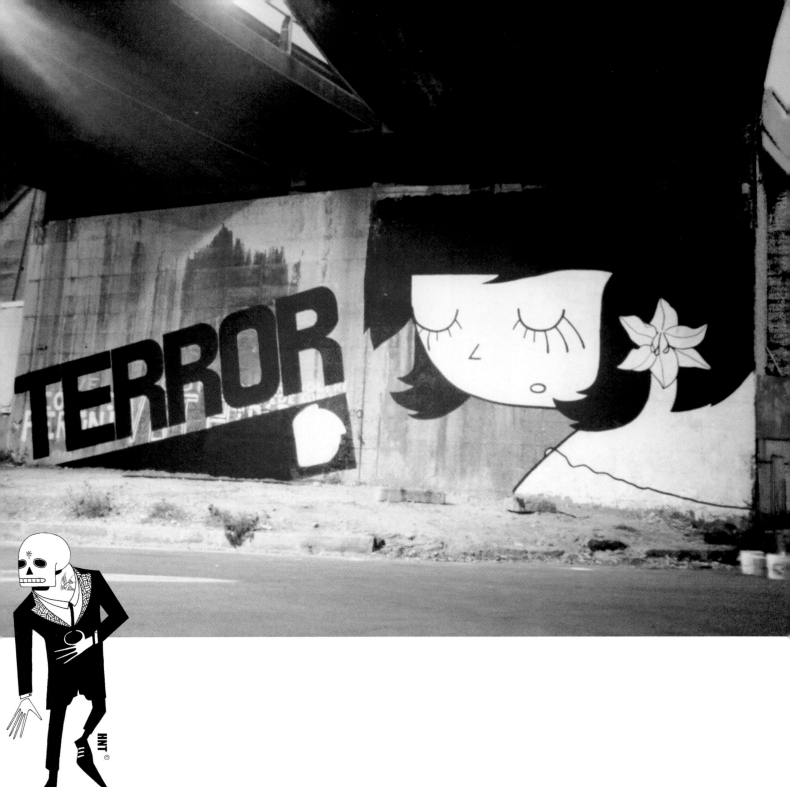

HNT / HONET

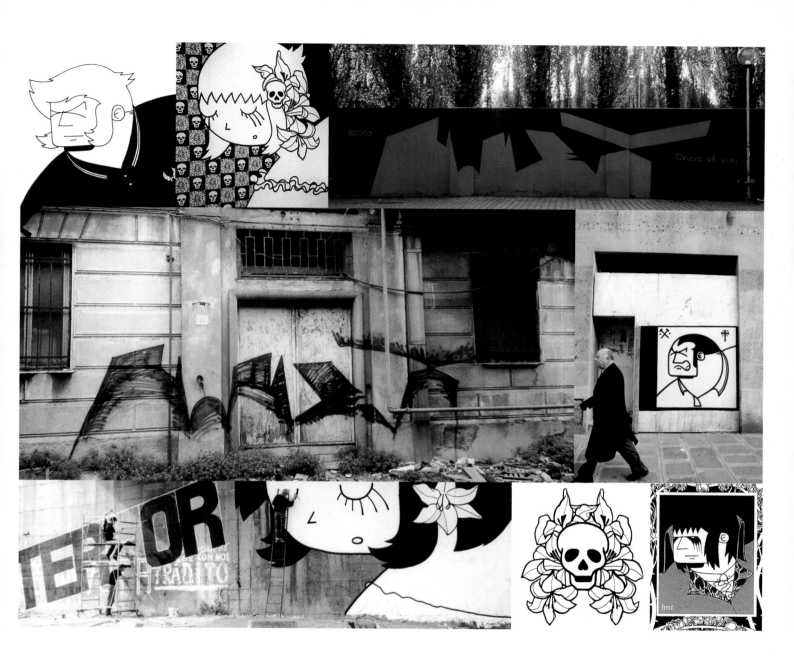

Enigmatic French artist HNT (also known as Honet) has been painting in Paris since 1988, and was influenced by Punk and Ska. His travels have since taken his art much further afield to the likes of Athens, Barcelona and Tokyo.

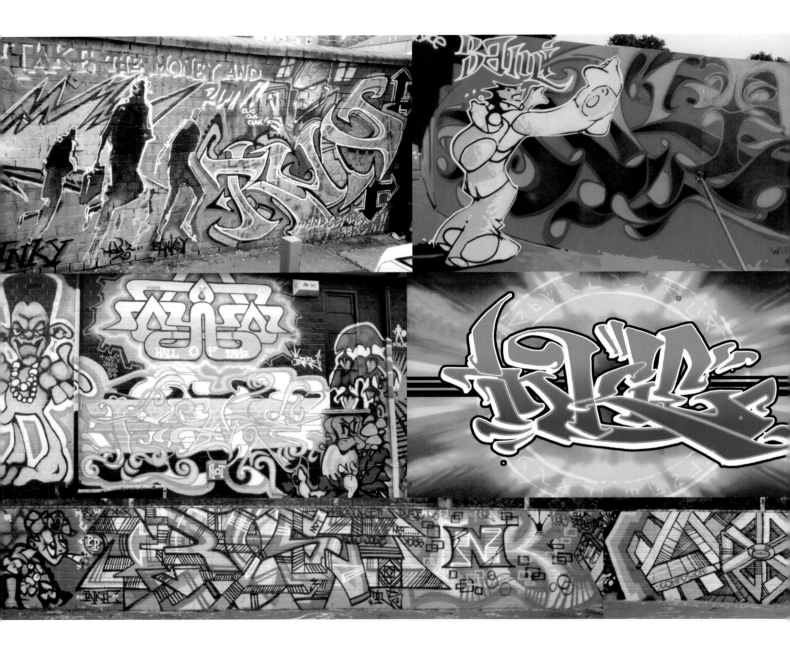

INKIE

Inkie was one of the first graffiti artists in Britain, inspired by the films *Wild Style* and *Beat Street*, as well as the book *Spraycan Art*. At the time, he was living in his home town of Bristol and was influenced by the early pictures of 3D, with whom he later founded the OGOG (Original Gods of Graffiti) crew. He painted his first wildstyle towards the end of 1983: 'Hip-hop was coming on but I was into punk and painting punk band logos. I saw the graffiti books that were coming out and started painting graffiti but was still into punk,' he said in *Graphotism* magazine in 2002. Over the years, he has spread his wild and, at times, abstract pictures over the whole of England, as well as travelling abroad. In the late 1990s, he moved to London and worked in the computer industry – in particular gaming, gaining notoriety with Jet Set Radio, in which the character rushes around the city painting Inkie pieces.

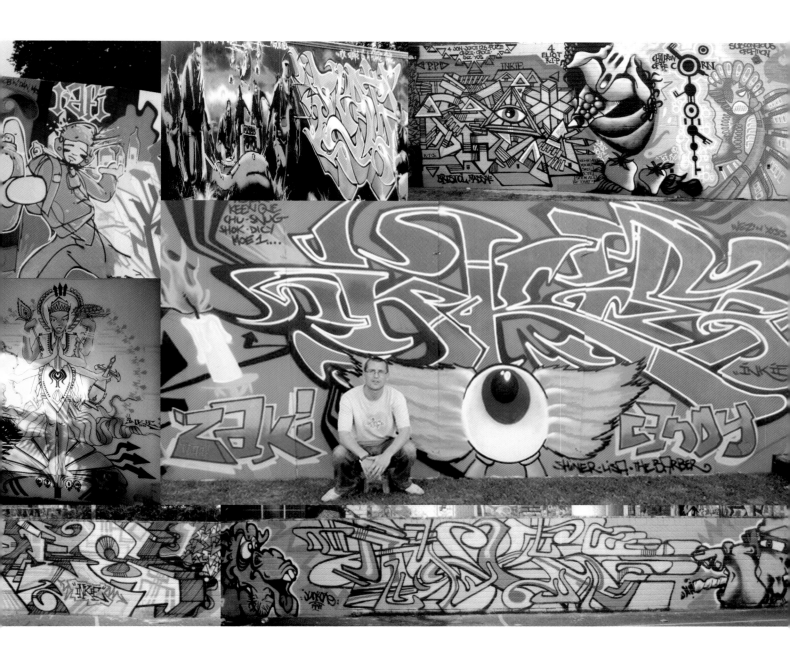

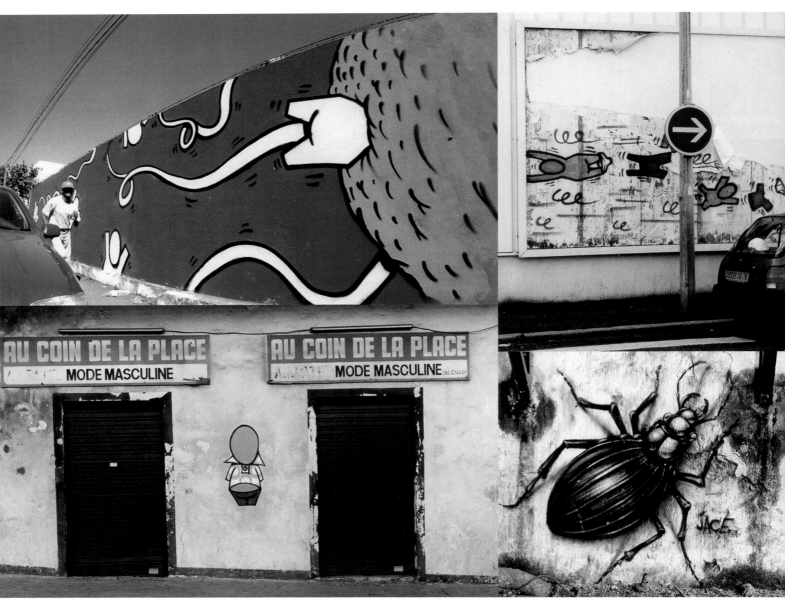

JACE

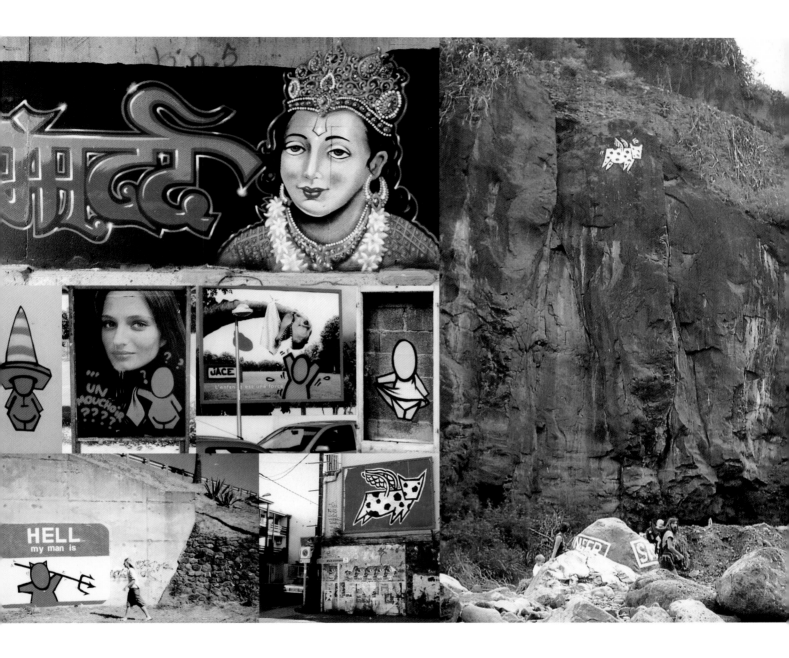

Jace was born in France and now lives on Reunion Island in the Indian Ocean with his family, where he works as an art teacher. He started to spray-paint and try out different styles and figures in 1984, after seeing a New York piece in a hip-hop report. In 1992, he created his character

Gouzou, which has become a feature of the local landscape and has even been noted by the Reunion Island tourist board. Trying out different techniques, including screen-printing, wallpaper, stickers and stamps, has become a way of life for him – particularly as he has to get his colour imported.

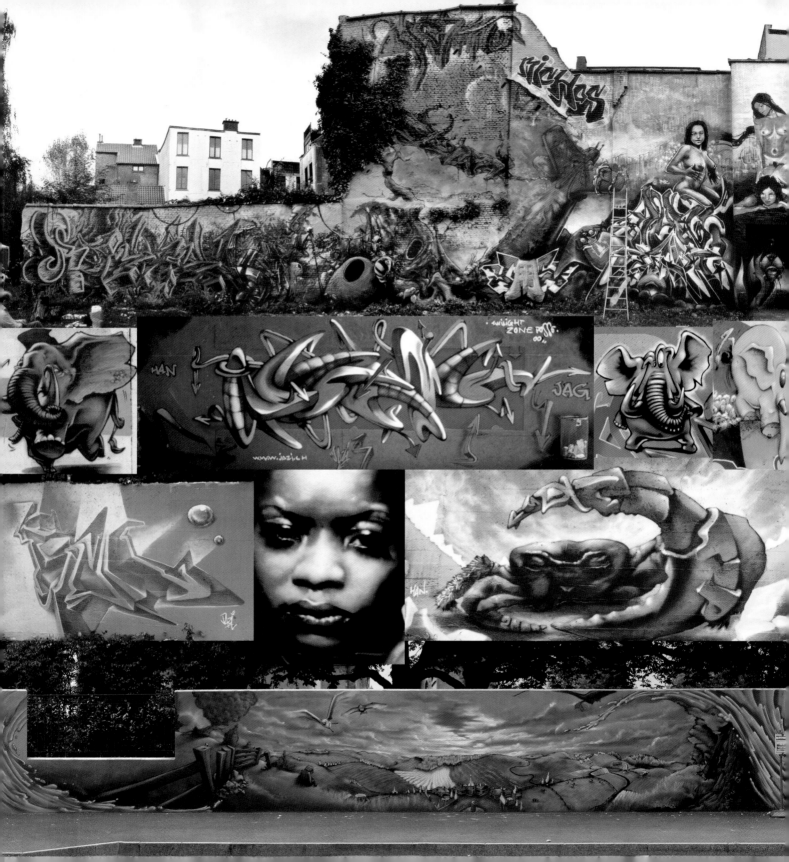

JAZI

Jazi, a very talented and versatile artist from Switzerland, works with various international graffiti artists on large murals. He likes drawing animals in his own comic-strip or realistic style, and has a particular soft spot for elephants. His letters vary from abstract to 3D, which he incorporates into his pictures with a huge amount of skill.

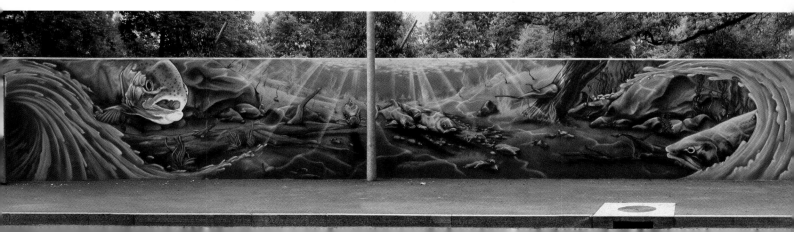

JOAN

JUICE

Nowadays, Amsterdam-based Juice and his Unlimited
Resources crew produce many elaborate paintings, although
he also works on his own projects. Juice has a very individual
and varied style, and his figures often feature wolves.

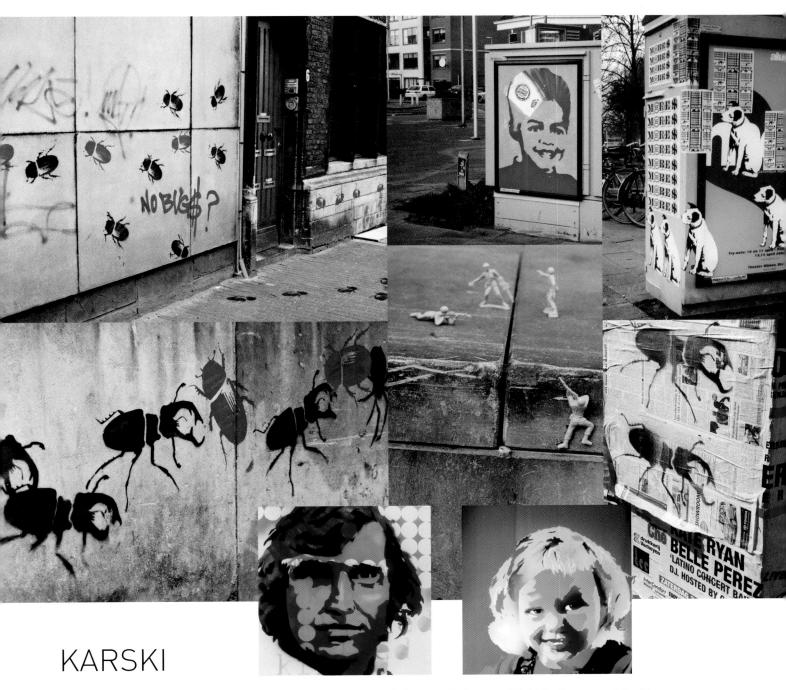

KARSKI

Karski is from the Netherlands and has been interested in graffiti since 1986, although he did not paint his first picture until 1988. He studied graphic design for four years and fine art for five, later founding his own design studio, and went on to work for important firms such as Coca-Cola and Sheraton Hotels. Nowadays, he works as a freelancer, using different techniques and influences: 'Well I don't wanna put the things I make in a box, like "oh that's pop art" or "photorealism"…but, how I see it, I do all kinds of styles, I do letters, I do cartoons, stencils….' His stencils are used lavishly, with different stencils for several colours, and he often dedicates his pictures to certain topics, such as dead rap artists or missing children.

219

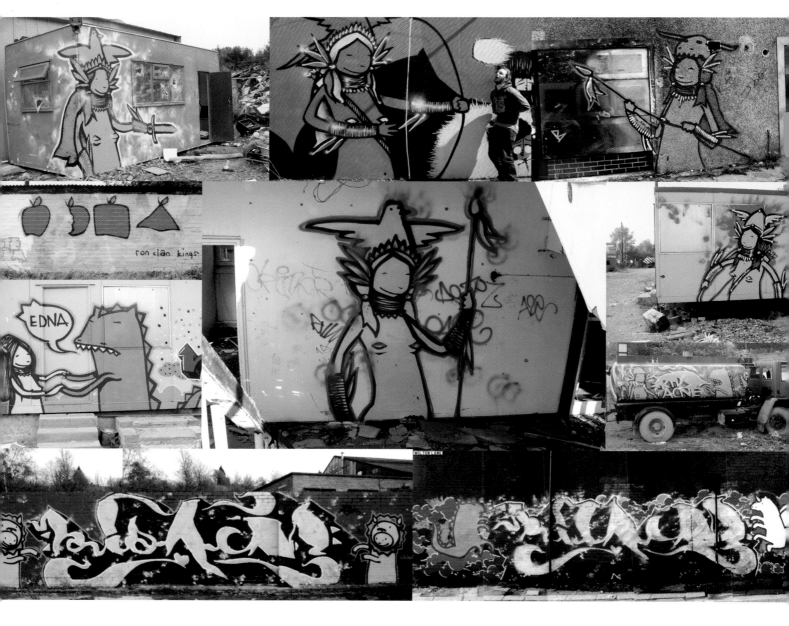

KID ACNE

Kid Acne (also known as Edna) was born in Malawi (Africa) in 1978, although he grew up in England and is now based in Sheffield. Inspired by local writer Solo One, he began painting graffiti in 1990 at the age of twelve. Acne went on to produce illustrations for club flyers, underground magazines and record sleeves, and he has also illustrated and published his own book, *Zebra Face*, written by his friend Sunshine Souljah. His works often feature fantastic figures, painted in a style which he calls 'Blood and Sand'. In addition to his artwork, he has brought out two rap albums on his label, Invisible Spies. 'Everything I do nowadays relates to my graffiti,' he says. 'I have the same approach to making music and doing illustrations as I do to painting on walls. The skills I have learnt have often been more valuable than what I was taught at art college…. That said, I couldn't care less about keeping it real and being part of a graffiti boys' club or whatever.'

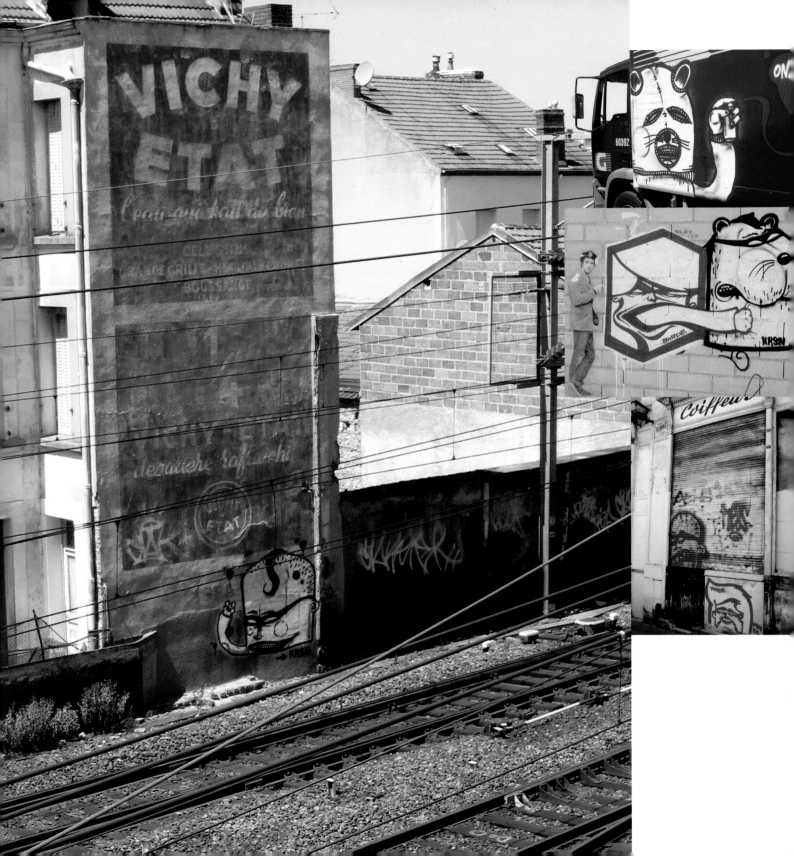

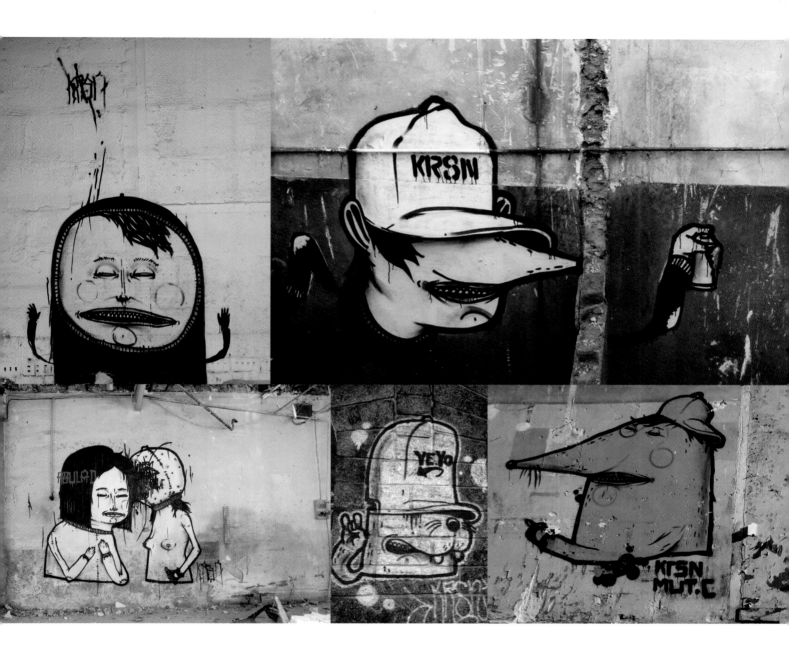

KRSN

KRSN began to spray-paint in 1990, when graffiti was exploding in France. He is one of the typical character painters to come out of Paris but, like many graffiti artists, started off painting trains and walls. His passion for illustrating inspired him to go on to design hand-made stickers. In order to reach a larger audience, he combined his interest in illustrations, paintings and graffiti to create comic-book characters and personal drawings on stickers, and later walls, with his partner Akroe. 'My ambition is to be an illustrator, with a kind of "author" attitude,' he says. 'I want to do personal stuff which people can relate to…characters are what I like to draw and they are also what people get touched by.'

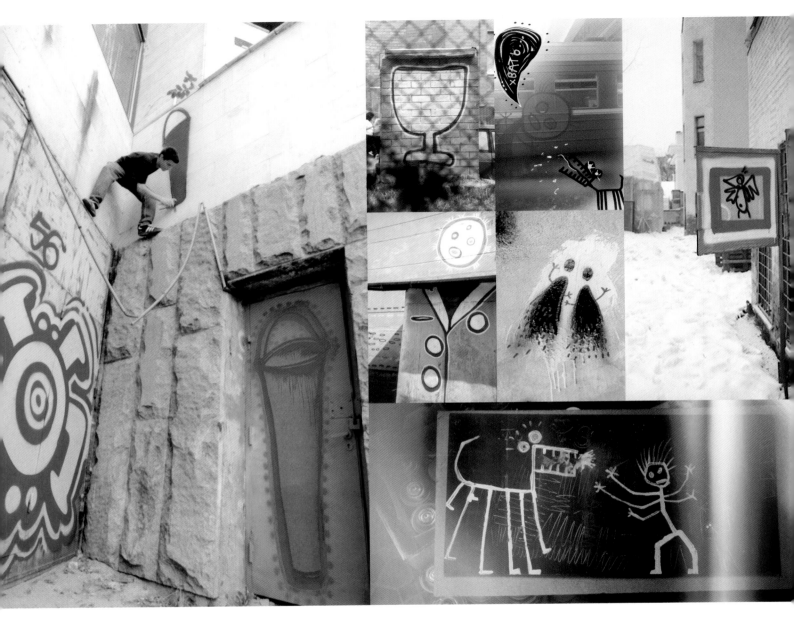

KTO

Moscow's graffiti movement has been very successful in producing a huge variety of different styles. KTO is a street artist, working on walls to create simple line drawings of figures and shapes.

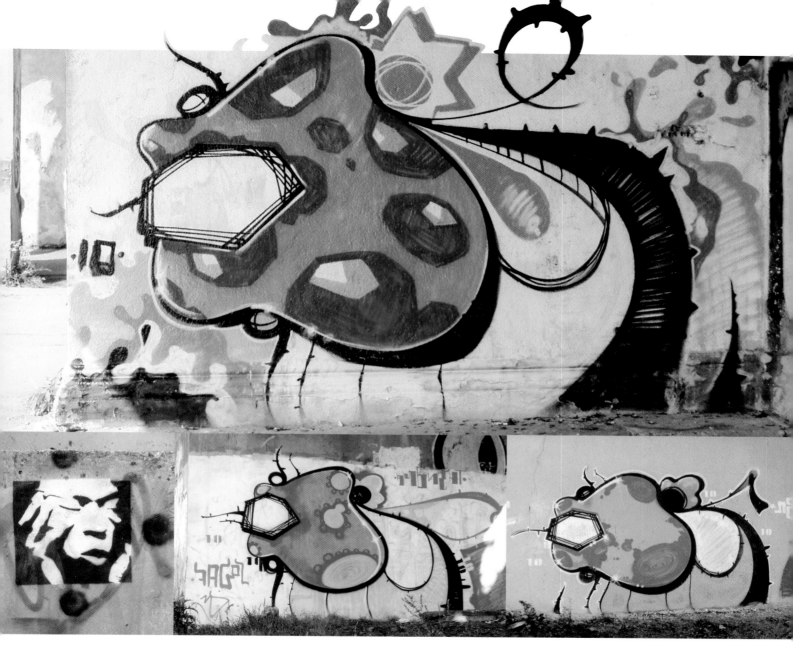

LA

Moscow-based LA's varied artistic works include spray-painted pictures on facades and stencilled images. He often mixes techniques and tries to blend his pictures with the urban landscape.

227

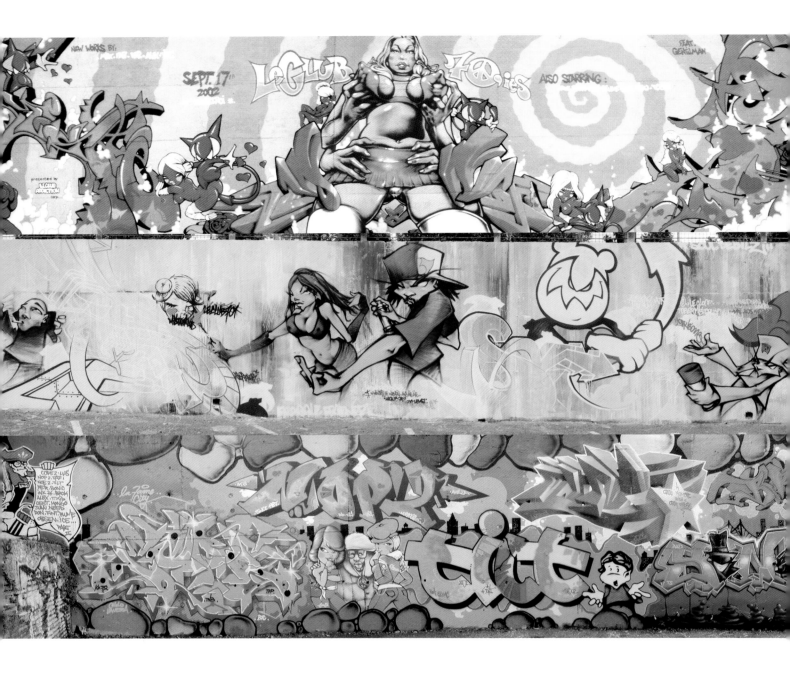

LE CLUB 70

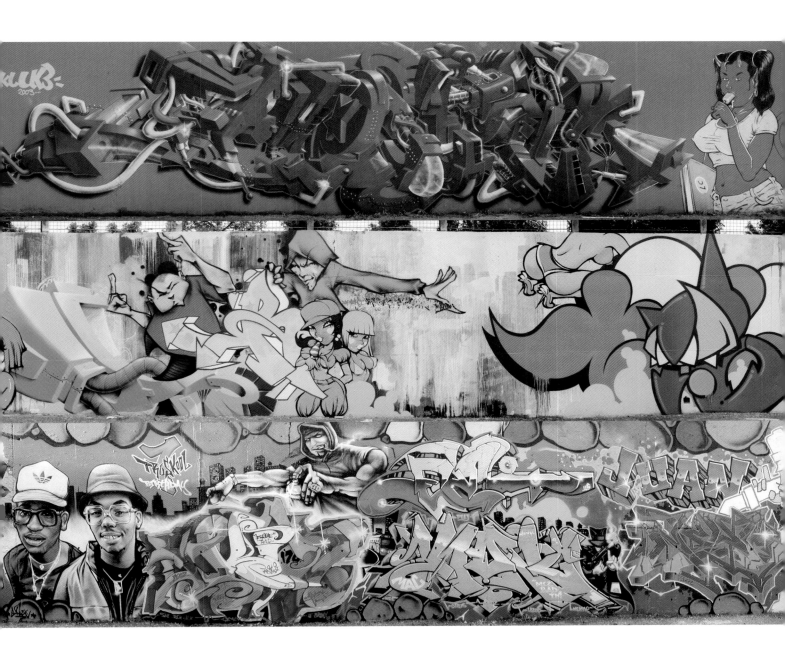

Le Club 70 developed on the back of Truskool, who was very active in Toulouse and organized a jam-exhibition there every year. Its members have remained pretty much the same, with just a few changes, and include some of the most established and talented artists. Fafi and Lus are two female artists who use a paintbrush to create their figures, and gained a worldwide notoriety with Miss Van through their small girlies and puppets. A number of members are in touch with a worldwide network of artists, travelling to Japan and the USA for work. Many individual styles have come into the Club through the different members, including individual 3D productions, semi-wildstyles and Tilt's bubble style.

229

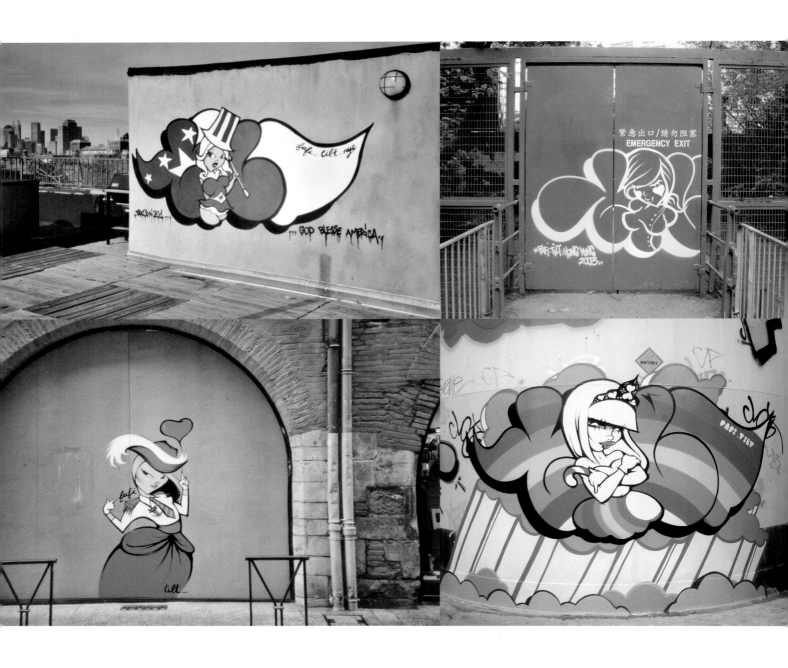

LE CLUB 70

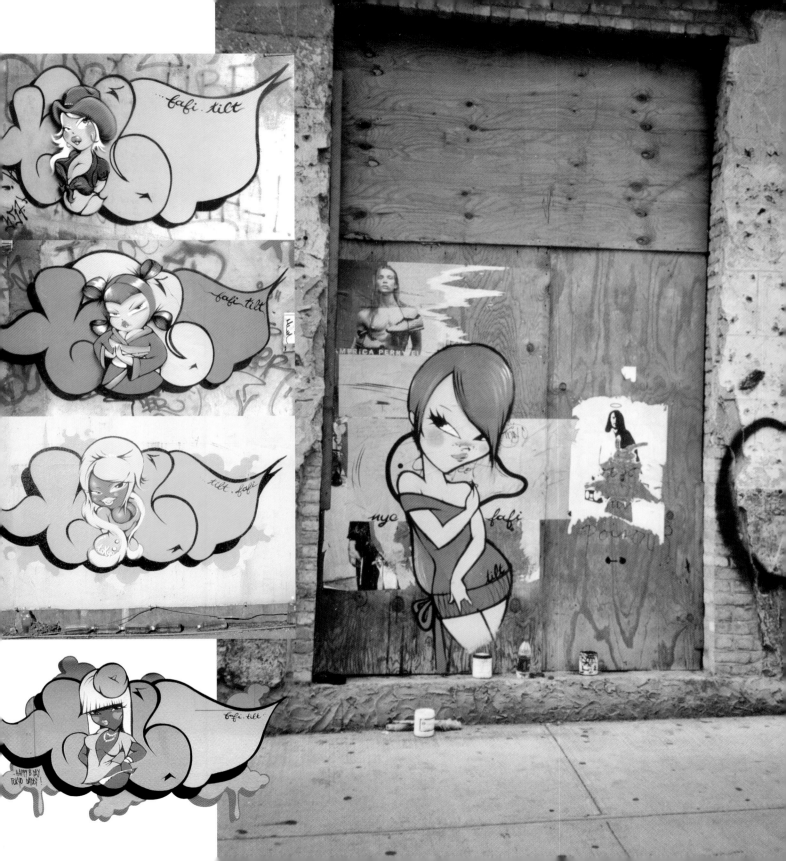

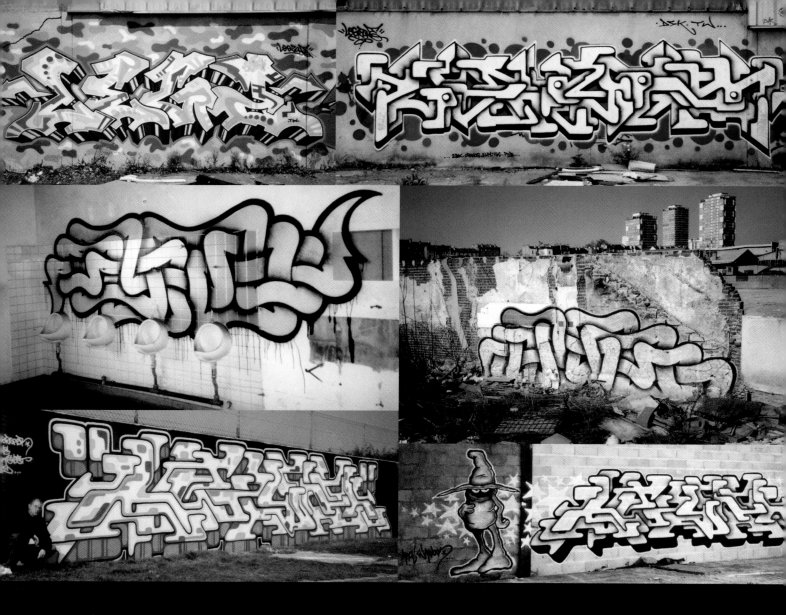

Legz got hooked on graffiti after seeing all the tags in Paris and on the metro. His early styles – painted with spraycans like Seat, Stak and Diadem – were strongly influenced by the Parisian legend Bando. Later, like many others, he adopted wildstyle, and created his Spaghetties. He was also influenced by the different styles that Stak, Stone, RCF 1 and Popay were coming up with. His first Spaghetties were letters constructed in wildstyle, but they later changed into pure freestyle objects. These days, he works for various magazines, and has published a book called *Outlines*. 'I'm now practising two forms of graffiti,' he says. 'On the one hand, I paint spaghetti in silver and black on bare walls in places that are falling into decay; on the other, I spray-paint colourful frescoes with my crews.'

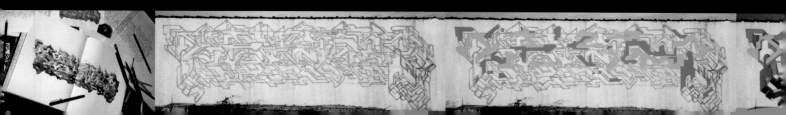

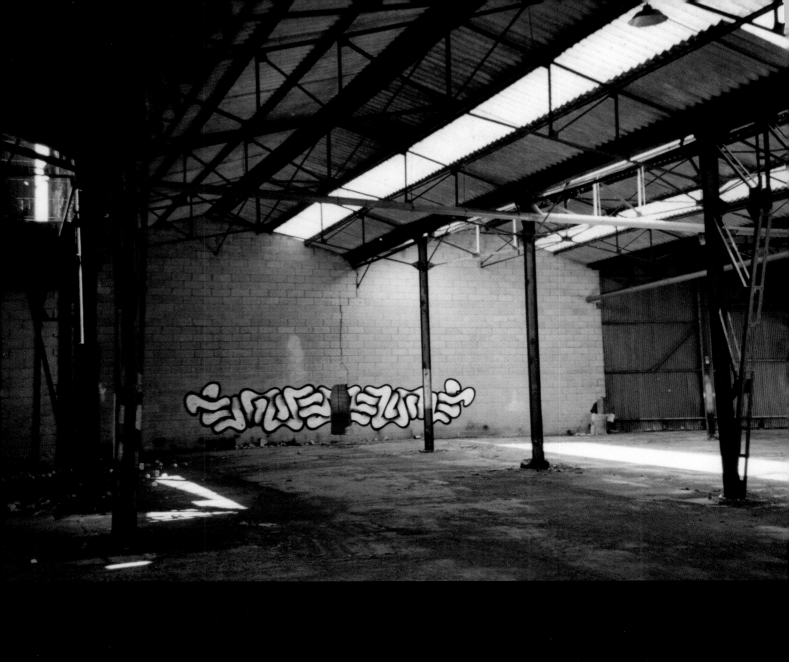

LEGZ

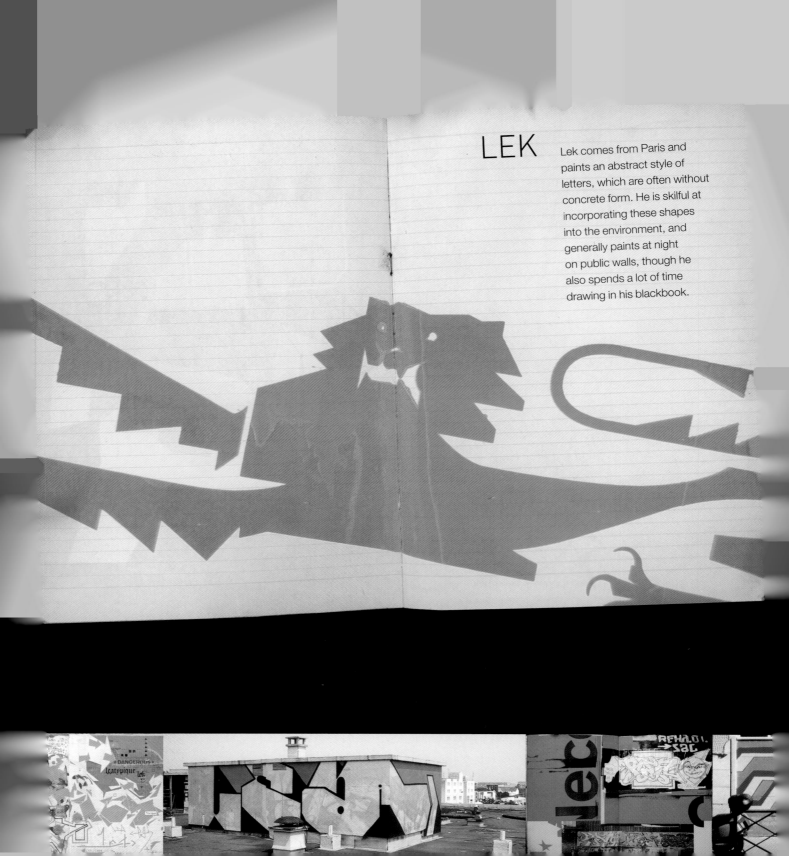

LEK

Lek comes from Paris and paints an abstract style of letters, which are often without concrete form. He is skilful at incorporating these shapes into the environment, and generally paints at night on public walls, though he also spends a lot of time drawing in his blackbook.

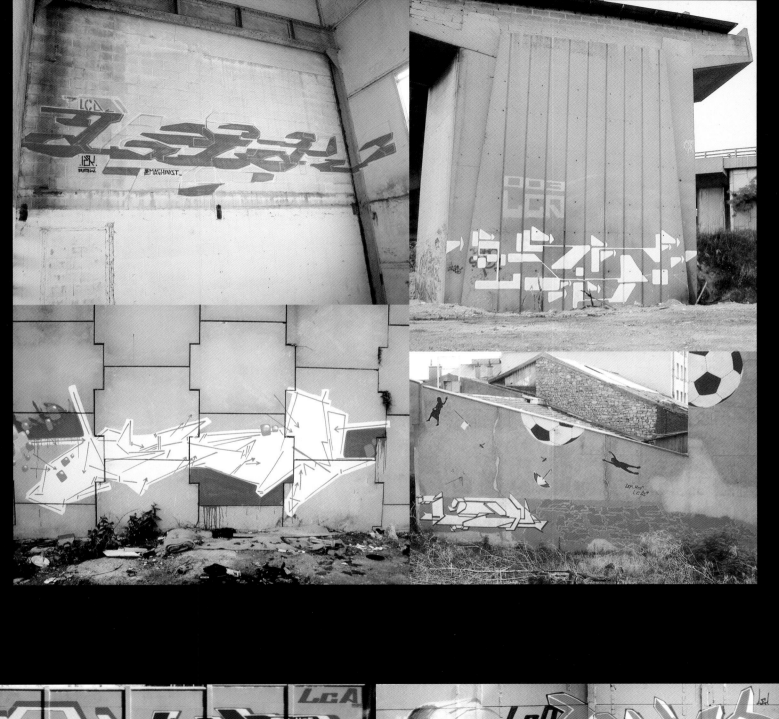
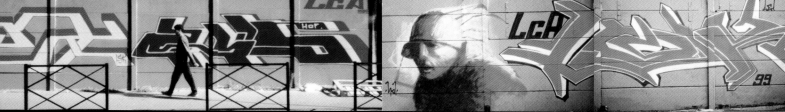

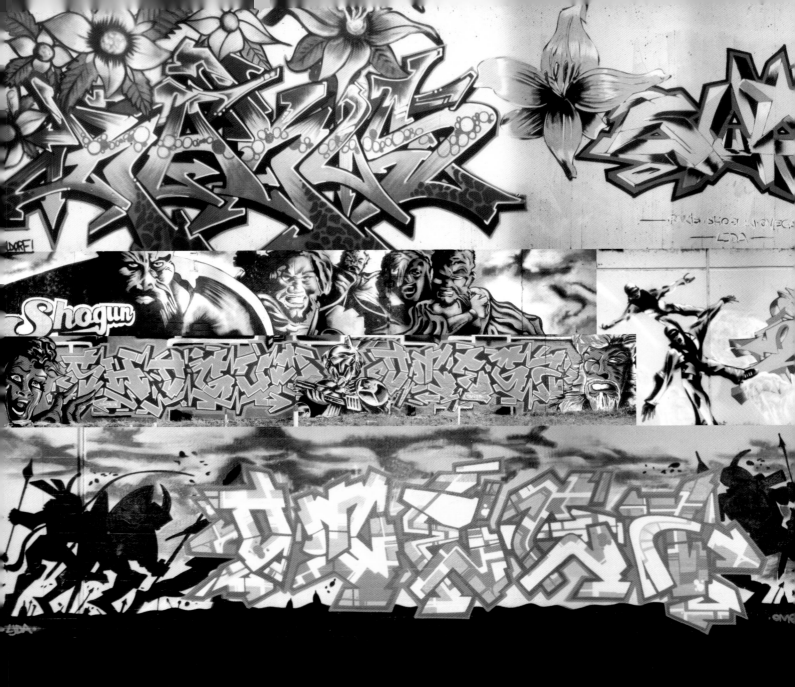

LJDA CREW

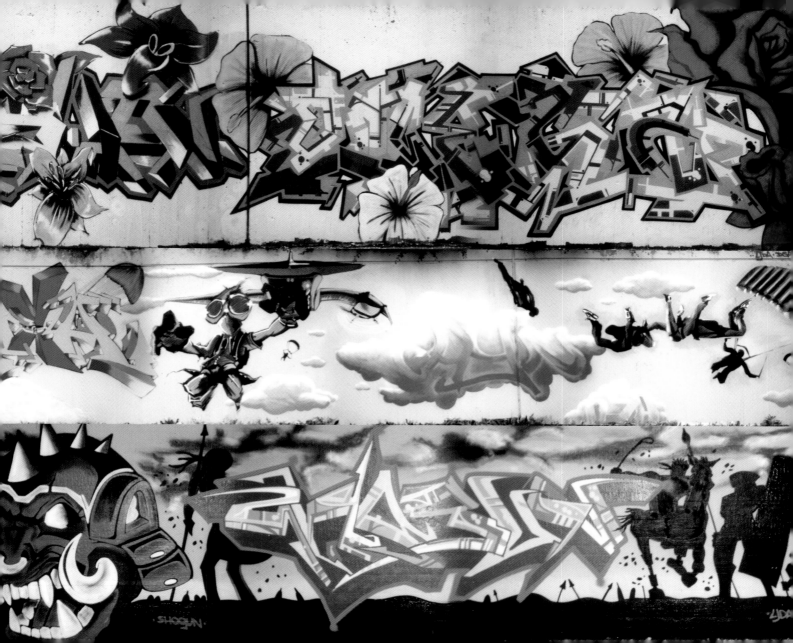

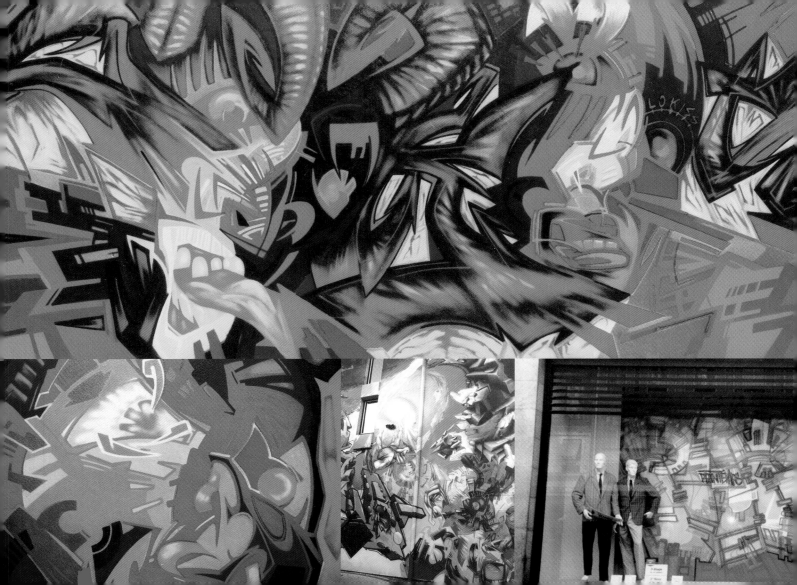

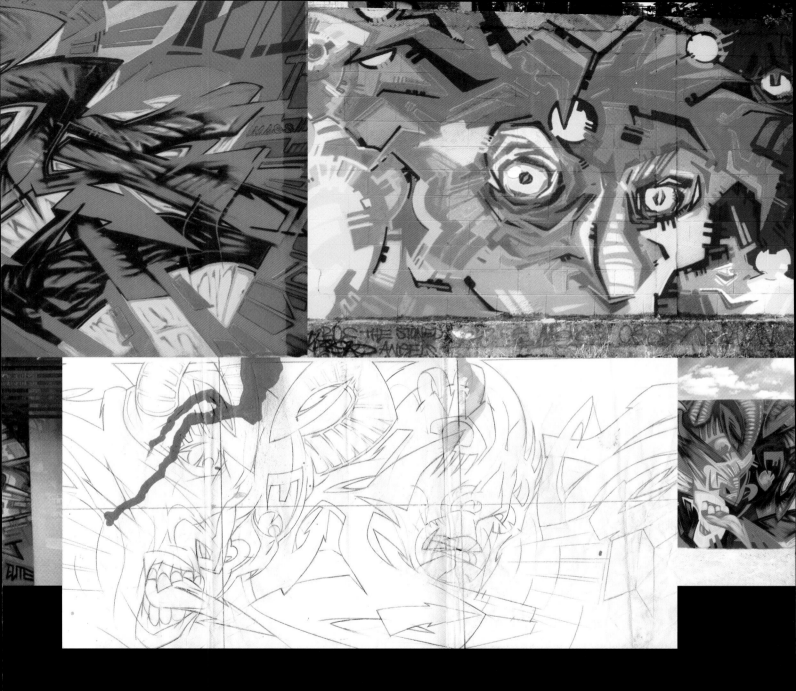

Old-school Parisian writer Lokiss has been active since 1985. He has created his own design-led style, in which it is less about the letters and more about separating himself from sketches and clear outlines, forming a new concept from basic lines and arrows. He wants his pictures to explode out of the background. Though he generally works alone, he does collaborate with other artists – on digital designs, for example. However, he makes his living from painting walls and interiors.

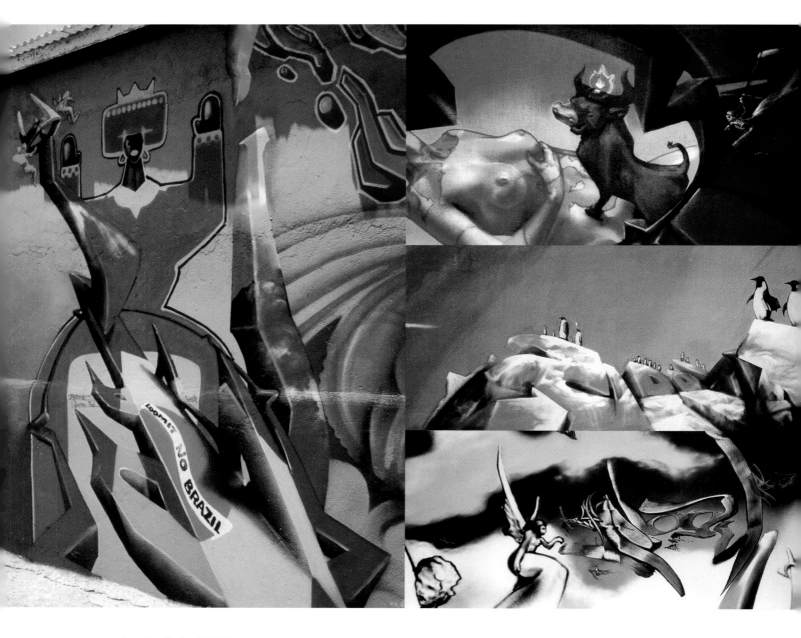

LOOMIT

'Graffiti writers have little in common with the classical image of the artist, working alone in his studio in order to present his creations to a comparatively tiny public in some gallery,' says Loomit. 'Every stroke of the graffiti artist's work is public. And he reaches not only the thirty per cent or so of the population that are interested in painting but virtually everybody....'

German-born Loomit spray-painted his first train in 1986 and has worked on pictures for several Halls of Fame during his career. Not only has he taken part in countless exhibitions both in Germany and abroad, but in 1995 he managed to get his name in the Guinness Book of Records for painting the highest graffiti in the world in Hamburg with other international artists.

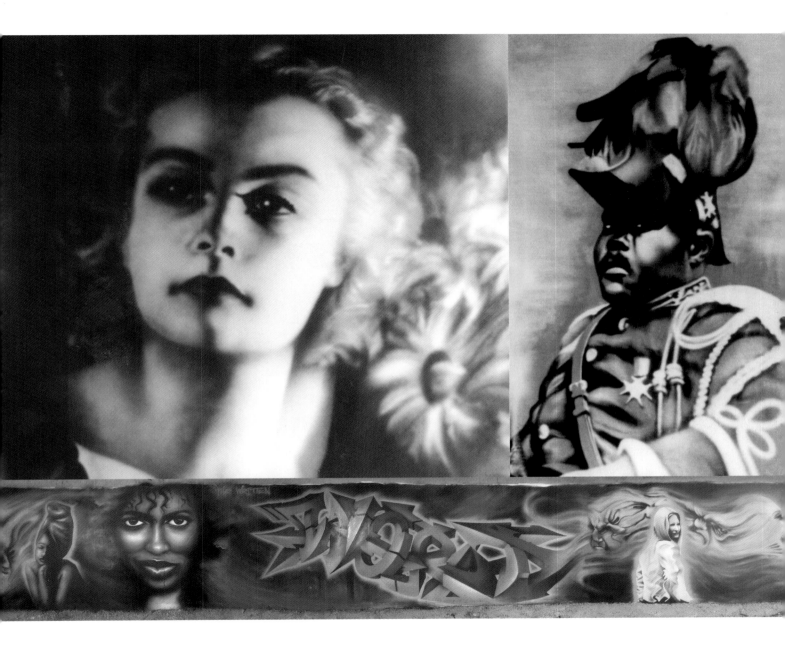

MAC 1

Birmingham's innovative scene brought us Mac 1. Although he often paints photorealistic compositions with his partners Juice 126 and China, he experiments with lots of different techniques and is keen to develop as an artist. It seemed a logical step to turn to canvas. His personal pictures touch on the world of dreams, for example, or nightmares and the dark side of the human psyche. His skills have enabled him to earn a living from his spray-painted pictures, the joint studio with Juice 126 and China, and the exhibitions and murals that they organize together.

241

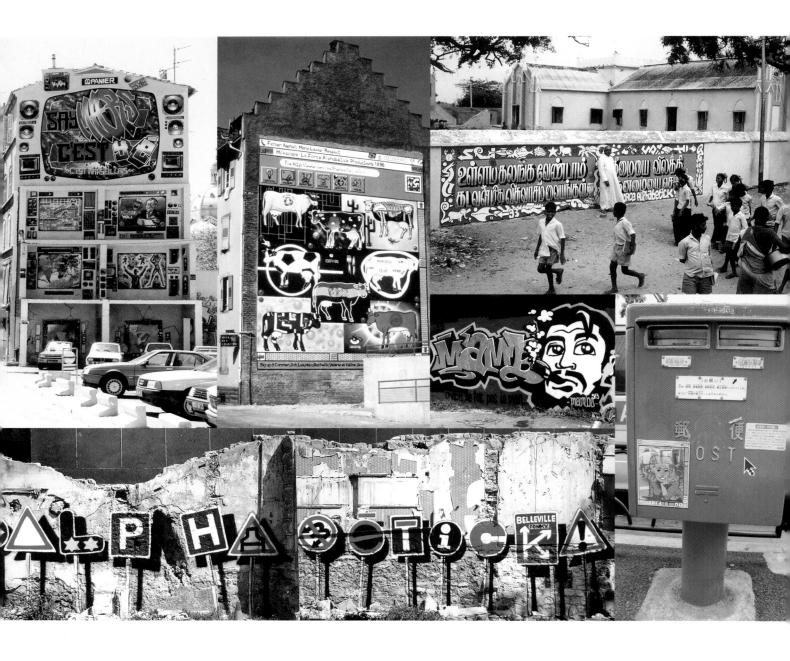

From 1986, Parisian Mambo was a member of the legendary Force Alphabetick, which emerged from one of the first crews: the Paris City Painters. Creative artists Spirit, Asphalt and Blitz were the core members of Force Alphabetick and painted awe-inspiring pictures with Franco-European themes and elements. When Asphalt died in 1992, some of the members went their own way. Since then, Mambo has been painting large murals with some of the crew and has travelled all over the world, managing to incorporate his pictures into the environment and culture of countries such as India.

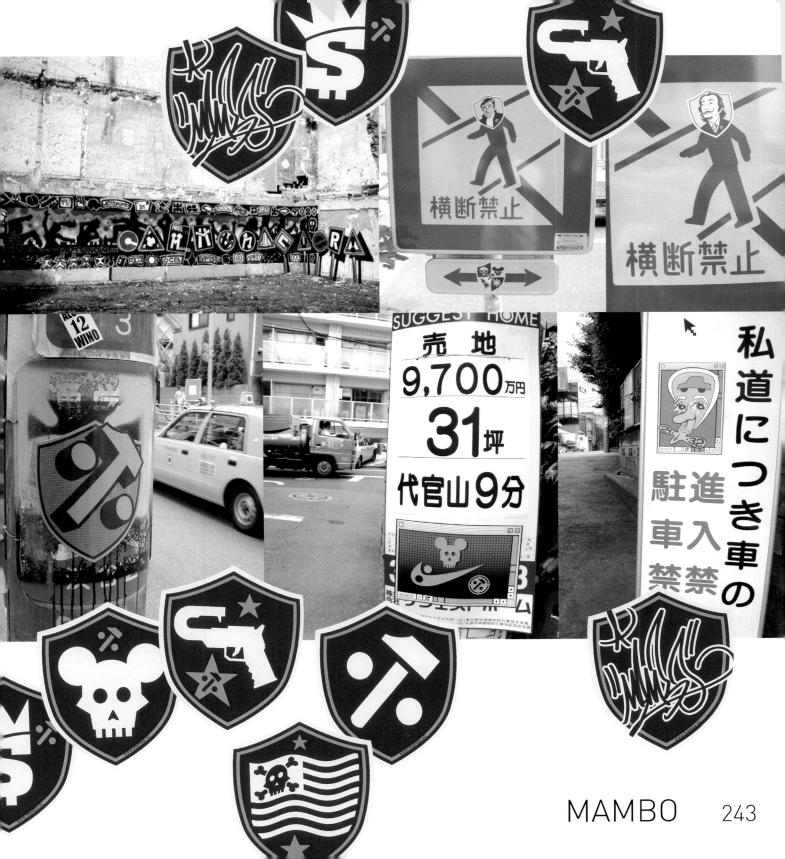

MAMBO 243

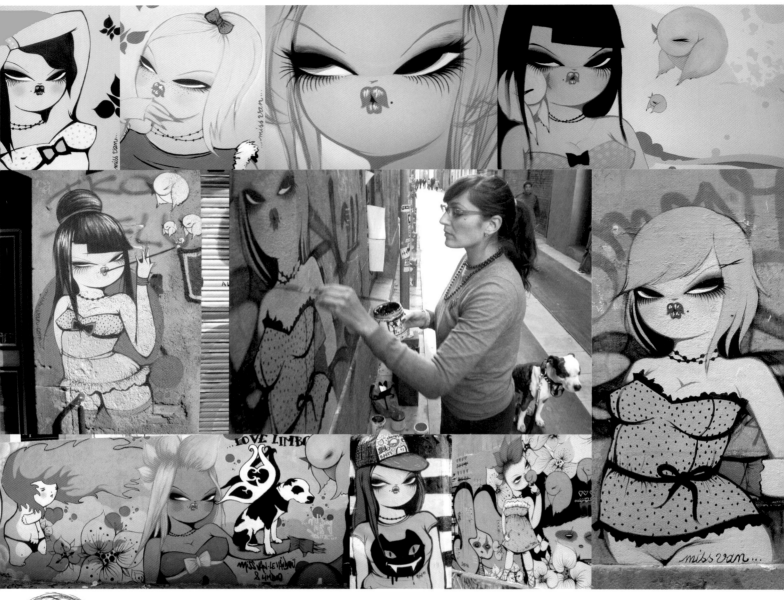

MISS VAN

Miss Van started to do graffiti in the early 1990s. Her first *poupées* appeared in her home town of Toulouse in 1993. As the first girl to start painting this kind of character, she created her own style of artwork, which makes a nice change to traditional masculine street art. 'My dolls are the expression of my feelings and fantasy,' she explains. 'Sensual, capricious, and yet sweet and sensitive, girls who are not yet women, full of ambiguity, they are disconcerting…they like to seduce and disturb the passer-by! I wonder whether I am not a doll, and if my dolls are not alive. We both evolve in an imaginary world, full of colours, erotism and voluptuousness.'

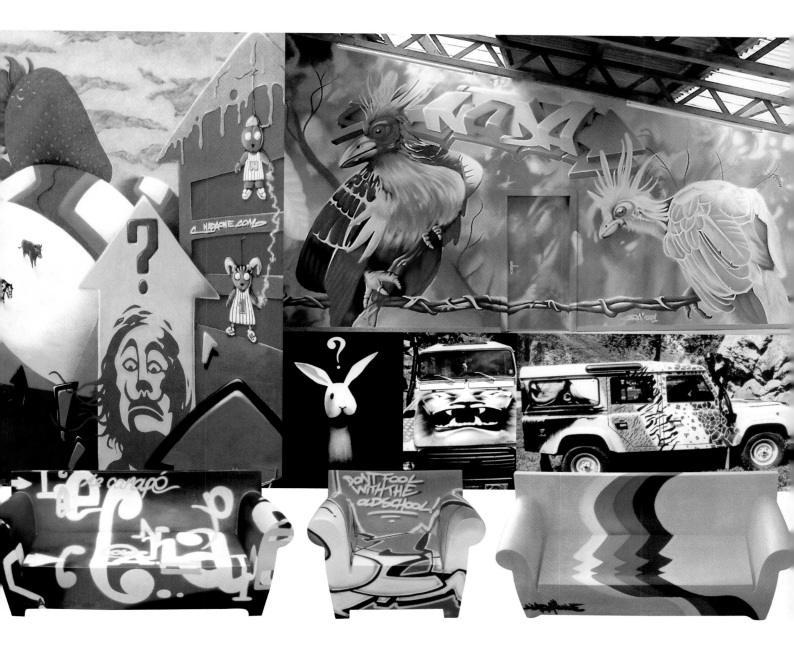

NADA

Nada lives in Switzerland, which has produced several high-quality graffiti artists and developed an independent graffiti scene, of which Nada is typical. His wide choice of colours and themes ranges from realistic pictures to abstract constructions. 'I always play with shadows and lights,' he explains. 'Also the style of the outlines and strokes that come out in my pieces makes it easier to recognize me. They are very varied. I try to put my personal touch to almost every work, even on a professional level, and there are a lot of reproductions of photos that I take....'

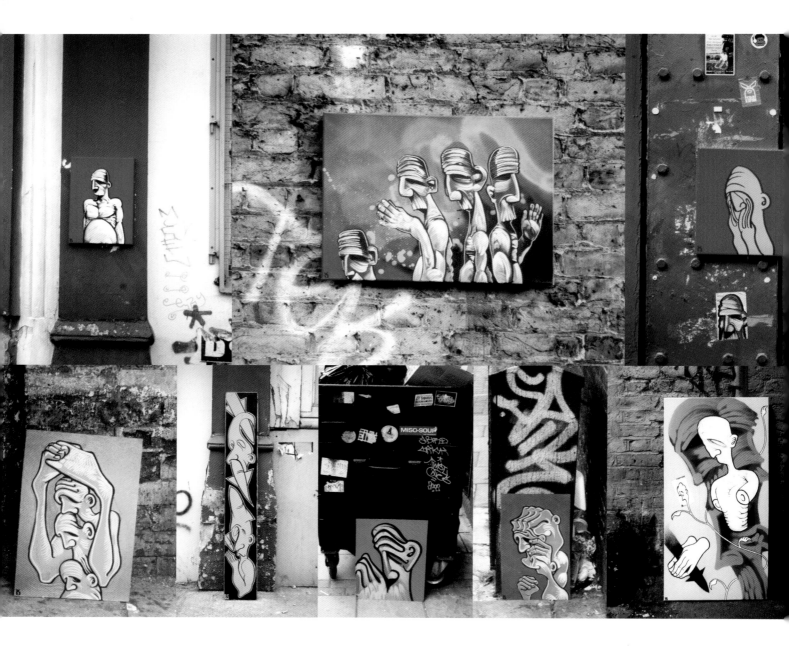

ADAM NEATE

Adam Neate lives and works in the heart of London's East End. His project, *Left and Found*, involved hanging more than 2,000 canvases and cardboard paintings on existing nails. He then left them for passers-by to take away with them. In his gallery project, 'What's the Magic Word?', he exhibited 200 canvases and stickers. The exhibition was free and people could help themselves to the pictures. This is his interpretation of being a 'free artist'. In more recent projects he has collected pieces of wood and cardboard from the streets, painted them, and then returned them to the streets. He photographs the objects he leaves, then exhibits them on his website.

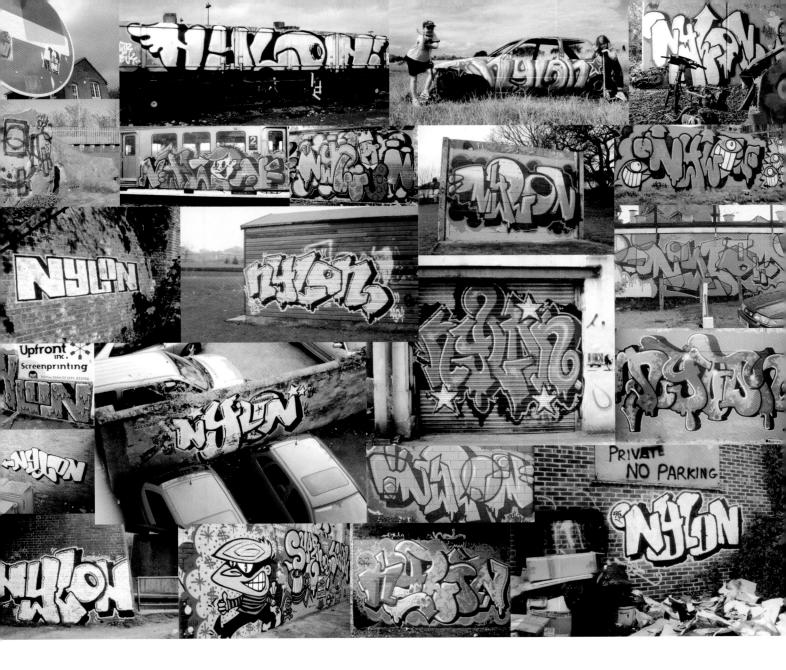

NYLON

Well-respected English artist Nylon chose his name as a reflection of his personality and identity. 'Nylon itself is a ubiquitous fabric and product,' he says. 'Graffiti artists strive to achieve the same effect.' He first came across graffiti in movies when he was nine. From the very beginning his work centred around letter styles. 'I hope that my style is a reflection of my passions outside graffiti…. My painting has become more fun and relaxed, gravitating towards pop art and away from hip-hop.'

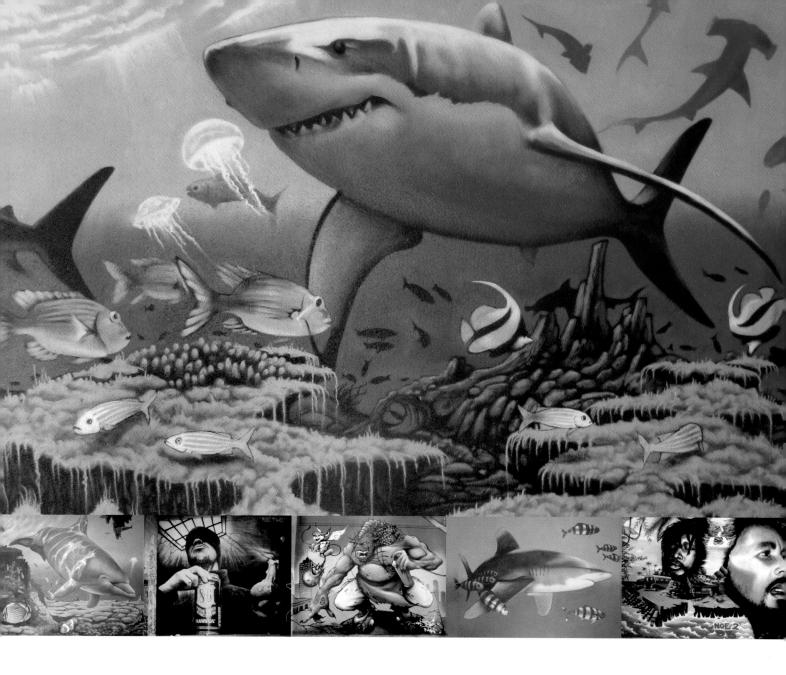

NOÉ 2

French artist Noé 2 is well known for his realistic portraits and pictures. He often works with graffiti artists from Toulouse but also cooperates on large-scale works in New York. As well as spray-painting, he produces a lot of drawings on paper and uses mixed techniques.

NTN CREW

Bulgaria's graffiti culture was hindered by Communism and did not develop properly until the mid-1990s. NTN's Nast and Ndoe formed part of the early scene, and their styles have evolved a great deal. Although it can be difficult to get good cans or caps, they paint large productions, sell canvases and work on their hip-hop project, *Dope Reach Squad*.

249

NYSF CREW

Italian crew New York Syndrome Family specializes in the New York style. It was formed in 2001 from several crews – LDR, AM, 5SK and ONU – and consists of a group of friends scattered throughout Italy. The use of the New York models has prompted Sat – one of the initial members, who publishes

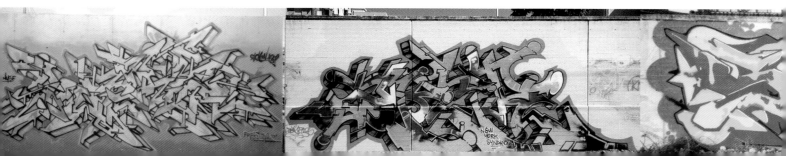

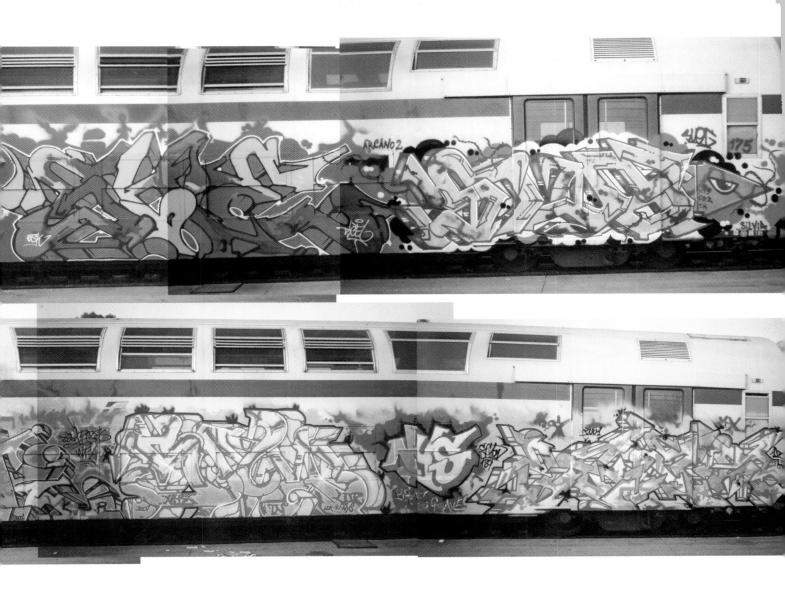

Arcano2 magazine with Slog – to say: 'I love the New York style, so what I do is basically try to re-elaborate it, personalize it and finally pour it into my pieces, drawing inspiration from the works of crews like FX, FC, GOD, TDS and many many more – too many to mention! I think that many of the NY old-school writers are the real "graffiti kings" because twenty or more years ago these guys created an entirely new art form without any mags, pieces, or any other points of reference to build their pieces on. And what really amazes me is that, in my eyes, many of their pieces can still compete today....'

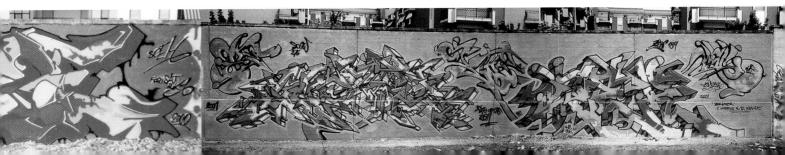

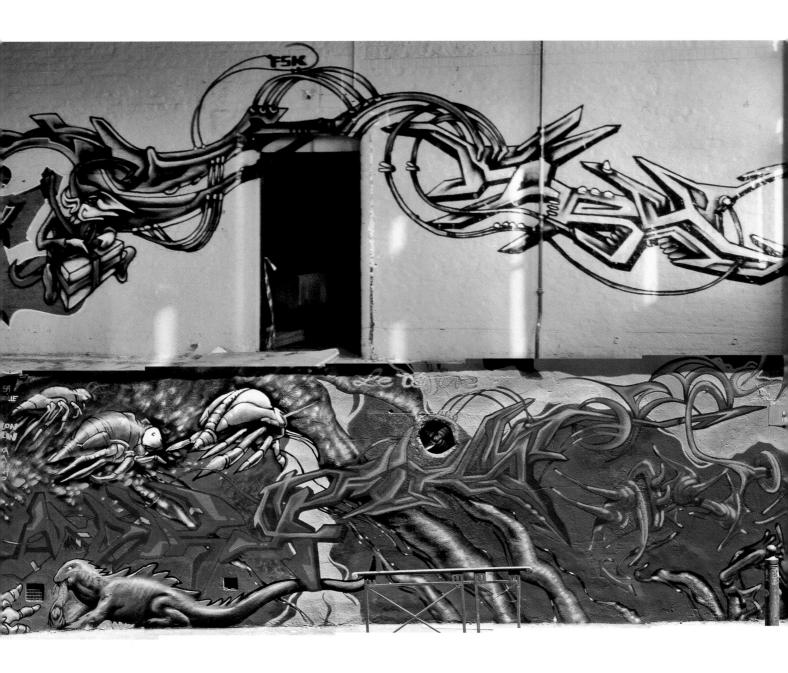

OESCH

French writer Oesch is known for detailed pictures, which he plasters across the subway and its surroundings. Next to his plastic, shaped compositions he often creates letters. He also uses a computer to work on his designs.

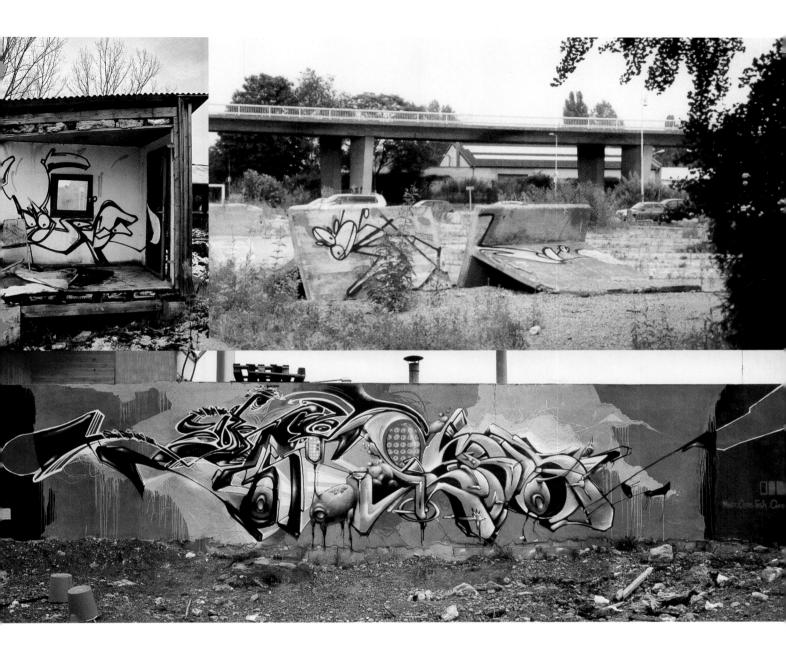

OGRE

Ogre, who is from Lyons, has been interested in graffiti since 1995. He uses his pictures – which regularly feature insects and styles that are connected to the background or disappear in brutal landscapes – to reflect his feelings, to let his own private garden grow or, as he himself says, to rear his own 'child'. In this way, he communicates with the passer-by: 'My "art" is really spontaneous…. I try to be polyvalent so I can mix it with every other writer I meet. Just call me a chameleon!'

253

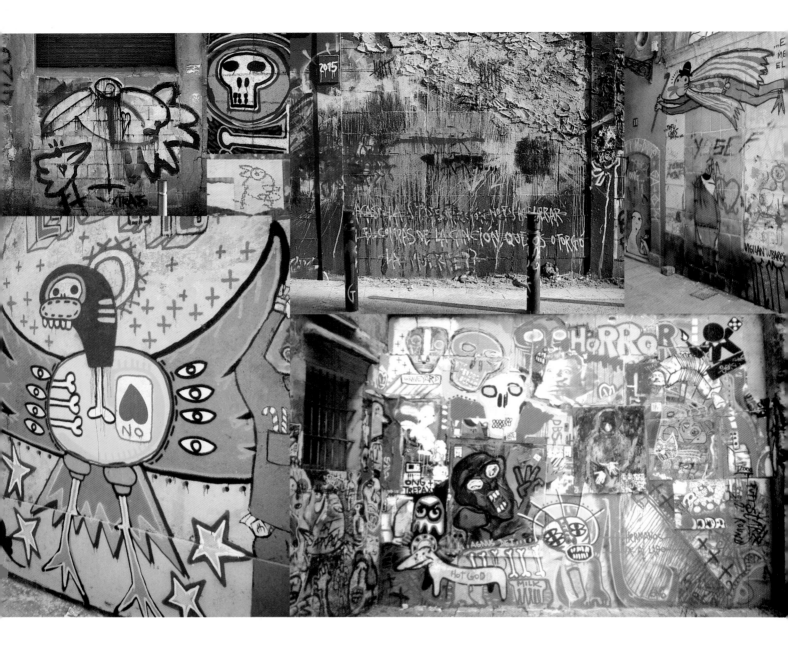

ONG CREW

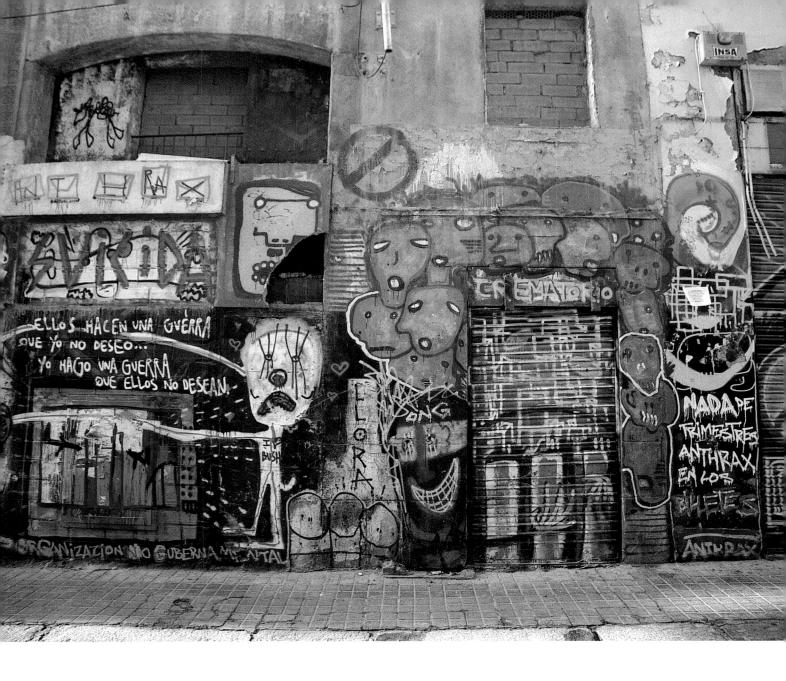

ONG, also known as Ovejas Negras (Black Sheep), is a graffiti collective at the centre of Barcelona's non-conventional and highly creative urban art scene. This diverse group of artists is responsible for many large-scale mural productions and also acts as a focus for alternative events and performances. Their work tends towards experimentation and has strong fine-art influences, including wild colours, abstractions and graphic distortions with collaged elements such as wood, plaster and paper. Skulls, dreams and social revolution are some of the visual and ideological themes that reoccur in the collective's work. Although not all its members are united in one political stance, many of the productions take on political subjects – for instance, the sinking of the oil tanker Prestige, which caused devastation to the north-western coast of Spain.

255

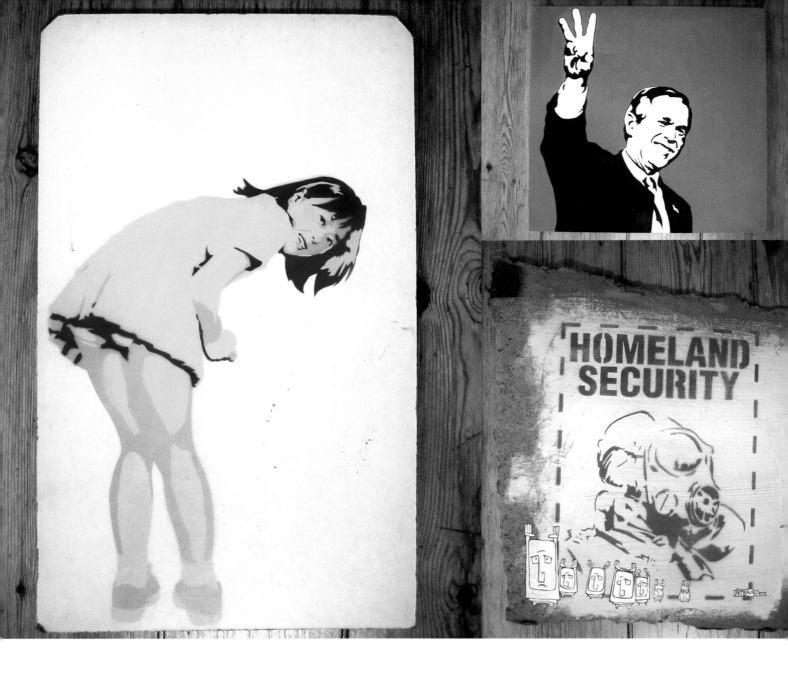

PISA 73

Pisa 73, one German artist to have been heavily influenced by Banksy, works as a designer, prints T-shirts and exhibits his canvases. He likes experimenting with new forms using stencils, stickers or posters, and his work often reflects his experiences or fears. Pisa 73's stencils are particularly clear and sometimes restricted to two colours: 'You find yourself somewhere between handicraft and printing. With photos as a basis, the result is a hybrid of photos and drawing.'

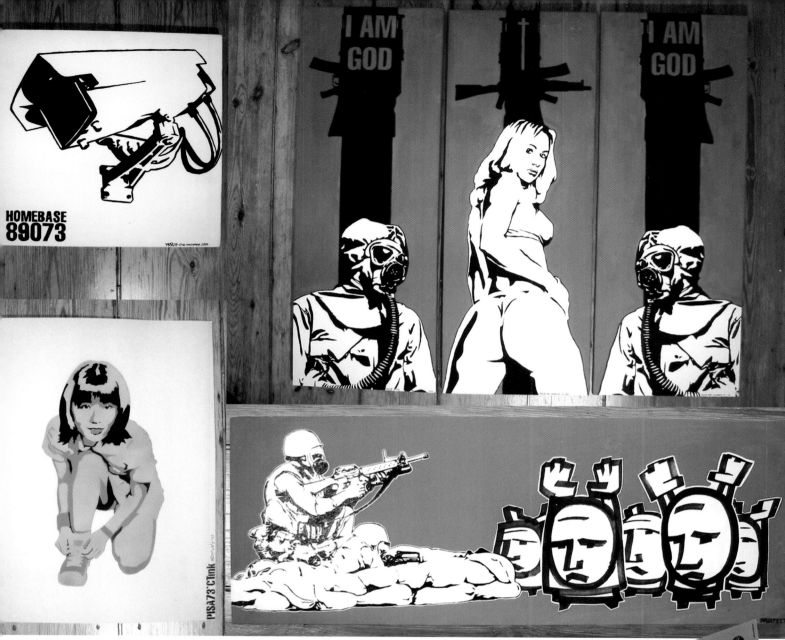

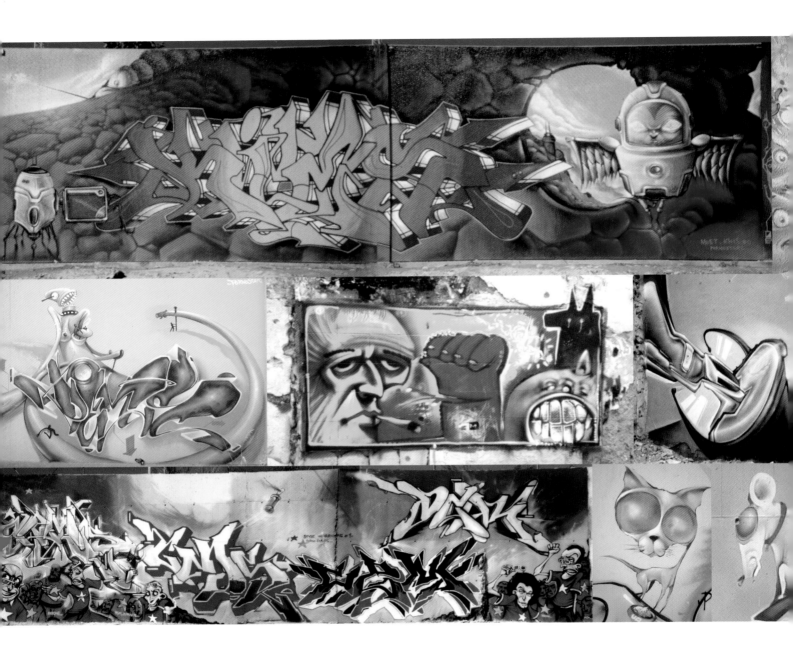

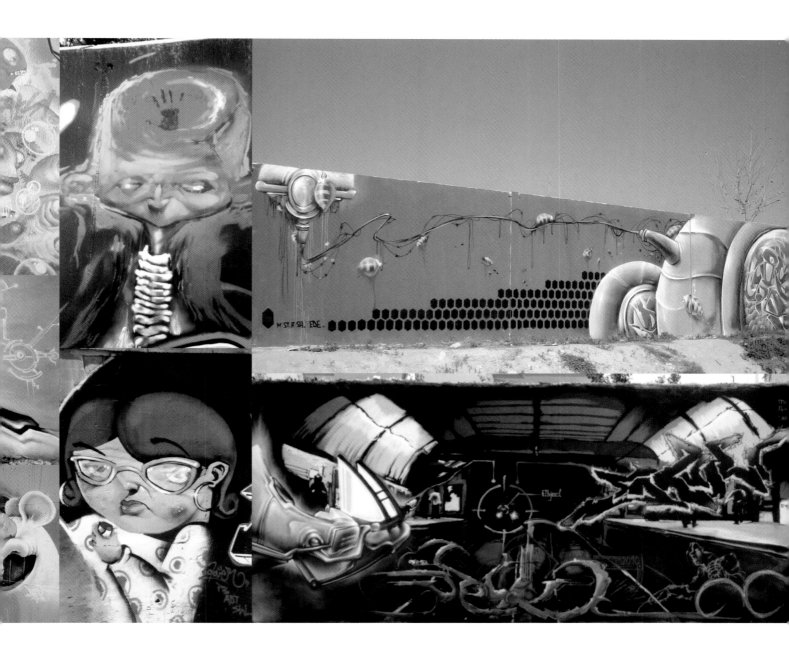

The Pornostars crew is based in Spain, and its pictures can be seen in towns such as Elche, Alicante or Granada. The crew contains a number of independent artists, and each brings many different elements to the joint productions, such as Most's 3Ds. Recently, new members have tended to have a straightforward comic style.

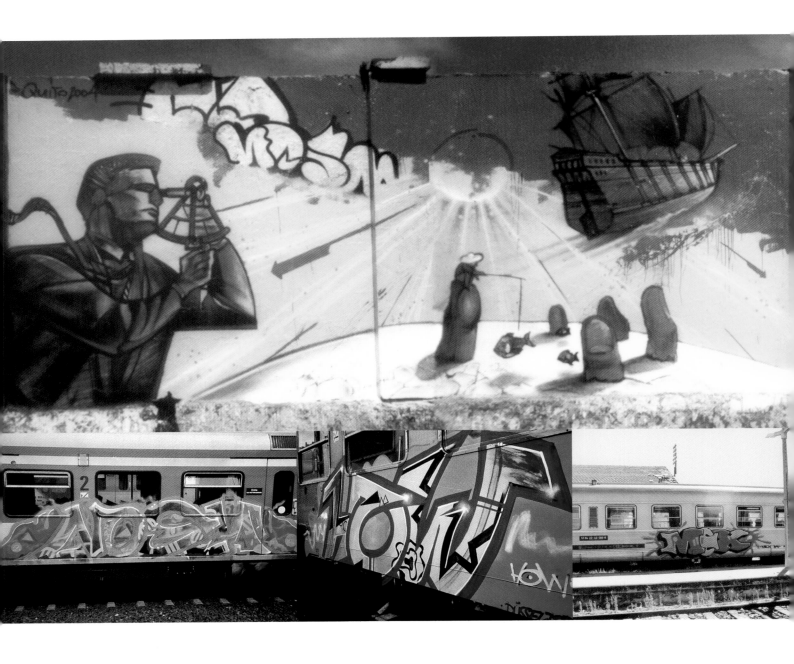

RAL CREW

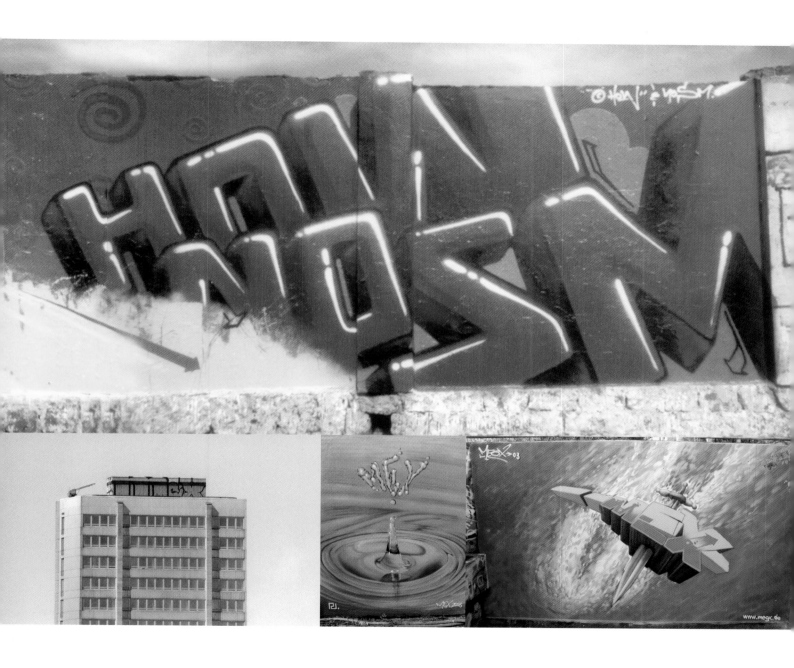

The RAL crew was started up by German artists How and Nosm, but also includes Megx. It was through their enthusiasm for skateboarding that How and Nosm first became aware of graffiti, and they soon began to tag for themselves. The members of the crew do not limit themselves to any particular style, but they do try to find different ways to write their names, combining them in carefully planned compositions.

'Today, the RAL crew is a fusion of good friends,' says Nosm. 'We are a family, and for me that's the most important thing. That's the only way a crew can continue to exist for any length of time.' How and Nosm now live in New York and work together with the TATS CRU. They have been able to earn a living with their art, and have travelled all over the world, gathering vital experience along the way. Megx now lives with his family near Wuppertal and works as a freelance artist.

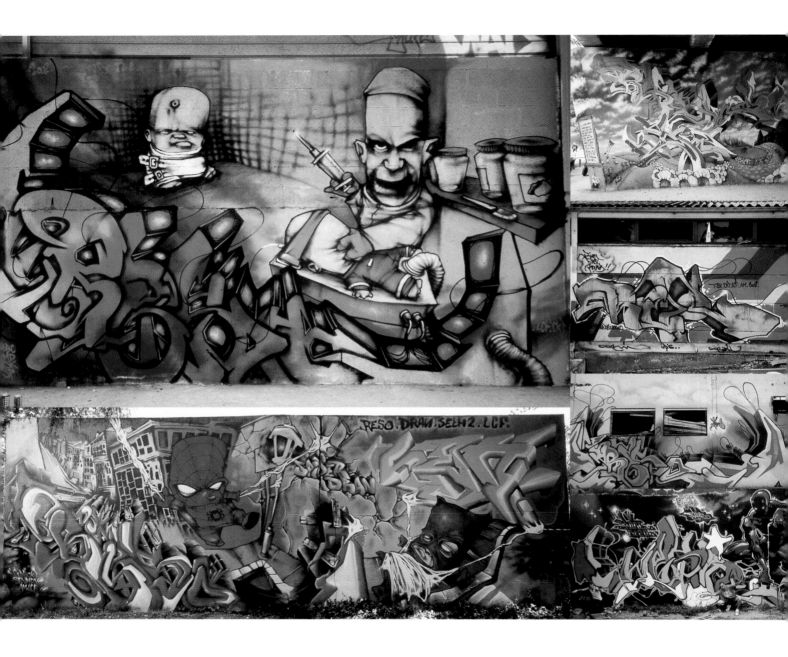

RESO 2

Reso 2 represents the multifaceted scene in Toulouse, and his style is particularly striking – a mixture of 3D and outlines. Together with local crews, he produces large-scale works, often using the many empty houses in the city which provide a perfect surface for his pictures.

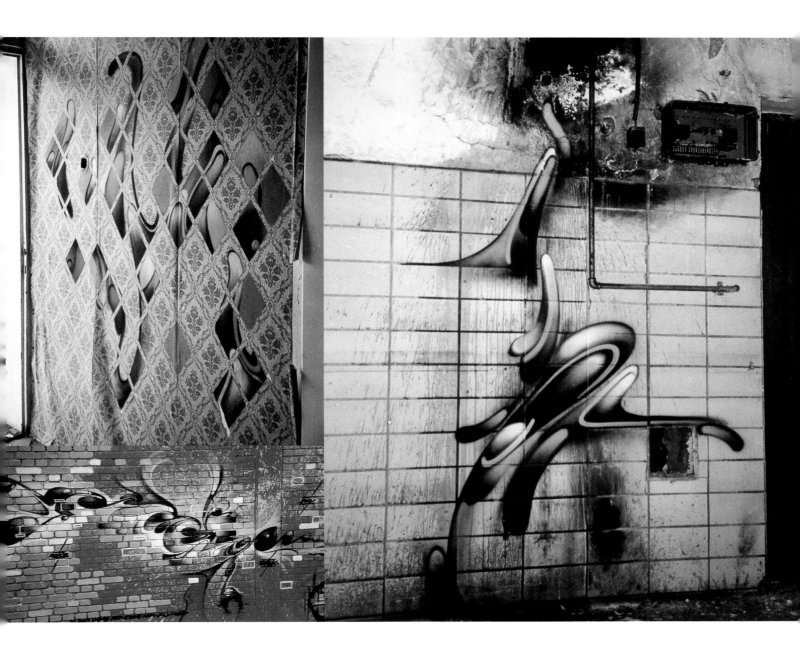

ROK 2

Austrian artist Rok 2 first noticed graffiti on a trip to Prague. The city's tags and pieces really impressed him and, at the time, there was hardly anything to match them in Innsbruck. On his return, he started his first sketches and soon experimented with spray-painting a wall. Nowadays, he strives to keep his artistic orientation as free as possible and no longer works with classic letter shapes. His pictures often unite 3D and abstract elements.

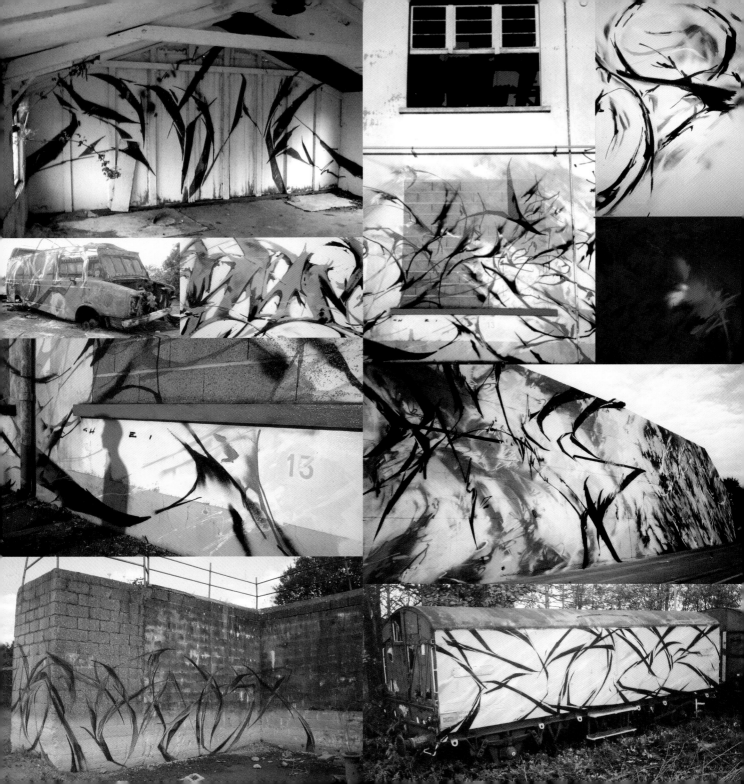

ROCKGROUP

England-based rockGroup was founded by artists She 1, Otwo and David S in 1999. She 1 is a stalwart of the English graffiti scene who has devised a very individual and original form of lettering and distortion. His pictures are abstract compositions with intense colours and shattered letters. Otwo has been drawing since he was little, but only started to get into graffiti in the early 1990s. He likes to communicate

with the passer-by through his pictures and installations, and is keen to shape the urban landscape in a creative way. 'Giving a meaning or a message to an otherwise dead space is both a challenge and a reward,' he says. 'It pushes an artist to change and develop his work constantly.' Together the members of the rockGroup paint murals around the world, and their canvases have gained international recognition

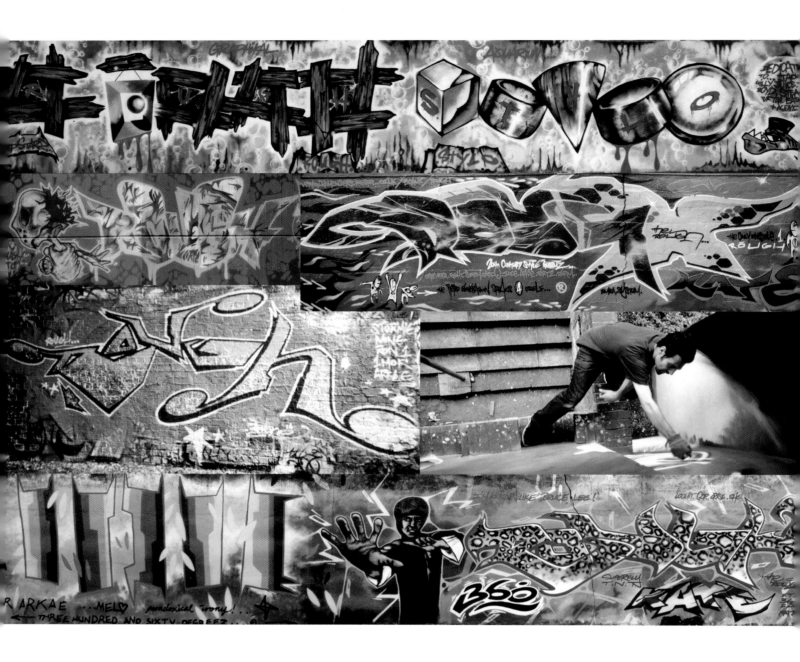

ROUGH

Rough is from London and got into graffiti in 1985. He works as a professional graphic designer and has developed his own lively style from his graffiti experiences – endeavouring to bring design and graffiti into a harmonious union. Describing his style as post-graffiti lettering and two-dimensional 3D, he prefers to work in black and white or with minimal colour.

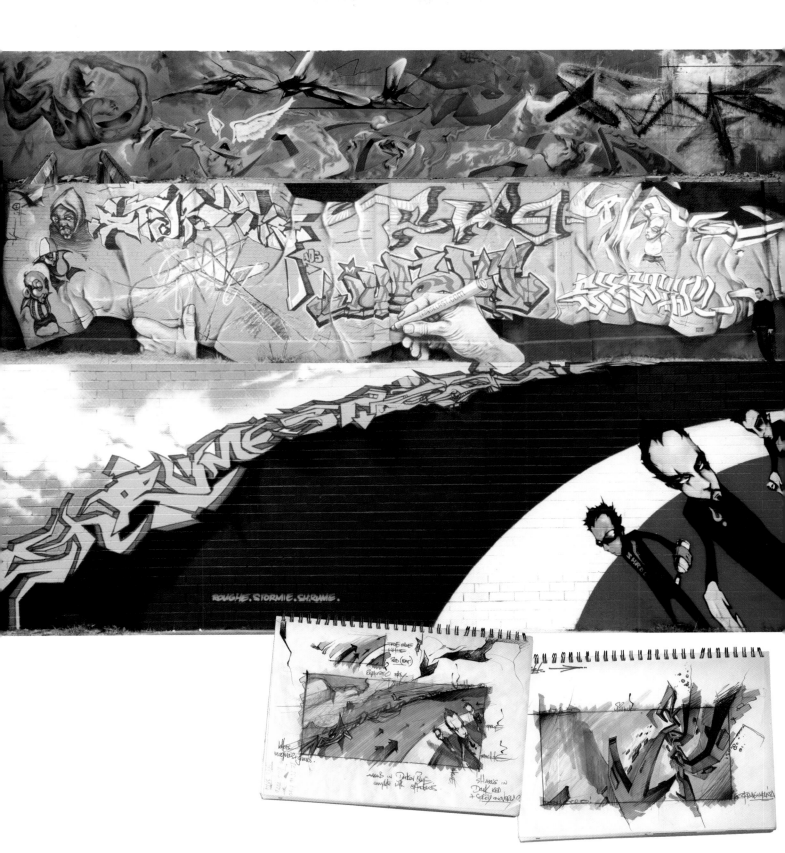

ROUGHE . STORMIE . SHRUME .

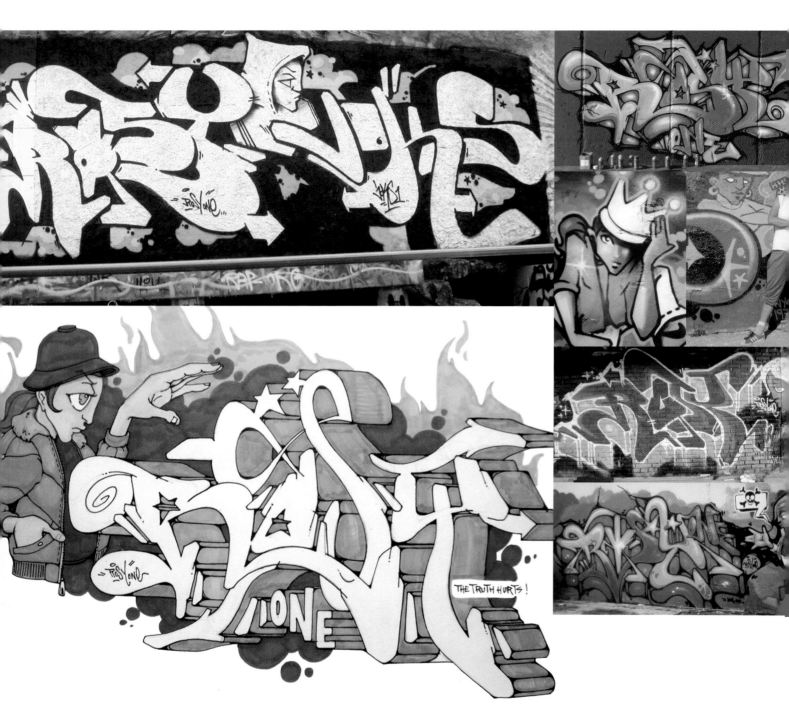

ROSY

Rosy is from Biel, Switzerland, and was inspired by Bboy characters. She works out the characters on walls or in drawings in her blackbook.

RUS CREW

Moscow's graffiti culture has developed a great deal over the years. RUS crew, which includes Komar, Chub (also known as Pustam) and Dudka, pioneered the graffiti scene in the 1990s but has changed its style completely since those early days. Their works alter the urban landscape through figures that play with the architecture and facades. Other activities include designing comic strips and poster advertisements.

269

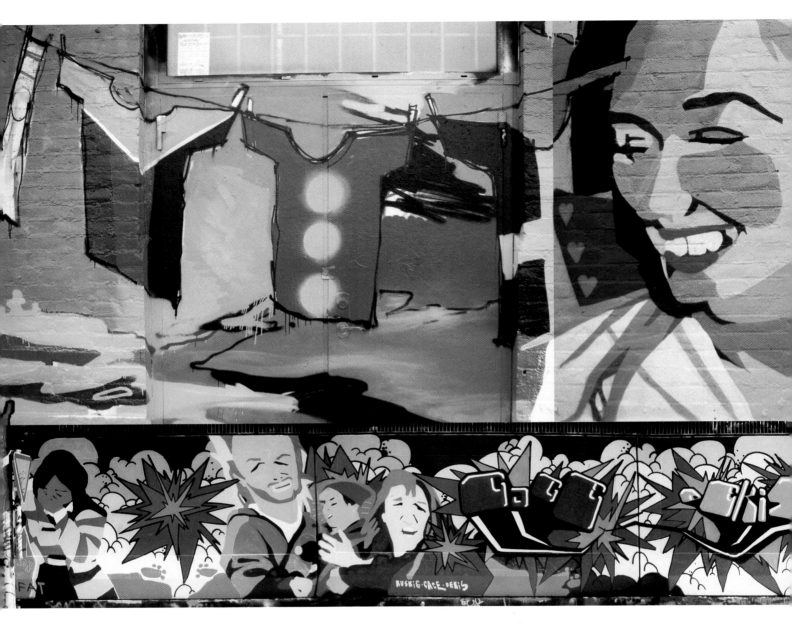

RUSKIG

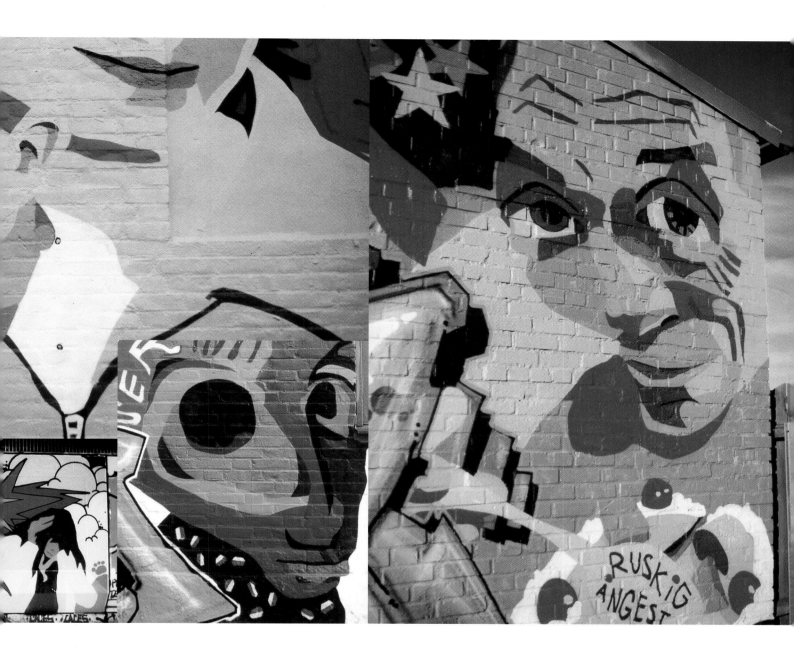

An interesting representative of the individual graffiti culture in northern Europe is Ruskig, who is from Sweden – which is renowned for its creative letter styles. His pictures are crafted onto the wall or canvas and resemble pop art through their conflicting use of colours.

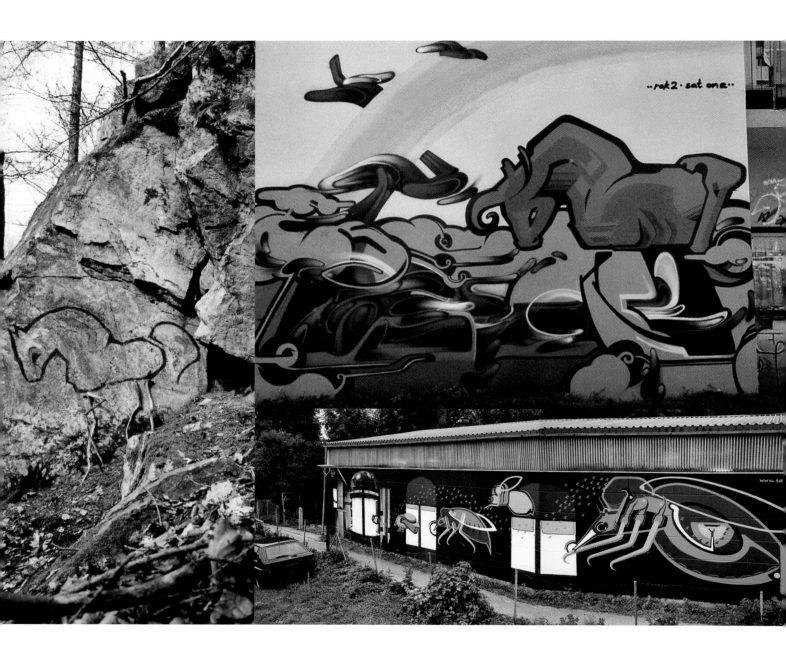

..rak2 · sat one..

www.sa

Sat 1 lives in Munich and began spray-painting in 1993. He is well known for his abstract pictures, which quite often tackle political or personal subjects, and sometimes joins up with prolific fellow graffiti artist Loomit: 'It's very important to keep repetition to the minimum, to make given forms abstract and to redefine them within a new frame. You can see when a personal statement hits the mark, or when your mood is reflected in the picture, or the end product has surpassed your original ideas. With a political statement, you have to be careful not to make the hint too general or too obvious and banal…. I find hidden or thoroughly sarcastic statements more exciting.'

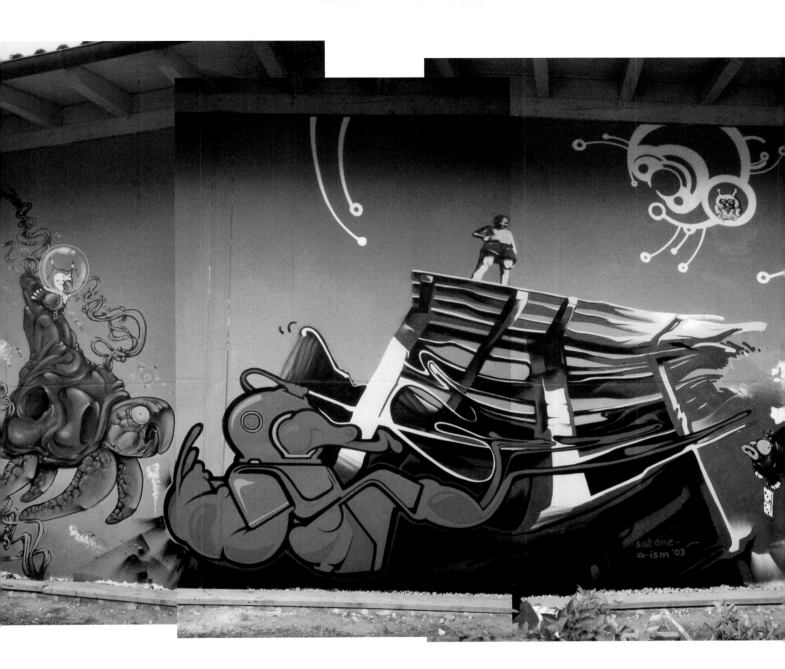

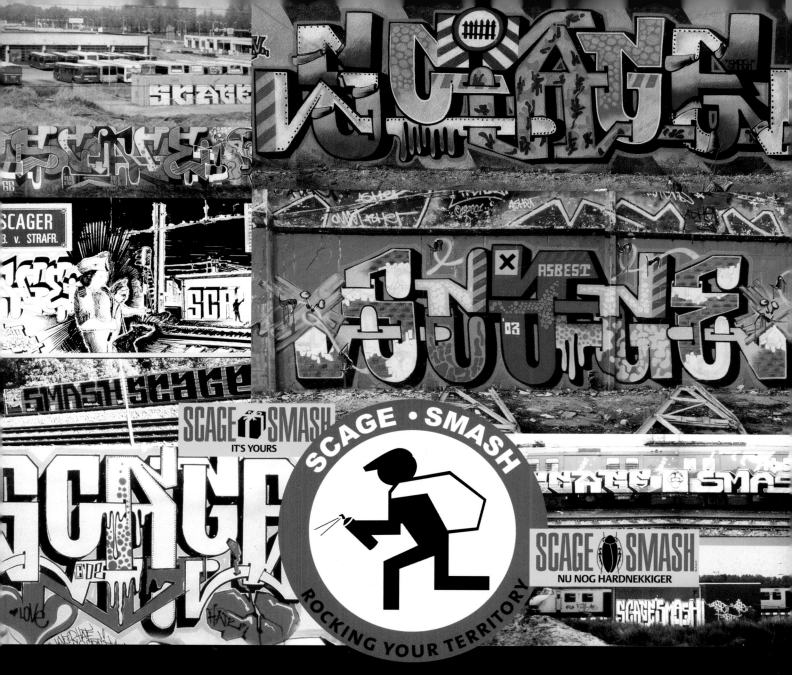

'Droid-like' is how prolific Dutch artist Scage prefers to
describe his style. The term refers to his stiff and lifeless
letters which, according to the artist, have no flow.

SCAGE 275

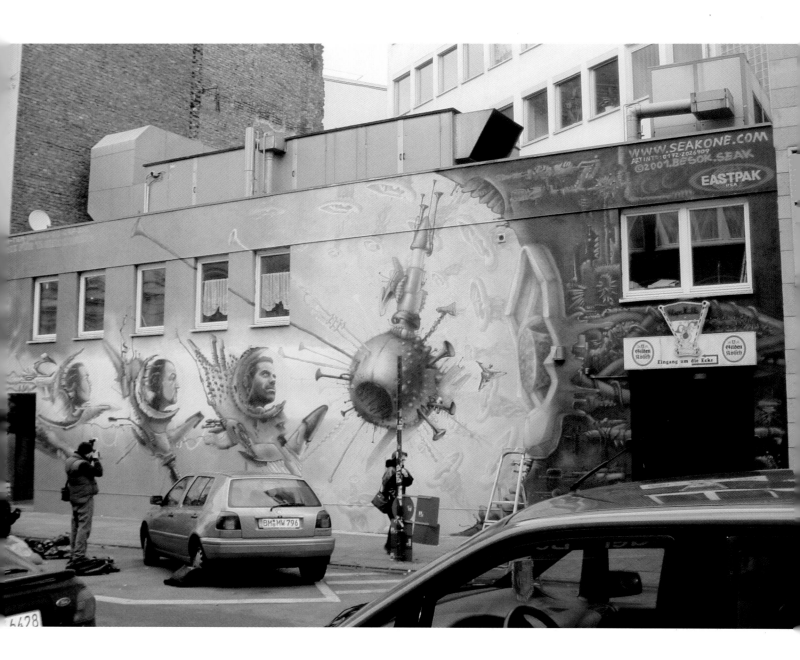

276 SEAK

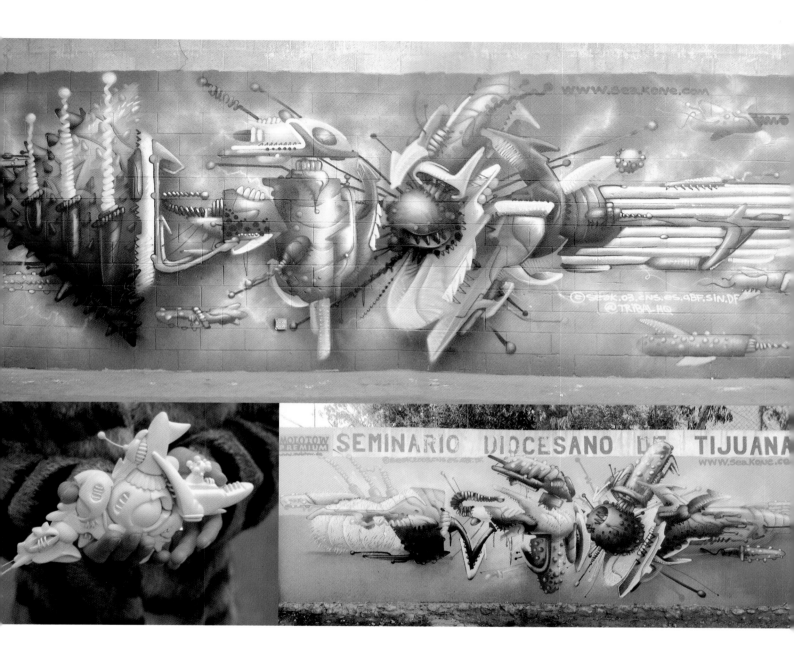

German-born Seak is a perfectionist, and his relationship with graffiti is definitely a love–hate affair. In 1984 he saw some pieces – a bombed wall with a spider and a robot with letters – by local pioneer King Pin that made a lasting impression on him, but it was not until 1992 that he began creating his own murals. Initially he made flat letters, but soon he started to develop his own 3D style with light effects.

Often he gets so into his work that he unintentionally destroys the structure of his letters, which have been likened to organic or biomechanical spacecraft. 'It's important for me that the letters are not "weak" and can stand up for themselves,' he explains. 'In other words, they must assert themselves against other styles, especially when they stand next to one another....'

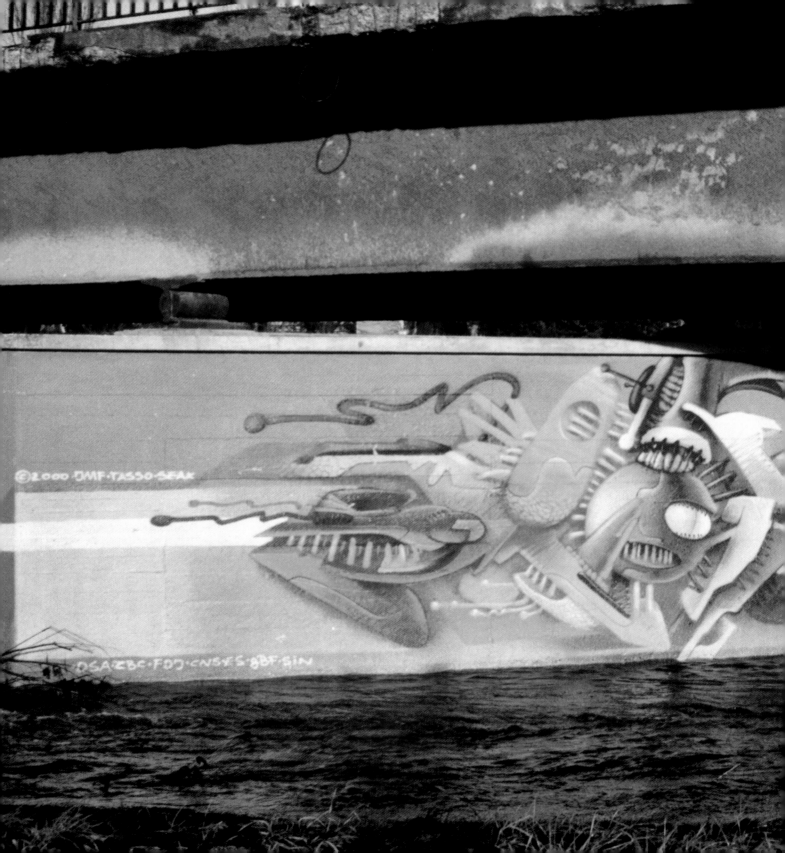

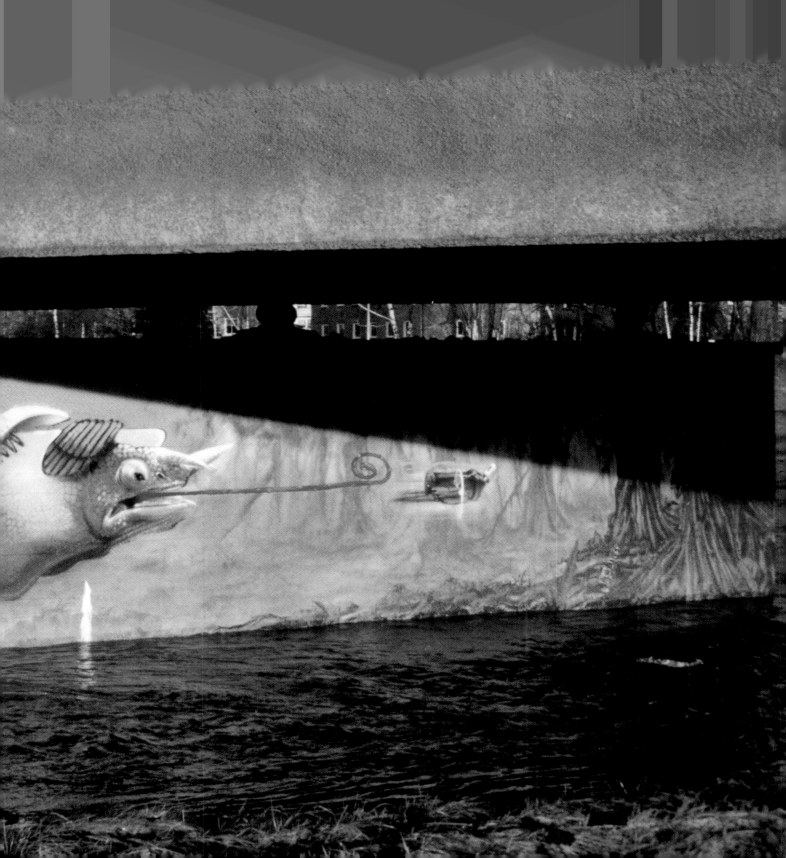

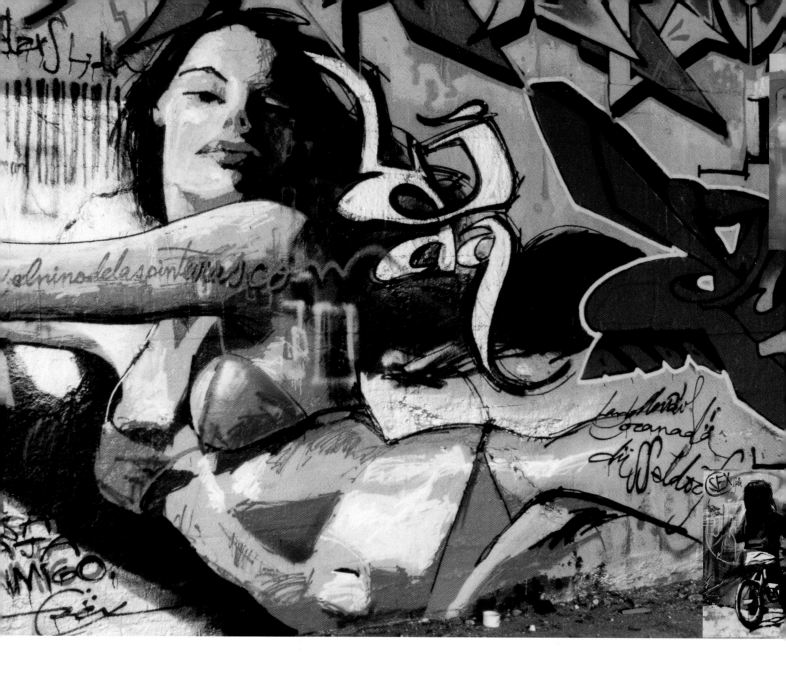

280 SEX

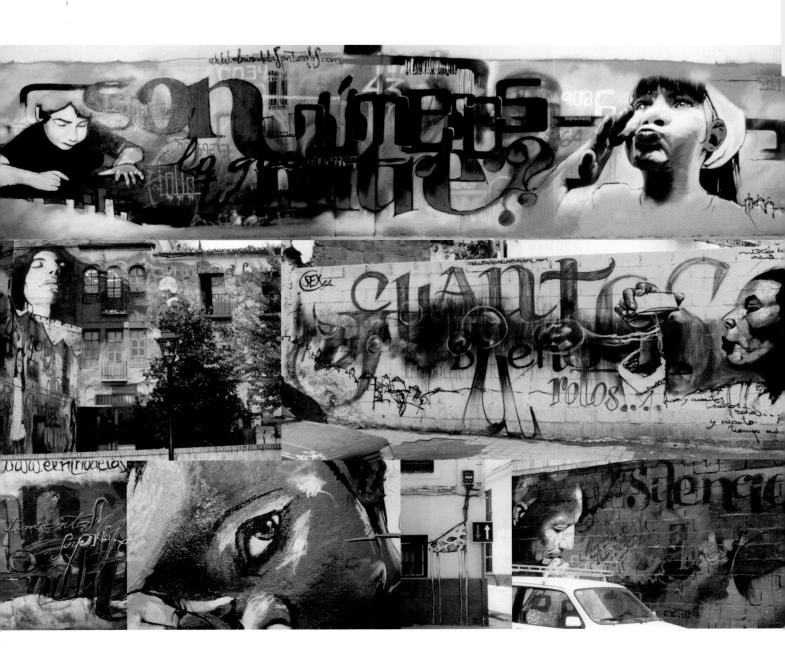

Spanish artist Sex comes from Granada. His pictures, spray-painted with thin strokes and shades, look like sketches. He is particularly admired for his striking figures – realistic portraits, often featuring words, in colourful, eye-catching collages.

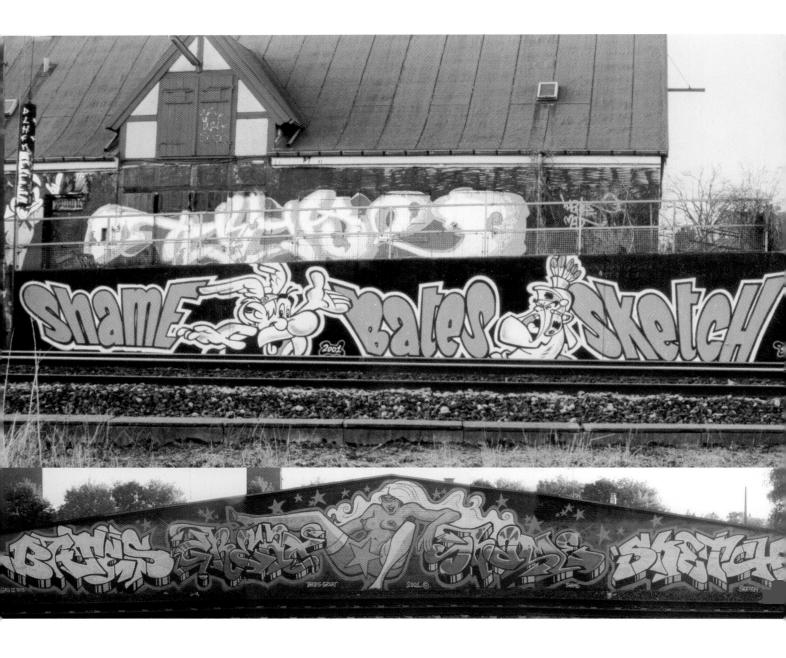

SHAME & SKETZH

Shame and Sketzh (also known as Sketch) are two early Danish writers. Sketzh got started in 1984 as a teenager, together with other graffiti pioneers like Kyle, Freez, Dimmer, Cres 1, Reakes and Zenith. *Beat Street* and *Wild Style* were sources of inspiration, helping him to develop his typical Danish old-school style, which he has refined over the years.

Before settling down in Copenhagen, his first few years were hectic. The last four years have seen him spray-painting with his old partner Shame and hanging out almost exclusively with artists from the early days: 'I never paint with new-school artists. Perhaps because I don't know any…! For me, graffiti is an old-school thing, and the platform from that time still exists today. I do the same thing now as I did in the 1980s.'

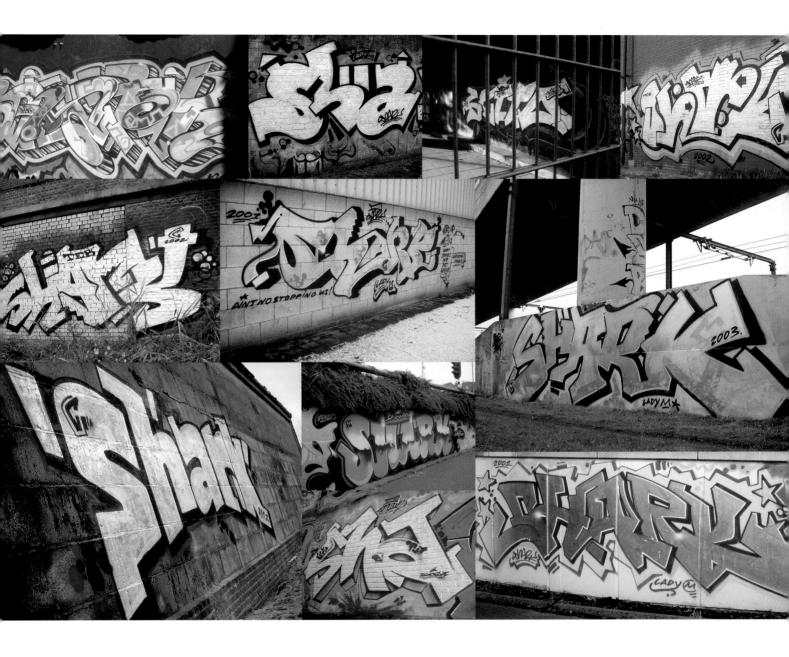

SHARK

Shark is an early representative of the Dutch graffiti movement and has been spray-painting pieces since 1985. Although he turned to sketching, he has since returned to the graffiti scene. His work is traditional in style, and he frequently uses a computer to create his pictures: 'I've tried combined techniques, like acrylic paint with markers and a bit of aerosol on canvas. I liked it, but it's not graffiti to me any more. Over the last couple of years, I've drawn a lot of my sketches digitally. It's another way of doing it but it's faster to develop and ready for our website straight away.'

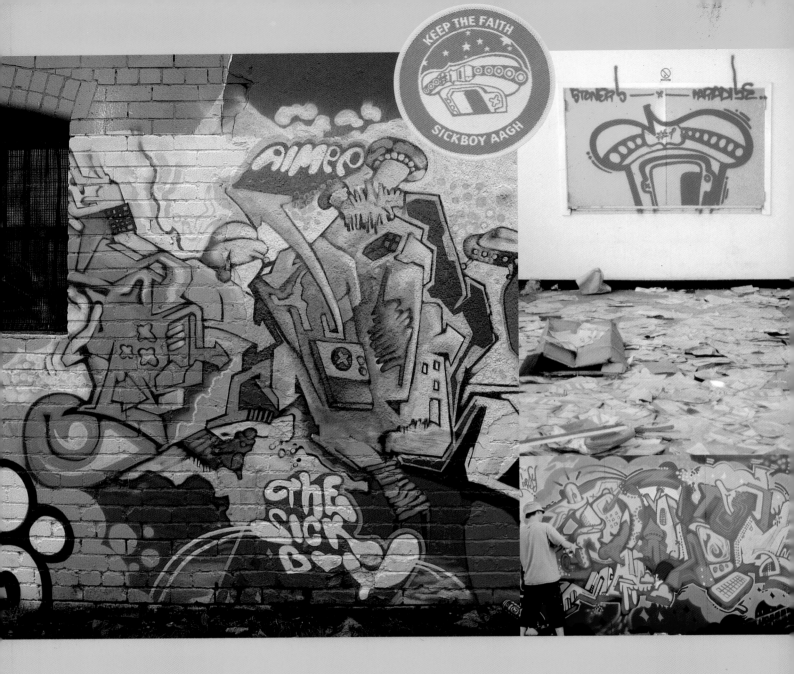

SICKBOY

Bristol-based Sickboy started off doing regular graffiti. His red-and-yellow temple logo, with organic shapes and freehand lines, has been appearing on rubbish bins and walls since the beginning of 2000. Now he is taking his art one step further and experimenting with new mediums, such as the reflective surfaces of demijohns.

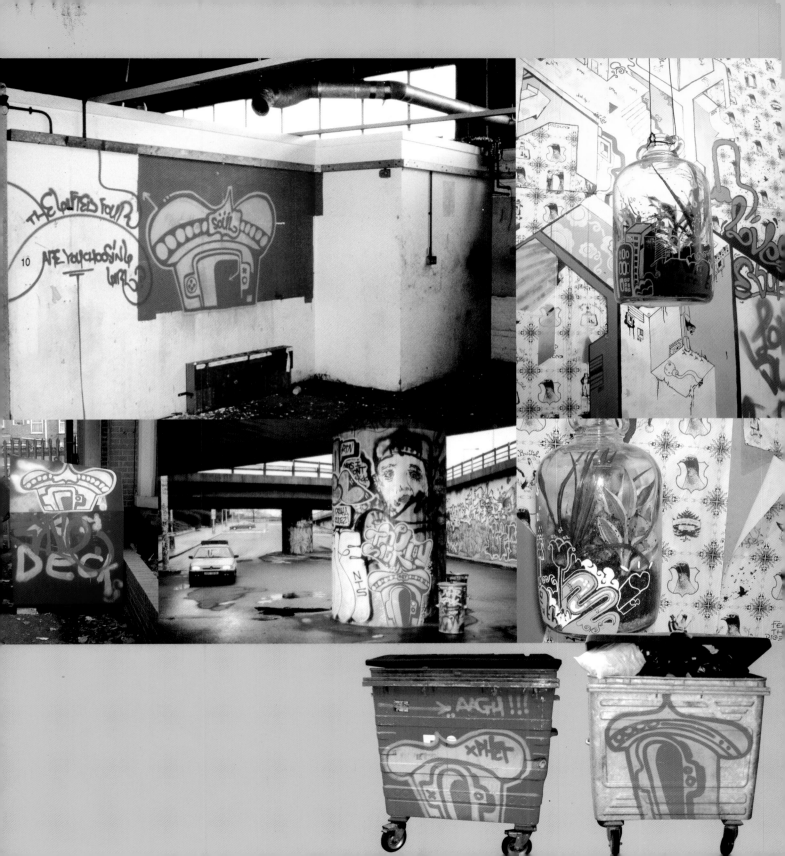

Signs of Life is a group of graffiti artists from Eindhoven in the Netherlands. Member Zime, who has an intricate, geometrical style of graffiti, first became aware of street art when the anti-graffiti squad, HALT, came to talk to pupils at his school. The crew has brought together various fantasy artists, who spray-paint their work on the streets and also create sticker collages. Fellow crew member Erosie tends to spray-paint bicycles and says: 'The crew stands for very different points of view on graffiti and our styles, but we seem to have a very constructive combination. Everybody tries to be progressive in their own style, so altogether it works out well….'

SOL CREW

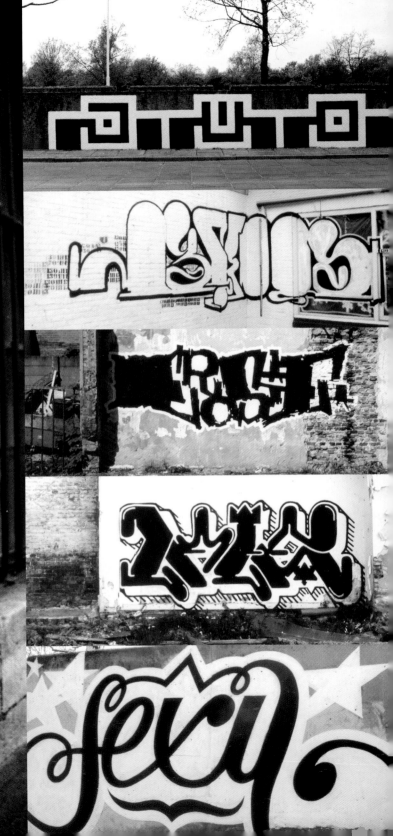

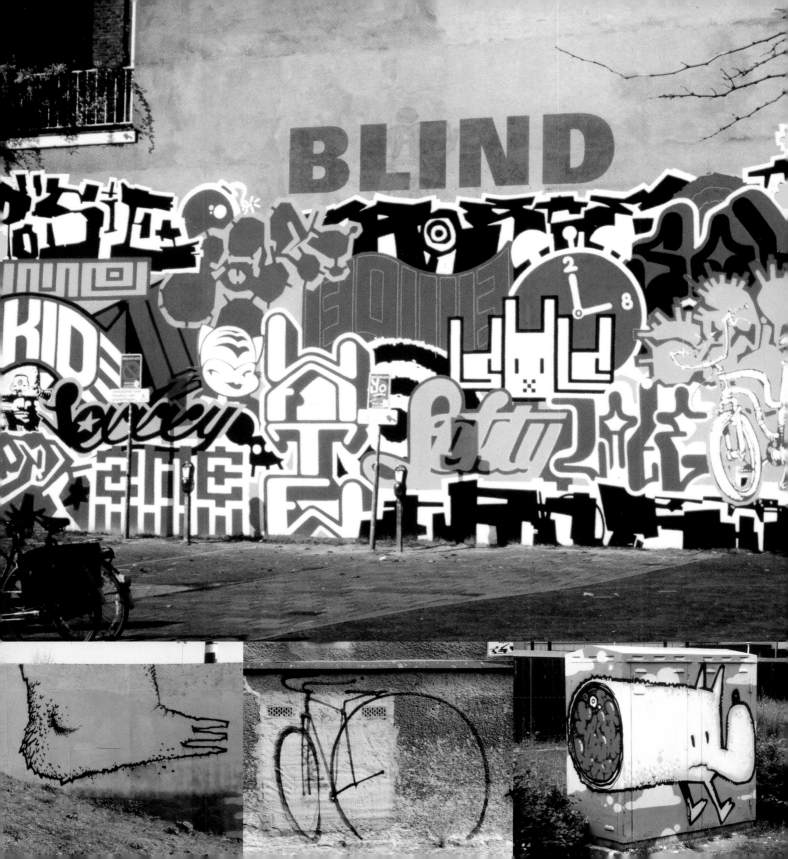

SP CREW

SP, or Serial Painterz, is a Paris-based crew, which was founded by Boher in 1997. Together, its members from Paris and further afield paint huge murals and travel the world. Some of the crew's artists also publish hip-hop magazine *Graff It!*

288

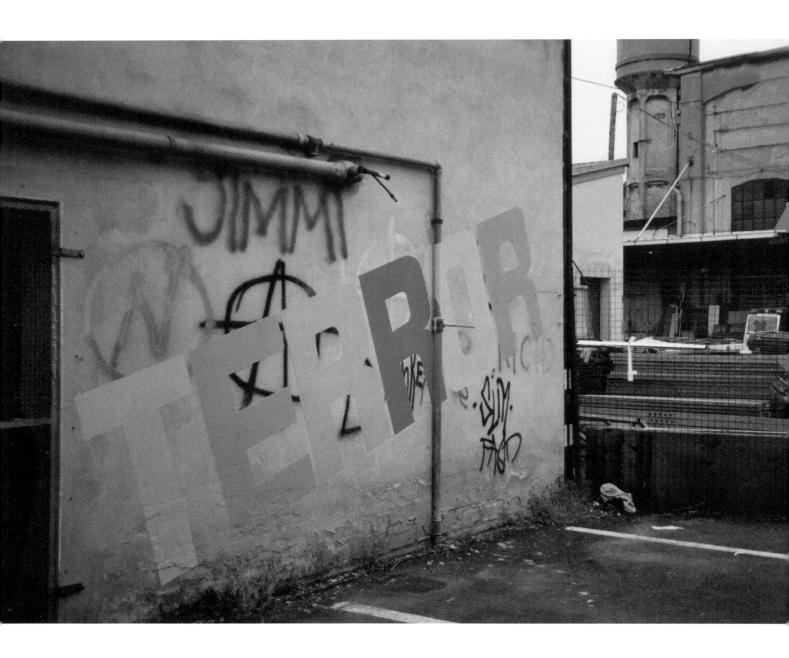

290 STAK

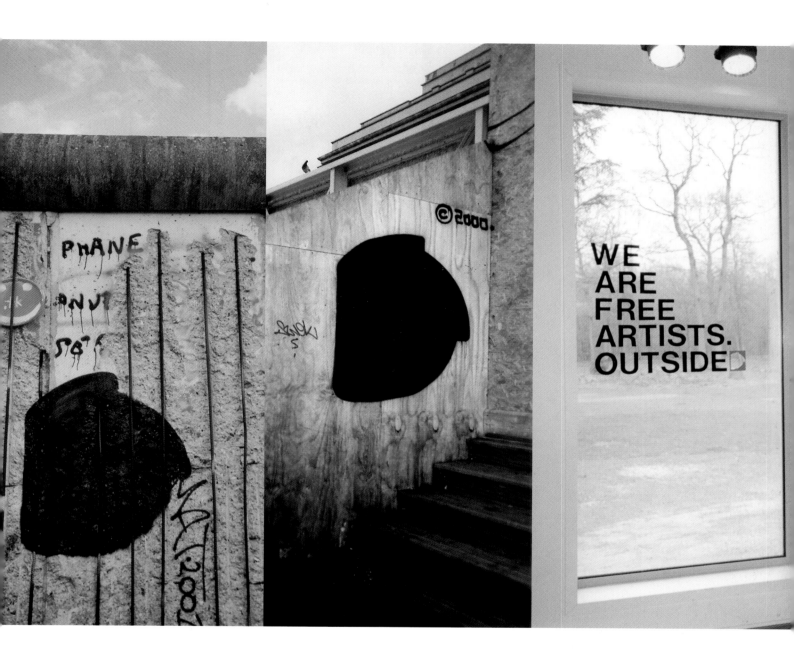

Stak is one of the best-known post-graffiti artists. From 1987, his work consisted of strictly classical graffiti pieces but in 1995, as he tried to think of a way to stand out from the thousands of tags across Paris, he came up with a logo. Encompassing stickers, texts and murals, his work is a form of wild advertising on the street through which he tries to analyse the relationship between the street, the art world, fashion and the media. Stak now works increasingly in

galleries and loves the idea of putting elements from popular culture in art spaces, as if they were masterpieces.

His *Terror* works feature flamboyant colours and are linked to the 'Gabber' musical movement, a high-speed techno that originated in Rotterdam. Gabbers like to use words such as 'terror', 'nightmare' and 'darkness' to highlight the paradoxical nature of the music, which combines deep, dark elements and partying. In 2003, he also launched *World Signs* magazine.

291

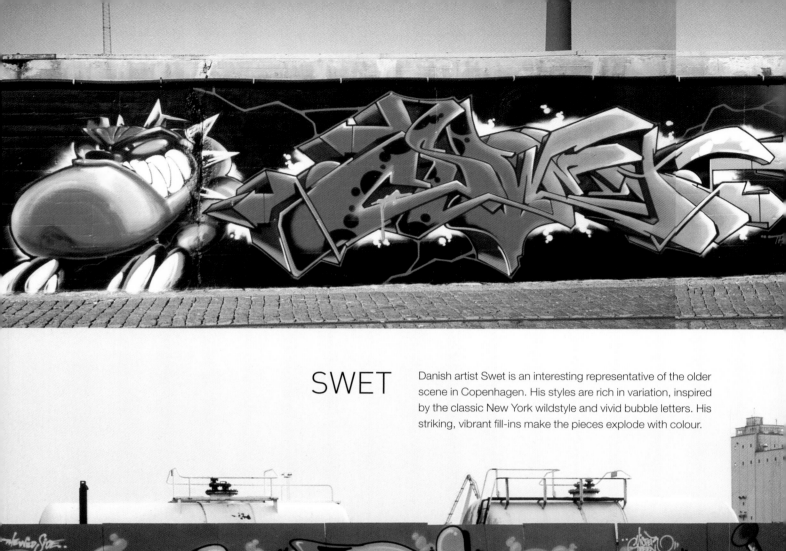

SWET

Danish artist Swet is an interesting representative of the older scene in Copenhagen. His styles are rich in variation, inspired by the classic New York wildstyle and vivid bubble letters. His striking, vibrant fill-ins make the pieces explode with colour.

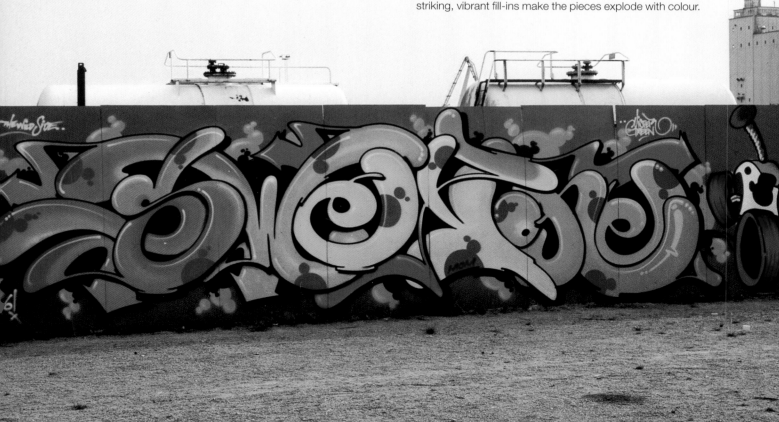

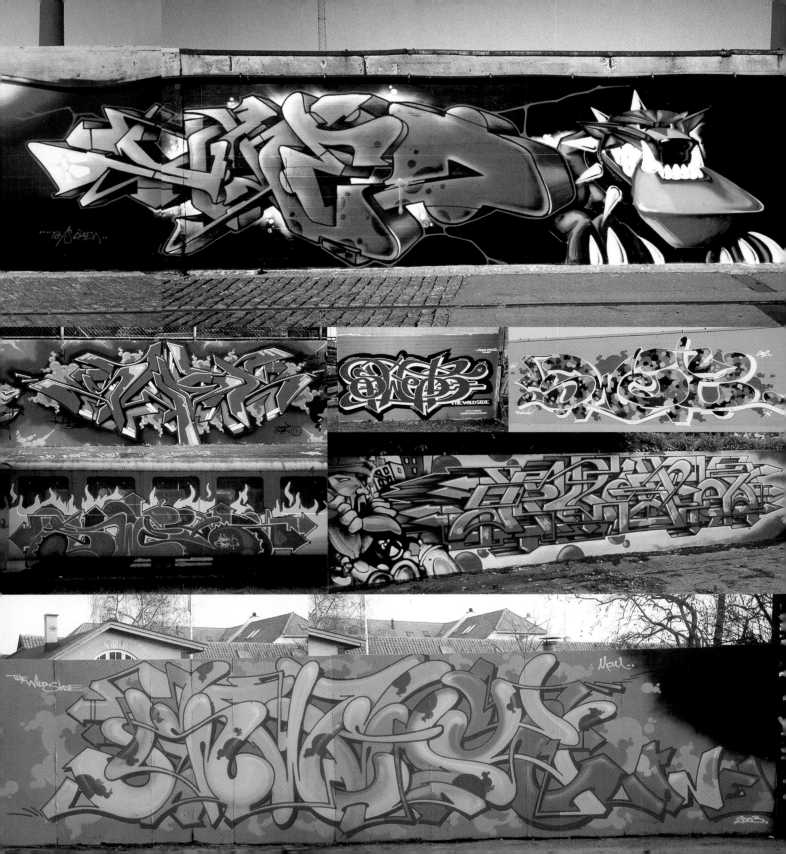

TASEK

A member of the Getting-Up Studio, Tasek started spray-painting around his home town of Hamburg in 1987 and creates figures that are influenced by Mode 2's interplay of colours. In many of his canvases he documents urban space, setting its many facets against a linear background, and reducing and abstracting it to its basic principles.

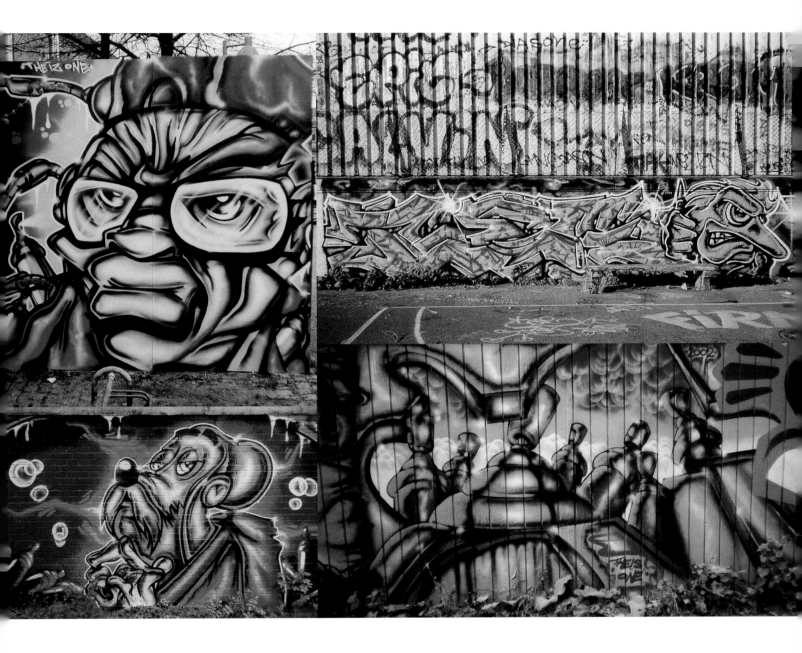

THEIS

Danish artist Theis started to spray-paint graffiti in 1989, although he has since taken breaks at various points in his career. His work focuses on characters, which often have a personal background, and he has developed his own high-quality comic style. These days, he also gets commissioned by shops and companies – keeping it very much legal!

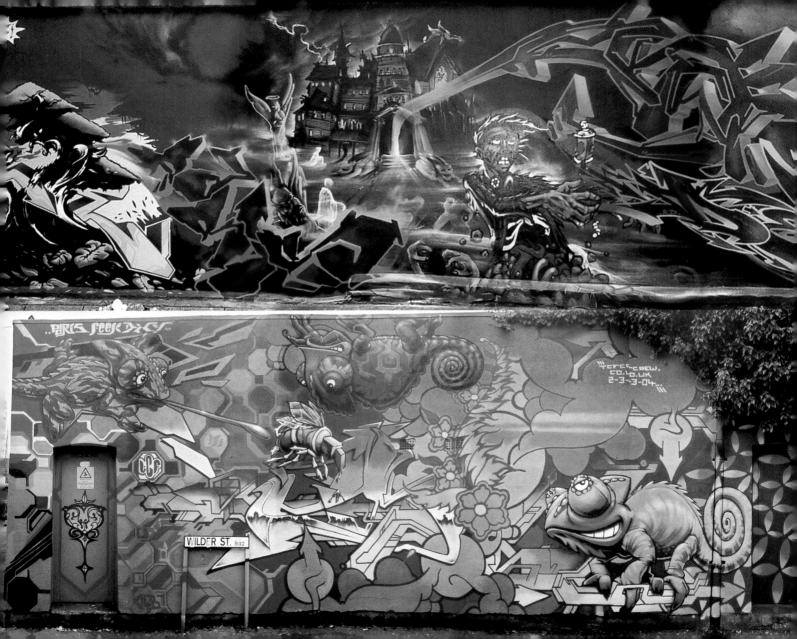

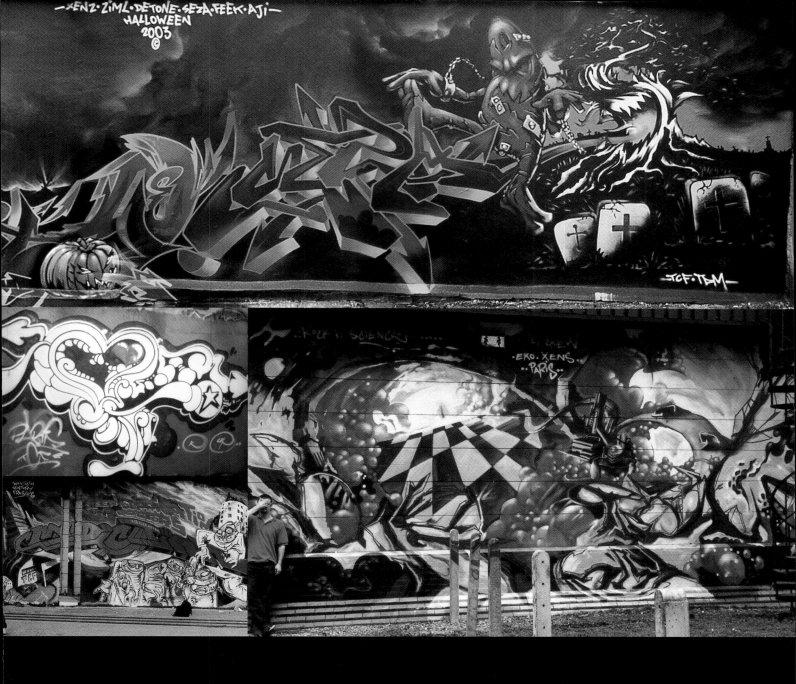

Twentieth Century Frescoes (TCF) formed in Hull in 1994. Originally consisting of three members – Xenz, Paris and Ekoe – the crew is now ten strong. Painting mainly in Bristol, its members have more recently been venturing further afield. In 2003, they united with the TDM family of Montpellier, France, and also took part in the 'Meeting of Styles' events

across mainland Europe. The dynamics of each individual's styles always result in unique combinations whenever they paint together. Moving within every sphere of the current scene, TCF's future aims include connecting with writers and crews all over the world and continuing to develop new fresh approaches to painting.

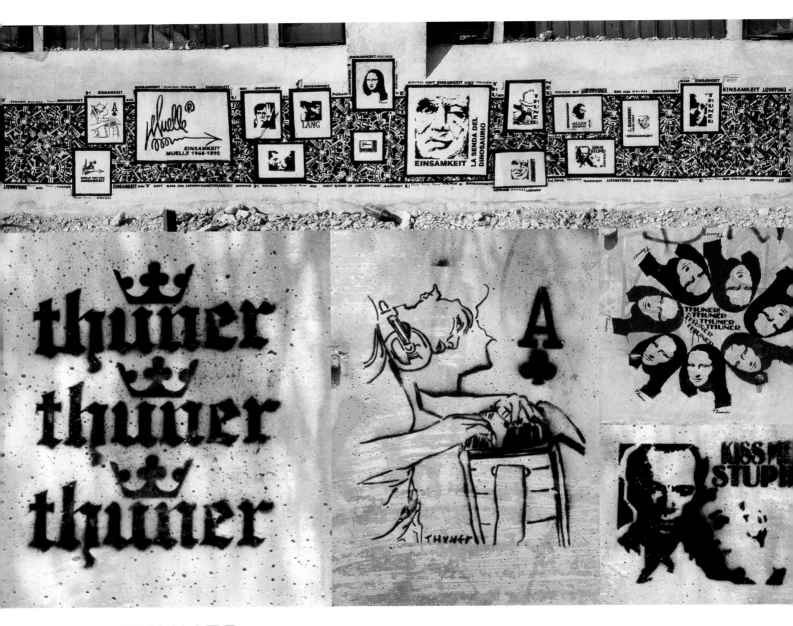

THUNER

Madrid-based stencil graffiti artist Thuner has been painting since 1989 and has collected together photographs of a lot of the city's graffiti in his book, *Madrid Graffiti: 1982–1995*. However, he did not take up stencil graffiti until around 2002 after he was inspired by Dr. Hofmann, one of Madrid's first stencil artists. Now stencils are his preferred medium. He particularly likes to be able to repeat the design again and again, changing the colours accordingly. His stencils are very direct, often inspired by classic film stories, like *Psycho* and *Kiss Me Stupid*, or film pioneers such as Alfred Hitchcock and Fritz Lang. He gives all of his pictures a background and message: 'The essential of my artwork is the message. I always try to give the viewer something that won't leave them indifferent. Every one of my stencils has some sense inside, a message. For me, this is the best thing about using stencils: they are direct, simple and effective!'

TRUE STILO CREW

True Stilo is one of the few Belarusian crews to have established itself worldwide. Despite the country's poor economic conditions and limited availability of good cans or caps, the scene in the crew's home town of Minsk has developed considerably and brought a number of interesting and individual artists to the fore. The Belarusian scene has only existed from the late 1990s onwards and, for this reason, the crew formed quite late. Its achievements include winning a contract with Montana and organizing graffiti jams, legal walls and Halls of Fame.

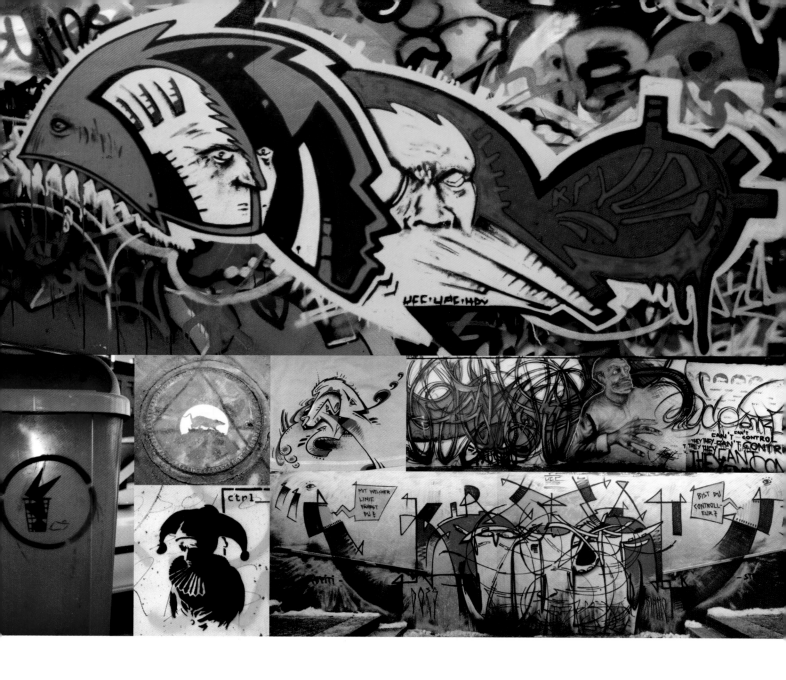

300 UCC CREW

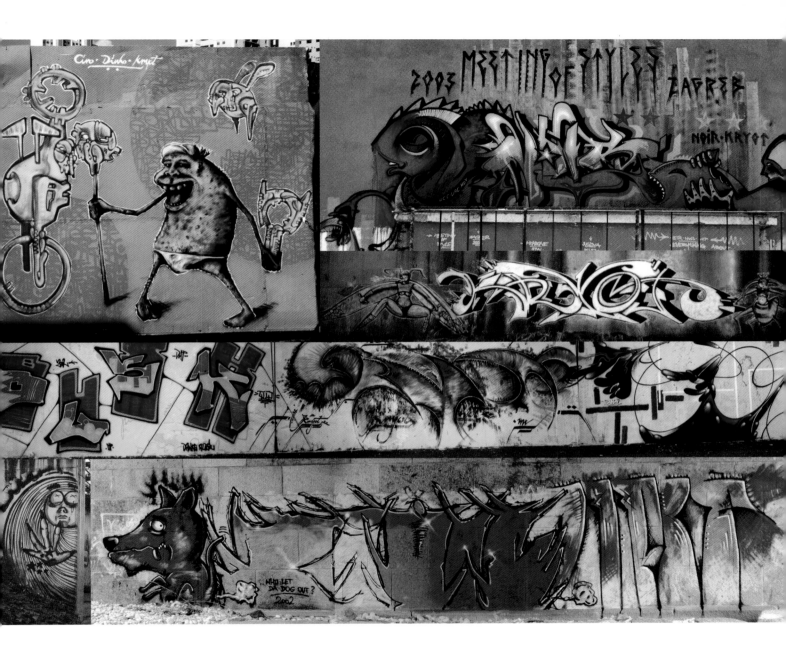

Underground Can Controllers crew from Linz in Austria was founded by Mamut and Kryot in 1999. The aim of the crew is to break free from 'traditional' graffiti and discover new forms, instead of producing the usual combination of styles and characters. The effect of the whole work is more important to them than the individual parts. Many of their new pieces and productions emerge freely, without sketches. Mamut also works on canvases, while Kryot has a diverse range of fields, including print and digital media, silk-screen printing and web design.

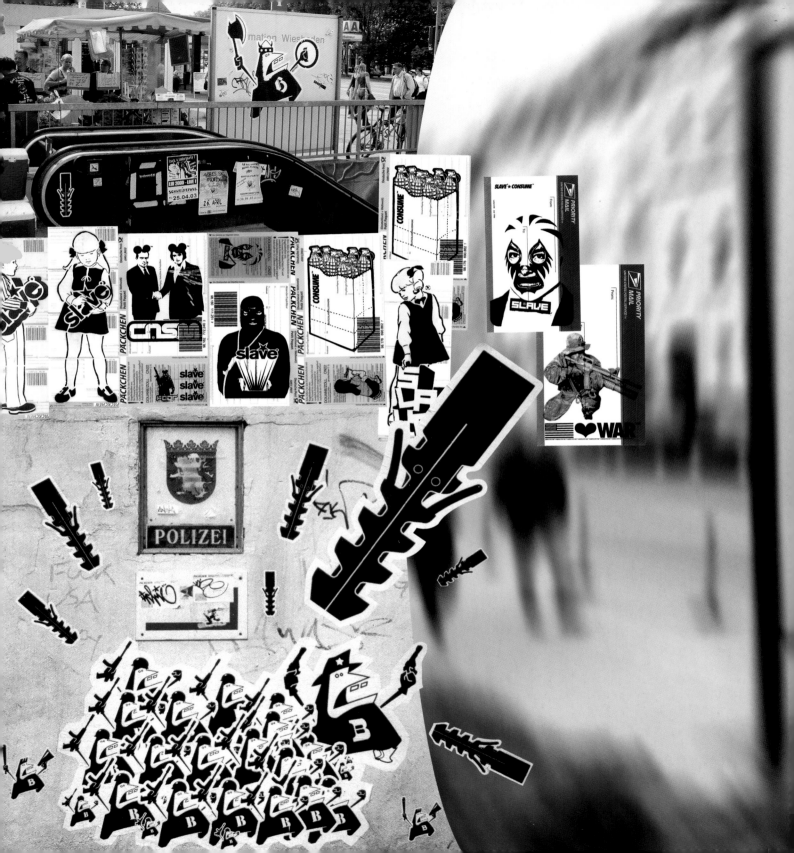

VIAGRAFIK

The designer group Viagrafik is based
in Germany and consists of four
painters and an underground artist.
Its members' work is very clear, often
produced on a computer, and their
illegal pieces are multifaceted,
sometimes in the form of advertising
campaigns or abstract letter
constructions that blend in with the
background and the architecture.

 This wide range of influences enriches
their art, and they remain open to new
ideas: 'The street as a neutral venue
gave us the chance right from the
start to work independent of rules and
models. Over time, other influences
and spheres of interest have been
added from outside the world of graffiti.
Through our work in graphic design,
for example, we learned various new
approaches to areas like composition,
and the balance of surfaces and
forms. Under the influence of the freer
language of form that you find in graphic
design, we got new ideas about how
to form letters, about irony, playing with
proportions, abstracting the original
form to the point of dissolving the letter,
transforming traditional forms and
styles through their combination with
hitherto alien elements, destruction
and construction, provocation, bold
open spaces – these are the lines
along which we work today.'

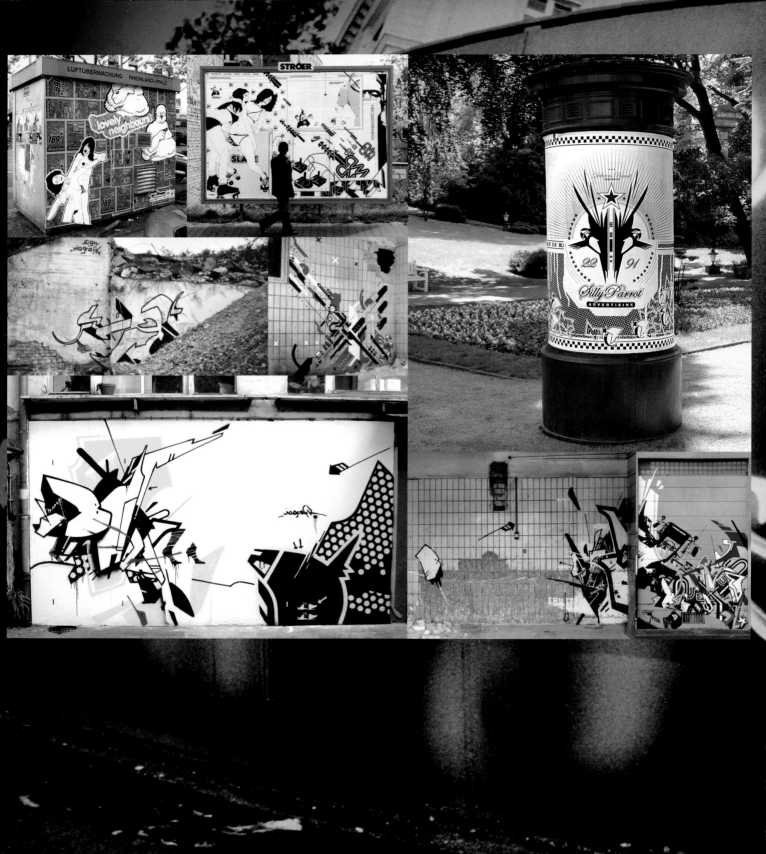

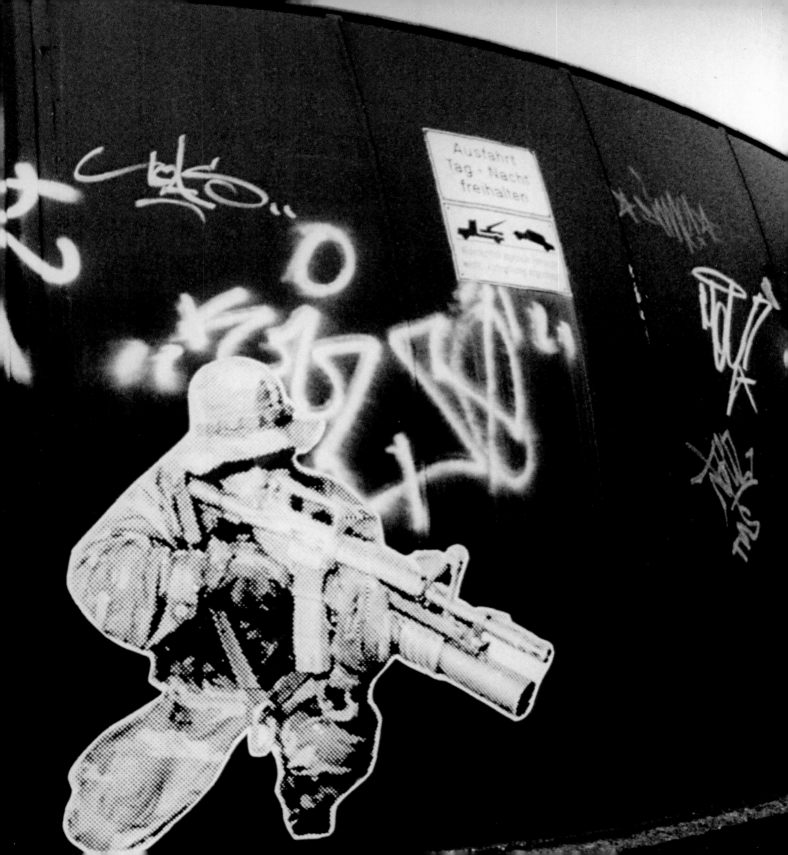

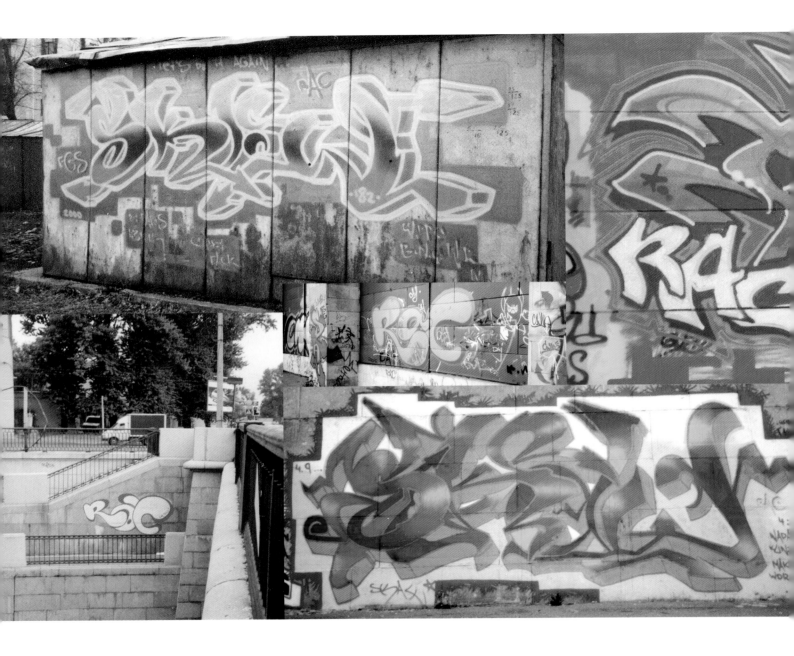

WAKS / SKAW

Waks comes from Saint Petersburg and did her first tags and bombings at the age of sixteen. In recent years, there has been an explosion of graffiti in Russia, and Waks is one of the earliest exponents in her home town. In Moscow in particular, hip-hop has become very fashionable and has fuelled a boom in graffiti. With money less of an issue in the big towns and cities, graffiti artists are able to work on various projects and Waks is no exception.

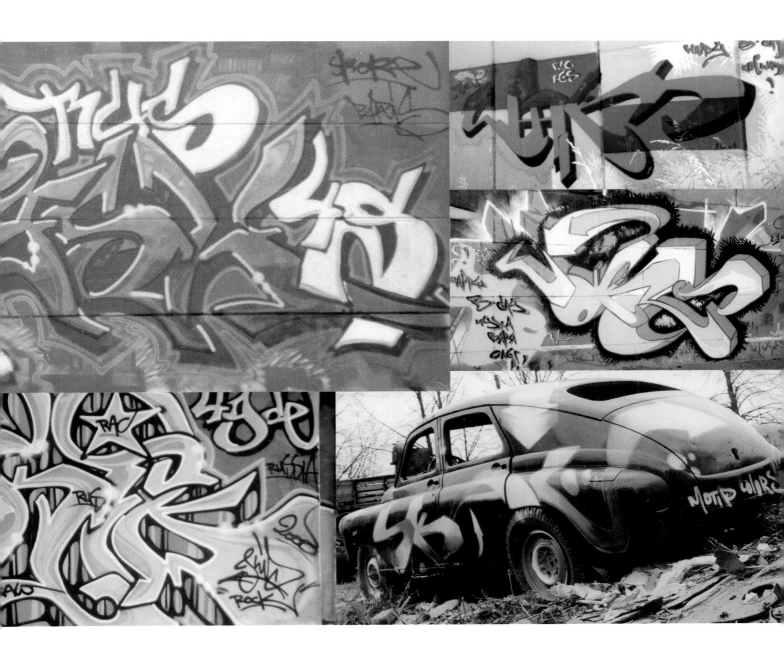

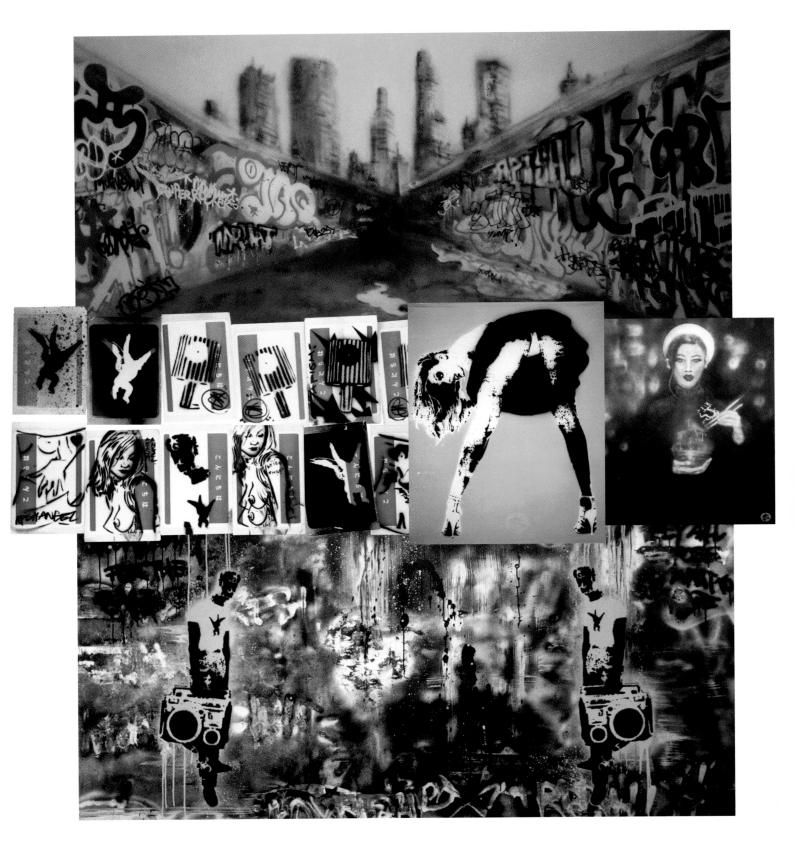

NICK WALKER

English graffiti artist Nick Walker used to spray-paint walls around Bristol in the early hours of the morning to avoid getting caught by the police. Now he works on canvas, using a combination of freehand techniques and stencils to produce dreamy and provocative pictures and achieve a photorealistic effect – so much so that, according to Walker, it is virtually impossible to tell that his pictures were created with spray-paint.

In 2002, he founded his T-shirt label, Apish Angel, and he often works on international live performances or exhibitions. He also designed graffiti for the films *Judge Dredd* and Stanley Kubrick's *Eyes Wide Shut*.

WALLDESIGN

The Walldesign Studio consists of two parties – Slobodan (Dizel) and Thomas (Sate) – who took up graffiti in around 1990 and teamed up to form a professional studio for the design of facades and computer design under the slogan 'We declare war against white walls'. Both started off as regular graffiti writers, painting trains and walls. After

working on the street, they spray-painted more large murals and founded a graffiti school in Norrköping (Sweden) in 1994. They were influenced by design and fashion, coupled with a desire to try out new things. The walls they design now have a clear, simple composition and place a great deal of emphasis on colour choice.

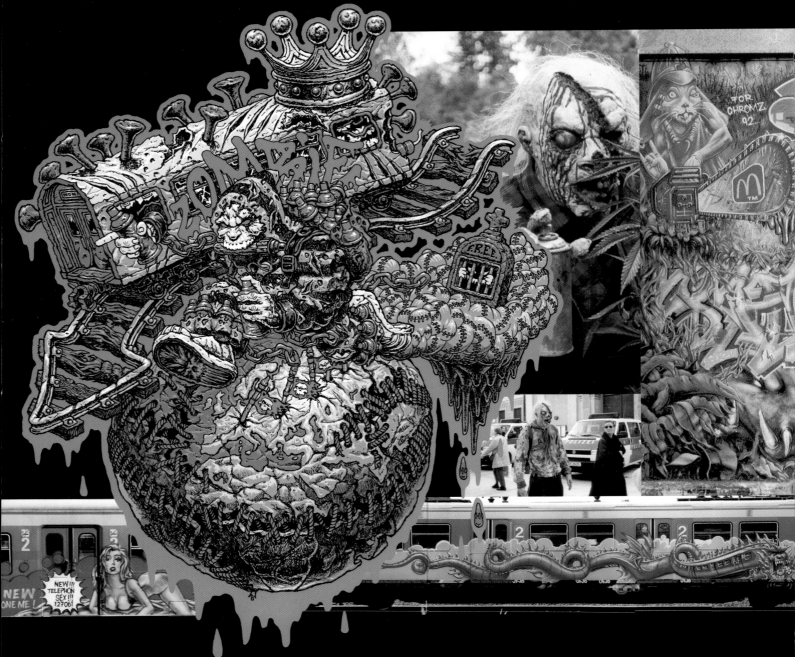

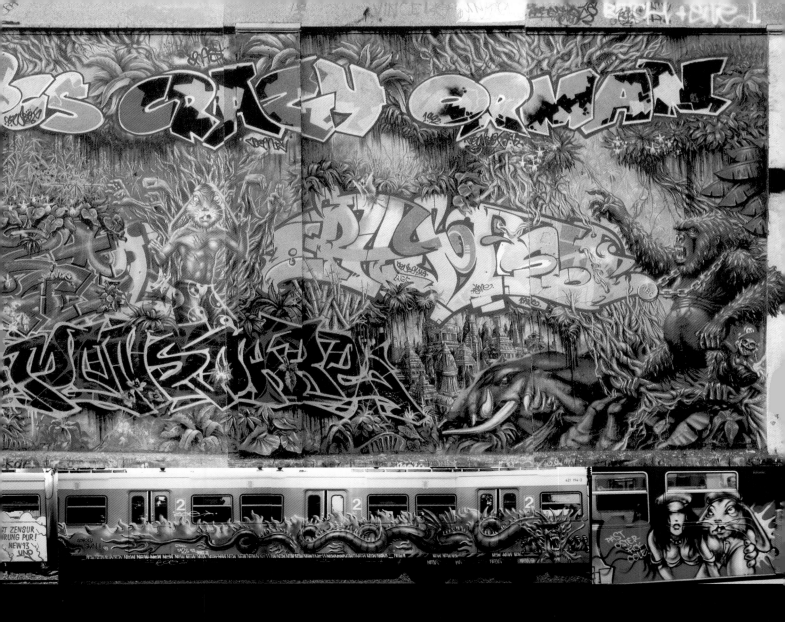

Won is one of the early pioneers of the Munich graffiti scene. His figures are dark and fantastic, inspired by the likes of Goya and Michelangelo. According to Won, the origins of his creations lie in a 'criminal virus' that infected him: 'Delivered into this beautiful sick world, a virus in the ward contaminated my brain. First of all, the virus was weak and solitary. But he gathered power as I grew. As soon as I was able to speak, he introduced himself to me. More and more he contaminated my thoughts and emotions. But it was good…. I was willing…. My only question was where the criminal element entered into the scheme…. If I didn't do it voluntarily, he would alter some of my brain receptors so that I did. That's how I came to steal cans, tagging up and painting trains day and night, smearing outlines on kilos of paper. Throwing up colour onto anything that caught my eye, building up my own cosmos…. Without question, the criminal virus commanded me.'

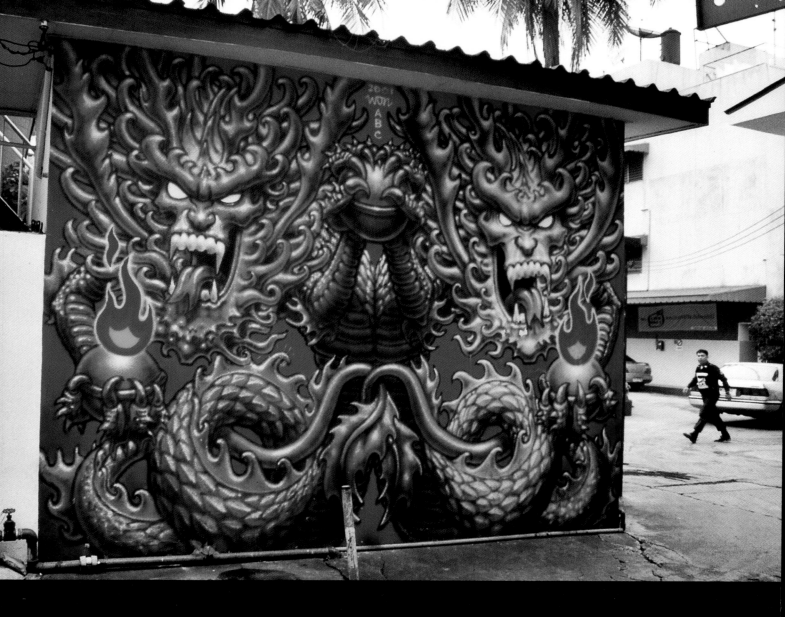

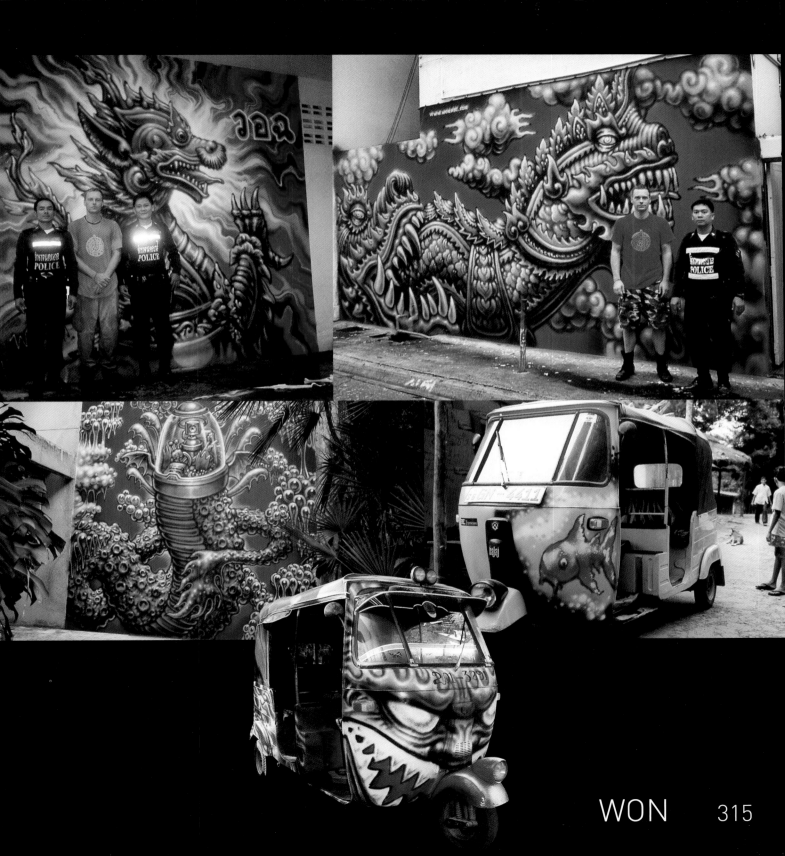

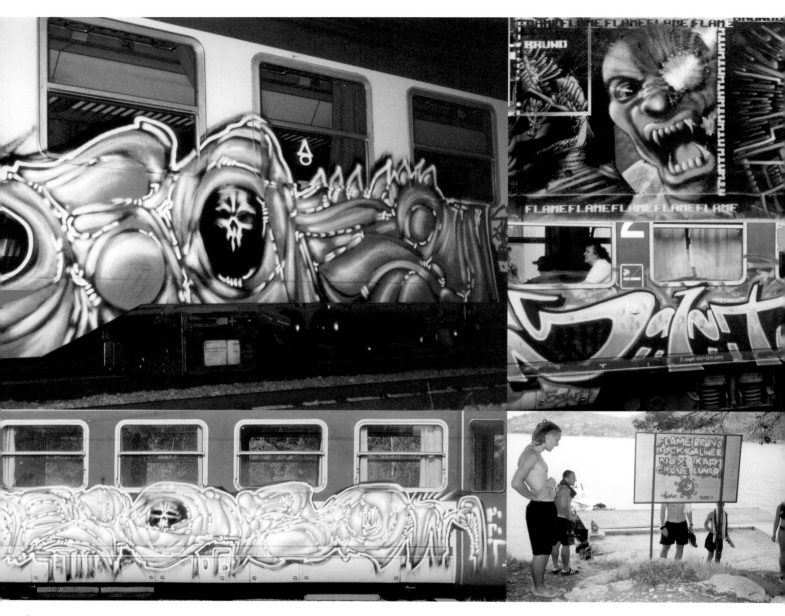

316 YCP CREW

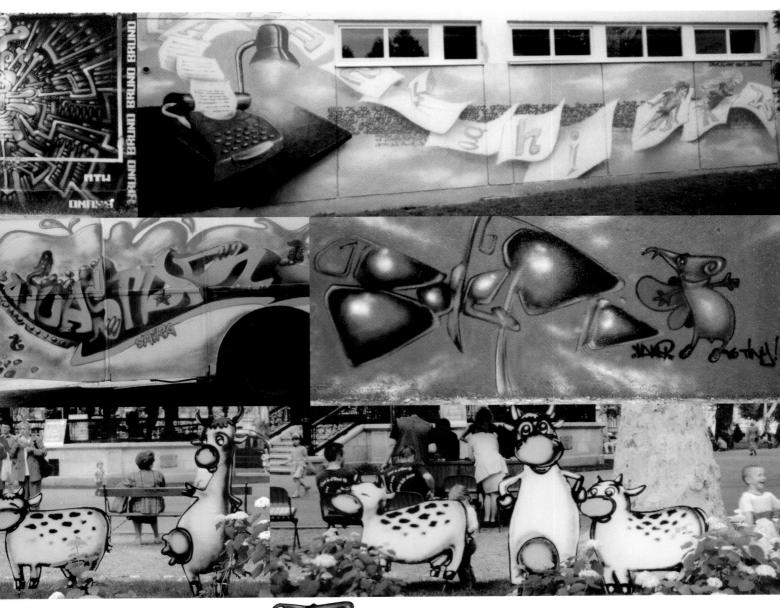

Standing for Yo Clan Posse, YCP was founded in 1992 by Croatian graffiti artists Lunar and 2 Fast. Alongside fellow Croatian crew GSK, it really helped to get Croatia's graffiti scene going. These days, its members are into graphic design, programming, photography, drawing and painting as well as graffiti.

317

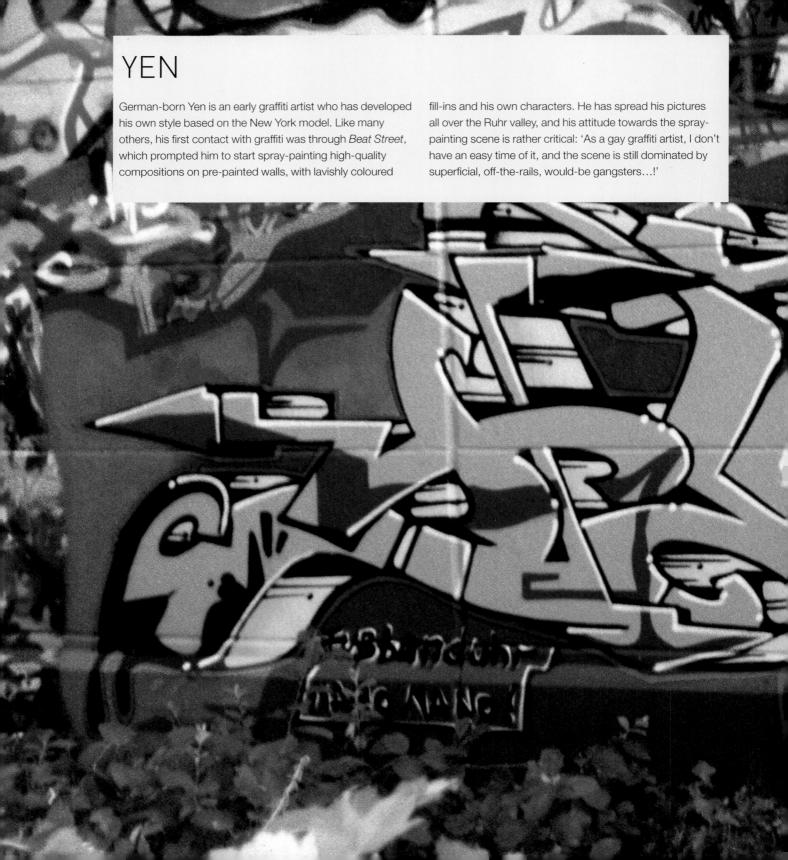

YEN

German-born Yen is an early graffiti artist who has developed his own style based on the New York model. Like many others, his first contact with graffiti was through *Beat Street*, which prompted him to start spray-painting high-quality compositions on pre-painted walls, with lavishly coloured fill-ins and his own characters. He has spread his pictures all over the Ruhr valley, and his attitude towards the spray-painting scene is rather critical: 'As a gay graffiti artist, I don't have an easy time of it, and the scene is still dominated by superficial, off-the-rails, would-be gangsters…!'

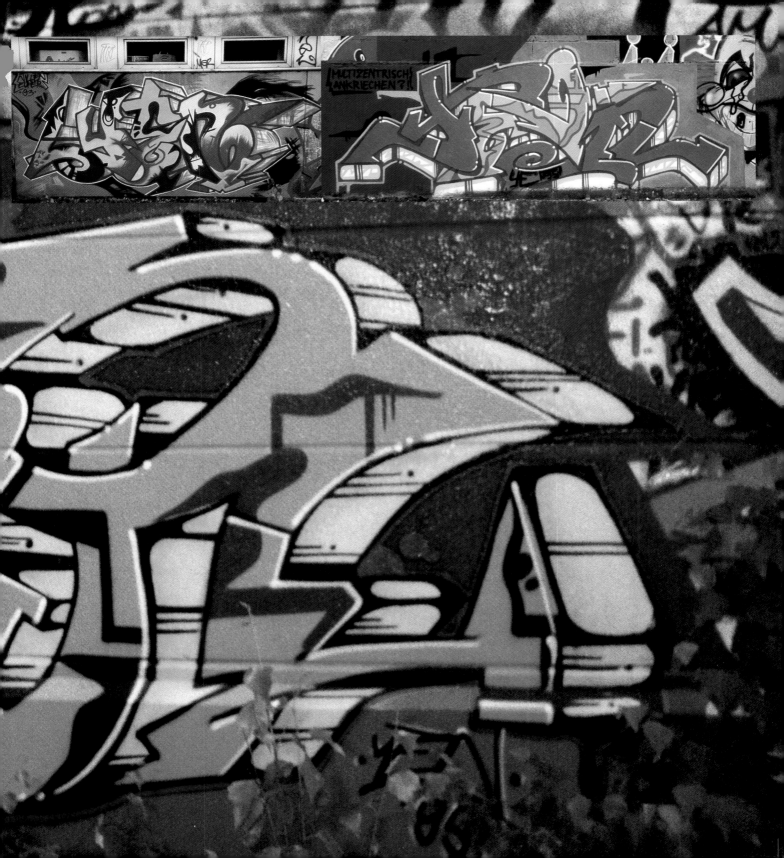

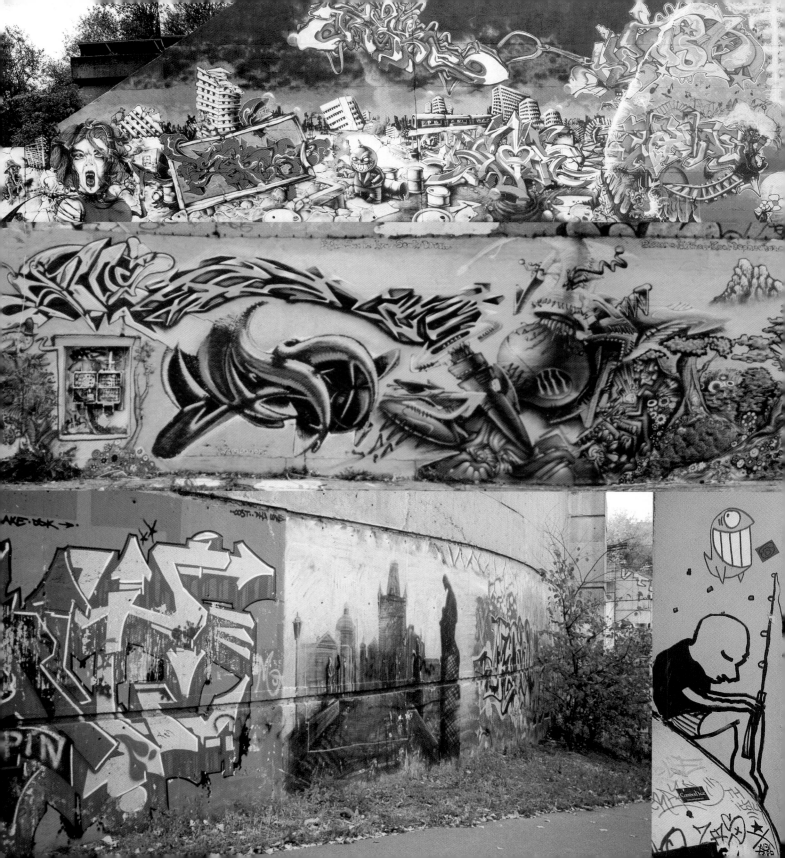

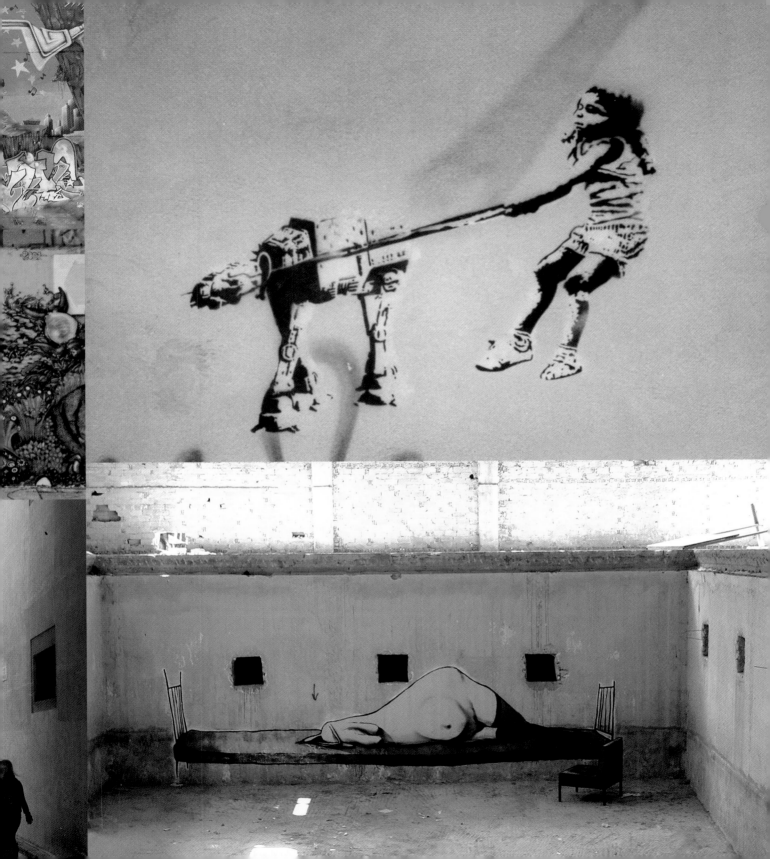

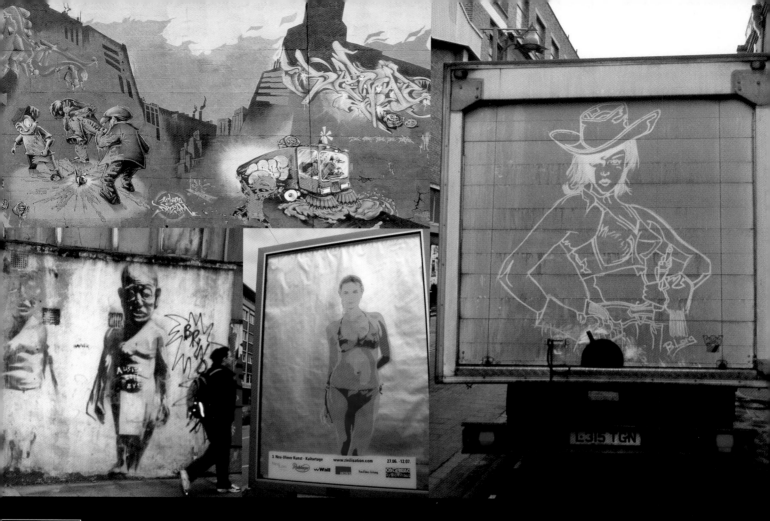

1 Nada, Jia, Shem, Shaolin, Sope 2, Seor, Kensa, Reso, 2 Rodé, Jag, Jazi, Esprit, Urban Dreams Festival, Charleroi, Belgium, 2002

2 Efas, Sonic, Ivas, Seak, Bruno, Bizare, Hitnes, Kool, Dephect, Wiesbaden, Germany, 2001

3 Mr. Yu (from Japan), London, UK, 2004

4 Mr. Yu (from Japan), London, UK, 2004

5 Pisa 73, Berlin, Germany, 2003

6 BLorg, London, UK, 2004

7 Unknown artists, Prague, Czech Republic, 2003

8 Pez, Barcelona, Spain, 2003

9 Unknown artist, London, UK, 2004

10 Norjin, Athens, Greece, 2003

11 Nano 4814, Madrid, Spain, 2003

12 Kevin Grey, Liverpool, UK, 2003

13 Lacuna, Germany, 2003

14 Microbo (from Italy), London, UK, 2003

15 Bo 130 (from Italy), London, UK, 2003

16 Charly the Cat, London, UK, 2003

17 Waf, Aalst, Belgium, 2003

18 Unknown artist, London, UK

19 Impe, Athens, Greece, 2003

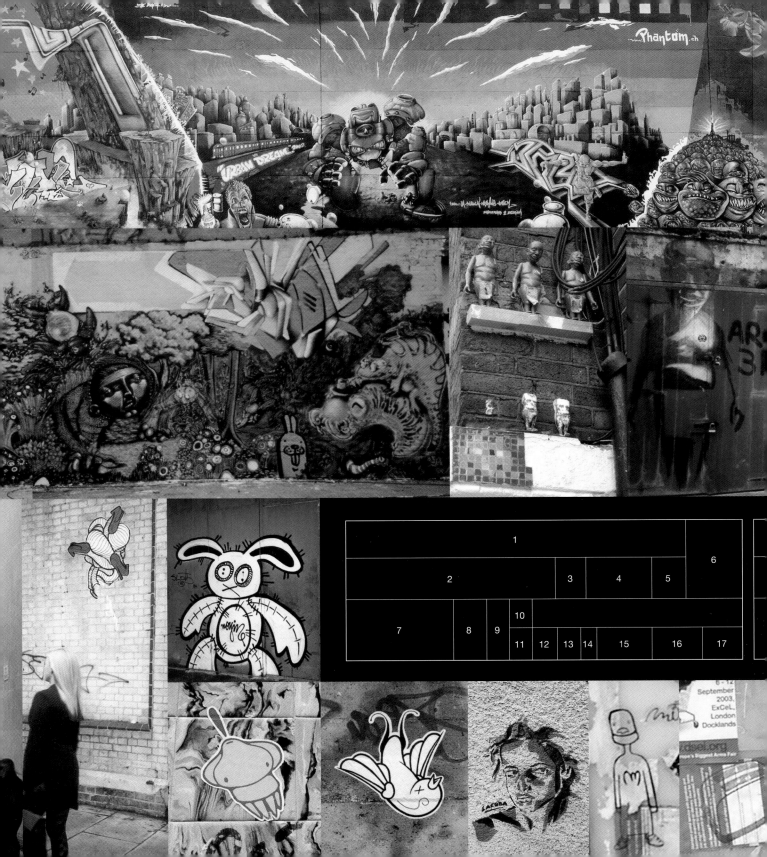

THE REST OF THE
WORLD

THE REST OF THE WORLD

Africa

The African graffiti culture is primarily based in South Africa, where a strong scene has been developing since around 1984, but spray-painted or painted pictures can also be found elsewhere. Although the scene tends to be cut off from what is happening in the rest of the world, South African graffiti artists are often very talented and work on many different levels.

The extreme social conditions in South Africa have played a big part in the development of graffiti there. The first graffiti artists came from the ghettos in Cape Town – from the cape flats, small metal huts without water, electricity or sanitation, in which whole families live together with their grandparents. Even though there are still no decent cans or markers today, graffiti artists try to produce lots of pictures with what they have to hand. They use the so-called 'female' cap system,

which does not meet the American and European standards. However, the advantage of these variants is that it is easier to control the pressure of the can – very thin and thick lines can be spray-painted with the same cap.

'There's the whole social thing here, which puts our scene on a different platform to other scenes as there's so much poverty here and also no funding or government support,' explains Faith 47, describing the situation in Cape Town. 'A lot of people are just struggling to get by. It's much harder to fund your graffiti habit. There is also the element of danger here. For instance, if you're out bombing, you are generally worrying about meeting some shady character or gang or some crackhead…. Writers have been shot at. The crime levels here make everyone a bit edgy. The trains are good though. There are whole cars that have been running for years. Some stuff gets buffed, but a lot of the trains are heavily tagged inside and out because they can't afford to clean it up.'

The artists on the scene have built up their own community, including jams, magazines, hip-hop events, commissions, and working in design studios or as tattooists, and a great deal of talent is emerging from these quarters. Cape Town and Johannesburg are very different stylistically because the scene in the latter is still very young, but an independent graffiti culture of train writers, stencil artists, 3D and character specialists is coming out of both.

Asia

A particularly innovative and diverse culture is developing across Asia, which has often prompted established graffiti artists to take study trips to this area of the world. Although the Asian graffiti scene remains underdeveloped, spray-painting is common in countries such as Thailand, the Philippines and Singapore, and Japan has a country-wide scene. Japan is probably one of the most developed cultures because young people there tend to be interested in and receptive to trends from Europe and America. In contrast, Indonesia's graffiti scene tends to be more political with stencils and posters.

In the whole Asian sphere, graffiti artists are generally clustered in capital cities. Over the coming years, a great deal can be expected from these artists, who work with digital techniques and are often designers and graphic designers.

Australia and New Zealand

Australia has a long graffiti history, and Arthur Stace, who famously wrote 'Eternity' all over Sydney in the early 50s, now has a plaque in his honour. Its graffiti is generally found in large towns and cities, and the sheer distance between Australia and other hotspots such as Europe and America has enabled it to develop a very individual scene, although, at the beginning, it naturally tended to reflect the New York model. Melbourne, Sydney and Brisbane are the epicentres of Australian graffiti and have become renowned for their record shops, magazines and strong hip-hop culture. 'Brisbane is a fun town to live in, but graffiti-wise it is mediocre,' says Australian writer Kasino. 'Lots of cameras, cops, heroes, security everywhere, so it's quick panels and lots of bombing on the lines. You can get up to nine years in jail for painting state property. There's a lot of stuff on the lines though. Australia has a number of great writers like Dmote and a lot of good guys like Scram and Peril, who do funky pieces. Merda from Melbourne is one of my favourite Australian writers, and I know he's also one of the superior stylists in the world, although certain Euro guys bit him hard in the late 80s.'

New Zealand, like Australia, has always been cut off somewhat from the rest of the graffiti world. Its scene also tends to be found in the large towns and cities such as Wellington, Christchurch and Auckland. However, there is a real connection between artists in New Zealand and Australia, and they often hold graffiti jams.

330　BELX2

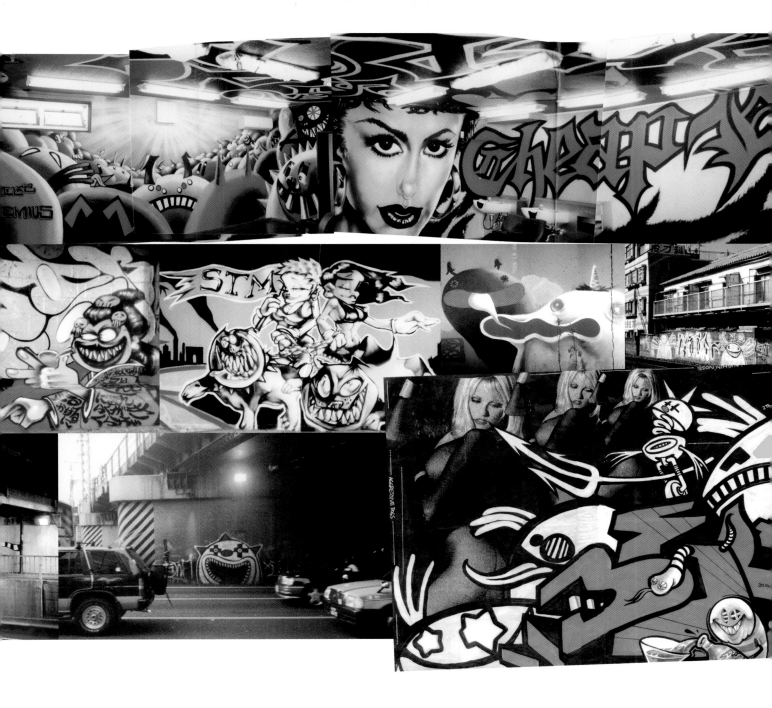

Belx2 is from Tokyo – Japan's graffiti metropolis – but you can also find graffiti artists and pictures in Osaka and Yokohama. The speed at which pictures have to be spray-painted to escape police detection has prompted Belx2 to develop clear and simple figures. On legal walls he is able to make his pictures more vivid with an interplay of colours, and light and shade. 'Japanese graffiti is different from person to person, so I can't speak for everyone. I can only give my point of view,' he says. 'You come to Japan, you see and you feel. What I know is that there are many people with different feelings, so it's better not to judge people or a country by what has happened in the past. That is the same everywhere, though.'

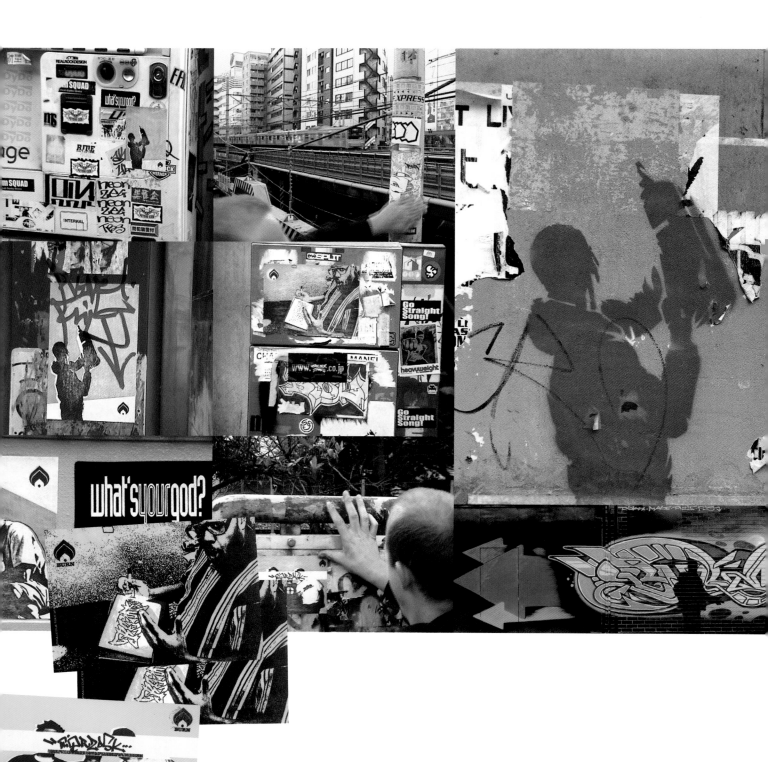

BURNCREW

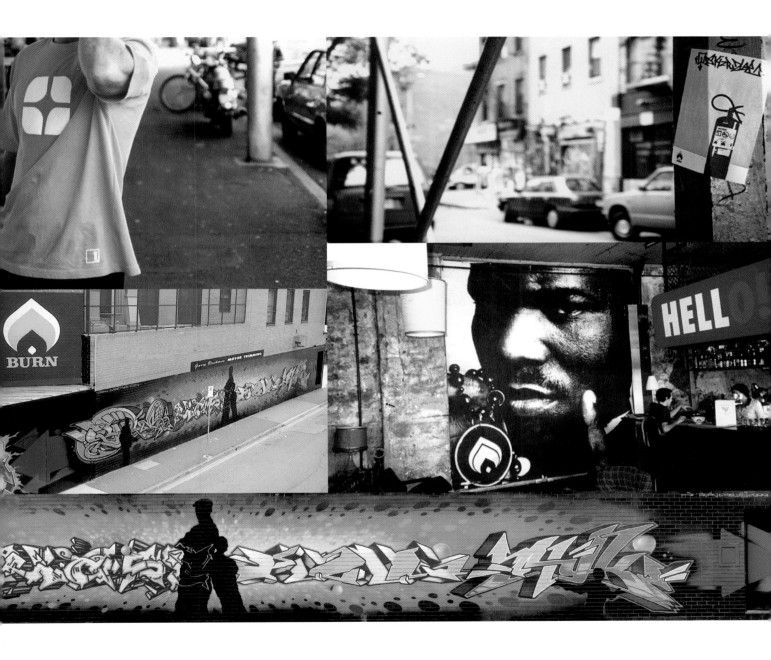

BurnCrew comes from Melbourne. Its many members have been pioneering new areas such as digital media, but its artists are also active in other fields including graphic design and music. More than an artists' collective, BurnCrew is actively involved in bringing some of the best events, music tours, exhibitions and parties to the local scene.

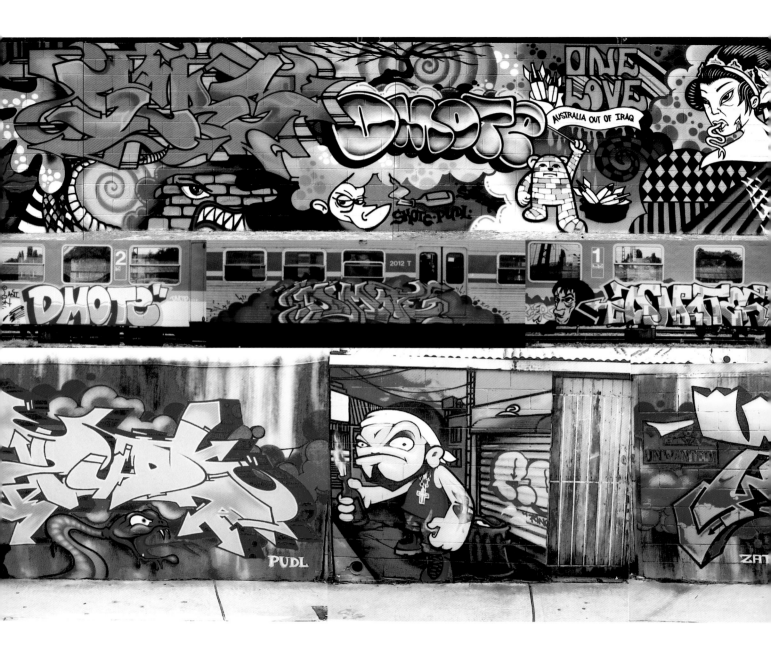

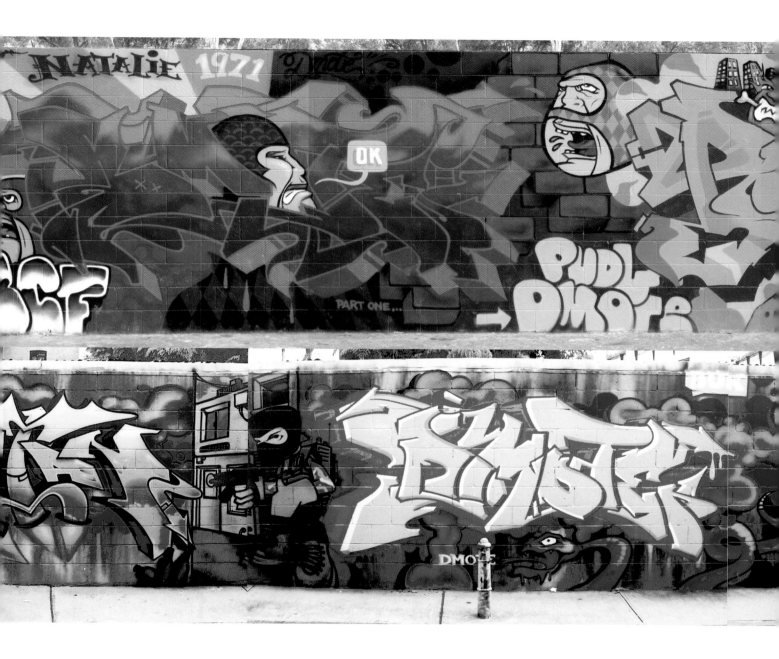

Dmote is a pioneer of the old Australian graffiti scene and is known for his ever-changing styles. Influenced by New York's semi-wildstyle, which started to emerge in the early 1980s,

Dmote created his own individual versions with new techniques and current trends in mind. He has also been working on commissions and gets involved in exhibitions.

FAITH 47

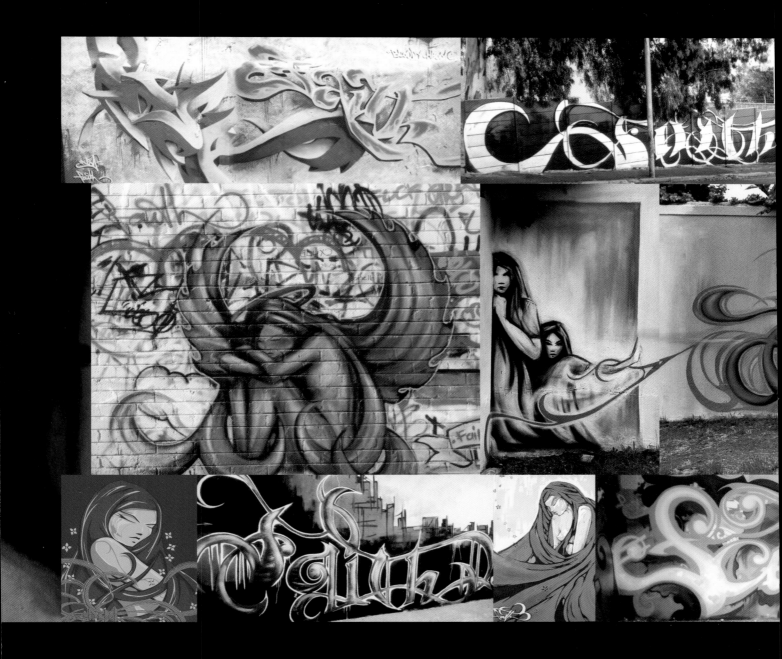

Cape Town-based artist Faith 47 paints her impressive, comical female heads and figures on canvases or shacks, small rusty metal huts in which whole families live: 'It's taking the stuff that everybody hates and nobody wants to see and making it more in their face. In South Africa, there are millions of people living in makeshift shacks.... It's so hard to see it all the time and not be able to change it. What can I do to save the fucking world? So I paint shacks.' She has travelled around Europe and has T-shirt and flyer designs, legal commissions and magazine work under her belt.

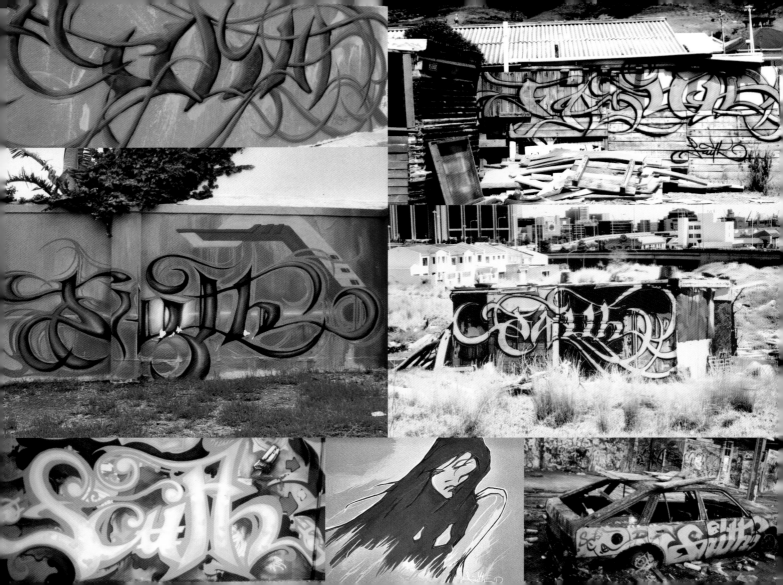

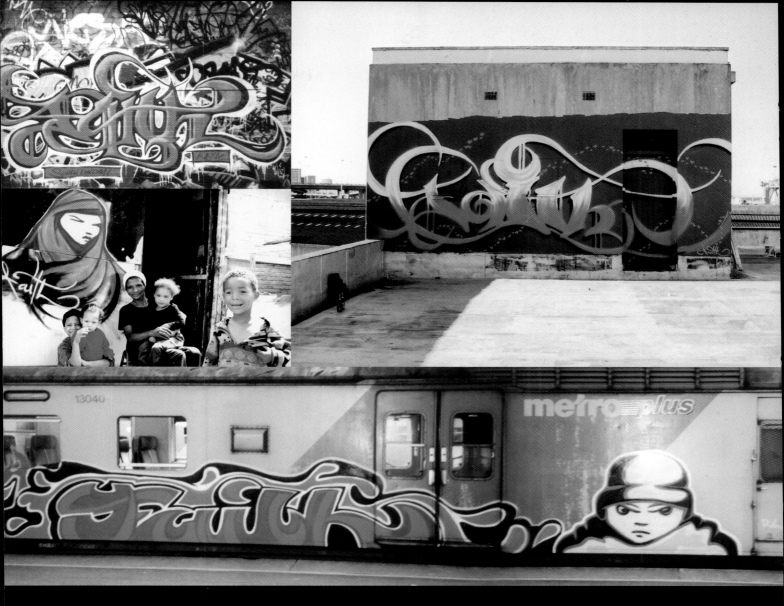

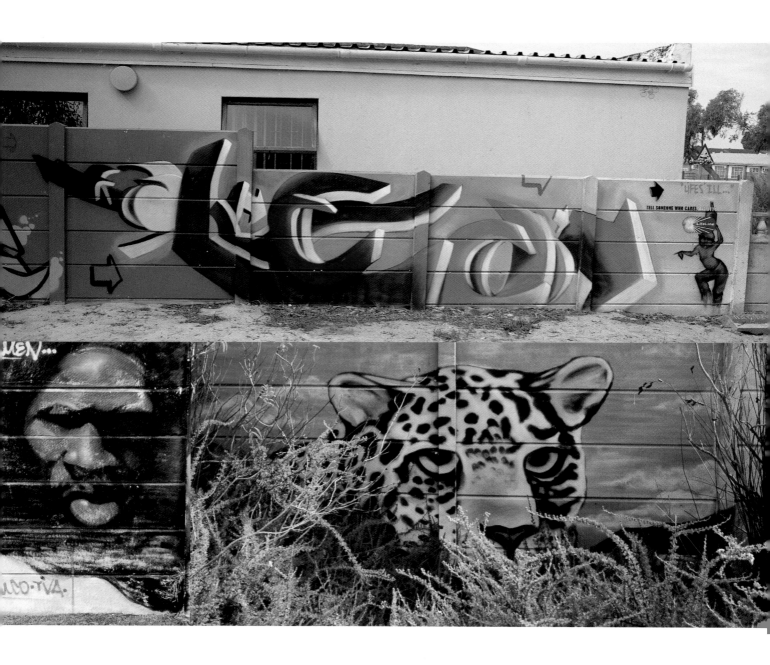

FALCO

Together with Mak 1, Falco is a pioneer of the early South African scene. He was a member of a freestyle dancing group, Supersonic Dynamos, and bought a spraycan one day with which he wrote the name of the group. Later on, he got to know other painters and was inspired by them. Sometimes, he takes short sentences or lyrics from rap songs and spray-paints them onto a wall to get the message across. He has tried out many different things, but now concentrates on the styles through which he feels he can best express himself.

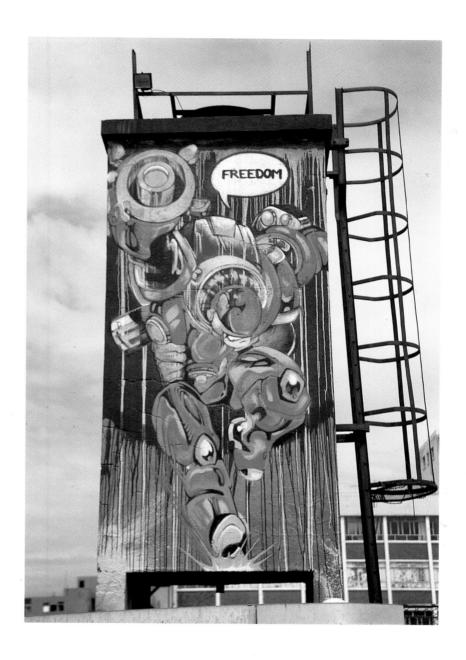

GOGGA

Gogga – one of the earliest pioneers on the South African scene – started off in Cape Town and now lives with his family in Johannesburg. He has influenced several generations of graffiti artists, and today works on commissions. Two of his walls have been used for posters and can be seen giant-size on the facades of different buildings.

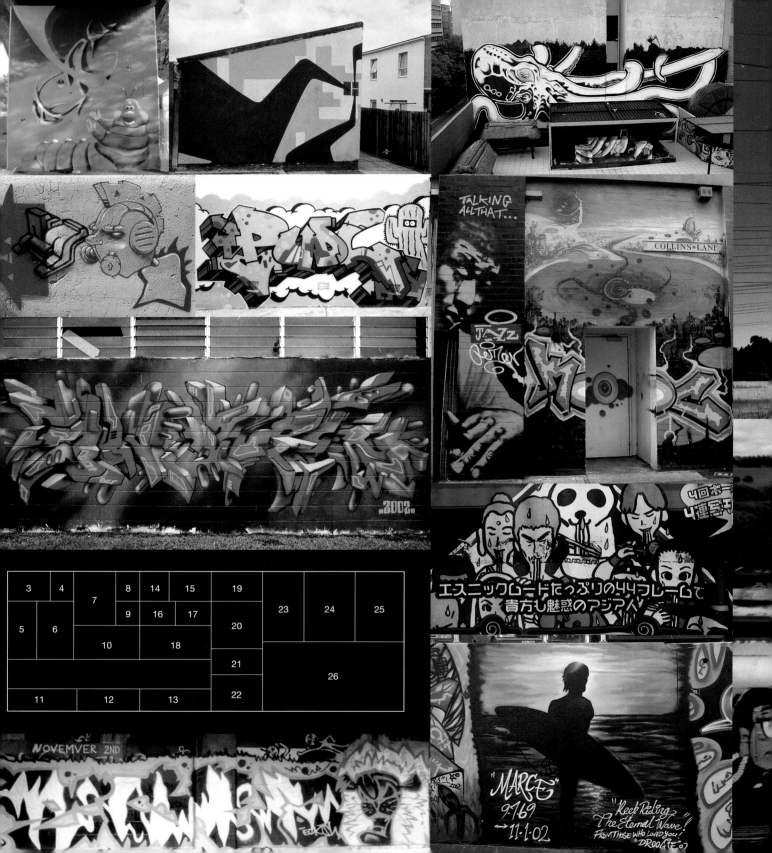

1 Unknown artists, Ulaanbaatar, Mongolia, 2004
2 Unknown artist, Sydney, Australia, 2002
3 Unknown artist, Sydney, Australia, 2002
4 Supa, *Home Is Where the Heart Is*, Cape Town, South Africa,
5 Nishi, Tokyo, Japan
6 Supa, *God Bless This Home*, Cape Town, South Africa

7 Unknown Artists, Sydney, Australia, 2002
8 Detail of illustration 7
9 Void tag, Johannesburg, South Africa, 2003
10 Nishi, Tokyo, Japan
11 Kab 101, Jam, Sydney, Australia
12 Ecka, Tokyo, Japan, 2003
13 Bask, Kane, Tokyo, Japan
14 Nishi, Tokyo, Japan

15 Keti, Mitchells Plain, South Africa, 2003
16 Mak 1, Cape Town, South Africa, 2003
17 Pudl, Brisbane, Australia
18 Snarl, Brisbane, Australia
19 Wealz, Johannesburg, South Africa, 2002
20 Unknown artists, Sydney, Australia, 2002

21 Unknown artist, Yokohama, Japan, 1999
22 Droogie, Bondi Beach, Australia, 2002
23 Unknown artists, Soweto, South Africa, 2003
24 Gogga, Johannesburg, South Africa, 2003
25 QP, Tokyo, Japan, 2003
26 Kasino, Tash, Brisbane, Australia, 2003

	1
	2

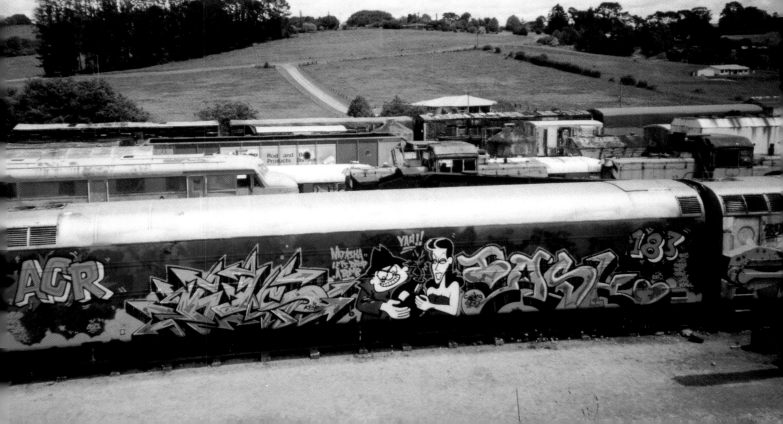

Kab 101 is from Prospect (Australia) and spray-painted his first picture in 1983. Back in the early 1980s, his tags were all over the place, but these days he works with a symbol-based form of design. Describing what he is trying to express in his pictures, he says: 'Letter exploration, surface transformation, marking symbols, and a calibre of design that has its own identity. Every style has to reflect my personality / identity, as writing is a reflection of one's existence. I only paint characters that relate to my own experiences or are something that I am

interested in, not just those that look nice. My work involves highly complex wildstyle designs, well-planned and time-consuming to produce. At the same time, it is also a simple two-colour piece that reflects style and doesn't rely on colour to enhance it. I am fascinated with the tools that are used in writing, and try and experiment with all mediums to experience the whole writing spectrum.' Kab 101 also works on canvas, using a variety of different techniques, and he has started his own brand of clothing, OK101 Army.

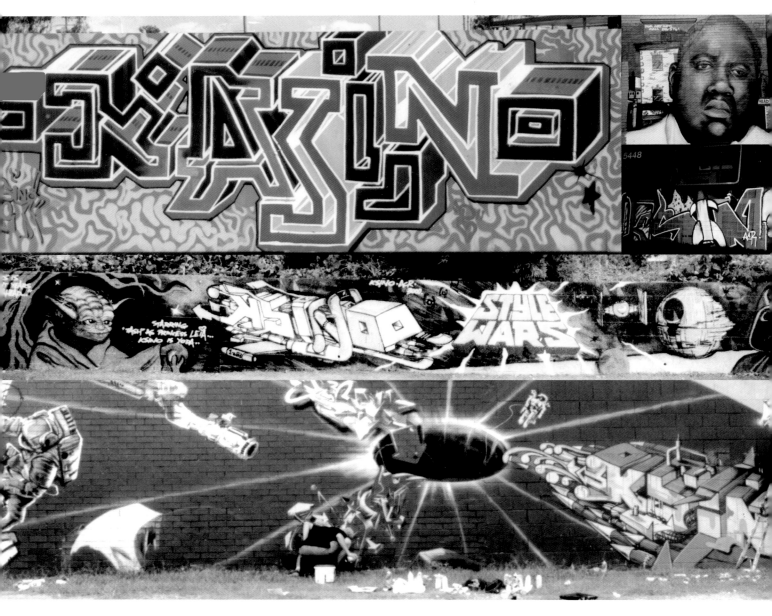

KASINO

Kasino is probably the best-known Australian writer. Born in Sydney, he now lives in Brisbane and runs the label 183. Like many other Australians, he was influenced by the New York model and developed his own personal style: 'To describe it, imagine a letter that has had its inner removed. A doubling of the letter frame, one inside the other, with the inner removed to empty out the letter. One letter frame is in positive space, one in negative.' Although he has clear political thoughts,

he rarely writes concrete messages next to his pictures. 'I have read a lot on the subject of Marxist or politically charged arts, and I feel that graffiti is unique as it is a true revolutionary art form,' he says. 'Space and materials are appropriated, defying and beating the capitalist system for a while. Normal advertising is subverted, and the capitalized space appropriated. It is a temporary art for its own rebellious sake.'

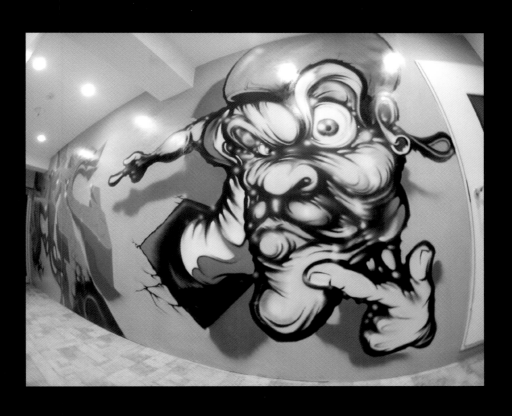

Tokyo-based Kazzrock has been a familiar face on the graffiti scene since the 1980s. His travels throughout the USA have brought him into contact with muralist Mear One, and they have become good friends. These days, Kazzrock works as a clothing designer and with design companies worldwide.

KAZZROCK 349

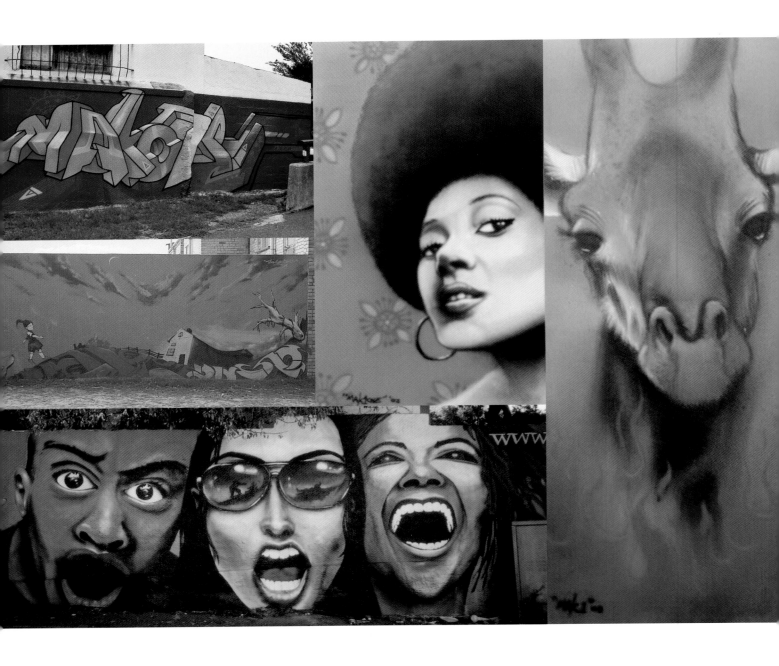

MAK1

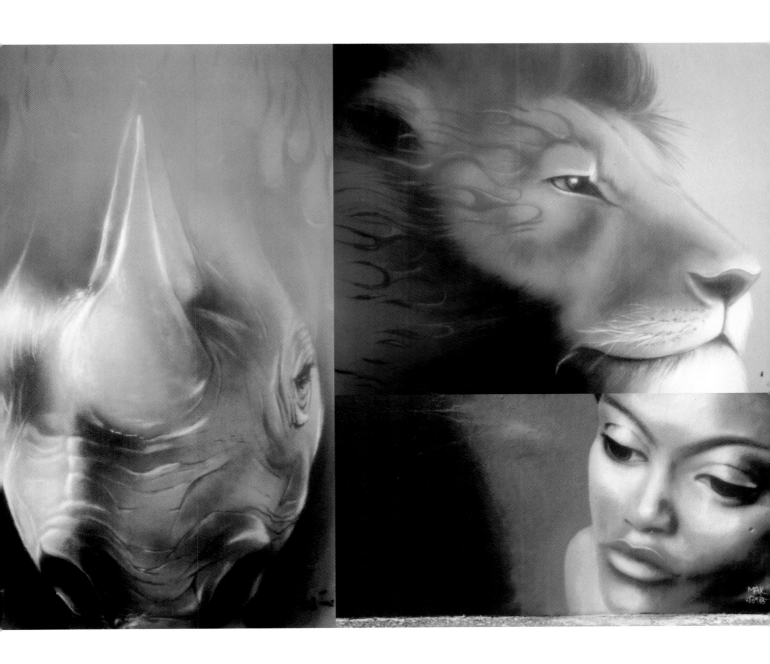

Mak 1 is part of the second generation of graffiti artists in Cape Town. He comes from the ghettos but has made a name for himself on the scene. He travelled to Greece with Falco for the *Chromopolis* project and created huge facades with other international graffiti artists. Extremely creative, he has been working with styles and characters on the computer as well as walls. There are a lot of African influences in his pictures: 'South Africa doesn't have a style that is our own like New York…. It's creating a style from where one comes from…. The unique thing about South Africa is that we have such a variety of cultures. This could have a huge impact on the graffiti scene, which I hope writers will be inspired by.'

351

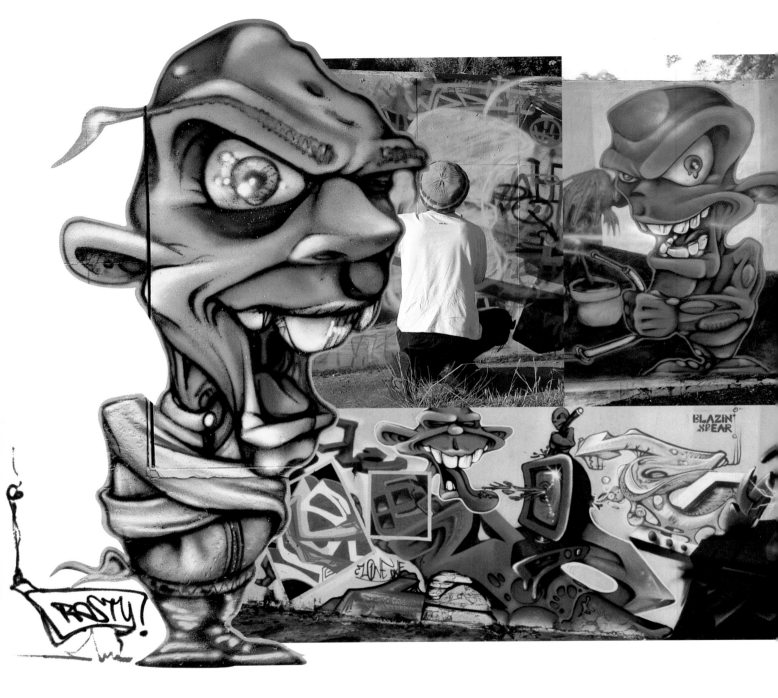

RASTY

As one of the younger generation of writers, Johannesburg-based Rasty focuses on his individual characters and tries to keep his styles as natural as possible, making them an addition to the figures. With other graffiti artists in Johannesburg, he also paints clubs and designs T-shirts.

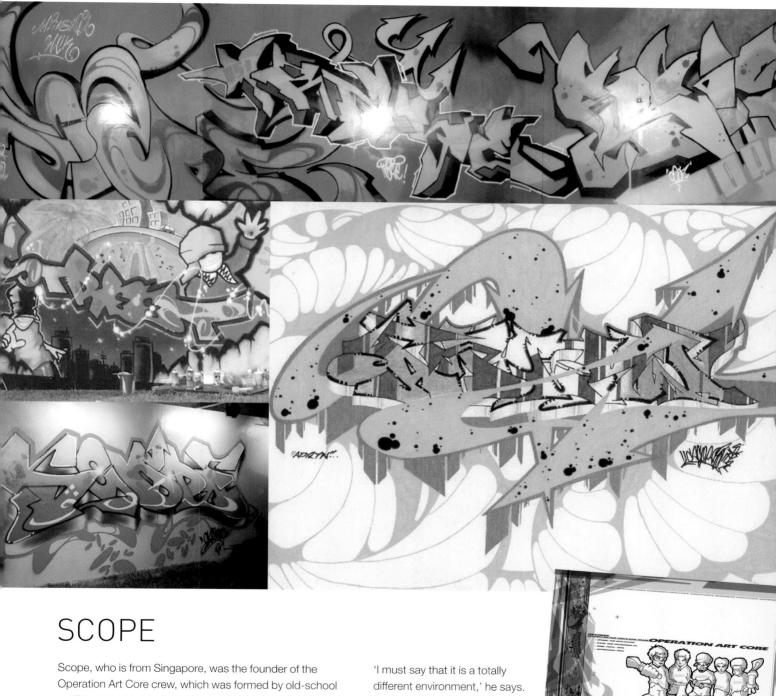

SCOPE

Scope, who is from Singapore, was the founder of the Operation Art Core crew, which was formed by old-school graffiti artists. He has been drawing letters since childhood and has specialized in a number of different techniques, both digital and with an airbrush. He has been able to take part in exhibitions in the USA because of his individual design, and has travelled to countries such as Malaysia or Indonesia.

'I must say that it is a totally different environment,' he says. 'Well, maybe not Malaysia – it's pretty much the same as Singapore – but Indonesia Jakarta is a whole lot different. I saw chickens walking by me when I was doing my art. It's more like a rural area than an urban scape....'

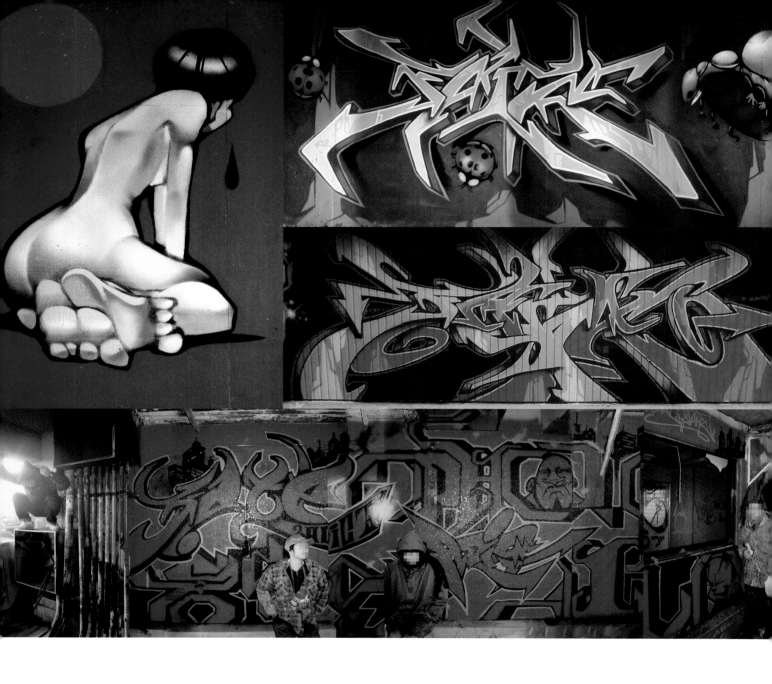

SCA CREW

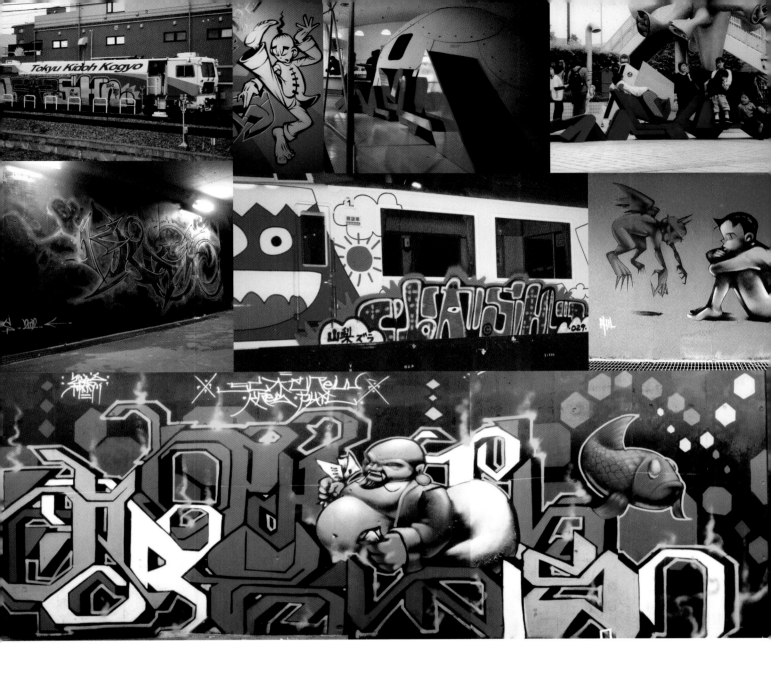

Since the mid-1990s, a number of creative artists have emerged in Japan's capital city of graffiti culture. Kres, Phil, Bask and Fate have combined a variety of individual styles by forming the SCA crew. Their pictures are individual, and are partly inspired by European 3D and western American wildstyle. However, they also experiment with many other different styles and projects. They regularly publish *Kaze Magazine*, with local pictures and reports in Japanese.

355

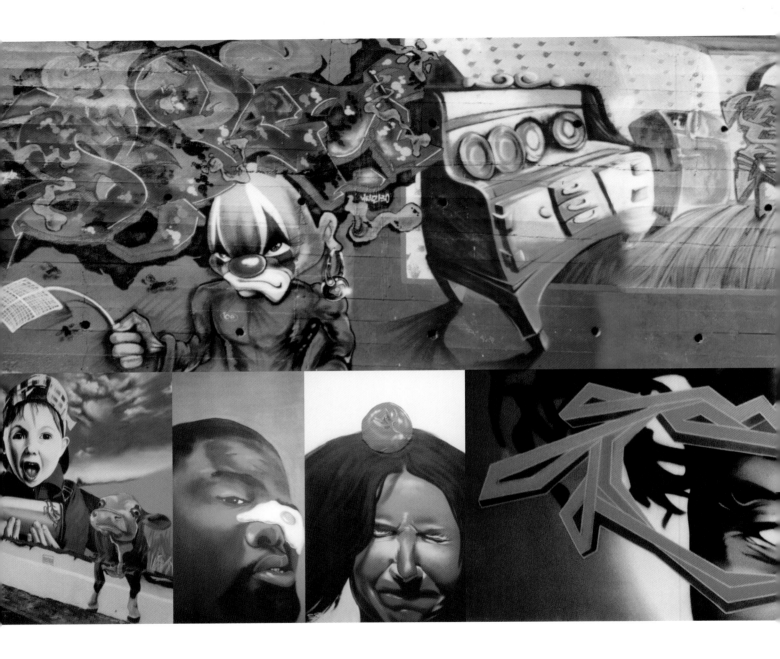

South African Sky 189 and Swiss-born Smirk are another married couple. Sky was born in Cape Town, where they now both live. They have a shared studio, Word on the Street, which they use to work on designs, make ceramic objects and create pictures with an airbrush. Initially Sky wanted to paint portraits and photorealistic pictures, and did not start to draw letters until six years later. Both are well known for their realistic figures and interesting concepts, or underwater landscapes. 'Graffiti for me is a form of escapism,' says Sky. 'It's getting away from what I see in this world and going to another world, where I can write anything, where I can make my letters fly in the sky!'

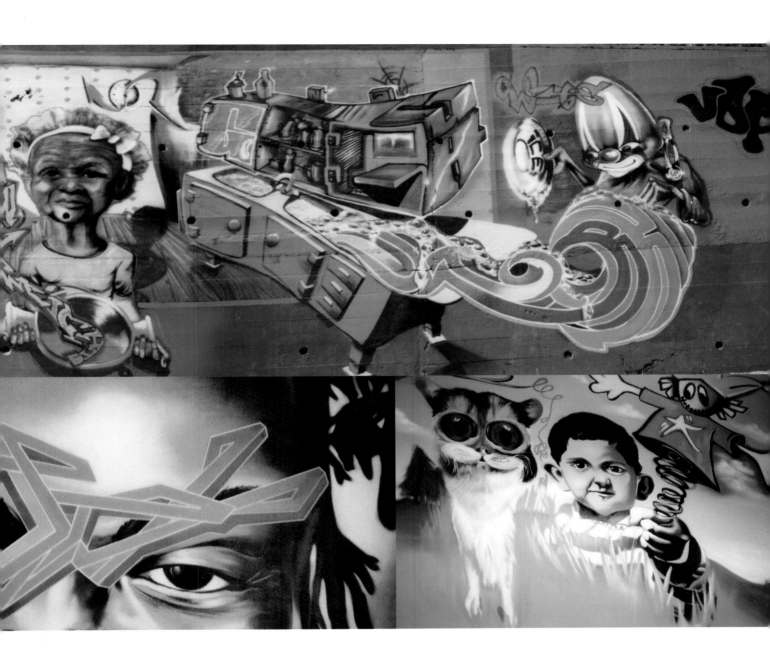

SMIRK & SKY 189

358 STORMIE

Stormie comes from Perth and is another member of the Ikonoklast crew. His unique figures and sculptures have an individual comic style, and he spends many hours in his studio designing, sketching and working on his blackbook.

STORMIE 361

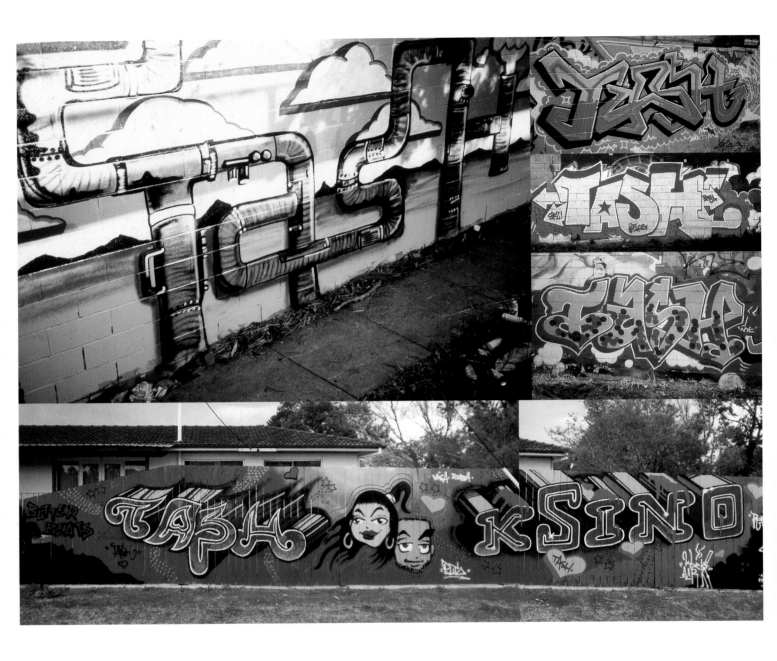

TASH

Australian writer Tash is also known as Queen MC Tash. Describing her style, she says: 'I do pop art with spray-paint or graffiti in a New York style. I like to do many styles so I don't get bored – Japanese, pop, bubble, block, funky public and semi-wild.' Working with Kasino in the 183 group, she also manages the attached record store, Butterbeats Recordstore, and brought out her first record in 1999 – *Gets a little Nasty* – which, at the time, was the first hip-hop vinyl in Australia by a woman. Through several tours and graffiti jams with the likes of Kasino, she has travelled around half the world.

TRASE

Graffiti reached Singapore at the beginning of the 1980s, although it was not recognized fully until 1994. Trase, part of a younger generation, works with different techniques but concentrates on digital tools, and he is a member of the Operation Art Core, along with Scope. He did not pick up the spraycan until 1998.

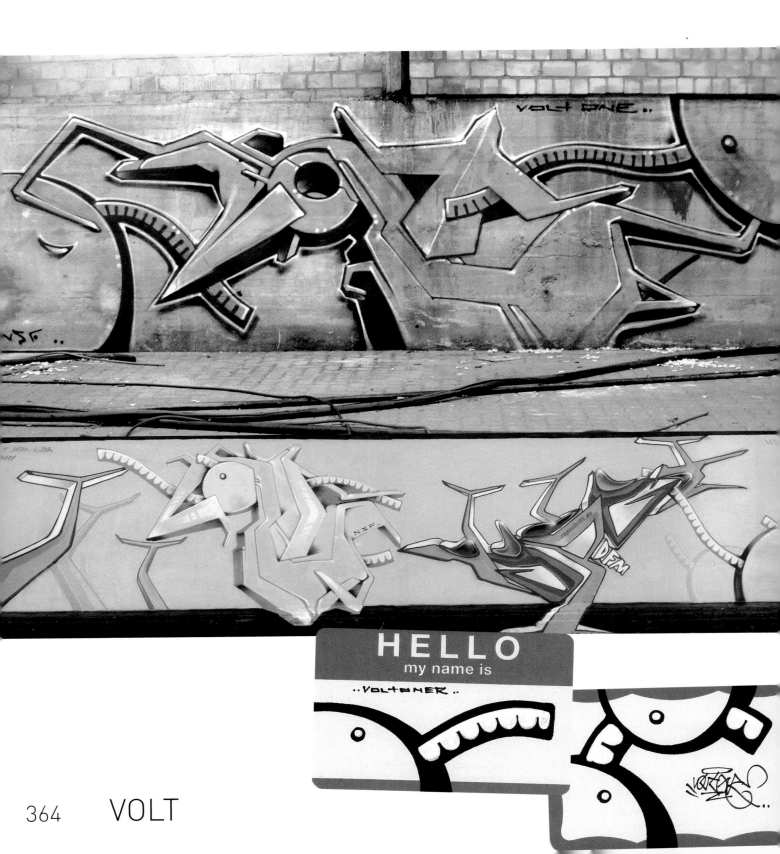

VOLT ONE ..

HELLO
my name is
.. VOLTONER ..

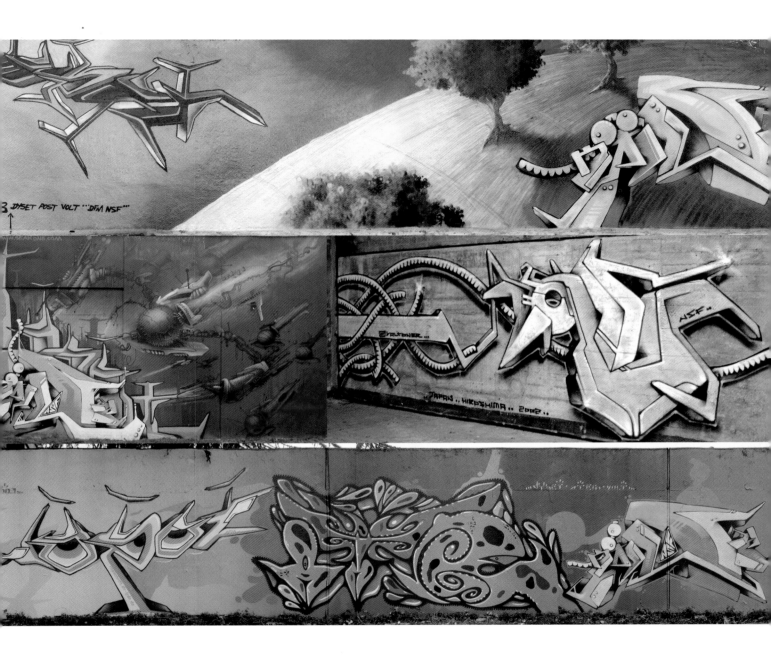

Volt, a young Japanese graffiti artist from Hiroshima, developed his individual style by painting with many well-known artists, including Dyset and Seak. Although the Japanese scene is still young, it boasts a lot of extremely talented artists, working with many different styles. Volt paints letters, combining structured 3D and flat styles in a typical format. He has also created a logo, which often consists of a sliced circle and a type of trunk or snout.

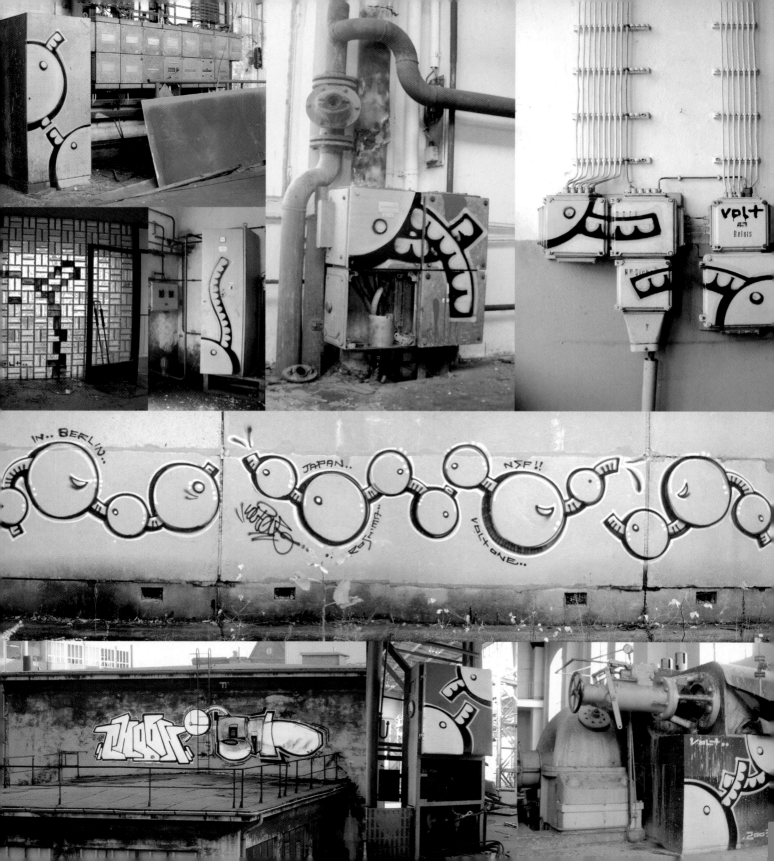

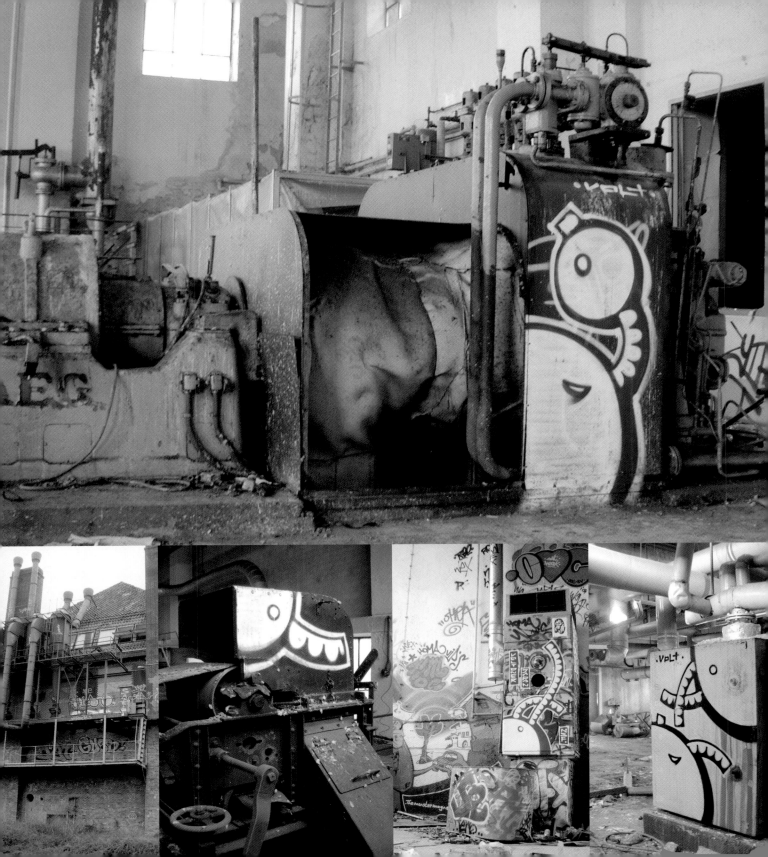

Information

Key:
(b.) born; (f.) founded; (g.) graffiti (the year in which an artist started to do graffiti); A above; B below; C centre; L left; R right

All works are located in the artists' home towns / resident countries unless otherwise indicated.

The Americas

14–15 Space Invader, New York, 2003

16–17 Top row: Else, San Francisco, USA, 2001; Broadway, New York, USA, 2003; Norm, San Francisco, USA, 2001. Bottom row: New York subway, USA, 2003; Toronto, Canada, 2003; Sectr, Cabin & Sixtoo, Canada

74 / 79 Berzerker, Labrona, Canada, 2003

3A Crew (f. 1995) USA
Members: Ges, Kem 5, Totem 2, Pure, Ouija, Kuaze, Marka 27, Vers, Brat, Sky, Cyde (Switzerland), Twesh (Italy) & Wink (Switzerland)
20 Totem 2, Atlanta, 2003
21 Clockwise from bottom: Ges, Kem 5 & Totem 2, Atlanta, 2001; Totem 2, Kem 5, Ges & Rex 2, *3 Angels*, Neuss, Germany, 1999; Totem 2, St Louis, 2001; Totem 2, Atlanta, 2001; Totem 2, Kem 5, Ges, Fewer & Rufio, Boston, 2001
22 Clockwise from top left: Ges, 2001; Ges, 2002; Kem 5; Ges, 2001; Ges, Connecticut, 2002; Ges, 2001
23 Canvases by Ges, 2001

Above (b. 1981 / g. 1997)
Los Angeles, USA
www.goabove.com
24 All by Above. AL: Los Angeles, 2003; AR: *Shoe Tree*, Nevada, 2003. Bottom row: Paris, France, 2002; *God Bless*, Reno, 2003; *Arsenal*, 2003; San Francisco, 2002

Acamonchi (b. 1970) San Diego, USA
www.acamonchi.com
25 All by Acamonchi

Asstro aka Eggs (b. 1977) Toronto, Canada
www.peanutbreath.com
Crews: UNC
26 By Asstro, 1999–2002
27 Clockwise from top left: Asstro; Asstro; Asstro, Dartmouth, USA; garbage can by Asstro & Deth; Asstro sketch, 2003; garbage can by Asstro & Deth

Asylm (g. 1989) Los Angeles, USA
www.asylm.sh
28 L: Vyal & Asylm, Venice Beach, 2002; RA & RC: Asylm; RB: Asylm, Highland

29 LA: Asylm; LC: Asylm, Tijuana, Mexico; RA & RB: Asylm & Man One, *Sweet Hummingbirds Capturing our Imagination*, Long Beach, 2003

Bask (b. 1977 / g. 1992) Detroit, USA
www.baskinyourthoughtcrime.com
Crews: SBS
30 All by Bask. LA: *Under Surveillance*, 14" x 21", 2002; LB: *Ready*, 36" x 48", 2000; RA: Atlanta, 2002; RB: *Bring Out The Gimp*, 24" x 36", 2001
31 L: Tampa, 2001; RA: Tampa, 2002; RB: *Nice Nice*, 2001

Berzerker Ottawa, Canada
32 All by Berzerker. LA: 2001; LB: character, marker on door, 2003; R: 2002
33 A: 2002. Bottom row: *Coats of Paint*, 2003; *Coats of Paint*, 2003; *Cardboard Soup*, 2003; *Black Sheep Inn*, Quebec, 2002

Binho (b. 1971 / g. 1984) São Paulo, Brazil
http://binhograffiti.cjb.net
Crews: 3°M, IC, LUZ, IWK & LP
34 Clockwise from top left: Binho, Rod, Toz, Lets & Br, Rio de Janeiro, 2002; Binho, Rio de Janeiro, 2004; Binho, São Paulo, 2001; Binho, Does, Prozak & Nois, São Paulo, 2002; Binho, 2002; Binho, Tokyo, Japan, 2000; C: Binho, Nagoya, Japan, 2000
35 A: Binho, Florianópolis, 2003; CL: Binho, São Paulo, 2003; CR: Binho, Stopa & Chivtz, São Paulo, 2002

Chaz Bojórquez (b. 1949)
Los Angeles, USA
chazbojorquez@hotmail.com
36–37 All by Chaz Bojórquez. L: *Graffiti Mandala*, 79" x 95"; LB: from *Señor Suerte* tag, 1975; CA: *Cowboys, Avenues Gang Member*, 1989; two images, *Niki*, for *Big Time* magazine, 2000; CB: Chaz with skull stencils, New York, 1999; R: *No More Pompadours*, canvas, 72" x 50", 1996

Buff Monster (b. 1978 / g. 1994)
Los Angeles, USA
www.buffmonster.com
38 L: Buff Monster, 2001; RA: Buff Monster & Siner, 2001; RC: Buff Monster, 2002; RB: Buff Monster, *Pink Pleasure*, 2003.
39 Clockwise from left: 2002; 2002; 2002; 2003; 2002; 2003; 2003

Cabin Fever Crew (f. 1998)
Pueblo, USA
www.cabinfevercrew.com
Members: Ninos Boom Box, The Tackle Box, Scagnetti, Felix Fontain, Chachi Deveroux & Kit Kat Calloway
40–41 All by Cabin Fever Crew

Caru (b. 1978 / g. 1994)
Born in Argentina, lives in France
Crews: CBB & LCF
44 All by Caru, apart from AL with unknown artists

Case (b. 1977 / g. 1992)
Toronto, Canada
Crews: KWOTA, TDV, AFC & BIF
42 All by Case unless otherwise indicated. Top row: canvas, 1" x 3", 2000; *Blue Jumper*, canvas, 2" x 3", 2000; *Frapper Girl*, canvas, 2" x 3", 2003; canvas, 2" x 3", 2003. Second row: *Smoking and Drinking on a Tuesday Night*, canvas, 3" x 2", 2002; tabletop, 4" x 2", 2001. Third row: 4" x 3", 2001; 8" x 12", 2001; 4" x 4", 2000. Fourth row: Case, Duro 3, Dyske & Sader, Montreal
43 First row: *Toddler*, bed frame, 3" x 4", 2002; canvas, 2" x 4", 1999; *Darcy Scott*, 3" x 4", 1998; *Revolver*, 3" x 4", 2001. Second row: 10" x 36", 2000; *William S. Burroughs*, 1" x 3", 2000; *Baby*, 8" x 8", 2000. Third row: *Black Nuns*, 20" x 44", 2000; *Pistol*, 3" x 4", 2000; *Silhouette*, mirror, 8" x 28", 2002; *Red Face*, 1" x 3", 1999; *4:20*, door, 2" x 6", 2002

Cattle aka Constance Brady (b. 1980 / g. 1993) New York, USA
joanofarc13@hotmail.com
45 All on canvas by Cattle. L: 24" x 36", 2003; RA: *Patriotic Painting*, 40" x 30", 2002; RB: 30" x 24", 2002

Dave Chino New York, USA
46 All by Dave Chino, apart from BL with Dash

Cope 2 (b. 1968 / g. 1979)
New York, USA
Crews: KD, GOD, FC, TNB & BTC
47 All by Cope 2

Craola (b. 1975 / g. 1993)
Los Angeles, USA
www.imscared.com
Crews: CBS, WAI, VT, LAHC & Bashers
48 Clockwise from top left: Craola, blackbook painting; Craola, illustration; Craola, Melrose, 2001; Craola, Rygar, Strip & Aura, Melrose, 2001
49 All by Craola. L: *Taming the Hellbender*, 2002; CA: *Bunny Skull*, 2002; C: 2002; CB: *What's 280*, 2002; RA: *Bunny with Apple*, 2002; RB: cans, 2002

Dalek (b. 1968 / g. 1993)
New York, USA
www.dalekart.com
50 All by Dalek. Clockwise from top left: Cincinnati, 2002; 2002; 2002; 2002; Kansas City, 2001; Kansas City, 2001
51 All paintings from 2002

Daze (b. 1962 / g. 1976) New York, USA
www.dazeworld.com
Crews: CYA
52 All by Daze. Clockwise from top left: *Adgenda painting #19*, 2001; *Study for Cyclone*, 48" x 48.5", 1998; *Adgenda painting #16*, 40" x 50", 2001; *Simpson Street*, 56" x 70" 2000; halloween piece, 1999; *Chill two piece*, 2001; 1996; C: Stockholm, Sweden, 2000

Michael De Feo (b. 1972 / g. 1993)
New York, USA
www.mdefeo.com
53 All by De Feo, 2002, apart from second from left, top row, from 1994

Dephect (b. 1982 / g. 1998) USA
Crews: 1SA
54–55 All by Dephect

Does (b. 1976 / g. 1988)
São Paulo, Brazil
www.artsampa.com/doismil.html
Crews: IC & HDV
56–57 Top row: Does, Badicos, Corvo, Irmaos, DKA, Nitros, Lado B, Victor & Tracos, Santo André, 2001. Bottom row: Does, Nitros & Harmony, Santo André, 2001

Dzine (b. 1970) Chicago, USA
Crews: Aerosoul
58 A: Dzine, Judy Ledgerwood & DJ Cam, *Search for Love*, installation, 14 x 40 ft, Chicago, 2001. Bottom row: Dzine, *Aces High, Deuces Low*, 64" x 82", 2001; Dzine, *Double Dipped*, 40" x 40", 2001; Dzine, *Untitled (Track #6)*, 61" x 52", 2001
59 Dzine, *Why R You Here?*, in memory of Dondi White, installation, 1998

EGR Toronto, Canada
www.egrart.com
60 All by EGR. Clockwise from left: *Earth Father*, canvas, 20" x 28"; Toronto; Toronto; EGR in action; Toronto

Flint... (b. 1957 / g. 1969)
New York, USA
www.flintfotos.com
Crews: Old School Kingz, Ex Vandals & The Rebels
61 All by Flint Gennari

Heavyweight (f. 1998)
Montreal, Canada
www.hvw8.com
Members: Dan Buller, Tyler Gibney & Gene Pendon
62 All by Heavyweight. L: Donny Hathaway, 2m x 2m, Los Angeles, USA, 2003; R: 12 skate decks, Antwerp, Belgium, 2003
63 A: *Angel's Levels*, nightclub flyer design, 2000; LB: album cover, Chris Bowden's *Slightly Askew (Ninja Tune)*, 2002; RA: album cover, *The Gift of Gab 4th Dimensional Rocketships Going Up (Quannum)*, 2003; RB: *Nina Simone*, 2m x 1m, 2003; C: *Fat Ride*, Heavyweight Logo, 1998

Herbert (b. 1977 / g. 1992)
São Paulo, Brazil
64–65 All by Herbert

Hewn (b. 1976 / g. 1995)
Wisconsin, USA
Crews: M12
66 All by Hewn

HSA Crew Toronto, Canada
Members: Kane, Artchild, Baron & Skew
67 Clockwise from top left: Artchild; Bacon, Hope, Kane & Recka, 2002; Kane; Artchild & Recka, 2002; Bacon, 2002

Kwest (g. 1990) Toronto, Canada
Crews: BSM Boxstars
68–69 All by Kwest, 2001–3

Labrona (b. 1973 / g. 1998)
Montreal, Canada
70–71 Top row: Labrona & Sixtoo, 9.11.2001; Labrona & Sixtoo, 2002; Labrona, 2002; Other, Labrona & Coco, 2001. Bottom row: Labrona, 2002; Labrona, 2003; Labrona, 2002; Labrona & Sixtoo, 2002; Labrona, 2002; Labrona, 11.2001; Labrona & Sixtoo, 2002

Mac (b. 1980 / g. 1995)
Phoenix, USA
www.elmac.net
Crews: NG
72 By Mac, 2000
73 A: Tucson, 2003; BL: freight train; BR: *Lee Morgan*, Tucson, 2001

Man One (b. 1971 / g. 1987)
Los Angeles, USA
www.manone.com
Crews: COI & 90DBC
80 All by Man One. LA: *Only Way Out*, paper, 1995; RA: *Face It*, canvas, 1997; LB: *Style Reliefs*, sculpture by D. Kawano, 2002; RB: *Couple of Inmigrantes*, 1997; C: *Beast*, sculpture by D. Kawano, 2002
81 *Style Reliefs*, sculpture by D. Kawano, 2002

Merz (b. 1980 / g. 1994) New York, USA
www.jwhiteley.com
82 All by Merz, 2003. L: paper, 18" x 24"; R: panel, 15" x 20"; CB: panel, 3" x 5"

Nina (b. 1977 / g. 1990)
São Paulo, Brazil
83 All by Nina

Os Gemeos (twins b. 1974 / g. 1986)
São Paulo, Brazil
84–85 All by Os Gemeos

Other (b. 1972 / g. 1987)
Montreal, Canada
86 All by Other. L: Quebec, 2002; R: 2003
87 All painted in Quebec. Top row: 2001; 2003. Second row: 2003; 2002. Bottom row: 1999
88 Top row: 1999–2000; Vancouver, 2002; British Columbia. Second row: Texas, USA, 2003; Quebec, 2000. Bottom row: Ontario, 2003; boat stencil, 2002
89 Painting on liquid paper, 2002

Persue (b. 1972 / g. 1988)
San Diego, USA
Crews: COD, Transcend, SUK, Bloodclots & SBA

90 All by Persue. Top row: San Francisco, 2002. Bottom row: Bronx, 2003; Los Angeles, 2002; New Jersey, 2003

Pose 2 (b. 1962 / g. 1976)
Philadelphia, USA
Crews: FX, TNB, UW & KD
91 All by Pose 2. Clockwise from top left: *Alphabet City*, 2002; *Things Fall Apart*, 1998; *Purple Granite*, 2002; *Loungin'*, 2003; *Fun*, 2003; *Light from Within*, 1999

Prisco (g. 1983) Manati, Puerto Rico
Crews: MTR
92–93 Top row: Siem, Dask, Klown, Prisco, G.nee, Part, Camp, Dez & Need, *Graffopoly*, New York, USA, 2001. Bottom row: 2002; 2001; 2003; 2001

Prism (b. 1974 / g. 1988–89)
Toronto, Canada
www.theartistformerlyknownasprism.com
Crews: PFG, NSF, TVA, CSN & TBC
94–95 All by Prism. Clockwise from top left: *Breaking the Law*, USA, 1999; *Metal Sculpture*, 11 (L) x 4.5 (H) ft x 20" (W), 1999; Ontario, 2003; Ontario, 2003; USA, 2002; USA, 1997

Sectr (g. 1995) Halifax, Canada
www.lounge37.com
Crews: HW
96–97 All by Sectr, North America, apart from those indicated. Top row: 2002; Sectr, Fatso & Fusion, 2002. Second row: 2002; 2002; 2002; Sectr & Fusion, 2002. Bottom row: 2002; Sectr, Fatso & Uber, 2002

Seeking Heaven Crew (f. 1989)
Los Angeles, USA
www.seekingheaven.com
Members: Bash, Eye, Modem, Panic, Size & Swank
98–99 A: Swank, Eye, Atlas & Skypage, 2001; C: Swank, 1997; Eye, 2003; CA: Eye, 2001; Eye, 2001; Eye, 2003; CB: Eye, 2003; Eye, 2003; Swank, 2001; B: Modem, 2002; Panic, 1997; Precise, 1997; Size, 1999; Panic, 2000; Bash, 2000; digital image by Eye, 2000

Siloette (b. 1981 / g. 1995) Phoenix, USA
www.siloette.com
100 Top row: Siloette, 2003; Siloette, Mac & Jaba, 2003. Second row: Siloette, *Copper Clouds*, canvas, 2003; Siloette, *Hermoso*, canvas, 2003; Siloette, *Taken Away*, canvas, 2003; Siloette, 2003. Bottom row: Siloette, sticker

Chris Silva (b. 1972 / g. 1986)
Born in Puerto Rico, lives in Chicago, USA
http://chrissilva.com
101 LA: Silva & Juan Chavez, *The Children's Place* mosaic, 1998; LB: Silva & Antck, Chicago, 1994; R: Silva & Michael Genovese, 'Human Mess' show, 2002; B: Silva, *Thanks for Liberating my Heart...From my Body, Asshole*, 2003

Siner
Los Angeles, USA
102–3 A: Siner & Klean, 2002; LC: Siner, 2003. Bottom row: Brail, Dry, Jesk & Kat, 2003

Sonik aka Caleb Neelon (b.1976 / g.1992)
Cambridge, USA
www.theartwheredreamscometrue.com
104–5 Top row: Sonik, *Ulysses*, São Paulo, Brazil, 2001. Bottom row: Sonik & Os Gemeos, *Dinosaur Hunter*, São Paulo, Brazil, 2001; Sonik, *Rub-a-dub-dub, Five Letters in a Tub*, São Paulo, Brazil, 2002; Sonik, *What's That Sound?*, *Bling Bling, Son!*, *Signs of Life* project, Somerville, 2000; Sonik, *The One That Got Away*, Boston, 2001; Sonik, *Meanderings*, Boston, 2001

Stain (b. 1972 / g. 1984) **& Scout**
New York, USA
106 All by Stain & Scout

Stayhigh 149 (g. 1969) New York, USA
Crews: Ex Vandals & UGA
107 All by Stayhigh 149. Clockwise from left: sketch, 2003; 2002; 2003; 2001; the artist, 1989

Tony 'Sub' Curanaj (b. 1973)
New York, USA
hellfish44@aol.com
108 All by Sub. LA: Ireland, 2002; LB: Antwerp, Belgium, 2002; RA: Cologne, Germany, 2002; RB: Denver, 2000
109 Top row: canvas, 2002; canvas, 1999. Bottom row: Bruges, Belgium, 2003

Swoon New York, USA
110–11 All by Swoon, 2003, apart from p. 111 RB: Havana, Cuba, 2004

Syndrome Studio Los Angeles, USA
www.syndromestudio.com
112–13 All by Syndrome Studio

TATS CRU (f. 1988) New York, USA
www.tatscru.com
Members: Brim, Bio, BG 183, Nicer, Ken, Cem, Shame, Raz, Wise, Maze, Lase, Sen 2, How, Nosm & Totem 2
114 Top row: Sen 2, Bio, Nosm & How, 2002; BG 183, 2003. Second row: Ken, BG 183 & Tkid, 1984; How & Nosm, Hamburg, 2002. Bottom row: BG 183 & Nicer, 1994; TATS CRU, 2002; Sen 2, 2002
115 Top row: TATS CRU, 2002; TATS CRU, 2002. Second row: Nicer jacket, 1990; Bio & Nicer, 2003

TS5 / TSF Crew New York, USA
Representatives: Priz 1 aka Prisma / Prism, Deadly-Done & Stan 1
116 A: Priz 1. Second row: Mach 2 & Stan 1, 1982; Priz 1; B: sketch by Priz 1

UNC (f. 1997) Canada
www.urbannightmares.ca
Members: Mine, Cinder, Deth, Jesp, Asstro, Echo, K 5, Loves, 45 Lies,

Sen, Wets, Asesr, Chum 101 & Sircuit
117 Top row: Mine, Deth & Asstro, Toronto, 2000; Mine & Asstro, Toronto, 1999; Mine, Deth & Knekt, Toronto, 2002. Second row: Mine & Knekt, Burlington, 2002; Mine & Asstro, Toronto, 1999. Third row: Sen, Burlington, 2002; Mine & Echo, UN, Toronto, 1998; Mine & Deth, UN, Toronto, 2001. Fourth row: Onset, Self, Werc, Phact, Sen, Wets, Cinder, Knekt, Mine, Ses & Skunk, Montreal, 2003

Vasko Santiago, Chile
118 All by Vasko

Vitché (b. 1969 / g. 1987)
São Paulo, Brazil
119 By Vitché, 2002

Dan Witz (b. 1957 / g. late 1970s)
New York, USA
www.danwitzstreetart.com
120 All by Dan Witz. L: 2001; RA: 1979; RB: 1998
121 2000

EUROPE

122–23 Jace, Le Havre, France, 2003

124–25 Clockwise from top left: Paris, France; Pisa, Italy, 2003; London, England; Blek Le Rat, Barcelona, Spain, 2000; Swoon, Prague, Czech Republic, 2003; Sixe crew, Barcelona, Spain, 2003

170 / 175 Laura, Boriz, Pez, Cha and La Mano, Barcelona, Spain, 2003

1 Mor (b. 1971 / g. 1985)
Scotland, UK
Crews: Ikonoklast
133 All by 1 Mor

108 (b. 1978 / g. 1990) Alessandria, Italy
http://www.108artworks.cjb.net
Crews: PRC, LAK & OK
132 All by 108

123 Klan (f. 1992) Haubourdin, France
www.123klan.com
Members: Scien, Klor, Dean, Sper, Skam & Reso
130–31 All by 123 Klan

Akroe (g. 1990) Paris, France
www.akroe.net
134–35 All by Akroe, 2002, apart from left with KRSN, 2002

Alëxone aka Oedipe (b. 1976 / g. 1988)
Paris, France
www.alexone.net
Crews: ESC, SP, HOP, GM & 9emem concept
136–37 All by Alëxone

Banksy (b. 1974 / g. 1989) London, UK
www.banksy.co.uk
138–41 All by Banksy

Besok (b. 1974 / g. 1990)
Münster, Germany
www.besok.de
Crews: TAF
142–43 LA: Besok, *Dizzy Gillespie*, 2000;
LB: Besok, *Playground*, 2000; Besok,
Taf-Stop, 2001; Besok, *Higher*, 2002;
Besok, *Silent*, 2002; Besok, *Diva*, 2002;
Besok & Seak, *Hans Solo: Music for
Deaf Ears*, Cologne, 2001; Besok,
Reflections, 2001; RB: Besok, *Sad Soup*,
Münster, 2003

Bizare (b. 1976 / g. 1994)
Athens, Greece
144–45 LA: Bizare & Norjin, 2000. Second
row: Bizare, Munich, Germany, 2001; Bizare,
painting on wood, 2002; Bizare, 2000;
LB: Bizare, 2002; R: Bizare, 2002

Blade (b. 1972 / g. 1984)
Bordeaux, France
www.blade-graphics.com
146 All by Blade

Blef (b. 1976 / g. 1990) Genoa, Italy
www.aerotismo.com
Crews: MOD & PDB
147 All by Blef, Genoa, Treviso & Parma,
2000–1

Blek Le Rat (b. 1951) Paris, France
http://blekmyvibe.free.fr
148 By Blek, Bagnac, 1992

Bogside Artists Derry, Northern Ireland
www.bogsideartists.com
Members: Tom Kelly, Kevin Masson
& William Kelly
149 All by Bogside Artists. L: *The Death
of Innocence*, 1999; R: *Operation
Motorman*, 2001

Burglar Paris, France
http://burglar.massatto.net
150 All by Hom-Burglar, apart from
those indictated. Clockwise from top
left: Dolobou (Burglar), 2003; Homz
character & Luis, 2002; Mr & Miss HöM,
2003; 2003; Burglar & Burglar Police Car,
2002; Phat Super Burglar, 2003
151 Clockwise from top left: Hom, 2002;
Burglar Character with Dr Slump
styled Sun, 2003; Burglar Police 'To Protect
With No Respect', 2002; Dolobou
featuring Barsky and Sturch, 2003; *Deep
Fried* character scene, Bagnolet, 2002;
Dolobou, 2003; HöM tag, 2003

CAPO Crew (f. 2000)
Tallinn, Estonia
www.zone.ee/CAPO
Members: Anton, Eagle 24, Click & Tyke 1
152 AL: Anton & Me, *Detail of Capom*,
Paljassaare, 2003. Second image from top
left: Anton & Me, *Capom*, Paljassaare, 2003;
AR: Anton, Taik, Eagle 24 & Lil'J, dedication
to CHR, 2001. Bottom row: Anton; Taik;
Kopli, 2000; CAPO logotype

Casroc (b. 1976)
Born in the Netherlands, lives in Belgium
www.casroc.com
153 A: Casroc, Stance, Resm, Bah & Nash,
Roermond, the Netherlands; B: Casroc,
Zenk, Makes, Sky, Sign, Chas & Stance,
Venray, the Netherlands, 2003

Ceet (b. 1971 / g. 1988)
Born in Algeria, lives in Toulouse, France
www.ceetone.net
Crews: KD, BAD, TNB & LKM
154 AL: Ceet, *Carnival*, canvas, 60 x 40 cm,
2003; Ceet & Lus, 2002; AR: Ceet, Paris,
2000; C: Ceet, Prague, Czech Republic,
2001. Second row: Ceet, Montpellier, 2000.
B: El Camion T-shirt design
155 AL: Ceet & Noé 2, Paris, 2002;
AR: Ceet, *Le Beige*, canvas, 1 x 1 m, 2003;
B: Ceet, Koralie & Snake, Béziers, 2001

CG Crew (f. 1999) Germany
www.chillaguerilla.de
Members: Lewy, Oups, Index, Koner,
Kiam 77 & Dome
156–57 Top row: Drew, Dome, Most & Dibo,
Mainz, 2002; Koner, Heidelberg, 2002;
Koner, Kiam 77 & Dome, Karlsruhe, 2004.
Second row: Kiam 77, the Netherlands,
2003; Dome, Karlsruhe, 2002; Dome,
Karlsruhe, 2002; Lewy, Munich, 2002;
Cover, Koner & Kiam 77, Stuttgart, 2002.
Bottom row: Dome & Kiam 77, Karlsruhe,
2002; Index, Koner, Kiam 77, Lewy, Roker
& Oups, Munich, 2003

Cha Barcelona, Spain
158 A: Cha, Pez & La Mano, 2001;
BL: Cha & Pez, 2003; BR: Cha; all 2003

Cheba (b. 1983) Bristol, UK
www.cheba.co.uk
161 All by Cheba in 2002–3

China (b. 1980 / g. 1996) Birmingham, UK
160 AL: 1999; AR: *Self-Portrait*, 2002;
BL: London, 2000; BC: 2001;
BR: *Blue Prototype*

Chrome Angelz (f. 1985)
London, UK
www.TheChromeAngelz.com
Members: Bando, Colter, Mode 2, Pride,
Scribbla, Shoe & Zaki 163
159 A: Mode 2, Pride, Zaki 163, Bando,
Scribbla & Colter, *Voluntary Defacing
of Public Property*, Paris, France, 1985;
C: Pride, Mode 2, Zaki 163 & Scribbla,
Angelz, 1985; B: Zaki 163, *Angel*, Milan,
Italy, 1987

Chromopolis
(Graffiti marathon, Greece,
29 June – 21 July 2002)
162–63 All by Besok, Bizare, Codeak,
Impe, Os Gemeos, Nina, Stormie & Woozy,
2002; L / p. 163 first, second & third images
from top: Volos; RA: Kalamata; RC: Patras;
RB: Chania

Ciber Stargass
Born in Italy, lives in Washington DC
Crews: IK
164 All by Ciber Stargass. Clockwise
from top left: the Netherlands, 2001;
Switzerland, 2002; 2000; Italy, 2001;
Italy, 2001; Italy, 2001

CMP (b. 1970 / g. 1984)
Naestved, Denmark
165 All by CMP. LA: pen on paper, 2003; LB:
The Comeback, pen on paper, 2002; C: *The
Night is Purple*, canvas, 2002; RA: *We Are
On a Mission*, canvas, 2001; RB: *Buying
Paint in New York*, canvas, 2002

Codeak (b. 1969 / g. 1984)
Born in London, UK, lives in Germany
www.codeak.de
Crews: ES, GBF & TAF
166 L: Codeak, Loomit & Vitché, *Mural Global*
167 Top row: Codeak, Vitché, Os Gemeos,
Loomit, Nina, Tasek, Daim & Herbert,
Mural Global, São Paulo, Brazil, 2001.
Bottom row: all by Codeak. First: *Vier
Elemente*, Gablingen, 2002; second top:
Refugium, drawing on paper, 22 x
30 cm, 2003; second bottom: *Vier
Elemente*, chemical transporter, Gablingen,
2002; third: blackbook sketch, São Paulo,
Brazil, 2001; fourth: *Doch es scheint
so...*, studiowork on wood, 2003

Corail (b. 1978 / g. 1996)
Toulouse, France
168 Corail, 2003
169 RA: Corail, 2002; RB: Corail, 2002;
LB: Corail & Dran, 2003

Daim (b. 1971 / g. 1989)
Hamburg, Germany
www.daim.org
Crews: TCD, GBF, SUK, FX, FBI & ES1
176–77 Top row: Daim, Loomit, Seak,
Tasek, Daddy Cool, Stohead, Peter
Michalski, Darco, Vaine & Toast, *The New
Hamburg & Its Partner Cities*, 2001; Daim,
Tasek, Daddy Cool & Stohead, *Getting Up*,
2001; Daim, Loomit, Darco, Vaine, Ohne &
Hesh, *Zeichen der Zeit*, 1995. Bottom row:
Daim & Seak, *Communication*, Neuss, 2001;
Daim, 2000; Daim, 2002; Daim, Seak &
Maze, Hamburg, 2000
178–79 All by Daim on canvas.
Top row: *Harlequin Lipfish*, 90 x 110 cm,
1996; *Clownfish*, 90 x 110 cm, 1997;
Shark, 90 x 90 cm, 1996. Bottom row:
220 x 150 cm, 2002; 80 x 100 cm, 2002;
80 x 100 cm, 2002; portrait, 2000–1; *Wasp*,
120 x 190 cm, 1998; 145 x 95 cm, 2000;
Robot, 145 x 95 cm, 2000

DFM Crew (f. 1998) Germany
www.rapschrift.de
Members: Batik, Dyset, Malun,
Pryme & Tesa 34
180 All canvases by Tesa 34 & Malun, 2003
181 First row: Dyset, Hanover, 2001; Batik,
Munich, 2003. Second row: Dyset,

Hildesheim, 2002; canvas, Tesa 34 & Malun,
2003. Third row: Dibone, Most & Dyset,
Hanover, 2003

Dier (b. 1979 / g. 1992) Madrid, Spain
182 All by Dier, 2003. RA: Puerta
Del Sol; RC: La Latina; RB: Puerta Del Sol.
Background: dinosaur, Madrid

DNS Crew (f. 1988) the Netherlands
www.sons.nl
Members: Romeo, Mega, Mark & Sperm
183 Top row: Mega, Romeo & Sperm,
Koersel, Belgium, 2002. Second row:
Sperm, 2002; CA: Mega, Heerenveen,
2003; CB: Mega, Leeuwarden, 2003; Mark,
Hengelo, 2002. Bottom row: Mega; Romeo,
Sperm & MC Rox, Wesel, Germany, 2002;
B: Romeo, Sneek, 2002

Done (b. 1977 / g. 1991) Barcelona, Spain
www.eldone.com
Crews: DMP
184 All by Done, 2000
185 Clockwise from top left: Ireland, 2001;
2003; 2000; 2003; Done & Skum, 1999;
Lérida, 1999; Done & Skum, 2000;
C: Bristol, UK, 2001

Dr. Hofmann Madrid, Spain
www.drhofmann.org
186 All by Dr. Hofmann. Top row: Lanzarote,
2003; Ibiza, 2003. Second row: 2003;
Lanzarote, 2003. BL: Namanga, Kenya,
2002; BR: 2003
187 2002; Ibiza; 2003

Dut (b. 1975 / g. 1988) Denmark
Crews: AFB, NES, XA & RIO
188 All by Dut. A: South Harbour, 2000.
Second row: Østergasværk, 2001; Roskilde,
2000; South Harbour, 2001. Bottom row:
Hvalsø, 2001; South Harbour, 2001

Einsamkeit (b. 1970 / g. 1987)
Madrid, Spain
www.geocities.com/stencil_einsamkeit/
189 All by Einsamkeit. LA: *Einsamkeit,
La senda del dinosaurio*, Vitoria-Gasteitz,
2003; LB: *C. Bukowski 1920–1994*, 2003;
CB: *Life is a Biodegradable Art*, 2003. Right
column from top: *Tribute to IVA: MakiNavaja*,
Extremadura, 2003; *Madrid Ticket
Transport*, 2003; *¿Te gusta lo que ves?*,
2003; *Tribute to El Muelle*, 2003

El Kitsch Tasso (b. 1966) Meerane, Germany
www.ta55o.de
Crews: Ma'Claim (f. 2001), DSA (f. 1997),
SWB, RAC & UAS
190 Top row: Tasso, Schkeuditz, 1999.
Second row: Tasso & Ma'Claim,
Crimmitschau, 2001; Tasso & Ma'Claim,
Meerane, 2002. Bottom row: Tasso,
Meerane, 2002
191 A: Tasso, Meerane, 2002. Bottom row:
Tasso, 80 x 100 cm, 2001; Tasso, *BMW
318ti*, 140 x 100 cm, 2002; Tasso, *Was
guckst Du?*, 100 x 80 cm, Meerane, 2001

El Tono (g. 1993) **& Nuria** Madrid, Spain
www.eltono.com
192 Top row: El Tono & Nuria, 2001; El Tono, Genoa, Italy, 2003; Nuria, 2002. Bottom row: El Tono, Venice, Italy, 2002; Nuria, 2002; El Tono, 2001
193 LA: Nuria, Paris, France, 2001; LB: El Tono, 2002; El Tono & Nuria, 2003

Esher (b. 1974 / g. 1990) Berlin, Germany
194 L: Esher; R: Esher & Imaq (Argentina), *Greenland*, 2002
195 LA: Esher; LB: Esher, *Verottet*, 2003; R: Esher, *Nymphen*, 2003

Etnik (g. 1993) Pisa, Italy
Crews: KNM, SA, ASP & Etruriarkor
196 All by Etnik

Evol (g. 1994) Berlin, Germany
www.evoltaste.com
Crews: Da Punx, CT-INK & OK
197 All by Evol. A: Heilbronn, 1999. Bottom row: *Strictly Evoltaste*, Heilbronn, 1997; *Bored2death*, Heilbronn, 2000; Canvas, 2001; *We Serve Ya*, Heilbronn, 2001

Flying Fortress (g. 1990) Munich, Germany
www.flying-fortress.de
198–99 All by Flying Fortress. First column from top: AL: Barcelona, Spain, 2003; AR: 2002; Barcelona, Spain, 2003; *Don't Copy Me*, 2002; BL: 2002; BR: 2002. Second column: 2002; CL: sticker box, 2002; CR: Hamburg, 2003; B: stickers, 2002; p. 199, 2002; stickers BL & BR, 2003

Fra 32 (b. 1977 / g. 1995) Pisa, Italy
Crews: KNM
200 Clockwise from top left: Fra 32 & Marù, 2002; Fra 32 & Grynz, 2002; Fra 32 & AISM crew, 2002; Fra 32 & Marù, 2002; Fra 32 & Buny, Madrid, 2001; Fra 32, Grynz, Chaos & Pera, 2002; Fra 32, 2002; Fra 32, 2002; Fra 32 & Grynz, 2003; Fra 32 & Marù, 2002
201 Fra 32 & AISM crew, 2002

Get 1 (b. 1970 / g. 1982)
Purmerend, the Netherlands
www.getone.tk
Crews: KOT, DSK & HCD
202 A: Get & Dopie, Utrecht, 2001. Second row: Get, Purmerend, 2003; Get, London, UK, 1994; B: Get & Dopie, Amstelveen, 2001

Glub (g. 1987) Madrid, Spain
www.grafiteros.com
203 Clockwise from left, top: Glub & Tarantini, Barcelona, 2001; Glub & Blek Le Rat, New York, USA, 2001; Glub tag, 2003; Glub, 2002; Glub tag, 2003; Glub & Smart, 1994; Glub, Hear, Spok, Know & Ars, 2002; Glub, 1992; Glub, Hen, Inupue & HIV, 1997; Glub, 2002; CA: Glub & Loco 13, Alicante, 2001; CB: Glub, 2002

Great & Bates Copenhagen, Denmark
www.greatbates.com
204–5 A: Great & Bates, 2001; LB: Bates,

Great, Shame & Skone, 2003; RC: Great & Bates, Malmö, Sweden, 2003; RB: Great & Bates, Malmö, Sweden, 2003

Hitnes (g. 1996) Rome, Italy
Crews: 1SA
206 L: Hitnes & Ivan, 2003; RA: Hitnes & Strom, Bern, Switzerland, 2001; BC: Hitnes, 2003; RB: Hitnes, Eindhoven, the Netherlands, 2001
207 LA: Hitnes, Tilburg, the Netherlands, 2001; LB: Hitnes & Sonik, Eindhoven, the Netherlands, 2001; R: Hitnes & Ivan, 2003

HNT / Honet (g. 1988) Paris, France
http://hnteuropa.st
208–9 L: Stak & HNT, Genoa, Italy, 2003. R, top row: HNT, logo sticker; HNT, Modena, Italy, 2003; HNT, Modena, Italy, 2003. Second row: HNT, Genoa, Italy, 2003; HNT, 2001. Bottom row: Stak & HNT; HNT, Glasgow exhibition logo, 2003; HNT, sticker

Inkie (b. 1970 / g. 1983) London, UK
www.inkie.co.uk
Crews: Crime Inc.
210–11 Top row: Inkie, Mode 2 & Banksy, Bristol, 2000; Inkie & Will Barras, London, 2001; Inkie & Bansky, Glastonbury Festival, 2000; Inkie & FLX, Birmingham, 1989. Second row: Inkie & Cheoah, Bristol, 1989; Inkie; Inkie; Inkie. Bottom row: Inkie & Cheoah, Bristol, 1988; Inkie; Inkie & Junk, Bristol, 1988; B: Inkie, from Jet Set Radio game

Jace (b. 1973 / g. 1984)
Born in France, lives Reunion Island
www.gouzou.fr.st
Crews: ADN (f. 1991) & ATS
212 All by Jace. Clockwise from top left: Reunion Island, 2002; Le Havre, 1999; Reunion Island, 2000; Reunion Island, 2001; Reunion Island, 2001
213 LA: Reunion Island, 2001; LC: Le Havre, 2001; Reunion Island, 2002; Reunion Island, 2003; Le Havre, 2000; LB: Reunion Island, 2002; Reunion Island, 2003; R: *Up in the Air*, Reunion Island, 2002

Jazi (b. 1973 / g. 1988)
Geneva, Switzerland
www.jazi.ch
Crews: TZP
214 Top row: Rocket, Lazoo, Stohead, Jazi, Yas 5, Wichos, Pwoz, Sex, Duck & friends, Antwerp, Belgium, 2002. Second row: Jazi, 1999; Jazi, 2000; Jazi, 2000; Jazi, 1997. Third row: Jazi, 2002; Jazi, 1998; Jazi, 2000. Bottom row: Jazi & Jag, 2003
215 A: Jazi, sketch; AL & AR: Jazi, sketches; Bottom row: Jazi & Jag, 2003

Joan (b. 1983 / g. 2000)
Lisbon, Portugal
Crews: LE
216 A: Joan, Kier & Smile, Odivelas, 2003. Bottom row: Joan, 2003; Joan, Oeiras, 2002; Joan, Cascais, 2002

Juice (g. 1984) Amsterdam, Netherlands
www.juiciegraphics.nl
Crews: UR, K9H & WPC
218 All by Juice, apart from those indicated. Top row: Breda, 2001. Second row: Amsterdam, 1998; Amsterdam, 2000. Third row: Juice, Duck & Nash, Amsterdam, 1999

Juice 126 Birmingham, UK
Crews: Ikonoklast
217 All by Juice 126

Karski (b. 1974 / g. 1986)
Utrecht, the Netherlands
www.fotolog.net/karski
219 Top row: Karski, Antwerp, Belgium; Karski, Utrecht; Karski & Mores, Utrecht. Second row: Karski, Antwerp, Belgium; Miss Dubline, *Soldiers*, Antwerp, Belgium; Karski & Miss Dubline, Antwerp, Belgium. B: Karski, canvas 70 x 70 cm; Karski, canvas 80 x 80 cm

Kid Acne (b. 1978 / g. 1990)
Born in Malawi, lives in Sheffield, UK
www.kidacne.com
www.invisiblespies.com
220 All by Kid Acne. Clockwise from top left: 2003; Liverpool, 2003; Pannessiere, France, 2003; 2003; 2003; 2001; 2001; 2003; 1995. C: 2003. B: 2003
221 Top row: 2003; 2003. Second row: 2003. Third row: Manchester, 2002. Fourth row: 2000; 2001. R: 'Blood & Sand' exhibition, Manchester 2003
222–23 'Blood & Sand', 2003

KRSN (b. 1972 / g. 1990) Paris, France
http://nsrknet.free.fr
Crews: Mutan Clan
224–25 All by KRSN, apart from p. 225 LC & LB with Akroe, Paris & Vichy, 2002

KTO Moscow, Russia
226 All by KTO

LA Moscow, Russia
Crews: FAG
227 All by LA

Le Club 70 (f. 2002) Toulouse, France
www.leclub70.com
Members: Tilt, Fafi, Lus, Alex, Ink 76, 2 Pon, Der, ATN, Mist, Tober, Ores, Plume, Piou & Brok
228–29 AL: Mist, Der, Fafi, Alex & Tilt, Charleroi, Belgium, 2002; AR: Der, 2003; C: Der, Alex, Mist, Orus (RIP), Fafi & Tilt, Angers, 2003; B: Noé 2, Cope 2, 2 Pon, Fafi, Tilt, Der, Sonik 002, Brok, Ink 76, Alex, Tkid, Ceet, Kongo, Juan, Need & Don, Toulouse, 2002
230 All by Tilt & Fafi. AL: New York, USA, 2001; AR: Hong Kong, 2003; BL: 2002; BR: 2003
231 R: New York, USA, 2001; L, from top to bottom: 1999; 1999; Tokyo, Japan, 1999; Tokyo, Japan, 2002

Legz (g. 1989) Paris, France
http://membres.tripod.fr/legz/
Crews: TW, DSK & Chrome Addict
232 All by Legz. Clockwise from top left: 2001; 2001; 2003; 2003; 2003; 2001. Bottom row: *Sequence*, 2001
233 A: 2002

Lek (b. 1971) Paris, France
www.lokiss.com/bloodbonus/inter.html
Crews: LCA
234 All by Lek, apart from those indicated. A: *Hof Lions*, 2001. Bottom row: *LCA Typique*, 2002; LCA, 2001; *Reha Style*, 2001
235 Clockwise from top left: 2001; Lek & Hof, 2003; Lek & Hof, Porte de la Chapelle, 2001; 2003. Bottom row: Lek & Hof, Rue LCA, 1999; Lek & Hof, 1999

LJDA Crew
Germany, Switzerland, USA, Spain
236–37 Top row: Rakis, Shogun & Omega, Münster, Germany, 2001. Second row: LA: Shogun, Düsseldorf, Germany, 2002; LB: Shogun & Omega, Düsseldorf, Germany, 2001; R: Shogun, Jaxa, Miro & Cayn, Neuss, Germany, 2002. Bottom row: Omega & Shogun, Kaarst, Germany, 2001

Lokiss (b. 1968 / g. 1985) Paris, France
www.lokiss.com
238–39 Top row: Lokiss, *Devils*, Savigny–sur–Orge, 1998; Lokiss, *Gold* detail, 1989. Second row: Lokiss, *Playing Toys* detail, 1999; Lokiss, Darco & Daim, *Test*, Niort, 1999; Lokiss, *Le Printemps Haussmann*, 1988; sketch for *Devils* wall, Savigny–sur–Orge, 1998

Loomit (b. 1968 / g. 1986) Munich, Germany
www.loomit.de
Crews: FBI & UA
240 L: Loomit & Sat 1, São Paulo, Brazil, 2001; RA: Loomit, canvas, 2002; RC: Loomit, *South Pole*, part of a *Chromopolis* wall, Greece, 2002; RB: Loomit, canvas, 2002

Mac 1 (b. 1973 / g. 1994) Birmingham, UK
www.mac1gallery.co.uk
Crews: Ikonoklast
241 All by Mac 1. Clockwise from top left: *Sepia Series No.1*, canvas, 48" x 60", 2002; *Markus Garvey*, 2002; *The Written Word*, 2003

Mambo France
www.mambo.vu
242 Top row: Mambo & La Force Alphabetick, *Say mars c'est yé*, Marseilles, 1991; Mambo & La Force Alphabetick, *Les Prairies de l'info*, Strasbourg, 1996; Mambo & La Force Alphabetick, *Tamil-Alphabetick*, Pulicat, India, 1993; C: Mambo, *Mambo-Che*, 1998. Bottom row: Alphabetick & Mambo, 1994; Mambo, *Jeanne is Waiting*, Tokyo, Japan, 2002
243 Top row: Mambo, *Il faut savoir communiquer*, 1994; Mambo, stickers, Tokyo, Japan, 2002. Bottom row: Mambo, stickers, Tokyo, Japan, 2002; green stickers A & B: *Explicit Pictograms Series*, 2002

Miss Van (g. 1993)
Toulouse, France
www.missvan.com
244 Clockwise from top left: Miss Van, canvas, 2003; Miss Van, canvas, 2004; Miss Van, canvas at Levi's girls store, Paris, 2003; Miss Van, Manchester, England, 2003; Miss Van, Barcelona, Spain, 2003; Miss Van & Sixe, Barcelona, 2003; Miss Van & Cha, Barcelona, 2003; Miss Van, Slurp, Le Vaudou & Limbo, Barcelona, 2003; Miss Van, Barcelona, 2003; Miss Van, Barcelona, 2003; C: Miss Van painting in Barcelona

Nada (b. 1975 / g. 1988)
Montreux, Switzerland
www.nadaone.com
Crews: AM7 & TDK
245 LA: Nada, Jia & Shaolin, Vevey, 2002; RA: Nada, Aigle, 2001. Right, bottom row: Nada, canvas, 2002; *Jeep*, Monthey, 2002. Bottom row: Nada, Aigle, 2001

Adam Neate London, UK
www.adamneate.co.uk
246 All by Adam Neate, 2003

Noé 2 France
248 All by Noé 2

NTN Crew (f. 2000)
Targovishte, Bulgaria
Members: Nast, Ndoe, Zero, Erka, Porn & Ghost
249 All by NTN Crew

Nylon UK
www.mister-nylon.com
247 All by Nylon

NYSF Crew (f. 2001) Italy
Members: Sat, Aze, Scaw, Schl, Billo, Kinda, Kone, Kye, Riko, Slog 175, Zehr & Zor
250–51 First row: Riky, Bize, Schl & Slog 175, 2001. Second row: Kone 167, Zehr 276, Sat & Scaw 189, 2001. Bottom row: all NYSF crew

Oesch Lille, France
Crews: Le Frelon
252 A: Oesch, Lille, 2002; B: Kwika, Moka, First, Oesch & Novo, Marseilles, 2002

Ogre (b. 1979 / g. 1995)
Lyons, France
Crews: Eska, LBN, 37c & Extralargos
253 All by Ogre, except for bottom image by Ogre, Most, Rusk and CME

ONG Crew Barcelona, Spain
www.tofulines.tk
254–55 All by ONG crew

Pisa 73 (b. 1973 / g. 1990)
Berlin, Germany
www.pisa73.com
Crews: CT
256 All by Pisa 73. L: *Asian Tennis*, 2002;

RA: 2002; RB: *Homeland Security*, 2003
257 LA: 2002; LB: *Asian Tennis*, 2002; RA: *I am God*, 2002.; RC: 2002; RB: *Pisapizza*; C: *Pisapizza Part II*; all from 2003

Pornostars Crew Spain
Members: Most, Rois, Sex & Dibo
258 Top row: Khis & Most, Elche, 2000; Rois, Elche, 2003. Second row: Most & Dibo, Elche, 2003; Most & Rois, Elche, 1999; Most, Elche, 1999. Bottom row: Most, Dibo, CMS, Rois & Fede, Elche, 2000; other images: Rois, Elche, 2003
259 Top row: Most, Alicante, 2002; Most, Rosh & Fons, Elche, 2003. Bottom row: Rois, Elche, 2003; Most, Sex & Reno, Granada, 2003

RAL Crew (f. 1991) Germany, USA
www.hownosm.com
www.megx.de
Members: How, Megx & Nosm
260–61 A: How & Nosm, Universidad Politecnica de Quito, Ecuador, 2004. Bottom row: Nosm, Düsseldorf, 1993; How, Düsseldorf, 1993; Megx, Portugal, 1997; Megx, Wuppertal, 1993; Megx, Wuppertal, 2003; Megx, Wuppertal 2003

Reso 2 (g. 1994) Toulouse, France
Crews: LCF & SP
262 LA: Dran & Reso, 2001; LB: Reso, Dran & Seth 2, 2002. Right, from top to bottom: Reso, Scope 2 & Seor, Niort, 2002; Reso; Reso; Reso & Wear, Paris, 2002

rockGroup (f. 1999) London, UK
www.sheone.co.uk
Members: Otwo, She 1 & David S
264 Clockwise from top left: Otwo, 2003; She 1, Niort, France; She 1, Niort, France; Otwo, *Blackmaple*, canvas, 2003; Otwo & She 1, *UrbanDreams*, Charleroi, Belgium; Otwo, *GhostRok*, 2002; Otwo, 2002; She 1, Niort, France; *Repo*, Otwo, 2001; She 1
265 She 1, London

Rok 2 (b. 1982 / g. 1995)
Innsbruck, Austria
www.rok2.at
Crews: BDMSK, ITD
263 All by Rok 2. LA: 2003; LB: 2001; R: 2003

Rosy Biel, Switzerland
Crews: SUK
268 AL: Rosy & Joks, 2003; BL: Rosy, blackbook sketch, 2001; AR: Rosy, Solothurn, 2001. Second row from top right: 2000; Rosy; 2001; 2000

Rough (b. 1971 / g. 1985)
London, UK
www.roughe.com
266 First row: Rough & Stylo, 1991. Second row: Rough, 1993; Rough, 1998. Third row: Rough, 2002; Rough, 1998. Fourth row: Rough & Arkae, 1997

267 First row: Mac 1, China, Rough, Marq 2 & Juice 126, Birmingham, 2000. Second row: Stormie, Fink, Rough, Juice 126, Just & System, Perth, Australia, 2001. Third row: Rough, Shrume & Stormie, Perth, Australia, 2001. B: sketches, 2002

RUS Crew Moscow, Russia
269 All by RUS crew

Ruskig Malmö, Sweden
www.ruskig.com
270–71 Clockwise from top left: Ruskig, Tele & Mabe, *Sweden Now* detail, Gothenburg, 2003; *Sweden Now* detail; Ruskig, *Who's afraid of red, blue and yellow?* detail, Ångest, Uppsala, 2002; Ruskig, Ångest, Gothenburg, 2001; Cake, Dekis & Ruskig, *To Arafat and Sharon*, Malmö, 2003; B: *Self-Portrait*, Copenhagen, Denmark, 2000

Sat 1 (b. 1977 / g. 1993)
Munich, Germany
Crews: AISM
www.satone.de
272 L: Sat 1 & Soot, *Horse*, 2003; RA: Rok 2 & Sat 1, *Horse in Clouds*, Zagreb, Croatia, 2003; RB: Sat 1, *Mosquito*, Germany, 2002
273 Hitnes & Sat 1, *Underwater*, Germany, 2003

Scage (b. 1974 / g. 1988)
Leiden, Netherlands
274 Text by Scage: A collection of stickers targeting the Dutch railway company; all tags in Amsterdam; all pieces in Eindhoven & Apeldoorn, 2000; all sketches on paper & paintings on canvas, 2003. Bottom row: second image from left, chilling with Seen in Amsterdam, 2003; third, an illegal piece on a 'workbum cabin', 2003; fourth, part of a Scage & Jake production on a scrap tram in Amsterdam, 2002
275 Scage along the railroad in Hoofddorp, 2000; three Hall-of-fame pieces, joint with Katwijk, 1999; Tilburg, 2003; Emmen, 2003; a blackbook sketch & Scage sketch on paper; black Smash-Scage blockbuster along the railroad in Leiden, 2000; stickers & illegal bombings with Smash in 2002

Seak (b. 1974 / g. 1992)
Cologne, Germany
www.seakone.com
Crews: CNS, ES, GBF, SIN & DF
276–77 L: Seak & Besok, 2001; R: Seak
278–79 Seak, JMF & El Kitsch Tasso, Glauchau, 2000

Sex Granada, Spain
www.ElNinoDeLasPinturas.com
Crews: LJDA & Pornostars
280–81 All by Sex

Shame & Sketzh (aka Sketch) (g. 1984)
Copenhagen, Denmark
www.sketch.dk
www.shame.dk
Crews (Sketzh): BAV, CS & Toys Crew
282 A: Shame, Bates & Sketzh, 2001; B: Bates, Great, Shame & Sketzh, 2001

Shark (g. 1985)
Utrecht, Netherlands
www.sharkhometerritory.tk
Crews: TCB & UCS
283 All by Shark between 2000–2, apart from top left, 1991

Sickboy (b. 1980 / g. 1995)
Bristol, UK
www.sickboy.uk.com
284–85 All by Sickboy

SOL Crew (f. 1990)
Eindhoven, Netherlands
www.solcrew.nl
Members: Bombkid, Erosie, Late, Sekty & Zime
286–87 L: Zime, Erosie, Sektie, Lempke, Influenza & Space 3, Zagreb, Croatia, 2003. Centre from top to bottom: Zime, Bkid, Erosie, Late & Sexy, all in 2003. RA: Zime, Bkid, Erosie, Late, Sexy & Sonik, 2003. RB: All by Erosie, 2003; Berlin, Germany, 2003; 2003

SP Crew (f. 1997)
Paris, France
288 AL: Jack 2, Lille; AR: Shadow, Zerie, 2001; CL: Jtwone on Mirage; CA: Boher, 2003; C: Boher, 2003; CB: Boher, 2003; BL: Shadow, Erod in action
289 Middle row: L: Shadow sketch; R: Shadow; B: Gustav, Boher, Shadow & 2 Rude, Lausanne, 2002

Stak (b. 1972 / g. 1987)
Paris, France
www.vivastak.fr.st
Crews: P2B, VAD, MFC & AAA
290–91 From left: *Terror*, Modena, Italy, 2003; Logo, Berlin, Germany, 2001; Logo, 2000; *We Are Free Artists. Outside*, Saran, 1999

Swet Copenhagen, Denmark
www.stick-up-kids.de/html/writers/swet.htm
Crews: TWS, DAM & The Southside Crew
292–93 All by Swet, apart from top image by Swet and Done

Tasek (b. 1973 / g. 1987)
Hamburg, Germany
www.tasek.de
Crews: SUK
294 AL: Tasek, *Godnat*, spraypaint on wood, 2000; AC: Tasek, canvas, 2003; R: Tasek, canvas, 2003; BL: Tasek, *Environmental*, Braunschweig, 2003; BC: part of *Style City* mural, Tasek, How & Nosm, New York, 2003

TCF Crew (f. 1994) UK
www.kuildoosh.com
Members: Aji, Eko, Paris, Seza, Xenz & Ziml
296–97 A: Mad, Acer, Detone, Paris, Feek, Zest, Exta, 1 Spekt, Ponk, AJI, TCF & TDM, Bristol, 2003; BL: Paris, *Duke Love*, Cardiff, 2003; BCA: Paris, *Freestyle*, Bristol, 2001; BCB: Ekoe, Xenz & Paris, *Sleep Deprivation & the Doctor's Medication*, Kingston-Upon-Hull, 1999; BR: Ekoe, Paris & Xenz, *Rocket Science*, Kingston-Upon-Hull, 2001

Theis (b. 1975 / g. 1989)
Copenhagen, Denmark
www.theisone.dk
Crews: JT
295 All by Theis. LA: Copenhagen Jam, 2002; RA: Østerbro, 1999; LB: Holbæk, 2001; RB: Copenhagen, 2002

Thuner (b. 1975 / g. 1989) Madrid, Spain
www.stencilarea.com
298 A: Thuner & Einsamkeit, 2003. Bottom row: Thuner, 2003; Thuner, *DJ Girl*, 2003; RA: Thuner, 2002; RB: Thuner, *Kiss Me Stupid*, tribute to Billy Wilder's movie, 2003

True Stilo Crew (f. 2001)
Minsk, Belarus
http://www.graffiti.org/truestilo/index.html
Members: Gemini, Kem aka Toze, Liquid, Matio, Denik & Denone
299 A: Mors, Komar, 2001. Second row: Iks, 2001; Monk, 2001. Bottom row: LA: Liquid, *Anya*, 2001; LB: Mors, 2001; R: Monk, Kem, 2001; B: sketch by Gemini

UCC Crew (f. 1999) Linz, Austria
www.cancontrollers.net
Members: Mamut & Kryot
300–1 Top row: Kryot, 2003; Ciro, Dinho & Kryot, São Paulo, Brazil, 2002; RA: Noi & Kryot, Zagreb, Croatia, 2003; RB: Mamut & Kryot, 2001; LB: Kryot, 2003. Second row: Kryot, 2003; Kryot, 2003; Mamut & Kryot, Wels, Austria, 2002; Busk, Kryot & Rok 2, Innsbruck, Austria, 2002. Bottom row: Kryot, 2003; Mamut & Kryot, 2003; Mamut, 2002; Mamut & Kryot, 2002

Viagrafik (f. 1999) Germany
www.viagrafik.com
Members: Boe (Bstrkt), Geist 13, Meanworks, Nexus 6 & Sign
302–3 L: Stickers by Slave & Boe, various cities; R: Slave, Mainz, 2003
304 Top left row: Boe & Slave, *Lovely Neighbours*, Mainz, 2003; Viagrafik, *Manipulation*, Mainz, 2003. RA: Boe & Nexus 6, *Silly Parrot Advertisink*, Wiesbaden, 2003. Second left row: Sign, Wiesbaden, 2003; Viagrafik, Wiesbaden, 2003. Bottom row: *Boe*, Villa Viagrafika, Mainz, 2003; Boe, Wiesbaden, 2003; Viagrafik, *Bagga,* Wiesbaden, 2003
305 Slave, *War in the Streets*, Mainz, 2003

Waks / Skaw St Petersburg, Russia
306–7 All by Waks

Nick Walker (b. 1969 / g. 1981–82)
Bristol, UK
www.apishangel.com
308 All by Nick Walker.
A: Alley, canvas, 1 x 3 m, 2003.
Second row: stickers, 2003;
White Panties, canvas, 16" x 20", 2002; *Chinese Salsa*, canvas, 32" x 40", 2003.
B: *Ghetto Ghosts*, canvas, 1 x 3 m, 2002
309 Stencil on concrete, 2003

Walldesign (f. 1999)
Stockholm, Sweden
www.walldesign.se
310 All by Walldesign. AL: *Hotel Berns*, 2002; R *Barbershop Hårdoktorn*, Norrköping, Sweden, 2002. Second row: *Superhype*, 2001; *Clothing Store 'Sisters'*, 2003. Bottom row: *Dowell & Stubbs*, 2002; Walldesign, the office, 2002
311 *Clothing Store 'Sisters'*, 2003

Won (b. 1967 / g. 1985) Munich, Germany
www.wonabc.com
Crews: ABC (f. 1988)
312–13 Clockwise from top left: Won, *Zombie*, 2003; AC & C: *Zombie Love Film Project*, 2003; Won, Cowboy 69, Vince, Dare & Show, 1992; Won, *Rab Lee*, 1993; New, 1993; New & Uno, 1993; Won, *Telephone Sex Phenomenon*, 1993
314–15 All by Won. L: *Siamese Twin Dragon*, Bangkok, Thailand, 2001; AR, row: *Thai Police Love Graffiti*, Bangkok, Thailand, 2001; *The King of Snakes*, Bangkok, Thailand, 2002; CR, row: *The Criminal Spraycan Virus Controls the Moon Dragon in Optikland*, Goethe Institut, Lisbon, Portugal, 2002; *Singalese Tuc Tuc*, Sri Lanka, 2003; BR: *Tamil Tuc Tuc*, Trinco, Sri Lanka, 2003

YCP Crew (f. 1992) Zagreb, Croatia
www.graffiti.org/ycp/index_ie.html
Members: Bruno, Crone, Flame, Lunar & Riox
316 AL: Bruno, Italy, 2001; AR: Bruno & Flame, 2000; CR: Saint, 2001; BL: Bruno, 2002; BR: YCP crew at island of Osjak, south Adria – taggings on the sign by Lunar, 2000
317 AR: 2 Fast & Lunar, *Kresimir Zimonic*, Sesvete, 1999; CL: Lunar, *Aquastar*, Komiza, Island of Vis, 2000; Lunar, *Bolero*, 2000. Bottom row: Lunar, *Cows*, 2001

Yen (b. 1969) Mülheim, Germany
318–19 All by Yen. Background: 1995; AR: 1995; 1993

Rest of the World

Belx2 (b. 1972 / g. 1993) Tokyo, Japan
Crews: STM & MUR
330–31 All by Belx2, apart from p. 331 top image with Remius

BurnCrew Melbourne, Australia
www.burncrew.com
332 Left side: all stickers & posters by Puzle

& Fliq, Tokyo, Japan, 2002; AR: Fliq, 2001
333 AL: T-shirt design, Fliq; AR: Fliq, New York, USA, 2001; CR: Puzle & Fliq, 2003; CL & B: Dskyz, Mase, Puzle & Fliq

Dmote (b. 1971 / g. 1985)
Sydney, Australia
Crews: BCF & SUK
334–35 LA: Sers & Dmote, 2003; RA: Dmote, Sydney, 2003. Second row: train, Dmote, Germany; train, Dmote, Melbourne; train, Dmote, Germany. Bottom row: Pudl, Zatan (Snarl) & Dmote, 2002

Faith 47 (g. 1997)
Cape Town, South Africa
www.faith47.com
336 By Faith 47, 2003
337 First row: Insa & Faith 47, 2002; 2002. Second row: 2003; 2003. Third row: design, 2003; 2002; canvas, 2002
338 First row: 2003; shack, 2003. Second row: 2003; shack, 2003. Third row: London, UK, 2002; canvas, 2003; car, 2002
339 LA: London, 2002; LC: shack, 2003; RA: rooftop, 2003; B: train, 2002

Falco (b. 1972 / g. 1990)
Cape Town, South Africa
Crews: TVA
340 All by Falco

Gogga Johannesburg, South Africa
341 By Gogga, 2002

Kab 101 (g. 1983)
Prospect, Australia
www.area101.com.au
Crews: TFC, TDC, FBI, SOS, MIA & MSA
346–47 All by Kab 101

Kasino (b. 1979 / g. 1984)
Brisbane, Australia
http://www.graffiti.org/kasino/kasino1.html
Crews: ACR, COD & 183 (f. 1992)
348 All by Kasino, apart from B with How & Nosm

Kazzrock (b. 1969 / g. 1990)
Tokyo, Japan
www.kazzrock.com
Crews: CBS & VGA (f. 1991)
349 All by Kazzrock

Mak 1 (b. 1975)
Cape Town, South Africa
Crews: TVA
350 All by Mak 1, apart from those indicated: AL: 2003; AC: canvas, 2002; R: canvas, 2002; LC: Mak 1 & DMO, 2002; B: digital design, 2003
351 L: canvas, 2002; RA: canvas, 2002

Rasty (b. 1982)
Johannesburg, South Africa
www.trocabanda.com
Crews: EM
352 All in Johannesburg, 2002, apart from AC, 2003

SCA Crew (f. 1995) Tokyo, Japan
www.scacrew.org
Members: Bask, Fate, Kres & Phil
354–55 All by SCA crew

Scope (b. 1976 / g. 1984–85) Singapore
www.scope01.com
Crews: OAC & KD
353 All by Scope, apart from top with Trase

Smirk (b. 1977 / g. 1997) **& Sky 189**
(b. 1974 / g. 1989) Cape Town, South Africa
Crews: WOTS (f. 1999)
356–57 A: Solo One (UK), Gogga, Ice, Smirk & Sky, 2001. Bottom row: Smirk, *Boy Found Spraycan*; 2003; Smirk, *Egg on the Face*, canvas, 2003; Smirk, *Tomatohead* (from her series *You Are What You Eat*), 2003; Smirk, canvas, 2003; Sky & Smirk, shop interior, 2003

Stormie (b. 1969 / g. 1982) Perth, Australia
www.stormie.com.au
Crews: Ikonoklast
358–59 All by Stormie: Top row: *falling2*, 13 x 100 cm, 2002; *falling3*, 130 x 100 cm, 2002; Wa Fringe Festival, 2001; 29 x 21 cm, 2002; LB: detail of *Reaching* canvas, 270 cm x 165 cm, 2003
360 L: Patras, Greece, 2003; CL: Patras, 2002; nail installation, 2003
361 AL: Patras, 2002; CL: Volos, Greece, 2002; CR: 2003; LB: 2003; RA: *falling1*, 130 x 100 cm, 2002; RB: detail of *shit*, 200 x 170 cm, 2003

Tash (b. 1977) Brisbane, Australia
www.oneeightthree.com
Crews: 183
362 LA: Tash, Brisbane, 1999; RA: Brisbane, 2000; RC: Brisbane, 2003; RB: Brooklyn, 2002. Bottom row: Tash & Kasino, Brisbane

Trase (b. 1982 / g. 1998) Singapore
Crews: OAC
363 All by Trase: A: *Experimental*, digital image, 2003; BL: '8 mile' graffiti competition Singapore, wood panel, 2003; BR: *Angst Youth*, paper, 2002

Volt Hiroshima, Japan.
Crew: NSF
364 A: Volt, Hanover, Germany, 2002; C: Volt, Dyset, Hanover, 2002, B: stickers, 2003
365 A: Dyset, Post & Volt, Hanover, 2002. Second row: Dyset, Volt & Seak, Cologne, Germany, 2003; Volt, Hanover, 2002. B: Volt, Atem & Dyset, Cologne, 2003
366 All by Volt: AL, AC, AR: Berlin, Germany, 2003. Second row: Munich, Germany, 2002; Berlin, 2003. Third row: Berlin, 2002. Bottom row: Hanover, 2002; Berlin, 2003; Munich, 2002
367 A: Munich, 2002. Bottom row: Hanover, 2002; Munich, 2002; Munich, 2002; Berlin, 2003

376 Jace, Reunion Island, 2001

CREW NAMES

3°M – 3°Mundo
183 – named after Taki 183
ABC – A Bomb Clan / A Break Crew /
 A Boarische Crew
AM7 – Angels of Madness 7th
BAV – Bomb Attack Vandals
BCF – Big City Freaks
CAPO – Crime Art Public Organization
CBB – Crazy Bombs Brains
CG – Chilla Guerilla
CNS – Checking Nuh Skillz
COI – Cause Of Insanity
CS – Can't Stop
CT – CreamTeam
DNS – Daddies Nasty Sons
DMP – Da Maniac Phsicokillaz
DSK – Dope Style Kings
EM – Evil Minds
ES – Evil Sons
ESC – Expressions Sans Conditions
FBI – Fabulous Bomb Inability

FBI (Kab 101) – Future Bombing Inc.
GBF – Gummi Bärchen Front
GM – Gentle Men
HCD – Hard Core Devils
HDV – Hora Do Vandalismo
HOP – House Of Paint
HW – Heavy Wreckers
IC – Intoxicação Corrosiva
ITD – In The Dream
IWDY – I Will Destroy You
IWK – Insane World Krew
JT – Jungle Tactics
K9H - K9 Hysteria
KD – Kings Destroy / Killa Dogs
KOT – Kingz Of Toys
LCA – Lettres Contre Architecture /
 Lektriq City Area
LCF (Caru) – Los Cuatro Fantásticos
LCF (Reso 2) – Le Cercle Ferme
LE – Lisbon Eyes
LJDA – Los Jinetes Del Apocalipsis
LP – Love Pizza
LTS – Last to Survive

LUZ – Life Under Zen
M12 – Majestic 12
MIA – Mission In Art
MOD – Monsterz Of Disasterz
MSA – Melbourne Suicidal Assassins
MTR – Mi Tierra Represento
MUR – Mad Underground Resistance
NTN – Nast To Ndoe / End 2 End
NYSF – New York Syndrome Family
OAC – Operation Art Core
OTD – Out To Live
P2B – Poseurs de Bomb
PDB – Poco Di Buono
RP – Restons Punk
SCA – Spray Can Addict / Sports
 Crime Art / Scribbla Carmar Art
SO – Stuff Only
SOL – Signs of Life
SOS – System Of Style
SP – Serial Painterz
STM – Step To Me
SUK – Stick Up Kids
TAF – The Arty Fumes

TATs – Top Artistic Talent / Transit Art Team
TCB – Take Care of Business
TCD – Trash Can Design
TCF – Twentieth Century Frescoes
TDC – The Death Connection
TDK – The Digital Kids
TFC – Twenty First Century
THS – The Huns Sect
TNB – The Nasty Boys
TS5 – The Spanish Five
TSF – The Spanish Five
TWS – The Wild Side
TZP – Twilight Zone Posse
UA – United Artists
UCC – Underground Can Controllers
UCS – Utrecht Central Station
UNC – Urban Nightmares Crew
UR – Unlimited Resources
VAD – Vau au Diable
WOTS – Word On The Street
WPC – Westpark Coalition
VGA – Vanguard Graffiti Art
YCP – Yo Clan Posse

GLOSSARY

blackbook The sketchbook of a graffiti artist
bombing / to bomb Prolific spray-painting on trains
 and walls
bubble style An early type of lettering, which developed
 in New York and gives letters a rounded appearance,
 making them look like bubbles or clouds
buff / to buff The chemical cleaning process undertaken
 by local authorities to rid trains or walls of graffiti
cap (fat or skinny) Spraycan nozzle that can be fitted to
 alter spray width (to produce thicker or thinner lines)
character A figurative element (animals, comical figures etc)
 of a picture. In the early days, characters were used as
 ancillaries to letters but now they are an independent
 style group.
crew A group of graffiti artists who create group pieces
 and tag the crew initials along with their name
end-to-end (e2e) A picture below the windows on a train,
 stretching the whole length of the carriage
fill-in The solid area inside a letter, which is coloured in
Hall of Fame Mostly legal walls on which high-quality
 pictures are produced
insides A train carriage that has been spray-painted inside

lay-up The siding in which a train is left between use
logo graffiti / iconic graffiti A relatively new graffiti style,
 specializing in the production of emblems and
 striking logos
mural A lavishly created piece, not dependent on technique
 whether painted with a brush or spraycan
nozzle Another expression for a cap
outline The outline of letters
outsides Carriages spray-painted on the outside
panel A picture painted below the window of a train
piece Short for 'masterpiece', the expression for a
 spray-painted letter-orientated picture
pochoir The French expression for stencil graffiti
post-graffiti (neo-graffiti) Modern development in graffiti
 culture, characterized by more innovative approaches
 to form and technique that go beyond traditional
 perceptions of the classic graffiti style
stencil graffiti A technique in which a motif is cut out
 of cardboard to create a template, through which
 an image can be painted or spray-painted again
 and again
street art An independent art form, which often has
 older roots and has not been influenced by hip-hop;
 nowadays it is often used as a generic term for art
 in urban, public spaces

style Previously a synonym for the individual letters of
 a writer; now refers to an artist's individual style
tag Striking signature of a graffiti artist
throw-up Simple letters, often only with an outline or
 a single-colour fill-in, which are generally painted
 very quickly
top-to-bottom (t2b) A piece that covers a carriage from
 top to bottom
toy Derogatory term for a beginner or unskilled graffiti artist
whole car A carriage that has been spray-painted all over
whole train A train that has been spray-painted all over
wildstyle A very complex construction of entwined letters
writer A graffiti artist who generally concentrates on letters
 (tags, styles etc)
yard A depot where trains are put when they are out
 of use

WEBSITES

Art Crimes www.graffiti.org
Ekosystem www.ekosystem.org
Nicholas Ganz www.keinom.com
Lost Art www.lost.art.br
Tristan Manco www.stencilgraffiti.com /
 www.streetlogos.com
Shady Lanes www.shadylanes.org
Subway Outlaws
 www.subwayoutlaws.com
Axel Thiel www.graffitiforschung.de
Wallstreetmeeting
 www.wallstreetmeeting.de
Wooster Collective
 www.woostercollective.com

SELECT MAGAZINES

Arcano2 (Italy)
 arcano2@yahoo.it
Brain Damage (Poland)
 www.bd.pl
 bd@bd.pl
Carpe Diem (Greece)
 carpe_diemgr@hotmail.com
Graff It! (France)
 www.graffitmag.com
 news@graffitmag.com
Graphotism (United Kingdom)
 www.graphotism.com
Lost (USA)
 lost@seekingheaven.com

Underground Productions (Sweden)
 www.underground-productions.se
 up@underground-productions.se
Under Pressure (Canada)
 www.urbanx-pressions.com
 info@urbanx-pressions.com
Worldsigns (France)
 www.ws-mag.com
 abo@ws.mag.com
ZGB Kaos (Croatia)
 www.zgbkaos.com
 distribution@zgbkaos.com

SELECT BIBLIOGRAPHY

Chalfant, Henry, & James Prigoff,
 Spraycan Art, Thames & Hudson,
 London, 1987
Cooper, Martha, & Henry Chalfant,
 Subway Art, Thames & Hudson,
 London, 1984
Cooper, Martha, & Joseph Sciorra,
 R.I.P.: New York Spraycan Memorials,
 Thames & Hudson, London, 1994
Dalek, Dalek: Nickel-Plated Angels,
 Gingko Press, 2003
Hundertmark, Christian, The Art of Rebellion,
 Gingko Press, 2003
Kelly, William, Murals: The Bogside Artists,
 The Bogside Artists / Guildhall Press,
 2001
Manco, Tristan, Stencil Graffiti,
 Thames & Hudson, London, 2002
Manco, Tristan, Street Logos,
 Thames & Hudson, London, 2004
Murray, James & Karla, Broken Windows,
 Gingko Press, Corte Madera (CA), 2002

Acknowledgments

Thanks to everyone who contributed. Special thanks to all the artists featured in this book – your help was amazing, and without you none of this would have been possible.

Thanks to everybody who helped me with images and contacts, showed me around or gave me other support: Alëxone, Bask, Binho, Bizare, Cattle, Caz, Cern, Ces, Ciber Stargass, Codeak, Cope 2, Corail, Crack 15, Daim, Dalek, Danger 59 and Andrea, Deadleg, Dephect, Ecka, Evoke, Faith 47, Falco, Mrs. and Mr. Foley, Flint Gennari and Sara Signorelli, Ges, Hewn, How, Keti, Kres, Labrona, Lens, Lines, Rose Lombard, Luca from *Arcano2*, Mak 1, Man One, Med, Megx, Merk, Merz, Most, Adam Neate, Ninos Boom Box, Nosm, Ogre, Paris, Marco Petrovic, Prism, Priz, Risk, Rok 2, Rosy, Rough, Sat 1, Seak, Sky 189 & Smirk, Sonic 002, Stayhigh 149, Stormie, Tony 'Sub' Curanaj, Supa, Syco, Ta550, Tash, Theis, Tilt, Tkid 170, Tracy 168, Urban, Volt, Waf, Nick Walker, Wealz, Won, Woozy, Yen & Yes 2.

Special thanks go to the following people for their great help, invaluable knowledge and contribution: Tristan Manco for his support during the research for this book and for lending his fantastic images; Sam Clark for his great design; my girlfriend Elena Jotow for being on my side during the two and a half years of research; my parents and brothers, Maurice and René, for their assistance; Karsten Zonta for his inspiring ideas; Rebecca Pearson and everyone else involved in the book at Thames & Hudson; Above; Shady Lanes for her atmospheric images; Susan Farell for her kind support on Art Crimes; the 'Urban Discipline' collective for their biographies; Ink 76 for his great help in New York; Other and Sue for a lovely time in Montreal; Mine One for his good contacts and an interesting journey to Toronto; Uri Kadanzev for the Russian section; Ekosystem for his great interviews with artists; *Lost Art*'s Ignacio for his Brazilian photos; Rasty for showing me round Johannesburg; and Faith 47 for all her wonderful help in Cape Town.

Photo credits

About the author

Nicholas Ganz (also known as Keinom) is a German street and fine artist from Essen who has travelled worldwide to gather material for this book. He has been documenting street art / graffiti culture for over ten years and is active as a writer, painter and designer in many fields. For further information on Nicholas Ganz and his work, please go to www.keinom.com and www.graffitiworld.org.

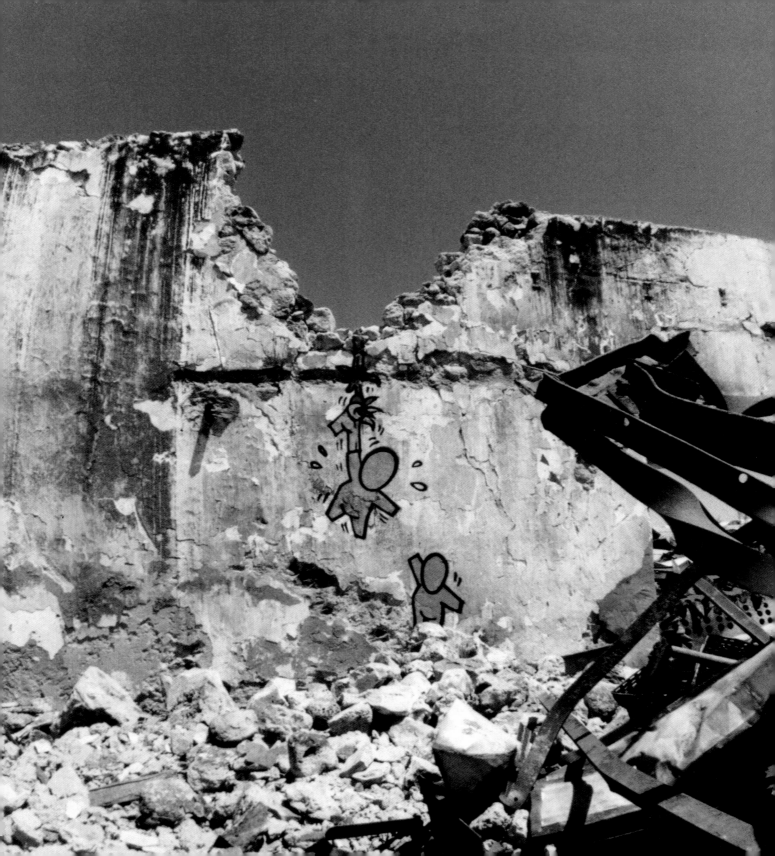

DATE DUE

DEC 1 0 2012	
MAY 1 5 2016	